THE MUSLIMS OF INDIA

THE MUSLIMS OF INDIA

A Documentary Record

Edited by
A.G. Noorani

OXFORD
UNIVERSITY PRESS

OXFORD
UNIVERSITY PRESS

YMCA Library Building, Jai Singh Road, New Delhi 110 001

Oxford University Press is a department of the University of Oxford. It furthers the
University's objective of excellence in research, scholarship, and education
by publishing worldwide in

Oxford New York

Auckland Cape Town Dar es Salaam Hong Kong Karachi Kuala Lumpur
Madrid Melbourne Mexico City Nairobi New Delhi Shanghai Taipei Toronto

With offices in

Argentina Austria Brazil Chile Czech Republic France Greece Guatemala
Hungary Italy Japan Poland Portugal Singapore South Korea Switzerland
Thailand Turkey Ukraine Vietnam

Oxford is a registered trademark of Oxford University Press
in the UK and in certain other countries

Published in India
by Oxford University Press, New Delhi

First published 2003
Oxford India Paperbacks 2004
Fourth impression 2009

ISBN-13: 978-0-19-567056-1
ISBN-10: 0-19-567056-6

Printed in India by Pauls Press, New Delhi 110 020
Published by Oxford University Press
YMCA Library Building, Jai Singh Road, New Delhi 110 001

To

The memory of my parents

Abdul Majeed and Havabai Noorani

Contents

List of Documents

Preface

This is a selection of source material recording how the Muslims of India responded to the situation in which they found themselves after the partition of India, on the attainment of independence on 15 August 1947. The documents selected illustrate the major landmarks, one hopes, as best as a single, compact volume covering half a century can. A definitive record will run into several volumes. The emphasis is largely on the Muslims' responses to the problems they face, and on the debates that ensued in the light of the advice which the community received, immediately on partition and thereafter, from India's leaders like Gandhi, Nehru, Azad, and Patel. The Introduction knits the documents together, drawing attention to the major themes. It is not a definitive essay on the subject of the volume. Variant spellings of names, places, or words have been retained as that in the originals. Every attempt has been made to keep strictly to the original documents.

I am solely responsible for any shortcomings or blemishes, whether in comments in the Introduction or in the selection of the documents.

A.G. Noorani
Mumbai

February 2003

Introduction

When India was partitioned into two states, India and Pakistan, on the attainment of independence from British rule, on 15 August 1947, the Muslims of India found themselves facing the same traumatic change which confronted their forbears ninety years ago at the time of the Mutiny in 1857. Radical change in the political order, amidst bloodshed and carnage, was accompanied with threat to old ways of living. Its dimensions they could only dimly perceive, its reality shook them. They feared the worst. As in 1857, their loyalty to the new state was suspect. They felt helpless and forlorn as they experienced distrust and hostile discrimination in their daily lives.

But there was a big difference between the two situations. The late nineteenth century threw up leaders of high stature—men of remarkable intellectual equipment, cultural attainment, strength of character, and commitment. They had capacity for leadership and were ready to plunge themselves in politics and provide the leadership which the community sorely needed.

In 1947, the Muslims of India found themselves leaderless. Those in whom they had, till the day before, reposed confidence, went to Pakistan. The ones who remained had none of the qualities of Syed Ahmed Khan, Ameer Ali, or Badruddin Tyabji. Maulana Abul Kalam Azad, their peer in most respects, demonstrated within months after the partition that his were the gifts of scholarship, even political wisdom and insight, but not of political leadership, still less of organization. Far smaller men came to the fore to grab the mantle of leadership and left imprints which the community has not been able to erase completely.

Bereft of determined and wise leadership, the Muslims of India took a wrong turn in 1948-49 and found themselves confused. Some treaded along the cul-de-sac of political mobilization for redress of grievances which shows no signs of lessening. The mobilization had been mostly on a commercial basis. Others found themselves largely ineffective in secular parties; not least because of their own inadequacies. On their part, the political parties reckoned that too

strident an espousal of the Muslims' cause might cost them support from the majority community and doom them to marginalization, if not extinction. The dilemma could be resolved only by a concerted effort by both sides; the Muslims should participate actively in all fields of national endeavour, striving to put to rest memories of an unhappy past, while the secular parties should assist them in this effort and make redressal of Muslims' grievances part of a wider campaign for eradication of social wrong and economic deprivation.

Things went wrong soon after the partition. Experience even during the British rule amply demonstrated that by themselves constitutional safeguards are hopelessly inadequate. They need political underpinning. If protection was no help, partition was no solution to the problem, rather it aggravated it. Participation in public life alone, in its entire range of activities, provides hope. The deepening divide between Hindus and Muslims was attributed to separate electorates which the Lucknow Pact between the Indian National Congress and the Muslim League endorsed in 1916. It held sway till the partition of India in 1947. But a vital aspect of the pact was neglected. It secured the Muslim League's acceptance of a whole set of proposals for substantial advance in responsible government. Protection of minorities was linked to their participation in the country's march towards freedom. Years later, two socialist leaders, Asoka Mehta and Achyut Patwardhan, made an important point: 'While the Muslims gained substantial weightage, they gave up their right to vote in the General Constituencies that they had enjoyed so long. In dropping it, they lost an important leverage and began to isolate themselves from the rest of India'.[1]

The Report on Indian Constitutional Reforms (1918), jointly authored by the Secretary of State for India, Edwin S. Montague, and Viceroy Lord Chelmsford, criticized the Lucknow Pact but acquiesced in it, because it represented an inter-communal accord.[2]

The Report, nonetheless, pronounced itself unequivocally against separate electorates:

A minority which is given special representation owing to its weak and backward state is positively encouraged to settle down into a feeling of satisfied security; it is under no inducement to educate and qualify itself to make good the ground which it has lost compared with the stronger

[1]Asoka Mehta and Achyut Patwardhan, *The Communal Triangle in India*, Allahabad: Kitabistan, 1942, p. 107.
[2]Report on Indian Constitutional Reforms, Calcutta: Superintendent, Government Printing, 1918, para 163, p. 105.

majority. On the other hand, the latter will be tempted to feel that they have done all they need to do for their weaker fellow-countrymen, and that they are free to use their power for their own purposes. The give-and-take which is the essence of political life is lacking. There is no inducement to the one side to forbear, or to the other exert itself. The communal system stereotypes existing relations. We regard any system of communal electorates, therefore as a very serious hindrance to the development of the self-governing principle.[3]

Incredibly, some prominent members of the Muslim League demanded separate electorates in the Constituent Assembly of India even in the fundamentally altered situation, and thus fuelled distrust of Muslims which pervaded significant sections in the Assembly. That is a measure of their incapacity for serious reflection and their utter incompetence in leadership.

Their erstwhile leader, Mohammed Ali Jinnah, had done nothing to prepare them to meet the new situation and a lot to impede them. Mohammed Raza Khan, a prominent Muslim Leaguer, ruefully recorded in his memoirs:

About the end of July 1947, the Muslim members of the Central Legislative Assembly met Mr Jinnah who was also the leader of the Muslim League Party in the Assembly. It was for the last time that they met him, for he was then arranging to leave for Karachi. It was their farewell meeting. Many members expressed concern about the future of the Muslims in India. When they sought his advice about their future, and that of the Muslim League, he refrained from saying anything specific. He, however, told them they had enough experience under his leadership, and they would have to evolve their own policy and programme. They had to decide things for themselves in the new set-up, and in the changed circumstances. But he made it clear, in no uncertain terms, that they should be loyal to India, and that they should not seek to ride two horses. It has, therefore, to be said in clearest terms that Mr Jinnah did not give any positive directions or instructions to Indian Muslims as to their future.[4]

Evidently Muslims did not take Jinnah very seriously when he said at Kanpur, on 30 March 1941, that 'in order to liberate seven crores of Muslims where they were in a majority he was willing to perform the last ceremony of martyrdom if necessary and let two crores of Muslims be *smashed*.'[5]

[3]*Ibid.*, para 230, p. 149.
[4] *What Price Freedom*, Mohammed Roya Khan, Chennai, 1969, pp. 321–2.
[5]*Speeches and Writings of Jinnah* by Jamiluddin Ahmed, vol. I, p. 246.

The only charitable explanation for this pronouncement is that Jinnah did not expect that his demand for Pakistan would be conceded in the form it was. It reflected, however, a certain awareness of what would befall Muslims in India were it to be—especially in the context of the two-nation theory he had espoused, a theory essentially false—riddled with contradictions and baleful in its consequences.

Jinnah's speech at the League's session at Calcatta in December 1917, a year after the Lucknow Pact, suggests that political participation was part of the scheme for constitutional protection. The goal was partnership in power sharing on a non-communal basis:

It is said that we are going on at a tremendous speed, that we are in a minority and the Government of this country might afterwards become a Hindu Government. I want to give an answer to this. I particularly wish to address my Mahomedan friends on this point. Do you think in the first instance, as to whether it is possible that the government of this country could become a Hindu Government? Do you think that Government could be conducted by ballot boxes? Do you think that because the Hindus are in the majority, therefore they could carry on a measure, in the Legislative Assembly, and there is an end of it ? If seventy millions of Mussalman do not approve a measure, which is carried by a ballot box, do you think that it could be enforced and administered in this country? (Cries 'No. No.'). Do you think that the Hindu statesmen, with their intellect, with their past history, would ever think of—when they get self-government—enforcing a measure by ballot box? (Cries of 'No.'). Then what is there to fear? (Cries of 'Nothing'). Therefore, I say to my Moslem friends not to fear. This is a bogey, which is put before you by your enemies (cries of 'Hear' 'Hear') to frighten you, to scare you away from the co-operation with the Hindus which is essential for the establishment of self-government (Cries of 'Hear', 'Hear'). If this country is not to be governed by the Hindus, let me tell you in the same spirit, it was not to be governed by the Mohammedans either and certainly not by the English (Cries of 'Certainly not'). It is to be governed by the people (Cries of 'Hear', 'Hear') and the sons of this country (Cries of 'Hear', 'Hear') and I, standing here—I believe that I am voicing the feeling of the whole of India—say that what we demand is the immediate transfer of the substantial power of Government of this country (Cries of 'Hear', 'Hear') and that is the principal demand of our scheme of reform.[6]

[6]R.K. Prabha (ed.), *An Anthology of Modern Indian Eloquence*, Bombay: Bharatiya Vidya Bhavan, 1965, p. 132.

The advice he gave to a Muslim delegation thirty years later (Chap., I, doc. 3) was as realistic as it was belated: be loyal to India, concentrate on education and politics, and avoid confrontationist politics. Perhaps the only Leaguer who cared to analyse the problem was H.S. Suhrawardy, former prime minister of Bengal, who became prime minister of Pakistan. His letter to Chaudhary Khaliquzzaman, leader of the Muslim League Party in the Constituent Assembly, posed the problem (Chap., I, doc. 4) and formulated three alternatives: 'holding fast to the two-nation theory', sharing truly in 'the common citizenship of the Indian Union', or 'complete subservience'. He preferred the second as' the best position to take' but asked whether Muslims will be accepted 'as an equal and as a common citizen'. He made two suggestions: a movement for raising the morale of the minorities in India as well as in Pakistan with 'Mahatma Gandhi as the spearhead of this movement' preceded by a convention of Muslim legislators and of 'Muslim leading men in each province'. In short, *mobilization of the Muslims for participation in a secular movement led by Gandhi.*

Khaliquzzaman was handpicked by Jinnah to lead Muslims of India, in preference to the independent-minded and statesmanlike Nawab Mohammed Ismail of Meerut. Before long, Khaliquzzaman went to Pakistan and settled down there; so did some other prominent Muslim members of the Constituent Assembly, namely, Z.H. Lari, Husain Imam, and Abdul Sattar Sait.[7] So, eventually also did Suhrawardy himself.

The All-India Muslim League met for the last time in Karachi during 14–15 December 1947 and decided to split the organization (Chap., I, doc. 6). 'There shall be separate Muslim League organisations for Pakistan and the Indian Union.' The assets and liabilities were to be 'equitably divided' between the two (that did not come to pass). The significance of this resolution lay in its nomination of Mohammed Ismail as a convener of the Indian Union Muslim League, as it still styles itself, and of Madras as the venue for the meeting of its Council. The powerful units, of Uttar Pradesh, Bihar, and Bombay, were bypassed. The proceedings reveal the *damnosa hereditas* which Jinnah imposed on Indian Muslims over the opposition of some of their leaders.

The Communist Party of India's organ *New Age* (11 January 1948) alone revealed what happened.[8] Jinnah said: 'There must be

[7]*What Price Freedom*, p. 323.
[8]S.S. Pirzada's *Foundations of Pakistan*, vol. II, pp. 570–2, draws on its version.

a Muslim League in Hindustan. If you are thinking of anything else, you are finished. If you want to wind up the League you can do so, but I think it would be a great mistake. I know there is an attempt by Maulana Abul Kalam Azad and others to break the identity of Muslims in India. Do not allow it. Do not do it.'

Hussain Imam of Bihar then moved his amendment: 'In the resolution, . . . "in place of the All-India Muslim League, there shall be separate League Organizations for Pakistan and the Indian Union" [and] the word "shall" should be replaced by "may".' He said 'People here do not know the difficulties the Muslims are facing in India. They should be left free to decide their future according to the circumstances.' No one supported the amendment.

Jinnah replied: 'I sympathise with Mr Hussain Imam. He has not read the resolution properly. You should constitute the Muslim League in India. If you do not you would go back to 1906. You are 40 million; you can have a leader; if not one, then two or more. We cannot give directives to you. When you are strong and Pakistan is developed, the settlement will come.' The resolution was passed with an overwhelming majority. Some ten members, including Suhrawardy and Mian Iftikharuddin, voted against it.

Liaquat Ali Khan and Ismail were elected as conveners for the Pakistan Muslim League and the Indian Muslim League, respectively. It was decided to hold their sessions shortly in Karachi and Madras. This belied Jinnah's claim on 19 December 1947 that Indian Muslims were entitled, by implication allowed, 'to form their own independent policy'.

The course which the League subsequently adopted is ably traced in Mohamed Raza Khan's book. He was a member of the League's Council since 1943, of the IUML till 1963, and of the Madras Legislature from 1946 to 1962 .

When the League's Council met in Madras on 10 March 1948, barely thirty members turned up. There were no representatives from Bengal, Orissa, Bihar, and Delhi. Uttar Pradesh had a sole representative in Maulana Hasrat Mohani. 'It was decided to continue the League with emphasis on non-political activities.'

Mohammed Ismail was elected president and was authorized to establish branches in all the states. The League continues still to be a regional body with a strong base in two states, Tamil Nadu and Kerala, and nowhere else. It began by according 'full and complete support to the Congress' and sought 'some sort of private

understanding between the Congress and League'.[9] It received encouragement from Congress leaders, particularly K. Kamaraj, who sought the League support, albeit on his terms. But Ismail, styling himself as Quaid-i-Millat, was the poor man's Quaid-i-Azam. When the emissaries reported to him, 'he rejected Mr Kamaraj's offer offhand and insisted that the Congress should recognize the League as the sole representative organization of Muslims; the League would select all the Muslim candidates and those nominees who would contest on Muslim League ticket should be supported by the Congress. When elected these Muslim League candidates and these nominees who would contest on the Muslim League ticket should support the Congress party in the Legislative Assembly.'[10]

In 1961 Raza Khan broke ranks. In a speech on 19 August, he deplored that instead of working amongst the Muslim masses to raise their social, educational, and economic levels, 'we bother ourselves only with elections in Madras and Kerala, and that too without any corresponding benefit'. Born in cynical opportunism, the League flourished by it. Its role during the Emergency was despicable.

Gandhi reacted to the League's resolution of 15 December 1947 by advising Muslims not to revive the League and support the Congress instead; yet, not rush to join it (Chap., I, doc. 7). It was a wise counsel which Suhrawardy welcomed (Chap., I, doc. 8).

Sadly, Azad failed to rise to the occasion. A demoralized and confused community was his to lead. He spoke to it, in a much acclaimed oration, at the Jama Masjid, on 23 October 1947 in the language of taunt and reproach ('I hailed you; you cut off my tongue').

His was by no means the first, or the last, instance of a politician who so revelled in his gifts of oratory as to forget the superior claims of sound statecraft (Chap., I, doc. 5). Nothing came of the Indian Union Muslim Conference at Lucknow, over which he presided, on 27 December 1947 (Chap., I, doc. 9); his claims to the contrary notwithstanding, (Chap., I, doc. 15), Azad withdrew from an active role in Muslim politics and confined himself, to imparting advice and exerting sound influence on the Cabinet and on the Congress till his death.

The gravest disservice to the community was done by leaders of the League in the Constituent Assembly (Chap., I, doc. 21). They

[9]*What Price Freedom,* p. 447.
[10]*Ibid.,* 467.

demanded not only reservation of seats but separate electorates as well provoking Vallabhbhai Patel to deliver remarks he could well have left unsaid. To do him justice he also said some home truths in the interest of the Muslims themselves.

He said:

I do not know whether there has been any change in their attitude to bring forward such an amendment even now after all this long reflection and experience of what has happened in this country. But I know this that they have got a mandate from the Muslim League to move this amendment. I feel sorry for them. This is not a place today for acting on mandates. This is a place today to act on your conscience and to act for the good of the country. For a community to think that its interests are different from that of the country in which it lives, is a great mistake. Assuming that we agreed today to the reservation of seats, I would consider myself to be the greatest enemy of the Muslim community because of the consequences of the step in a secular and democratic State. *Assume that you have separate electorates on a communal basis. Will you ever find a place in any of the Ministries in the Provinces or in the Centre?* You have a separate interest. Here in a Ministry or a Government based on joint responsibility, where people who do not trust us or who do not trust the majority cannot obviously come into the Government itself. Accordingly, *you will have no share in the Government.* You will exclude yourselves and remain perpetually in a minority. Then, what advantage will you gain?[11]

The Leagues were split. But the course was set for years to come. Mohammed Ismail remained for long leader of the Indian Union Muslim League. The Jamiat-ul-Ulema-i-Hind wended its way as an ally of the Congress. Azad confined his exertions to the Congress Party and in the Cabinet. The minorities problem became a weapon in the Indo-Pak cold war. Patel made support to Kashmir a test of the Muslims' loyalty to India (Chap., I, doc. 11). Jayaprakash Narayan's appeal to Muslims to join the Socialist Party (Chap., I, doc. 22) held out a ray of hope. There was little follow-up by the party and less response from the Muslims.

Prime Minister Jawaharlal Nehru's letter to the chief minister of Madhya Pradesh on 20 March 1954 (Chap., I, doc. 27) and his circular letter to the chief ministers on 26 April 1954 (Chap., I, doc. 28) succinctly described the state of the Muslim's deep frustration, persistent discrimination in the public services and in commerce and industry, educational backwardness, the Congress's apathy, and the Muslims' withdrawal into a political ghetto.

[11]*Constituent Assembly Debates*, 26 May 1949, vol. VIII, p. 350; his reply to the debate on 25–26 May 1949.

Dr B.R. Ambedkar made some pertinent observations when, as chairman of its drafting committee, he moved for the consideration of the draft Constitution in the Assembly on 4 November 1948: 'It is wrong for the majority to deny the existence of minorities. It is equally wrong for the minorities to perpetuate themselves. A solution must be found which will serve a double purpose. It must recognize the existence of minorities, to start with. It must also be such that it will enable the majorities and minorities to merge some day into one.' He claimed that the solution proposed in the draft (based on the 1947 decision) met this test.[12] However, if self-perpetuation of the minorities is to be averted, *constitutional safeguards must be matched at the political level by a party system which cuts across the majority–minority divide.*

The Muslim League, and very many Muslims outside it as well, were quite oblivious to the sentiment prevailing in the country after the partition. The partition inflicted as grave a wound on the Hindu psyche as it did on that of the Muslims. To not a few, partition was the culmination of a process which began with separate electorates and took in its train various charters of demands like Jinnah's famous fourteen points. Any expression of Muslims' grievances or of Muslims' identity reminded them of that and caused disquiet. Muslims' grievances increased, but channels of protest were constrained. Muslims' positive contribution to the secular ideal, as distinct from protests against injustices, was weak. There were few to counsel them that the politics of protest alone—especially if organized on a communal basis—would *aggravate* the problem.

The political clime immediately after the partition was well described by Nehru's biographer:

In performing this duty, his first as the leader of a free people, Nehru could not rely on the unqualified support of his Cabinet. Some of the members, such as Azad, John Mathai, Kidwai and Amrit Kaur, were with him; but they carried little influence with the masses. The old stalwarts of the Congress, however, such as Patel and Rajendra Prasad, with the backing of the leader of the Hindu Mahasabha, Syama Prasad Mookerjee, believed not so much in a theocratic state as in a state which symbolized the interests of the Hindu majority. Patel assumed that Muslim officials, even if they had opted for India, were bound to be disloyal and should be dismissed; and to him the Muslims in India were hostages to be held as security for the fair treatment of Hindus in Pakistan.[13]

[12]CAD, vol. VII, p. 39.
[13]S. Gopal, *Jawaharlal Nehru*, Oxford University Press, vol. II, pp. 15–16.

On one occasion (15 October 1948) Patel went so far as to advise Nehru to warn Pakistan that if the exodus of Hindus from East Pakistan continued, India would send out Muslims from West Bengal in equal numbers. Nehru, needless to add, rejected the advice.[14] Patel did not indicate the basis on which or the process whereby the Muslim expellees would he selected.

The RSS and the Hindu Mahasabha were demoralized after bans were imposed on them in the wake of Gandhi's assassination on 30 January 1948. The Mahasabha leaders, Syama Prasad Mookerjee, resigned from the Nehru Cabinet adroitly at a moment when he could strike hard. It was in protest over the Nehru–Liaqat Pact, on 8 April 1950, on the treatment of the minorities in both countries with specific reference to the two Bengal's, Assam, and Tripura.[15]

Mookerjee lost little time in setting up a new platform. Based on an understanding with the leader of the RSS, M.S. Golwalkar, he floated the Bharatiya Jan Sangh on 21 October 1951.[16] To anticipate, the Jan Sangh dissolved itself on 1 May 1977 and re-emerged as the Bhartiya Janata Party on 5 April 1980. Meanwhile, Golwalkar founded the Vishwa Hindu Parishad (VHP) in Mumbai on 29 August 1964 which, in turn, set up the Bajrang Dal in May–June 1984. Shortly afterwards the first Dharma Sansad had passed a resolution in April 1984 for the 'liberation' of the site on which stood the Babari Masjid at Ayodhya.[17]

Thus from 1951 onwards the ethos of the national movement of which Gandhi and Nehru were the foremost exponents, but which had also been expressed in resolutions of the Indian National Congress since 1885 was under direct attack.

[14]Durga Das (ed.) *Sardar Patel's Correspondence 1945–50*, Ahmedabad, Navajivan Publishing House, 1973, vol. VII, p. 670.

[15]For the text vide A. Appadorai, *Select Documents on India's Foreign Policy and Relations 1947–1972*, Oxford University Press, 1982; vol. I, pp. 88–98.

[16]*Vide* the author's *The RSS and the BJP: A Division of Labour*, Leftword Books, 2001, 2nd Edn., pp. 6 and 57.

[17]*Organizer*, 22 April 1984. *Vide* Walter K. Andersen and Shridhar D. Damle, *The Brotherhood in Saffron: The Rashtriya Swayamsewak Sangh and Hindu Revivalism:*, Vistaa, 1987, pp.133–7. On the VHP and the Bajrang Dal, *vide* Christophe Jaffrelot, *The Hindu Nationalist Movement in India*, Viking, 1996, pp. 363 and 478 respectively on the VHP's 'militant wing', The Bajrang Dal.

Its impact on the communal situation was direct. A leading journalist, Inder Malhotra wrote in 1969:

The strength and influence of the avowedly communal and objectionably militant Hindu parties have grown alarmingly. This cannot be utterly unconnected with the distressing rise in the number of communal incidents and riots. It would, of course, be unfair to believe or even allege that the entire or even the bulk of the majority community is under the influence of communalists. . . . [18]

On New Year's Day 1970, *The Indian Express* carried a detailed report on the RSS which noted that 'the growth of the RSS has coincided with the recent wave of communal riots in the country'.

That the riots spread at an alarming pace after a period of quiet destroys a good many hypotheses. A Union home ministry review recorded:

From 1954 to 1960 there was a clear and consistent *downward trend*, 1960 being a remarkably good year with only 26 communal incidents in the whole country. *This trend was sharply reversed in 1961*. The increase was, however, largely in Bihar, Madhya Pradesh, Uttar Pradesh, and West Bengal. There was a substantial fall during the next two years indicating stabilization of the situation. 1964 was an abnormal year when largely as a repercussion of serious communal riots in East Pakistan there was large scale communal violence in West Bengal, Bihar, and Orissa. There was no marked rise in communal incidents in other parts of the country. Because of the two conflicts with Pakistan, there was serious apprehension of communal trouble in 1965, but most parts of the country remained on the whole peaceful; it was only in Maharashtra and particularly in and around Poona that there was a very large number of incidents mostly involving loss of property; the incidents followed a case of sacrilege and had no connection with the Indo-Pak conflict. In 1966 the number of incidents fell, but it was still relatively high and therefore a matter of concern. The special feature of incidents in 1966 was that Andhra Pradesh and Maharashtra which had earlier been relatively free from communal trouble (except the Poona incidents of 1965), indicated persistent tension. The deterioration in communal relations noticed in 1966 continued in 1967, the most serious outbreak of violence being in Ranchi where 155 lives were lost in week-long disturbances. There was a marked rise in incidents in Andhra Pradesh, Bihar, and Uttar Pradesh as compared to 1966. A disturbing development of 1967 was extension of communal tension to Jammu & Kashmir. . . . [19]

A record or analysis of communal riots falls outside the scope of this work. They are relevant in the impact they had on Muslim

[18]*The Statesman*, 6 October 1969.
[19]Mimeographed copy, Union home ministry, June 1968, prepared for the National Integration Council.

politics. The Jabalpur riots in February 1961 marked a watershed. Dr Syed Mahmud, leading Congressman, convened an All-India Muslim Convention in New Delhi during 10–11 June 1961 in which *non-Muslims also participated* (Chap., II, doc. 2).

On 16 April 1954, Jayaprakash Narayan wrote a moving letter to the Speaker of both Houses of Parliament on the spread of communal riots (Chapter II, Doc. No. 3). He had left party politics. There were but a few Muslims like M.K. Shervani who rallied around him (Chap., II, doc. 4). Syed Mahmud took a fateful step. He founded the Muslim Majlis-e-Mushawarat, an umbrella body comprising Muslim organizations; alone. It still functions (Chap., II, doc. 5b). Other bodies followed in their train (Chap., II, docs. 8 and 8a). Only the All-India Personal Law Board, established during 27–28 December 1972, endured and flourished (Chap., II, doc. 10). It went far beyond its initial remit of preservation of Muslim personal law and opposition to a uniform civil code. It was to the president of the Board, Maulana Mujahidul Islam Qasmi, that the Shankaracharya Shri Jayendra Saraswati of Kanchi Kamakoti Peeth addressed his proposals on the Ayodhya issue on 8 March 2002. The executive committee of the Board responded to them by its resolution on 10 March 2002.

There was no let-up in the problems the Muslims faced and hardly any redress for their grievances. Two documents illustrate that: *The Hindustan Times* editorial of 11 February 1967 (Chap., II, doc. 6) and the chief minister of West Bengal, Siddhartha Shankar Ray's plea, on 2 January 1975, for recruitment of Muslims in the police force.

But the Muslim leadership, such as it was, was set on the sterile course of communal mobilization. Sheikh Muhammad Abdullah discovered a use for the Mushawarat when out of power, but ignored it later. He counselled secular politics one day (Chap., II, doc. 11) but led a delegation of Muslims to Prime Minister Indira Gandhi eight days later to ventilate Muslim grievances on personal law, on the Aligarh Muslim University, and other issues (Chap., II, doc. 12).

Muslims were confronted with an acute dilemma. Till as late as 1961, any expression of Muslims' grievances was regarded as obscenity. The frowns did not vanish thereafter; disquiet at mention of the grievances lingered. On the other hand, the grievances brooked no neglect either.

Emotional integration was surely not to be achieved by denial of the minorities' handicaps. But, then, nor is it attainable by pleas

for protection. This brings one to what is really the crux of the problem. To deny discrimination and pretend all is well is to fly in the face of facts. *But agitation against discrimination can arouse the very emotions that foster discrimination. The solution of the Muslim problem lies in a resolution of this dilemma by devising a form and context of agitation which heals old wounds and inflicts no new ones.* This resolution can be achieved by regarding discrimination as what it is; a problem of Indian democracy to be resolved within the framework of national integration. This is best done by associating men of goodwill of all communities in the task of making a success of Indian secularism.

It was vain to draw comfort from the establishment of the Minorities Commission (Chap., III, doc. 5) or Indira Gandhi's election-eve pledges to the Shahi Imam Abdullah Bukhari (Chap., III, doc. 7). On her return to power in January 1980, she followed a policy fundamentally different from the one she had adopted after the Congress split in 1969. Her concern for the Muslims' plight was by no means totally insincere. In 1959, as president of the Congress she chaired a committee on national integration which made useful suggestions. But during 1969–71, electoral considerations were dominant in her calculations. From 1980 onwards she sought to forge a different winning coalition based on the Hindu vote, a development which the BJP's president, Atal Behari Vajpayee viewed with dismay and strong disapproval (Chap., IV, doc. 8).

Meenakshipuram marked another major landmark. The director of Scheduled Castes and Scheduled Tribes, K. Arunugam found that allegations of use of money and a 'foreign hand' in conversion to Islam were proved untrue. But a lot of damage had been done, meanwhile. Indira Gandhi treated with disdain any assertion of their rights by the Muslims themselves (Chap., IV, docs. 3, 4, and 5). She would grant them what she would of her own accord (Chap., IV, doc. 6). Muslim leadership raised issues of lesser concern such as prayers in mosques and protected monuments (Chap., IV, doc. 7).

Secularism was increasingly under attack but the government of the day was in no mood to stem the tide. It sought, rather, to ride to electoral victory on its crest.[20] While the Muslim League supported 'the Emergency' which Indira Gandhi clamped on the country on 25 June 1975 (Chap., III, doc. 1), the Muslims, as Professor Myron Weiner noted, were 'particularly hostile to the emergency.

[20]*Vide* the writer's analyses of her record, 'Indira Gandhi and Indian Muslims', *Economic and Political Weekly*, 3 November 1990.

When the emergency was suspended and elections were held in early 1977, the Muslim community in northern India exploded in anger at the Congress government'. She succeeded in wooing them back, however. 'Without their support, Congress could not have won in 1980, and with their support Congress probably would have won in 1977.'[21]

Indira Gandhi decided to make the minorities' support expendable and seek power in 1984 on the plank of 'national security' on the strength of the vote of the majority community. After her tragic assassination on 31 October 1984, her successor, Rajiv Gandhi, followed the line she had laid down, with signal success. The BJP found that its plank was stolen and it faced a bitter defeat in the 1984 Lok Sabha elections.

It was while the appeal of the secular ideal was at its lowest in the ruling party, the Congress, that two crises erupted which were to mould the course of Indian politics for years to come and affect the Muslims far for the worse—the Supreme Court's ruling in the Shah Bano case on 23 April 1985 and the opening of the locks at the Babari Masjid on 1 February 1986. A myth was fostered sedulously and with considerable success that nullification of the Court's ruling by the Muslim Women (Protection of Rights on Divorce) Act, 1986 constrained Prime Minister Rajiv Gandhi to secure the opening of the locks of the Masjid and, thus, revive an issue that was to blight relations between the communities and undermine secular values in the country. Neerja Choudhary's reports in *The Statesman* on 20 April and 1 May 1986 (Chap., V, docs. 1 and 2), revealed, on the basis of authoritative sources, that, in fact *the sequence was the very opposite* of the one in political mythology, which even genuine sympathizers of Muslims had come to accept.

Deoki Nandan Agarwal, a former judge of the Allahabad High Court and one of the leading figures in the Ramjanambhoomi movement has recorded the background. The Vishwa Hindu Parishad (VHP) owed its existence to the Rashtriya Swayamsevak Sangh (RSS) Chief M.S. Golwalkar and Swami Chinmayananda's deliberations in Bombay on 19 August 1964. Its first session was held at the 1966 Kumbh Mela in Allahabad. Agarwal recalled:

At its session held at Vigyan Bhavan, New Delhi, on 7 and 8 April 1984 the Dharma Sansad of the Vishwa Hindu Parishad gave a call for the

[21]Myron Weiner, *India at the Polls 1980: A study of Parliamentary Elections*, American Enterprise Institute, 1983, pp. 115 and 133.

removal of the three mosque-like structures raised by Muslim marauders after destroying the ancient Hindu temples, at Sri Rama Janma Bhumi, Ayodhya, Sri Krishna Janmasthan, Mathura, and of Kashi Vishwanath at Gyanvapi, Varanasi. The so-called Babari Masjid at Ayodhya was taken up first. Sri Rama Janma Bhumi Mukti Yagna Samiti was formed with Sri Dau Dayal Khanna as its convenor and Gorak Shapeethadishwar Mahant Sri Aveda Nathji as its President. In order to create national awareness and arouse public opinion in support of the cause of liberation of Sri Rama Janma Bhumi, the Vishwa Hindu Parishad organized a Ratha-Yatra of Sri Rama Janakji Virajman on motorized chariot, which started from Sitamarhi in Bihar on 25 September 1984. The Ratha passed through important towns of Bihar and reached Ayodhya on 6 October 1984.

Indira Gandhi's assassination on 31 October 1984 led to the suspension of the *rath-yatra*. But it was revived from twenty-five places on 23 October 1985. The VHP spearheaded the move. The D-day was fixed as 9 March 1986. Its leaders met the chief minister of Uttar Pradesh, Vir Bahadur Singh and the district magistrate.

Agarwal admitted: 'On 19 December 1985 Sri Veer Bahadur Singh, the Chief Minister of Uttar Pradesh visited Ayodhya on the occasion of the Ramayana Mela sponsored by government agencies. A few of us headed by our President Justice Shiva Nath Katju, had assembled at Ayodhya.' They met V.B. Singh.

A twenty-eight-year old local lawyer, Umesh Chandra Pandey, filed an application on 25 January 1986 in the court of the munsif seeking removal of the restrictions on the puja, in the case to which he was not a party. Nor did he implead the Muslims who were parties to the suit. The munsif declined, judiciously enough, to pass the order since the file in the main case of 1961 was in the High Court and orders could be made only in that suit. An appeal was filed on 31 January and heard on 1 February 1986. An application by Mohammad Hashim, a plaintiff in the case who came to know of the proceedings, for being impleaded, was rejected. K.M. Pandey, the district judge of Faizabad, recorded the statements of the district magistrate and the superintendent of police on the issue of law and order and in forty minutes ordered the opening of the locks. The locks were opened, instantly enough. A TV crew was at hand.

The fate of the Babari mosque was sealed well before Rajiv Gandhi began his parleys with Muslim leaders on the Supreme Court's ruling.[22]

[22]*Vide* the writer's essay, 'Legal Aspects to the Issue', in Sarvepalli Gopal (ed.), *Anatomy of a Confrontation: The Babri Masjid–Ram Janmabhumi Issue*, Viking, 1991, pp. 77–8.

In *Mohammed Ahmed Khan v Shah Bano Begum*,[23] the Supreme Court was concerned with the application to Muslims of Section 125 of the Criminal Procedure Code, 1973. It provides a speedy remedy to, among others, a wife for securing an order for payment of maintenance against a husband who does not perform his duty to maintain her and she is unable to maintain herself. It is protection against destitution. While the Code was being drafted, to replace the Code of 1898, a delegation of Muslims had urged Indira Gandhi to exempt Muslims from the purview of Section 125 as, in their view, it conflicted with the Muslim law on maintenance which restricted payment of maintenance to the period of *iddat* (Chap., II, doc. 12). Clause (3) was added to Section 125 to exclude cases in which 'under any customary or personal law' a divorced wife had received money payable on divorce (*meher*).

The Court held that Muslim personal law did not bar provision of maintenance to a divorced wife even after the period of *iddat* and, and in any case, it was a protection against destitution which affects society at large.

It is certainly arguable that the ruling was erroneous. None can deny the fact that the Muslim law on marriage and divorce, as in force in India—the Anglo-Muhammadan law—violates the rights' enjoyed by women in Islamic law (Shariah). Equally incontestable is the utter indifference of Muslim politicians to reform of Muslim law in order to secure for Muslim women rights that belong to them in Shariat. They mounted a campaign for nullification of the ruling and secured in May 1986 the enactment of the Muslim Women (Protection of Rights on Divorce) Act, 1986.

It was cited as a precedent for legislation which would grant to the Hindus title to the Babari Masjid—to its site—after its demolition on 6 December 1992, thus aborting the civil suits to title pending before the Allahabad High Court. The parallel is a false one. There is a world of difference between a law which decides a pending litigation in favour of one side, in usurpation of the judiciary's power and authority, and one which alters the law of the land, in a purely legislative act. The distinction was recognized by the Supreme Court in *Indira Gandhi v Raj Narain* (1975). A constitutional amendment which aborted the election case was struck down as void. Amendments to the election law, retrospectively in her favour on issues decided against her by the Allahabad High Court, were

[23][1985] 2 SCC 556.

upheld. The Supreme Court affirmed this distinction more recently in *Re: Cauvery Water Disputes Tribunal*:[24]

The legislature can change the basis on which a decision is given by the Court and thus change the law in general, which will affect a class of persons and events at large. It cannot, however, set aside an individual decision *inter parties* and affect their rights and liabilities alone. Such an act on the part of the legislature amounts to exercising the judicial power of the State and to functioning as an appellate court or tribunal.

The aftermath is interesting. Courts invoked the Act of 1986 to award very considerable sums of money as maintenance which they could not have under Section 125 of the code. Muslim women secured a right unavailable to women in other communities. The Supreme Court upheld the Act as constitutionally valid and the grant of 'reasonable and fair provision and maintenance' for the entire life of a divorced wife provided, however, that the order was made *within* the period of *iddat*.[25]

The record is an unedifying one. Muslim politicians who hailed the Act of 1986 were discomfited by its application. Rajiv Gandhi who appeased them (Chap., V, docs. 8 and 9), against his better judgment and as a sop to offset the promises he had given to the VHP, lost on both counts. The Muslim community suffered grievously.

When the Babari Masjid question arose in February 1986 the Muslim community seethed with resentment at the gross injustice it had suffered, dimly aware of the games that were being played out in secret. Muslim politicians chose mindlessly to pursue the course on which they had embarked since 1948—mobilization of Muslims 'to assert Muslims' rights; ventilation of Muslims' grievances, agitation for Muslims' protection against wrongs. The documents in Chapter VI record their responses; sterile and counter/productive. They could not work together even in adversity.

In truth, every wrong, every act of injustice done to a Muslim—or for that matter, any other citizen—is an Indian lapse from Indian ideals, for Indians to set right, cutting across the religious divide. The Babari Masjid question was pre-eminently a *national* question. As it happens, the highest quality of research on its various aspects—historical, archaeological, or other—was accomplished by scholars of high eminence who were not Muslims: Romila Thapar,

[24][1993] 1 SCC 96 at p. 142.
[25]*Daniel Latifi v Union Of India* (2001) 7 SCC 740.

R.S. Sharma, Sushil Srivastava, Sarvepalli Gopal, and Neeladri Bhattacharya, to name a few.

The BJP took up the issue in its Palampur resolution on 11 June 1989 on the eve of the Lok Sabha elections and cited the Babari Masjid Action Committee as a case of Muslim 'confrontationism'. Muslims watched helplessly as the BJP reaped electoral gains. The Babari Masjid was, eventually, demolished on 6 December 1992.

The documents in Chapter VII reveal that the Muslim leadership was bereft of any creativity even after a colossal misfortune. It was the same old story of efforts at mobilization of Muslims for the redress of Muslim grievances. Morally and constitutionally, they have every *right* to do so. The issue is the *wisdom* of adopting such a course. Little thought is given to devising an alternative strategy which would not incur the odium which communal mobilization does in the context of the Indian situation. It is unlikely, to say the least, that Muslims would ever secure reservation as the National Convention demanded in 1994 (Chap., VII, doc. 1). Empowerment of Muslims will not be achieved through communal mobilization (Chap., VII, doc. 6) but as part of a process in which Muslims participate actively in national politics, engage themselves enthusiastically on national issues, and bring to the fore Muslim grievances as aspects of the injustices that scar Indian society.

A keen sense of realism must inform this effort, besides considerable patience. No political party would risk its popularity by being seen as a 'champion' of the Muslims. A wider educative effort is necessary. It will take time. But there is much promising material in the country which is ready to help. The growing number of NGOs, human rights activists and a whole array of voluntary agencies would profit by Muslims' participation and thus learn more of their plight. *A new climate would be generated in which the secular parties would find it easier to exert themselves to secure redress of Muslims' grievances.*

It would, however, be wrong to blame the Muslim politicians, still less the community itself, for the sad state in which the community finds itself. Leadership is not confined to politicians. There was little sign of it in fields other than politics, though there were some notable exceptions in education.

The state of Urdu illustrates one of the dilemmas the Muslims had to face. Nothing they could or should have done would have arrested the hostile trends that had set in years before the partition. The Muslim League's propaganda that it is the language of Muslims

might have aggravated it; but the trends had begun long before the 1930s. Rajeshwar Dayal, then chief secretary of UP, Urdu's heartland, described (Chap., VIII, doc. 3) the change that had come over in language, culture, and decorum. A government publication (Chap., VIII, doc. 1) accurately states the correct position. Urdu is by no means the language of Muslims alone. 'Non-Muslims . . . too cherish and enrich Urdu as their own language.' Dr S. Abid Husain explained why Muslims are so keen on Urdu's preservation. It is 'the storehouse of all the religious, scientific, and literary wealth which they had' (Chap., VIII, doc. 2). The Koran is in Arabic. But the Hadith, the traditions of Prophet Muhammad, is in Urdu. Few read it in Arabic. The *maulvi*, say in Kerala or Assam where Muslims speak the regional language mostly, would be familiar with Urdu.

Gandhi preferred Hindustani as India's national language. Chapter, VIII, docs. 4 to 7 record how advocates of Hindustani fought a battle they were doomed to lose. Already by 1953, as Nehru noted 'In UP and elsewhere there is a *deliberate* attempt to push out. Urdu' (Chap., VIII, doc. 9).

As in many cases, constitutional safeguards proved a frail reed to rely on. On 15 February 1954, a deputation of the Anjuman-e-Taraqqi Urdu led by Dr Zakir Husain and comprising men of the eminence of Pandit Hriday Nath Kunzru and Krishen Chander, met President Rajendra Prasad and presented a memorandum signed by over 2,700,000 persons (Chap., VIII, doc. 8). They invoked Article 347 of the Constitution of India which reads thus:

On a demand being made in that behalf the President may, if he is satisfied that a substantial proportion of the population of a state desire the use of any language spoken by them to be recognized by that State, direct that such language shall also be officially recognized throughout that state or any part thereof for such purpose as he may specify.

It is difficult to imagine a stronger case for exercise of the power.

However, the president can issue a directive under Art. 347 only on the advice of his Council of Ministers headed by the prime minister. Nehru's letter to Azad dated 12 March 1954 (Chap., VIII, doc. 9) reveals that he was against exercising the power not because it would 'create some kind of *constitutional* crisis'. It would have been a perfectly valid exercise of power which the Constitution conferred on the Union *precisely for such cases* to bring a recalcitrant state to heel. Nehru did not wish to alienate Uttar Pradesh and create a *political* crisis.

What followed is recorded in the other documents—speeches full of anguish at the plight of Urdu; a succession of delegations and memoranda; and steady banishment of Urdu as a medium of instruction at the school level in Uttar Pradesh (Chap., VIII, doc. 23). Atal Behari Vajpayee differed with Charan Singh's bizarre view that Urdu led to the partition of India (Chap., VIII, docs. 22 and 25).

On 5 May 1972 the Government of India set up a committee, headed by I.K. Gujaral, to consider what steps could be 'taken *urgently* for the promotion and development of Urdu'. Few official committees had as distinguished a composition. Among its members were, to name a few, Professor M. Mujeeb, Dr Sarup Singh, Malik Ram, Krishan Chander, and Sajjad Zaheer. It submitted its report to the minister of education, Professor S. Nurul Hasan, on 8 May 1975. Prime Minister Indira Gandhi kept it under wraps. It was published by the Janata Party government in 1979.

That was part of her style of functioning. On 10 May 1980 a 'High Power Panel' on Minorities chaired by Dr Gopal Singh was set up. Its report was submitted on 14 June 1983. It was published by the National Front government in 1990.

The Sixth and Seventh Reports of the Commissioner for Linguistic Minorities are particularly noteworthy. The office was held by Anil K. Chanda and he spared no pains in exposing how the records were being maintained. That was forty years ago.[26]

The Aligarh Muslim University issue is now behind us. The course of the debate is recorded to show how for a decade and a half, successive governments at the Centre dealt with a matter which *clearly affected* the rights of Muslims as a minority. The facts are set out authoritatively in a Report of the Minorities Commission.

A school or college can be founded by any individual or society. A university is a body corporate. It needs the imprimatur of a statute to become a juridical personality even if it is founded by a person or society. The two major communities founded the Benaras Hindu University and the Aligarh Muslim University. Both were accorded corporate status by Acts of the Central Legislature, in 1915 and 1920, for Benaras and Aligarh respectively.

Aligarh came under a cloud after the partition and suffered. As its vice chancellor, Dr Zakir Husain did a lot to revive its fortunes. He *was aware of* symbolic significance. 'The way Aligarh participates

[26]*Vide* the writer's article 'Urdu' in the collection of his articles *India's Constitution and Politics*, 1970, p. 377.

in the various walks of national life will determine the place of Muslims in India's national life. The way India conducts itself towards Aligarh will determine largely, yes that will determine largely, the form which our national life will acquire in the future'.[27]

It is for Aligarhians to determine whether the AMU has met the first test. For long, India failed dismally on the second. Every national institution pronounced against the AMU and pronounced in grave error, the Supreme Court included (vide Minorities Commission; Report to the Government of India Regarding the Aligarh Muslim University [Amendment] Bill, 1978). The Report traces the AMU's history and how it was enveloped in a crisis created in 1965 by the education minister of the day, M.C. Chagla.[28]

In 1965 the vice chancellor of the AMU, Ali Yavar Jung was grievously assaulted. That was enough for the Government of India to advise the president to promulgate an ordinance which reduced the university court, the supreme governing body, to a nominated advisory body and make other changes which effectively robbed the AMU of its autonomy and made it an institution under Central control.

A writ petition was filed in the Supreme Court invoking the fundamental right embodied in Article 30 (1): 'All minorities, whether based on religion or language, shall have the right to establish and administer educational institutions of their choice.' The Government of India filed a sworn affidavit in Court to assert that 'Aligarh Muslim University is an institution established, not by a minority community so as to attract the provisions of Article 26 or 30 (1) of the Constitution of India, but by the Central Government'. It categorically denied 'that the Aligarh Muslim University had a Muslim character' as suggested by the petitioners, and argued, instead, that like any other university, it was only one of the powers of the university to promote oriental and Islamic studies and to provide instructions in Muslim theology and religion'. It added: 'Merely because the said University has been named as Muslim University, it does not necessarily savour of the character of the institution of the minority community.'

[27]*Vide* the author's *President Zakir Husain: A Quest for Excellence*, Popular Prakashan; Bombay, 1967, p. 73.

[28]*Vide* also the French scholar, Viollette Graff's able essay '*Aligarh's Long Quest for "Minority" Status: AMU (Amendment) Act, 1981, Economic and Political Weekly*, 11 August 1990.

In *S. Azeez Basha v Union of India*[29] the Supreme Court held that the words 'Educational institutions 'in Article 30 'would include a University also'. The Court also held that the words 'Establish and administer' in Article 30 cannot be read disjunctively but must be read conjunctively. In other words, 'the Article gives the right to the minority to administer institutions established by it. If the educational institution has not been established by a minority it cannot claim the right to administer it under Article 30 (1)'. In its view it was not established by the Muslims but by a statute.

H.M. Seervai, one of the country's leading constitutional lawyers, carefully analysed the judgment. His critique of the judgment was widely acclaimed as sound.[30]

Seervai remarked:

This is the first case in which the Supreme Court has departed from the broad spirit in which it has decided cases on cultural and educational right of minorities, which was reflected in the passage from the judgment of Chief Justice Das. In the present case, the Supreme Court has on narrow, technical grounds, which are erroneous, held that a minority which had striven for and obtained the establishment of a Muslim University and endowed it with considerable property and money, had not established that University, and that provision of the Act of 1920 vesting the Supreme governance of the University exclusively in Muslims did not vest the administration in Muslims. On the Supreme Court's judgment, there is nothing to prevent Parliament from converting the Muslim University into a University for foreign students or for backward classes. It is submitted that the decision is clearly wrong and productive of grave public mischief and it should be overruled.[31]

It took over a decade to set right the wrong done by the executive in 1965 and the Supreme Court in 1968. The documents in Chapter IX trace the debate between Education Minister M.C. Chagla and Vice Chancellor Ali Yavar Jung who, though personally wronged, differed from the former's hostile position (Chap., IX, docs. 2, 3, 4). Two years later, Chagla's successor Dr Triguna Sen sharply criticized his approach (Chap., IX, docs. 6).

In this, Dr Triguna Sen was not alone. The vice chancellor of the AMU, Ali Yavar Jung, himself the victim of the dastardly attack,

[29]AIR 1968 SC 662.

[30]H.M. Seervai, *Constitutional Law of India* N.M. Tripathi Pvt Ltd, Bombay, vol. I, 1975, pp. 610–16.

[31]*Vide* H.M. Seervai, *Constitutional Law of India*, Fourth Edn, 1993, vol. II, p. 132, para 13, 23.

was less indignant than Education Minister M.C. Chagla, who was isolated within the Congress Party and expressed 'surprise and pain' at the lack of support. In a statement on 4 July 1965, Chagla said he did not find much criticism in the English papers 'which I read. But I am told that the Urdu papers are still agitating on the same question. I have made my own position and that of the Government perfectly clear. If there are people who will wilfully misunderstand my point of view, I cannot help it. But those who are honest and those who want to appreciate the reasons which led me to promulgate the Ordinance should have been satisfied that what has been done is in the larger interest of Aligarh University and of national integration.

What surprises and pains me most is the almost complete silence on the part of the nationalist Muslims and the nationalist Muslim Press. I can understand the attitude of the people whose outlook has been reactionary and communal. But what has happened to those who have put themselves forward as nationalists and progressive Indians'.[32]

Following a familiar pattern, which continues still, seven 'nationalist' Muslims promptly issued a statement in his support and drew a withering response from Dr A.J. Faridi:

It is ridiculous to say that the basic character of the Muslim University will not be changed by the Government. I think the moment the University Court and the Executive Council were dissolved, without any rhyme or reason, and the Ordinance promulgated, that very day the basic character of the Muslim University was changed.[33]

Nor was the English press as supportive as Chagla imagined. In an editorial entitled 'A Question of Confidence' *The Hindustan Times* wrote on 19 July 1965:

In the immediate wake of the dastardly attack by students on the person of the Aligarh University's Vice-Chancellor and under Parliamentary pressure, the Union Education Minister may have made statements on the floor of the House that were not exactly calculated to inspire confidence among the Muslim community in the Government's policy concerning the University's future. Mr Chagla has since explained that he never made the damaging statements attributed to him and that certain background statements which appeared in the Press then had not been authorized by him. The psychological damage—so vital an aspect in these matters—had however already been done. Even at the time, some of the statements officially put out struck a chord so obviously discordant with the facts that

[32]*The Hindustan Times*, 5 July 1965.
[33]*The Statesman*, 8 July 1965.

the Vice-Chancellor had himself to intervene to set the record straight. He specifically denied the allegation that the University had become a centre of pro-Pakistani activities. A negative finding on this point was also returned by a mixed committee of U.P. legislators which had inquired into the incident and reported on it. In considering the present crisis centring round the Government's Ordinance of 20 May, it may be as well to remember that many of the doubts entertained today by representative Muslim religious and cultural organisations about the real movtive behind it stem originally from the statements now so strenuously impugned by the Education Minister.

Chagla went so far as to deny, in the Lok Sabha on 3 September 1965, that the AMU was founded by a minority, the Muslims, and was, therefore, not entitled to invoke the fundamental right embodied in Article 30 (1) of the Constitution which guaranteed its autonomy.

To his credit, Ali Yavar Jung persisted in his defence of the university. At a press conference in Bombay on 12 May 1966, he ably summed up the ethos of the AMU. To quote a report in *The Times of India* the next day:

Nawab Ali Yavar Jung said that there need be no controversy about the basic character of the university. He saw no contradiction in its being a national Muslim university. It was principally meant for Muslims in the sense that education was provided in their religion, philosophy and traditions. But that did not mean that it was to be run for Muslims exclusively. It must continue to be a national university. He said there was no distinction of religion in the recruitment of teachers. About 40 per cent of the students were non-Muslim.

There was a sequel to this. The Congress had issued a three-line whip to its members in Parliament to secure the passage of the Amendment Act of 1965 which completely deprived the university of its autonomy. It, however, allowed a free vote on the proposal to change the name of the Benaras Hindu University, as a first step towards a similar move on the AMU. The proposal was defeated in the Lok Sabha on 15 November 1966. *The Times of India*'s correspondent noted that 'most of the Congress members who spoke on the Bill were completely opposed to the idea of changing the name of Hindu University.' A leader of the Samyukta Socialist Party, Kishan Pattanayak,'had some harsh things to say about Mr M.C. Chagla . . . for not seeing to it that a whip was issued to the Congress members'.[34]

[34]*The Times of India*, 16 November 1966.

After independence, the Muslim politics saw spread of the 'Uncle Tom' phenomenon. M.C. Chagla is significant because he represented it in its grossest form. As High Commissioner to Britain, he contributed to *The Times* on Republic Day 1962 an article, not on the country's achievements, but as a tirade on Indian Muslims. Entitled 'Muslims Stand Apart', the article began with the question: 'Is there a Muslim problem in India?' and proceeded to answer: 'If there is a problem it is an emotional one, and it exists largely because of the unwillingness of the Muslims to integrate themselves into the country, and then desire to consider themselves as separate and even to emphasize this separation (*sic*).'

He proceeded to lament: 'They still talk of minorities, of minority rights, *and even the most nationalist among them can foregather in a Muslim Convention to give expression to their fears and suspicions*' (italics added throughout).

His recipe was breathtaking: 'The very first thing the Muslims have to do is to forget that they are religious minority and to give up claiming that they should be considered separately outside the context of a completely Indian setting.' The ignorance was shocking, an assertion of minority rights in a plural society was treason. For good measure, he remarked: 'The Hindus have not forgotten that the Muslims were responsible for the partition of the country. In many Hindu eyes, Muslims are still suspect and I do not deny that there may be discrimination in giving jobs and in supporting (*sic*) Muslim industry.'

None who knew Chagla was surprised to find him inaugurating the foundation session of the Bharatiya Janata Party (BJP) in Bombay on 5 April 1980. What is little known is his opposition to Dr Zakir Husain's candidature for the presidency in 1967. He was so exercised as to approach the president, Dr. S. Radhakrishnan, and urge him to continue in office. S. Gopal's record is revealing for reasons more than one. 'M.C. Chagla, a member of the Cabinet *and a secular-minded Muslim* urged him not to expose Zakir Husain to an election for, even if Husain won, it would strengthen communal feeling in the country with disastrous consequences.'[35]

That a scholar of impeccable credentials and a secularist like S. Gopal should view Chagla as he did reveals a lot. It is unlikely that Chagla would have reacted in the same manner had he been offered

[35]S.Gopal, *Radhakrishnan: A Biography*, Oxford University Press, 1989, p. 358.

the candidacy. A highly respected contemporary, M.C. Setalvad's comments on Chagla were scathing:

The Law Commission had, after careful consideration, expressed the unanimous view that the practice of a Judge looking forward to or accepting employment under the Government after retirement was undesirable as it could affect the independence of the Judiciary. We, therefore, recommended that a constitutional bar should be imposed on Judges accepting office under the Union or State Governments similar to the bar in the case of the Auditor and Comptroller-General and members of Public Service Commissions. Chagla, who was Chief Justice of Bombay and a member of the Commission, had concurred in this recommendation. He had, however, always yearned to be in politics, and had while Chief Justice expressed political opinions which a Judge ought not to. He was so keen to get into politics that soon after the Report was signed by him ('even before the ink of his signature on the report was dry'—as observed in a letter to the Press) he resigned his office to become India's Ambassador to the United States. His action was characteristic of the self-seeking attitude of many of our leading men.[36]

Profession of leftist views did not inhibit acceptance of a judgeship in the Bombay High Court in 1941. In the famous case of Keshav Talpade—as significant in 1944 during the Quit India Movement as the habeas corpus case was during the Emergency—Chagla joined Chief Justice John Beaumont in deciding *against* the detainee. Another English Judge Eric Weston dissented from both and ruled in favour of Talpade. Setalvad charaterized Chagla's stand as 'strange'.

Chagla symbolized 'the Uncle Tom' phenomenon which was a plague on the politics of Indian Muslims. Muslims who meet to urge redress of grievances are branded 'communal'. They are hailed as 'nationalists' if they congregate to pass resolutions supporting India's stand on Kashmir. The external publicity division of the ministry of external affairs revels in producing brouchures on 'Indian Muslims speak on Kashmir' and even 'Muslim Press on Kashmir'.

Far from promoting 'national integration' this policy fosters separatism—one promoted by the state itself. Chagla enjoyed no support among Congress Muslims, but only among the rest. National politics was none the richer for his presence. In the Lok Sabha debate, in Feburary 1965, on a well-documented CBI Report on Biju Patnaik, former chief minister of Orissa, Chagla said: 'I would not

[36]Motilal C. Setalvad, *My Life: Law and Other Things*, N.M. Tripathi, 1970; p. 261.

hang a dog on the basis of an ex parte statement.' The report was based on official records. Chagla promoted his career. He harmed the national interest.[37]

Men like him turned a deaf ear to Muslim pleas. The field was left open to communal leaders. The 'nationalist' Muslims in the Congress and outside came under a cloud whenever he spoke of the Muslims' plight. The historian Mushirul Hasan has ably highlighted the incongruities that surround the 'nationalist theme'. Referring to the contribution to the freedom movement of Muslim leaders like Dr M.A. Ansari and Maulana Azad, Mushirul Hasan wrote:

Yet, it is extraordinary how the protagonists of such ideas continue to be categorized as 'Muslims', placed in a separate domain of enquiry, often outside the discourse on nationalism. When the Indian State grudgingly commemorates their memory to advertise its secular credentials, it does so with much fanfare as an act of goodwill to the Muslims, a concession to their sentiments. Organizers are carefully picked from the 'Muslim' intelligentsia and the chosen venue of conferences and symposia are, predictably, the university at Aligarh, the Jamia Millia Islamia and the Khuda Baksh Library in Patna.

It is equally extraordinary how an inappropriate expression— Nationalist Muslims—has gained such wide currency and is bandied about to detail the activities of people like Ansari and Azad. Its inappropriateness lies in the majoritarian view of Indian nationalism which assumes the presence of nationalistic and patriotic sentiments in the 'majority community alone'. If 'others' shared the same feelings, it is seen as an exception rather than a rule. Thus Ajmal Khan, Ansari and Azad—all 'Nationalist Muslims'—are set apart from their co-religionists. They are treated as exceptional men, uncommon and unique to a community which was structured to favour pan-Islamism and repudiate nationalism.

If Ajmal, Ansari and Azad were 'Nationalist Muslims' because of their loyalty to particular stand of nationalism, one must surely, by the same logic, designate Gandhi, Nehru, and Patel as 'Nationalist Hindus'. Again, if religion is the sole criterion for categorizing an individual or a group, how do we, then, describe a kisan or a trade union leader? Was Muzaffar Ahmed a 'Nationalist Muslim' and P.C. Joshi a 'Nationalist Hindu'? It is not enough to search for answers but to provide a corrective to a highly distorted image of India's recent past.

Identities, religious or otherwise, are created through a dialectical process. After, they are also superimposed in order to lend credence to a stereotyped image of a community. In consequence, the actions of the 'Nationalist Muslims', which should ideally be part of the nationalist

[37]*Vide* A.G. Noorani, *Minister's Misconduct*, Vikas, 1973, p. 100.

discourse, as aspect of the collective memory of a nation, are inextricably intertwined with Muslims alone. In such a scenario, Raja Rammohan Roy belongs to 'us'; Syed Ahmed Khan belongs to 'them'. Rabindranath Tagore is 'ours', Mohammad Iqbal, author of the most secular national anthem ever to be written, is 'theirs'. Urdu, the victim of independent India, is assigned to Muslims, while Hindi, elevated to the status of a 'national' language, to the 'Hindu majority'. In this way the partition of the nation's heritage goes on uninhibitedly.[38]

Ayesha Jalal makes the same point:

India without Islam is an ingenious idea. It would certainly have obviated the need for endless scholarly outpouring on communalism. But however much Muslims may take Hali's lead in blaming *qismat*, Islam in India, united or divided, is a fact of history and an intrinsic feature of the subcontinent's future. What is less clear is whether communalism should continue to serve as a descriptive or analytical clincher in representations of the Muslim past, present and future in the South Asian subcontinent. In the 1990s it has once again taken centre stage in academic and political debates, a consequence of the resort to what has been called Hindu majoritarian communalism seeking to preserve or capture centralized state power. Successive Congress regimes in the 1980s surreptitiously invoked a nebulous form of Hindu majoritarianism which has been crafted into a more potent political ideology by the forces of Hindutva. Neither the Congress nor the RSS, BJP and VHP combination would plead guilty to the charge of communalism. Not only the self-professedly secular Indian state and the Congress regimes at its helm, but also their challengers claim the appellation of nationalist. The original sin of being communalist for the most part has been reserved for the subcontinent's Muslims. Notwithstanding the compromises of secular nationalism with Hindu communalism, the burden of this negative term in the history of late colonial India has fallen on the Muslim minority. The establishment of a Muslim state at the moment of the British withdrawal added immeasurably to the weight of the burden. In the post-colonial scenario in general, and the conjuncture created by the Ayodhya controversy in particular, the Indian secularist response has been to tar both Hindu majoritarianism and Muslim minoritarianism with the brush of communalism. This asymmetry has expressed itself not only in state policy but also in secular academic discourse. Muslim minority 'communalism' has occupied a critical location in academic texts organized around the binary opposition between secular nationalism and religious communalism. If this neat but misleading dichotomy is to be dismantled, the entire notion of a Muslim minority

[38]Mushirul Hasan, *Islam and Indian Nationalism: Reflections on Abul Kalam Azad*, Manohar, 1992, pp. 6–7.

[communalism] at the subcontinental level needs to be subjected to a probing analysis.[39]

Jawaharlal Nehru's understanding was fundamentally different. Communalism 'grows surreptitiously, not openly', he said at a public meeting in Lucknow on 16 September 1951:

I become even more worried when I see the elements spreading in the Congress also. I am extremely perturbed because if these sentiments spread to the Congress, there will be no other organization willing to stand up for the principles for which the Congress has stood. We keep passing resolutions but *many* of our Congressmen have shown by their behaviour and in practice that they do not believe in them and look elsewhere.

That included 'some of the most important members in the Congress'.[40]

A few years later, on 11 May 1958, he told a meeting of the AICC that the 'communalism of the majority is far more dangerous than the communalism of the minority'. He was certainly not condoning the latter. But as he explained later (5 January 1961) he refused to accept that one particular community was communal and not the other. 'When minority communities are communal, you can see that and understand it. *But the communalism of a majority is apt to be taken for nationalism.*' (Italics mine throughout)

In this spirit, the AMU was a 'haven of communalism' and the BHU of nationalism. In a meticulously researched article, the Italian scholar Maria Casolari concluded:

Referring to the BHU, Malaviya asserted that it 'would be a denominational but not a sectarian institution'. The foundation of the BHU was the accomplishment of Malaviya's efforts to strengthen the Hindu sense of identity and cohesiveness. The BHU thus became the public platform from which Malaviya propagandized his political idea. His was a two-pronged approach. As a prominent member of the Hindu Mahasabha, of which he was president in 1923, he could finally extend his programme of reorganizing Hindu identity and society to the national level. Founding Hindu primary schools with Hindi as official language, and grass-roots level Hindu organizations, as well as participation in the 'Shuddi' movement, were main lines of Malaviya's political involvements. I do not agree with the interpretation according to which the Hindu Mahasabha was the daughter of the movement for the creation of *the BHU*. I think it

[39]Sugata Bose and Ayesha Jalal (eds.), *Nationalism Democracy and Development*, Oxford University Press, 1997, pp. 77–8.

[40]*Selected Works of Jawaharlal Nehru*, Second Series, vol. 16, Part II, 1994, pp. 85–6.

was just the opposite: the BHU *was the result of the increasing sense of militancy in the Hindu segment of Indian society*. Ultimately, Malaviya's project of founding a Hindu University was part of a wider project for the promotion of Hindu education, and it also attracted many other organizations and supporters in other parts of northern India. He was part of a political milieu that considered Gandhian non-violence a form of cowardice and harmful to Hindu society, because it would stigmatize the Hindus as weak and 'emasculated', according to the terminology used at that time. Like other members of Hindu organization, including Hedgewar and Moonje, Malaviya was convinced that Hindu militancy might serve as a valid deterrent should Muslim demands become detrimental to Hindu interest. According to this view of Hindu/Muslim relations, peace between the two communities could be maintained only by showing to each other the possible destructiveness of a reciprocal attack. It was therefore necessary to delete any impression of weakness of the Hindu community. Certainly, Malaviya's project had a great deal in common with the RSS programme of building up the Hindu national character. Physical education and military training of BHU students took place under Malaviya's exhortations. Indeed, the BHU had a most vigorous University Training Corps (UTC). Malaviya had never been a member, but he encouraged students to take part in the activities of the RSS and authorized an RSS building within the campus. The BHU branch of the RSS became very active from 1928, thanks to Malaviya's sanction and the activity of a number of volunteers. The BHU was thus finally absorbed in the milieu of militant Hinduism. Nevertheless, on several occasions in his public speeches Malaviya underlined the necessity to India's military service, almost in the same terms and with the same emphasis used by B.S. Moonje.

It is well known that Golwalkar was himself a 'creature' of he BHU, where he graduated in biology and subsequently worked as a zoology lecturer. He joined the RSS, at the BHU, after a visit by Hedgewar to the University in 1931.

On Malaviya's invitation, Jawaharlal Nehru also visited the BHU in November 1933. He considered 'the Hindu University as the very citadel of Hindu communal thought'.[41]

Strong as were the prejudice against the AMU, attempts at redress of the patent wrong of 1965 were both inadequate and insincere.

Indira Gandhi promised redress on the eve of the UP Assembly election but reneged on them. The UP Muslim Majlis leader Dr A.J. Faridi's exposure (Chap., IX, doc. 8) is noteworthy for three reasons. It is detailed and was not controverted. It explains how a member of the Praja Socialist Party became a participant in Muslim politics.

[41]'Role of Benares in Constructing Political Hindu Identity', *Economic and Political Weekly*, 13 April 2002.

Lastly, it reflected the clout which the community wielded politically. It could be ignored at whim even when the political cost of redress was small Jayaprakash Narayan's remarks on the AMU (Chap., IX, doc. 2).

In May 1972, the Union minister for education, Nurul Hasan, pushed through the Lok Sabha a new amendment which, far from fulfilling the electoral manifesto promises, in effect tightened the control of the Centre over the university. There was a storm of protests leading to riots. At long last, the Aligarh Muslim University (Amendment) Act, 1981 (Act No. 62 of 1981) was enacted on 31 December 1981. Section 3 (III) defined 'University' to mean 'the educational institution of their choice established by the Muslims of India, which originated as the Muhammadan Anglo-Oriental College, Aligarh and which was subsequently incorporated as the Aligarh Muslim University'.

It was a grudging concession, not to be followed in the future. The Jamia Millia Islamia was also established by the Muslims who responded to Gandhi's call to shun government-aided institutions. It was founded on 29 October 1920, a month after the *Congress resolution on the subject*.[42] But the Jamia Millia Islamia Act, 1988 did not confer on the Jamia the same 'minority status' as the AMU (Amendment) Act, 1981 did. Section 2 (0) reads thus: 'University' means the educational institution known as 'Jamia Millia Islamia' founded in 1920 during Khilafat and Non-cooperation Movements in response to Gandhi's call for a boycott of all government-sponsored educational institutions which was subsequently registered in 1939 as Jamia Millia Islamia Society, and declared in 1962 as an institution deemed to be a University under Section 3 of the University Grants Commission Act, 1956, and which is incorporated as a University under this Act.'

The Minorities Commission worked erratically and spasmodically, depending on its composition.[43]

There has, however, been a significant improvement in one respect, namely, the disengagement of the Indo-Pak factor from the Muslims' position in India. Time there was when even a judicial body felt itself free to opine that 'genuine improvement of the

[42]*Vide* A.G. Noorani, *Dr Zakir Husain*, p. 6.

[43]*Vide* 'Collapse of the Minorites Commission', in A.G. Noorani, *Indian Affairs: The Political Dimension*, Konark, 1990, pp. 277–80. Vide also Tahir Mahmood, *Minorities Commission: Minor Role in Major Affairs*, Pharos, New Delhi, 2001.

relations between the two countries—Pakistan and India—may go a long way in allaying the apprehensions born out of mistrust and ultimately in removing the distrust'.[44]

Muslim representation in the Lok Sabha and the Rajya Sabha has never been satisfactory. It reflects accurately their insignificant role in national affairs since independence.

Maulana Abul Kalam Azad's presidential address to the Ramgarh session of the Indian National Congress in 1940 is recorded as a classic pronouncement. It provides guidance to the Muslims of India even now six decade later:

I am a Muslim and profoundly conscious of the fact that I have inherited Islam's glorious traditions of the last thirteen hundred years. I am not prepared to lose even a small part of that legacy. The history and teachings of Islam, its arts and letter, its civilisation and culture, are part of my wealth and it is my duty to cherish and guard them. As a Muslim I have a special identity within the field of religion and culture and I cannot tolerate any undue interference with it. But, with all these feelings, I have another equally deep realisation, born out of my life's experience, which is strengthened and not hindered by the spirit of Islam. I am equally proud of the fact that I am an Indian, an essential part of the indivisible unity of Indian nationhood, a vital factor in its total make-up, without which this noble edifice will remain incomplete. I can never give up this sincere claim.

It was India's historic destiny that its soil should become the destination of many different caravans of races, cultures, and religions. Even before the dawn of history's morning, they started their trek into India and the process has continued since. This vast and hospitable land welcomed them all and took them to her bosom. The last of these caravans was that of the followers of Islam, who came in the footsteps of their many predecessors and settled down here. This was the meeting point of two different currents of culture. For a time they flowed along their separate courses, but Nature's immutable law brought them together into a confluence. This fusion was a notable historic event. Since then, destiny, in her own secret ways, began to fashion a new India to take the place of the old. We had brought our treasures with us to this land which was rich with its own great cultural heritage. We handed over our wealth to her and she unlocked for us the door of her own riches. We presented her with something she needed urgently, the most precious gift in Islam's treasury, its message of democracy, human equality and brotherhood.

[44]Report of the Commission of Inquiry headed by Justice Raghubir Dayal of the Supreme Court on Communal Disturbance in Ranchi-Hatia during 22–29 August 1967, Government of India, 1968.

Eleven centuries have passed by since then. Islam has now as valid a claim on this land as Hindus. If Hinduism has been the religion of its people for several thousand years, Islam too has been its religion for a thousand years. Just as a Hindu can say with legitimate pride that he is an Indian and a follower of Hinduism, so can a Muslim proudly claim being an Indian and a follower of Islam. I would go further and say that an Indian Christian (or the follower of any other religion) can similarly claim, with legitimate pride, that he is an Indian following one of her many religions.

Eleven hundred years of common history have enriched India with our common creative and constructive achievements. Our language, our poetry, our literature, our culture, our art, our dress, our manners and customs all bear the stamp of this common life. Our languages were different, but we grew to use a common language; our manners and customs were dissimilar, but they acted and reacted on each other and thus produced a new synthesis. Our old dress may be seen only in pictures of bygone days; no one wears it today. These common riches are the heritage of our common nationality and we do not want to leave them and go back to the times when this adventure of a joint life had not begun. If there are any Hindus among us who desire to bring back the Hindu life of a thousand years ago and more, they are just dreaming and such dreams cannot become real. Likewise, if there are any Muslims who wish to revive their past civilisation and culture, which they brought a thousand years ago from Iran and Central Asia, they too, dream and the sooner they wake up the better.

Our shared life of a thousand years has forged a common nationality. Such moulds cannot be artificially constructed. Nature's hidden anvils shape them over the centuries. The mould has now been cast and destiny has set her seal upon it. Whether we like it or not, we have now become and Indian nation, united indivisible. No false idea of separatism can break our oneness. We must accept the inexorable logic of facts and apply ourselves to fashioning our future destiny.[45]

[45]Syeda S. Hameed, *India's Maulana*, vol. II, pp. 161–2.

CHAPTER 1

Adjustment to the New Order

1. Chaudhary Khaliquzzaman Pledges Loyalty to the National Flag[1]

M r President! I support the resolution moved by Pandit Nehru. I think that from today everyone, who regards himself as a citizen of India—be he a Muslim, Hindu, or Christian—will, as a citizen, make all sacrifices to uphold and maintain the honour of the flag which is accepted and passed as the flag of India. I do not wish to narrate again history which is wrong. I want that all of us should forget the past and should oust from our minds the old things. Therefore, I hope that the majority too shall forget the past. All of us should make a fresh history of India from today in which everyone, who has got sincerity, dignity, and interest in the reconstruction of the country and the nation, may join hands. I know that a flag, to look at, is simply a piece of cloth but a country's flag symbolizes its ideals and its aspirations, both moral and spiritual. I feel happy that none, who calls himself a citizen of India, can have occasion to disagree with the speech of Pandit Nehru in support of the flag. Therefore, I think that from whatever angle we may view it, the step taken today will only strengthen the foundations of India. Every Muslim, Hindu, and Christian will feel proud in hoisting this flag throughout the length and breadth of India, and he shall honour it. With these words I support the motion.

[1]Extracts of English translation of Hindustani speech delivered by Chaudhary Khaliquzzaman (United Provinces: Muslim) on 22 July 1947. CAD, vol. iv, p. 745.

2. Partition Council Adopts Pledge for the Protection of Minorities[1]

L ord Mountbatten summoned a meeting of the Partition Council, to which he invited Baldev Singh, the defence minister. After

the meeting, the following communiqué was issued:

At their meeting at 5 p.m. on Tuesday, 22 July 1947, the members of the Partition Council (which included Sardar Baldev Singh for this item) decided to issue the attached statement:

In the chair: His Excellency the Viceroy.

For the future government of India: The Hon'ble Sardar Vallabhbhai Patel and the Hon'ble Dr Rajendra Prasad.

For the future government of Pakistan: Mr Mohammad Ali Jinnah and the Hon'ble Mr Liaqat Ali Khan.

On behalf of the Sikhs: The Hon'ble Sardar Baldev Singh.

Now that the decision to set up two independent Dominions from 15 August has been finally taken, the members of the Partition Council, on behalf of the future governments, declare that they are determined to establish peaceful conditions in which the processes of partition may be completed and the many urgent tasks of administration and economic reconstruction taken in hand.

Both the Congress and the Muslim League have given assurances of fair and equitable treatment to the minorities after the transfer of power. The two future governments re-affirm these assurances. It is their intention to safeguard the legitimate interests of all citizens irrespective of religion, caste, or sex. In the exercise of their normal civic rights, all citizens will be regarded as equal, and both the governments will assure to all people within their territories the exercise of liberties such as freedom of speech, the right to form associations, the right to worship in their own way, and the protection of their language and culture.

Both the governments further undertake that there shall be no discrimination against those who before 15 August may have been political opponents.

The guarantee of protection which both governments give to the citizens of their respective countries implies that in no circumstances will violence be tolerated in any form in either territory. The two governments wish to emphasize that they are united in this determination.

To safeguard the peace in the Punjab during the period of change-over to the new conditions, both governments have together agreed on the setting up of a special military command from 1 August, covering the civil districts of Sialkot, Gujranwala, Sheikhupura, Lyallpur, Montgomery, Lahore, Amritsar, Gurdaspur, Hoshiarpur, Jullundur, Ferozepore, and Ludhiana. With their concurrence, Major General Rees has been nominated as military commander for this purpose and Brigadier Digambar Singh (India) and Colonel Ayub Khan (Pakistan) have been attached to him in an advisory capacity. After 15 August, Major General Rees will control operationally the forces of both the new states in this area and will be responsible through the Supreme Commander and the Joint Defence Council to the two governments. The two governments will not hesitate to set up a similar organization in Bengal should they consider it necessary.

Both governments have pledged themselves to accept the awards of the Boundary Commissions, whatever these may be. The Boundary Commissions are already in session; if they are to discharge their duties satisfactorily, it is essential that they should not be hampered by public speeches or writings threatening boycott or direct action, or otherwise interfering with their work. Both governments will take appropriate steps to secure this end; and, as soon as the awards are announced, both governments will enforce them impartially and at once.

[1]V.P. Menon. *The Transfer of Power in India,* Orient Longmans, 1957, pp. 408–9.

3. Jinnah's Advice to Coorg State Muslim Delegation[1]

The main points of Jinnah's advice to Muslims in India during his meeting with the leader of the Muslim delegation from Coorg on 25 July 1947 were:

1. To maintain their identity and individuality,
2. The advisability of their adapting themselves to the changed circumstances without sacrificing their identity and individuality,
3. Progress and prosperity by advancing themselves educationally and economically,
4. Disintegration of the ruling party owing to natural causes, and
5. The ultimate triumph of Muslims in India as a balancing factor in power politics and the resultant advantages accruing from it.

As luck would have it, I was entrusted with the task of leading a deputation on behalf of the Muslims of Coorg on some of their local problems. 25 July 1947 was fixed as the date for meeting Quaid-i-Azam at his residence in Aurangzeb Road, New Delhi. After discussing with him some matters relating to Coorg along with the other deputationists, who had accompanied me, I requested Quaid-i-Azam to kindly let me have an exclusive interview with him so that I could discuss with him certain problems facing the Indian Muslims. He was pleased to grant me this privilege and I

had the unique honour of sitting at his feet for about an hour. To start with, I respectfully addressed the following questions to him, namely:

1. Now that Pakistan has come into being and you are already appointed Governor General of Pakistan, it is obvious that we in India will be without your leadership, guidance, and advice. Whom shall we look to for such guidance, advice, and inspiration hereafter? (Quaid-i-Azam was visibly moved by the question and asked me to go ahead if I had any more questions to ask so that he could answer all of them together.)

2. Now that so many of us will be left behind in India, what should be our attitude towards the majority community from whom we differed so much till lately and towards the government of the country? Have we to change our outlook on life and things like that? In other words how are we to adjust ourselves?

3. What will be the future of Muslims in India as a minority reduced to a still smaller number and what guarantee is there of their safety and security?

Quaid-i-Azam was greatly pleased with these questions. He said there were very important questions and that he would gladly answer them.

As regards the first question, Quaid-i-Azam said, 'Muslims in India have nothing to be afraid of. They will still be several crores in number. They have made many sacrifices along with the Muslims of the majority provinces. It is as a result of the sacrifices made by all of them in India that we have been able to achieve Pakistan. While the Musalmans of the majority provinces will be in a position to wield authority and power and mould their destinies according to their genius, the Musalmans in India have yet to go through a number of ordeals, sufferings, and sacrifices. Their future will remain dark for some years to come and thick clouds will be hanging over them. The only way out for them will be to become much more active, much more courageous, and work harder than ever before. Trusting in God they should always be up and doing and go forward undeterred by the discouraging circumstances around them.

'What they need first is the correct leadership. If they could find men who are possessed of high ideals and sterling character and men who could understand their difficulties and men who are above board, it will be some consolation to start with. What you have to do is to maintain your identity and your individuality in

the first instance. You can adopt [*sic* for adapt] yourselves to the changing circumstances and environment, without sacrificing your identity and individuality. If you sacrifice these two ideals, you will have lost everything, and your survival without this distinction will hardly do any good to you. You can maintain your identity and at the same time serve the best interests of your country. It is only then that your position as a cultural and historic minority will be recognized and as a minority with these distinctive features, you will be able to compel others to respect you. You should not only assert yourselves but also find a proper place for yourselves, from which you can make yourselves felt. You must also avoid occasions of conflict with the majority community and show by dint of your merit and intellectual capacity that you cannot be ignored under any circumstances.

'As regards your loyalty, you cannot but be loyal to your country. Just as I want every Hindu in Pakistan to be loyal to Pakistan, so do I want every Muslim in India to be loyal to India. There is no other alternative.

'You can be useful citizens of your country in two ways by becoming (i) educationally forward and (ii) economically sound, and thereby making yourselves indispensable to the country.

'To achieve this you have to devote much of your attention to the education of your young men and see that they are well equipped. You should prepare them for technical and professional careers. If you can find means to educate them well and make them work hard, you will make a good beginning. Any country would need such useful young men. See that your men are well trained for taking up any work in any sphere of activity, technical or professional, government or public. See that they are not found wanting in anything so that the country in which they live is proud of them.

'While you make progress educationally, you should at the same time continue your business activities so that you are economically strong. Without this you will not be able to keep pace with the march of events. If you are economically behind others in your country, you will get crippled and you will be relegated to a corner. This is a field in which you can always keep your head erect and command respect from others. For a time there may be factors which may be very discouraging to you but that should not prevent you from going forward with a determination to achieve

success in this field which alone will enable you to walk shoulder to shoulder with your fellow men in your country.

'Sometimes you will have to face worse situations but you must be bold enough to face the difficulties as they come. I assure you that there is no difficulty that you may not overcome. You will certainly emerge triumphant from any ordeal, however trying.

'Disintegration is bound to set in at some stage or the other because of lack of homogeneity in the ruling junta. If you are well equipped educationally, you will catch the opportunity by the forelock and hit the bargain politically. Just then you will be awakened to your potentialities and aspirations and appear again on the scene as a balancing factor in the power politics. You will then have nothing to lose but everything to gain. You will be a power to be reckoned with and the majority community or the powers that be will find it impossible to run the administration of the country without your help and cooperation and you will have a larger slice of share in the authority and power which were denied to you [for] so long. The blessings to you will be all the greater [*sic*]. It is at this psychological moment that all the major problems with which you were confronted will be solved in a friendly atmosphere. However big or great your problems, don't run to solve them with a hammer in your hand. You must have the sagacity and wisdom to solve them at an opportune time when circumstances are more favourable. It is only a question of time, maybe ten years or twenty years. You will then breathe a sigh of relief. So I advise you to take things calmly and coolly. Be always up and doing.

'You must work with zeal and enthusiasm, however much you may feel crushed for the time being. Worse coming to worst, you will have a homeland in Pakistan which will give you a shelter whenever you need it. What is more, there will be adjustments between the two countries and there will be territorial safeguards for the protection of minorities on either side. All that you have got to do is to find the correct leadership in India, which will guide you and take you through your ordeals smoothly without involving you in a conflict with the powers that be and provide opportunities for you to develop educationally and economically. Cautiously and zealously guard your interests till you have passed through this critical period.

'So long as I am alive, I shall watch with great interest, care, and anxiety your struggles in India, your interests, and your future. I shall pray that God may come to your succour in times of your

difficulties and be with you to lead you to prosperity and happiness. Your sacrifices in the making of Pakistan are great. How can we ever forget them or forget you? You and your sacrifices will always be in my thoughts and feeling. May God be with you. Goodbye!'

[1]*Jinnah Papers*, First Series, vol. iii, Quaid-i-Azam Papers Project, Cabinet Division, Government of Pakistan, Karachi, distributed by Oxford University Press, 1998, pp. 694–7. The document contains the following note:
'My last but momentous interview with the late lamented Quaid-i-Azam M.A. Jinnah of revered memory (peace be on his soul), and my conversation with him on the future of Muslims in India on 25 July 1947 at 10 Aurangzeb Road, New Delhi (15 days prior to his departure to Karachi as Governor General of Pakistan)'. Name of the leader of the deputation is not traceable.

4. Suhrawardy on Choices Before the Muslims in India[1]

40, Theatre Road, Calcutta
10 September 1947

My dear Khaliquzzaman Sahib,

We are now all thinking very hard as to what should be the position of the minorities, particularly of the minority Muslims, in the Hindu-majority provinces. We had not thought about it earlier, as we did not expect Bengal to be partitioned and Muslims being reduced to a minority in any part of Bengal. I think that your move and your speech regarding the flag was a very wise one, as any hesitation in accepting it would have created indelible suspicion in the minds of the Hindus regarding our loyalty and bona fides. The good feeling between Hindus and Muslims at present existing here and let us hope that this will be permanent— is largely due to the wholehearted acceptance of the Indian Union flag by the Muslims and their adoption of the cry of *Jai Hind*. At the same time, we have got to think what should be the policy of the Muslims for the future. And the whole question turns on this, can we rely upon the Hindu governments to look after the interests of the Muslims or shall we be let down at a crucial moment? We appear to have the following alternatives:

1. Continue to live as Muslims in the best Islamic tradition connected with the Muslim League and holding fast to the two-nation theory. In this alternative we shall have to be very strong

and disciplined and must be ready to undergo sacrifices and must look to Pakistan for support and protection. We shall certainly get the respect of the Hindus, but equally their indignation. They will see to it that we do not become strong and I doubt very much whether Pakistan can come to our rescue and support. The theory of hostages has broken down. The fear of reprisal does not prevent a Hindu from killing us although he may be endangering his brother Hindus in Pakistan, but when a person gets mad and becomes insane, he does not think of the consequences to his coreligionists in other parts of the country. Further, in spite of the best efforts of the authorities, the rank and file of the law and order force are intensely communal. They are adopting an anti-Muslim complex and will not move an inch to prevent a Muslim being murdered or his shop looted or his property destroyed. I am, therefore, not in favour of adopting an attitude of aloofness dependent upon the two-nation theory.

2. Be a good Muslim and remain on friendly terms with your Hindu neighbours on the basis of common citizenship of the Indian Union. This obviously is the best position to take up but the snags are the following:

(a) Will the Hindu accept you as an equal and as a common citizen or will he try and assert superiority in every way and humiliate the Muslims?

(b) Will he treat you with cordiality? What attracts me most to Mahatma Gandhi's mission is his insistence that the majority must not feel a sense of superiority or of domination and the minorities must not be made to feel any sense of subservience. He says that the minorities have rights for which they must fight unto death. They must not adopt an attitude of giving up rights in order to purchase the goodwill of the majorities. In order to bring the majority Hindus to a proper frame of mind it is necessary to have continuous propaganda amongst them and it is going to take time. What I fear is, will they have respect for you if you have no strength, that is to say if you give up your particular group solidarity? At the same time, any attempt to acquire solidarity and strength will raise suspicion in their minds as regards bona fides. Here the question of what our attitude towards the Hindus should be is very important. Shall we treat them as League treating the Congress or shall we create a political party of Hindus and Muslims? They may refuse

to accept you as the League treating the Congress and in a system of joint electorate will support the breed known as the Nationalist Muslims.

(c) Complete subservience and submergence in some places as in Bihar. This is the attitude of Hindus towards the Muslims. In order to prevent this there are three alternatives:

(i) The Muslims should form themselves into strong pockets. In my opinion this should be done even with the best cooperation in the world with the Hindus. It is politically desirable as well as necessary for survival and also culturally desirable.

(ii) Transfer of population while the going is good. Although we have had a bad lesson in the Punjab I still think that transfer of population is an impossibility. It is doubtful how many of those who have been transferred from one side to the other will survive. I think we have to take the risk and stand fast to where we live.

(iii) Annihilation. This is too awful to contemplate not from the personal point of view but from the point of view of Hindus and Muslims as a whole because nothing can then stop a general carnage.

So now the question is what are we going to do next. You must have thought over these problems because these problems have been with you for a much longer time than with us. I would like to have some guidance from you. Personally, I think that Pakistan has provided a homeland for the Muslims living in those majority areas, but not a homeland for the Muslims of India. The Muslims in the Indian Union have been left high and dry and must shape their own destiny and the question arises what should be our future organization. The fact that there is a Pakistan government of course does give a certain amount of reflected prestige to the Muslims of India but at the same time it makes them a target for antagonism, and we have to choose between the two. I think that the Muslims of the minority provinces will have to chalk out their own plan. The Quaid-i-Azam and the Muslim League in general are too busy with doing nothing in Pakistan. I think the solution lies in finding some ways and means to induce all governments whether they are of Pakistan or Hindustan to accept the minorities as their own and to destroy the complex of superiority in the majority population. For this purpose an all-round effort should be made and we are extremely lucky in having Mahatma Gandhi as the spearhead of

this movement, for herein lies peace with dignity and honour and also the dictates of humanity. What do you think, first of all, of a few of us meeting together and then possibly a convention of the Muslim legislators of the minority provinces followed by conventions of Muslim leading men in each province?

As I said above I look to you for guidance.

Yours sincerely,
Shaheed Suhrawardy

[1]*Pathway to Pakistan* by Chaudhary Khaliquzzaman, Longmans Green, Pakistan Branch, 1961, pp. 397–9.

4a. H.S. Suhrawardy to M.A. Jinnah[1]

Confidential

Palace Hotel,
Karachi
8 October 1947

Respected Quaid-i-Azam,

I am taking the liberty of placing below some suggestions which may help to improve the condition of the Muslim minorities in the Indian Union and to rescue them from the dangers which encircle them. There is little doubt that the tension between Sikhs, Hindus and Muslims has assumed serious proportions, and the statements and the counter-statements issuing from the two Dominions help in increasing the tension. People begin to imagine that there is serious want of cooperation and the gulf between the two is widening to such an extent that it may lead to an ultimate conflict between the two Dominions. The refugees and their woes and miseries have added further to the problem. The mind of the majorities is getting hostile towards the minorities, and unless something is done to change the psychology there may be a general conflagration which can well destroy the Muslim minority in the Indian Union. The suggestions which I am making are nothing such which are new to you, but if you could see your way to adopt them and reiterate them, where they have already been adopted, it will, I submit with respect, help in easing the situation.

2. I presume to make the following suggestions:

 a. A declaration of cooperation and mutual assistance between the two Dominions.

b. A declaration that it is the policy of both the Dominions that peoples of all the communities should live together.

c. That both the Dominions desire peace and unity amongst the various communities.

d. That it is not the intention of either of the Dominions to go to war and that both the Dominions renounce war for all time as a method of settling disputes.

e. That both deprecate the issue of provocative statements and aspersions against each other.

f. That both the Dominions are determined to put down disorders and lawlessness with a firm hand.

g. That both the Dominions are determined to see that the officials act impartial and action shall be taken against those who fail in their duty.

h. A declaration of guarantee to minorities of protection of life, property, etc.

i. The Dominions should call upon the press to cooperate and not issue the statements calculated to excite communal hatred and bitterness.

j. Representatives of both the Dominions (who may be called Peace Commissioners with diplomatic privileges) will be stationed in various parts of the Dominions and will do all they can to promote peace and harmony between the communities, acquaint themselves with the difficulties and complaints of the majority and minority communities, keep themselves informed of incidents and remove all causes of suspicion and mistrust. They shall be assured safety of their persons and facilities to move wheresoever they deem it necessary to proceed for the discharge of their duties.

k. In the services, there should be a mixture of Hindu and Muslim officers and steps should be taken for this purpose.

l. Representatives of minorities should be included in the Ministries.

m. A statement which will admit, however vaguely, that the Governments have not been able to give that protection to the people which it is the duty of Governments to ensure, extending sympathy to the sufferers with the further declaration that both Dominions disapprove of migration or transfer of population.

n. A statement condemning acts of barbarities, forcible conversions, and kidnapping.

o. A call to the public to cooperate with Government in restoring peace. I feel that the old scheme of preserving law and order depending upon the prestige of the Government will not work at this stage and we can only succeed if the public of the third State [sic] are prepared to cooperate and to safeguard the interests of the minorities and assume responsibility for looking after their interests.

p. There should be a joint policy regarding States, otherwise this would give an excuse to the Indian Union not to take action against the States on the ground that the Pakistan Government has not declared whether it will interfere with the States in their internal administration.

q. The houses and properties of refugees are being dealt with in different manners in the two Dominions. There should be a common policy.

r. The contacts between two Dominions should be more frequent at a high level with the Premiers, a Minister as well as Governors, Premiers and Ministers of East Punjab and West Punjab.

3. These suggestions have been embodied to some extent in the form of declarations which have been drafted by me, and I am taking the liberty of sending the draft to you to clarify the above points.

Yours,
[H.S. Suhrawardy]

[1]*Jinnah Papers: Pakistan Battling against Odds, 1 October–31 December 1947,* First series, vol. VI, Edition Chief Z.H. Zaidi. Quaid-i-Azam papers project, culture division, Government of Pakistan; distributed by Oxford University Press, Pakistan, 2001, pp. 689-738.

Annex 1

Draft Declaration proposed by H.S. Suhrawardy

Confidential

We hereby solemnly and sincerely declare that it is the aim of the Dominions of India and Pakistan to promote peace and friendship between the Dominions and its inhabitants and to

cooperate for the well-being of each other and to assist each other in every possible way so that the prosperity of each may be promoted and the relationship of the two Dominions be based on neighbourliness and mutual reliance.

2. We further declare that we consider peace and unity amongst the various communities within the two dominions essential for the preservation of independence and for reaping the full fruit thereof; that all the communities together go to make a nation, that they have to live with each other as one family within each State, pledging unstinted and unswerving loyalty to the State in which they live.

3. It is our considered opinion that separate communal and theocratic States are undesirable and in course of time are bound to lead to a perpetual conflict; that disunity and disorder amongst the peoples make economic progress impossible and is bound to impoverish the Dominions to such an extent that they will not be able to improve the lot of the common man. The Dominions are likely, under these circumstances, to lose their independence and will stand eternally disgraced in the eyes of the world.

4. We further declare that we renounce war for all time as the method of settling disputes between us. We deprecate the issue of provocative statements and aspersions attacking the bona fides of each other and containing charges and counter-charges which only tend to embitter feelings and give an incorrect impression that the relationship between the two Dominions are strained and may at some future time lead to an armed conflict.

5. We further solemnly declare that it shall be our endeavour to put down disorder and lawlessness with a firm hand. We demand impartiality and a high sense of duty from the officials of both the Dominions and shall take the strongest measures against officers and other Government personnel who do not perform their duties with absolute impartiality and without fear or favour.

6. We hereby guarantee to the minorities within our Dominions fullest protection of life, property, culture, religion, language and customs and declare that there shall be no discrimination between the communities by virtue of their caste, creed or religion, that we shall deal with all the peoples within our Dominions equally and justly.

7. We call upon the people of the Dominions to shed any tendency towards militancy or violence, to rid themselves of mutual hatred and distrust, to live in friendliness with their neighbours, and for the majority to assume responsibility for protecting the minorities and their rights.

8. We hereby call upon the press to cooperate with us in stressing the need for peace and unity, cooperation and trust, and cease to publish stories and accounts—factual or otherwise—of incidents that may tend to excite communal hatred and bitterness. Only such accounts of incidents should be printed as have had the imprimatur of a Joint Board set up by the Dominion Governments.

9. In order to ensure cooperation between two Dominions as well as to minimize occasions for misunderstanding we have decided to set up joint committees of representatives of the two Dominions, which will be stationed in various important places in the country and whose duty it will be to promote peace and harmony between the communities, acquaint themselves with the difficulties and complaints of the majority and minority communities, keep themselves informed of incidents and remove all causes of suspicion and mistrust, not only between the peoples but also between the two Dominions. These representatives will be given diplomatic privileges and assured the safety of their person by the Dominion or State in which they happen to discharge their duties.

10. In order to obviate misunderstandings and to enable us to take joint and quick decisions, and to cooperate on all matters which may promote our mutual welfare, we have decided to maintain constant contact with each other, and for this purpose the Ministers of the Dominions as well as of the Provinces of the Dominions shall meet together as often as possible and shall visit any part of any Dominion as they may deem advisable.

11. For the purpose of instilling confidence in the minorities we have decided to ensure that the services are not exclusively manned by the personnel of one community but that we have therein an adequate mixture of all communities. This shall, as soon as possible, be made applicable to all the branches of the service including the Police and the Army.

12. We also desire, in order to give further confidence to the minorities and to recognise their right to participate in the administration that the Ministries should include representatives of the more important minorities.

13. The events that have occurred in both the Dominions have been a stain on civilisation. We greatly regret that we have not been able to afford that protection to the people, which it is the duty of all governments to ensure, and we extend our deepest sympathies to those who have suffered. It is not easy for people who have been

victims of atrocities or have lost their near and dear ones, whose lives have been scared and dislocated, to forgive and forget, but we have to urge upon them to do so, as any other alternative will lead to a continuance of untold miseries on innocent and unoffending persons who desire to live in friendship and amity with each other. We assert that there is no other alternative and we must not allow lawlessness to spread further and invade new territories. We must now proceed to establish a brighter future for the people of the two Dominions. For those who have had to leave their homes, it shall be our endeavour to re-settle them in their orginal homes and to protect them fully; but where such re-settlement is not desired then to rehabilitate them in new surroundings. We strongly disapprove of migrations from one part of the country to the other or of transfer of populations from one part of the country to the other or of transfer of population as being detrimental to the future welfare of the two Dominions.

14. We strongly condemn the acts of brutality which have been perpetrated by various sections of the people against each other and in particular we condemn forcible conversion and abduction of women. We consider that forcible conversion is no conversion at all and is not sanctioned by any religion. We call upon all persons forcibly converted to go back to the religion which they professed, and the people around them to see that they are in no way molested, but are allowed the fullest liberty to practise their religion, consonant with the common law of the land and good manners. We declare that we shall take the strongest action against those who put any impediments in this way. We consider it shameful and cowardly to attack defenceless women and desire that all women abducted should be returned to the members of their community as soon as possible.

15. For the better attainment of peace, unity, and harmony and toleration among the peoples of our Dominions, and for putting down disorder and lawlessness and ensure impartial and just administration, we consider it not only highly desirable but necessary to enlist the cooperation of the public. We urge upon them to form Peace Committees in all cities and villages which would be composed of such members of all communities as feel the urge to secure peace and harmony and are ready to make sacrifices in this cause. Such Committees should be set up as early as possible and will form a meeting ground whereby constant contact [and]

mutual confidence may be restored, cooperation ensured and the forces of lawlessness and disorder effectively checked. Each of these Committees should have under their control a number of peace volunteers who will prevent miscreants from creating mischief and carry on constant propaganda in favour of peace and goodwill and toleration and brotherliness. Such peace volunteers should be drawn from members of all communities pledged to work with each other in amity and discipline. We trust that the members of the public will respond to our request, give us their cooperation and lay the foundations of peaceful and progressive States that will find an honoured place in the comity of nations.

4b. M.K. Gandhi to M.A. Jinnah[2]

Confidential

Birla house,
New Delhi,
11 October 1947

Dear Quaid-i-Azam,

Shaheed Sahib has reported to me your reaction to my endorsement on the suggestions drafted by him. I am sorry to learn about it. In any case I endorse them subject [to] as follows:

In paragraph 2(4) of his letter dated the 8th October to you, I would add 'and will submit to a tribunal of permanent arbitration selected from Indians alone (i.e. from the members of the two Dominions).'

In paragraph 2(8) or in any other suitable place, I would like the following idea to be brought out: 'Each State will induce the refugees to return and occupy their respective homes.'

I find that this idea to some extent is brought out in paragraph 13 of the proposed declaration. It should be emphasized, and steps taken to implement it. In my opinion some such agreement as suggested by Shaheed Sahib should precede any move for hearty cooperation between the two States. What is wanted, no doubt, is like mind, like word and like action between the two.

Yours sincerely,
M.K. Gandhi

[2]*Ibid.*, p. 702.

4c. H.S. Suhrawardy to M.A. Jinnah[3]

Confidential

Birla house,
New Delhi,
28 October 1947

I crave leave to refer to your letter No. 1990-GG/47 of the 18th October 1947. I received it on my return from a tour in East Punjab.

In view of your desire to see the first draft which contained Mahatmaji's endorsement, I must regret that the first draft which contained his endorsement was destroyed, with all their copies and subsequent drafts with all their copies, as they had been revised and final suggestions approved, and all the previous drafts had lost their importance. Mahatmaji's endorsements embodied his own immediate reactions and were not meant as a message to you; and the succeeding draft incorporated such suggestions as he had made. His comments ceased to be of any importance thereafter. The final suggestions are now before you, and await your approval, or reactions.

I have seen some of the Muslim refugee camps in East Punjab. Their misery is appalling; most of them have been uprooted from their houses with hardly any resources; in many cases their carts and cattle were looted before they could get to the camps. Many are so weak and exhausted that if they are called upon to trek to Pakistan thousands will die on the way. The lorries that follow pick up those who cannot proceed further, but they cannot save people dying from exhaustion. Their condition would draw tears of blood from those who can see. And this will be the condition of Muslims all over India, if nothing is done to change the mentality of the people. It is not possible for Government to enforce law and order completely and *permanently* as long as Hindus and Muslims are made to look upon each other as enemies. Government can bring the situation under control for some time only, but unforeseen incidents, and even rumours, can easily produce an explosion, with unending repercussions. Government force is no solution; the psychology of the people must change; and it can change only if there is real and true cooperation between Pakistan and the Indian Union. The suggestions as approved by Mahatma Gandhi are drafted with that view; they are not comprehensive, and can

certainly be adjusted by the representatives of the two Dominions, but I beg of you for the sake of the helpless and hapless Muslims of the Indian Union to take steps in this direction. We know that we are subjects of the Indian Union, that our loyalty is pledged here, but the Dominion of Pakistan can help us greatly by coming to an agreement on the treatment of minorities, and outlining a scheme of cooperation, which will benefit the minorities of both the Dominions and make for peace and toleration and mutual goodwill. I beg this of you with folded hands. Please do not leave us in the lurch at the present juncture. We do not ask of you to intervene, or go to war for our sake; we only want you to cooperate with the Indian Union, so that Hindus and Muslims in both the Dominions may live together in peace and security in full exercise of their rights and liberties.

It is up to you now to make or unmake, to save us or send us to destruction.

[H.S. Suhrawardy]

[3]*Ibid.*, p. 716.

4d. H.S. Suhrawardy to Jawaharlal Nehru[4]

Confidential Birla house,
 New Delhi
 14 November 1947

My dear Prime Minister,

I know it is imposing upon you to request you to read my speech. But I am not doing so out of the traditional conceit of an author but because it does contain certain claims on your attention.

You may remember that some time ago I sent you what I called the draft declarations which I hope would form the basis of discussion between the two Governments. I hoped that the Pakistan Government would take the initiative. Although their principles appear to agree with the declarations, they seem hesitant to take the initiative or perhaps they don't consider them to be of sufficient importance. We, Muslims of India, however, consider the principles underlying the declarations to be very vital. For instance, cooperation between the two Dominions, eschewing of war for all time, melange of Muslims and non-Muslims in the administration, in the Army, and in the Police, representations in the Ministry of Muslims, etc.,

etc. Would it be possible for your Government to take the initiative in promoting such a conference? I think if you did so and the Pakistan Government did not respond, the world will then see who is creating the difficulties.

May I request once more that you do me the honour of reading my speech. If at any time you would care to comment upon it, I shall feel doubly honoured.

Yours sincerely,
[H.S. Suhrawardy]

[4]*Ibid.*, p. 738.

5. Maulana Azad's Address to Delhi Muslims at Jama Masjid, Delhi, 23 October 1947[1]

My brethren! You know what has brought me here today. This congregation at Shahjehan's historic mosque is not an unfamiliar sight for me. Here, I have addressed you on several previous occasions. Since then we have seen many ups and downs. At that time, instead of weariness, your faces reflected serenity, and your hearts, instead of misgivings, exuded confidence. The uneasiness on your faces and the desolation in your hearts that I see today, reminds me of the events of the past few years.

Do you remember? I hailed you, you cut off my tongue; I picked my pen, you severed my hand; I wanted to move forward, you broke of my legs; I tried to turn over, and you injured my back. When the bitter political games of the last seven years were at their peak, I tried to wake you up at every danger signal. You not only ignored my call but revived all the past traditions of neglect and denial. As a result, the same perils surround you today, whose onset had previously diverted you from the righteous path.

Today, mine is no more than an inert existence or a forlorn cry; I am an orphan in my own motherland. This does not mean that I feel trapped in the original choice that I had made for myself, nor do I feel that there is no room left for my *aashiana* (nest). What it means is that my cloak is weary of your impudent grabbing hands. My sensitivities are injured, my heart is heavy. Think for one moment. What course did you adopt? Where have you reached, and where do you stand now? Haven't your senses become torpid? Aren't you living in a constant state of fear? This fear is your own creation, a fruit of your own deeds.

It was not long ago when I warned you that the two-nation theory was death–knell to a meaningful, dignified life; forsake it. I told you that the pillars upon which you were leaning would inevitably crumble. To all this you turned a deaf ear. You did not realize that fleet-footed time would not change its course to suit your convenience. Time sped along. And now you change its course to suit your convenience. Time sped along. And now you have discovered that the so-called anchors of your faith have set you adrift, to be kicked around by fate. Their understanding of the word does not correspond with the lexicon of your belief. For them, fate is another name for lack of courage.

The chessboard of British gamesmanship has been upturned. Those pawns called 'leader' which you had carved and installed, have disappeared overnight. You believed that the chessboard had been spread forever and forever, and the worship of those pawns was the summun bonum of your existence. I do not want to lacerate your wounds, or aggravate your agony. However, if you look into the past you will find that through hindsight you can unravel several mysteries.

There was a time, when exhorting the need for achieving India's independence, I had called out to you.

No nation, however depraved, can stop the inevitable turn of events. A revolutionary political change has been inscribed in India's book of destiny. The twentieth-century maelstrom of freedom is about to break India's chains of slavery. If you falter and fall behind the march of the times, if you remain inert and lethargic, the future historian will record that your flock, a cluster of seven crores, adopted an attitude towards freedom, which was characteristic of a community heading towards extinction. Today, the Indian flag has been hoisted in all its majestic splendour. This is the very same flag which evoked sneers and contemptuous laughter from the rulers of the time. . . .

The partition of India was a fundamental mistake. The manner in which religious differences were incited, inevitably led to the devastation that we have seen with our own eyes. Unfortunately, we are still seeing it at some places.

There is no use recounting the events of the past seven years, nor will it serve any good. It must be stated that the debacle of Indian Muslims is the result of the colossal blunders committed by the Muslim League's misguided leadership. These consequences, however, were no surprise to me; I had anticipated them from the very start.

Now that Indian politics has taken a new direction, there is no place in it for the Muslim League. Now the question is whether or not we are capable of any constructive thinking. For this, I have invited the Muslim leaders of India to Delhi, during the second week of November.

The gloom cast upon your lives is momentary; I assure you we can be beaten by none save our own selves! I have always said, and I repeat it again today; eschew your indecisiveness, your mistrust, and stop your misdeeds. This unique triple-edged weapon is more lethal than the two-edged iron sword which inflicts fatal wounds, which I have heard of! . . .

Where are you going and why? Raise your eyes. The minarets of Jama Masjid want to ask you a question. Where have you lost the glorious pages from your chronicles? Was it only yesterday that on the banks of the Jamuna, your caravans performed *wuzu*? Today, you are afraid of living here! Remember, Delhi has been nurtured with your blood. Brothers! Create a basic change in yourselves. Today, your fear is as misplaced as your jubilation was yesterday.

The words *coward* and *frenzy* cannot be spoken in the same breath as the word Muslim. A true Muslim can be swayed neither by avarice nor by apprehension. Don't get scared you in a single fold was to facilitate their own flight. Today, if they have jerked their hand free from yours, what does it matter? Make sure that they have not run away with your hearts. If your hearts are still in the right place, make them the abode of God. Some thirteen hundred years ago, through an Arab *ummi*,[2] God proclaimed, 'Those who place their faith in God and are firm in their belief, no fear for them nor any sorrow.' Winds blow in and blow out; tempests may gather but all this is short-lived. The period of trial is about to end. Change yourselves as if you had never been in such an abject condition. . . .

I do not ask you to seek certificates from the new echelons of power. I do not want you to lead a life of sycophancy as you did during the foreign rule. I want to remind you that these bright etchings which you see all around you, are relics of the *Qafilas* of your forefathers. Do not forget them. Do not forsake them. Live like their worthy inheritors, and, rest assured that if you do not wish to flee from this scene, nobody can make you flee. Come, today let us pledge that this country is ours, we belong to it and any fundamental decision about its destiny will remain incomplete without our consent.

Today, you fear the earth's tremors; once you were virtually the earthquake itself. Today, you fear the darkness; once your existence was the epicentre of radiance. Clouds have poured dirty waters and you have hitched up your trousers. Those were none but your forefathers who not only plunged headlong into the seas, but trampled the mountains, laughed at the bolts of lightning, turned away the tornados, challenged the tempests and made them alter their course. It is a sure sign of a dying faith that those who had once grabbed the collars of emperors, are today clutching at their own throats. They have become oblivious of the existence of God as if they had never believed in Him.

Brothers! I do not have a new prescription for you. I have the same old prescription that was revealed to the greatest benefactor of mankind, the prescription of the Holy Quran: 'Do not fear and do not grieve. If you possess true faith, you will gain the upper hand.'

[1]Saiyida Saiyidain Hameed (ed.), *India's Maulana Abul Kalam Azad*, Centenary vol. II, ICCR, Vikas, 1990, pp. 170–3.
[2]Illiterate. The Prophet of Islam could neither read nor write.

6. All-India Muslim League Splits into Pakistan Muslim League and Indian Union Muslim League[1]

During the All-India Muslim League session held at Karachi on 14 December 1947, Mr M.A. Jinnath deplored the human madness that had overwhelmed people and brought misery to many homes. While condemning the disturbances in both the Dominions, the Quaid-i-Azam reminded the Muslims that it was against Islam to indulge in such crimes. He expressed the hope that the minorities in both the Dominions would be assured adequate protection, and as the Governor General of Pakistan, he would do his duty.

The Quaid-i-Azam recalled the charges that were being levelled against Pakistan and its leaders about the betrayal of Muslim masses in the Indian Union. He said he was full of feelings for the Muslim masses in the Indian Union who were, unfortunately, facing bad days. He advised the Indian Muslims to organize themselves so as to become powerful enough to safeguard their political rights. A well-organized minority should be powerful enough to protect its

own rights—political, cultural, economic and social. On his part, he assured them of his full realization that the achievement of Pakistan was the outcome of the labour and toil of the Muslims in India as well as of those who were now enjoying its fruits. Pakistan would help them in every possible way.

A member interrupted and asked the Quaid-i-Azam if he would, once again, be prepared to take over the leadership of the Muslims of India in the present hour of trial. The Quaid-i-Azam replied that he was quite willing to do so if the Council gave its verdict in favour of such a proposal. He recalled his statement at the time of the achievement of Pakistan that his job had been done, and with the achievement of Pakistan, the cherished goal of the Muslim nation, he wanted to lead a retired life. But if called upon, he was quite ready to leave Pakistan and share the difficulties of the Muslims in the Indian Union and to lead them.

Mr Liaquat Ali Khan then moved the main resolution, calling for the splitting up of the All-India Muslim League into two Leagues, both independent and separate from each other. Sardar Abdur Rab Nishtar seconded the resolution. Several members wanted time to consider the resolution and move amendments. . . .

The Council adjourned after three hours to resume the discussion, and met again on 15 December.

Discussion on the first resolution was resumed. Mr Jinnah addressed the Council again and said: 'There must be a Muslim League in Hindustan. If you are thinking of anything else, you are finished. If you want to wind up the League you can do so; but I think it would be a great mistake. I know there is an attempt. Maulana Abul Kalam Azad and others are trying to break the identity of Muslims in India. Do not allow it. Do not do it.'[2]

Mr Hussain Imam then moved his amendment: 'In the resolution, ". . . in place of the All-India Muslim League, there shall be separate League organizations for Pakistan and the Indian Union", the word "shall" should be replaced by "may".' Mr Imam said, 'People here do not know the difficulties the Muslims are facing in India. They should be left free to decide their future according to the circumstances.' No one supported Mr Hussain Imam's amendment.

Mr Jinnah said, 'I sympathize with Mr Hussain Imam. He has not read the resolution properly. You should constitute the Muslim League in India. If you do not, you would go back to 1906. You are forty million; you can have a leader—if not one, then two or more.

We cannot give directives to you. When you are strong and Pakistan is developed, the settlement will come.'

Speaking next, Mr Suhrawardy added: 'I oppose this resolution. I am amongst those who had proposed some time ago that the League should be split. So, some might be surprised at my opposition. But before we split, my concern is to do something practical about the protection of minorities. I say when our objective is achieved, then why should we not organize ourselves in such a manner that the minorities are given the opportunity, on a national basis, to join us in the same organization? If you do that in Pakistan, it would help us in the Indian Union. If you form a national body here it would strengthen the hands of Nehru and Gandhi. The AICC passed a very good resolution. We should also have passed a similar resolution.'

Sardar Abdur Rab Nishtar made an appeal to the members and said, 'Our two friends want to finish the League. I say if the League exists, Islam exists, Musalmans exist. We shall never allow the League to be wound up. The protection of minorities in India depends on the strength of Pakistan. We shall do all to protect them.'

Mr Liaquat Ali Khan supported Sardar Abdur Rab Nishtar. The resolution was passed with an overwhelming majority. Some ten members, including Mr Suhrawardy and Mian Iftikharuddin, voted against it.

Mr Liaquat Ali Khan and Mr Ismail, president of the Madras Provincial Muslim League, were elected as convenors for the Pakistan Muslim League and the Indian Muslim League respectively, and it was decided to hold their sessions shortly at Karachi and Madras.[2]

The Council of the Muslim League concluded its sitting, after it had adopted the following resolutions:

Resolutions Adopted by the Council Meeting

The Council of the All-India Muslim League, having reviewed the situation and the happenings in various parts of the Indian subcontinent since its last meeting, held in New Delhi on 9 June this year, places on record its deep sense of sorrow and its feelings of horror at the widespread acts of organized violence and barbarity which have taken place, resulting in the loss of hundreds of thousands of innocent lives, colossal destruction of property, wanton outrages against women, and mass migration of populations,

whereby millions of human beings have been uprooted from their hearths and homes and reduced to utter destitution.

The Council expresses its deep regret that, although the division of India has taken place on the basis of an agreement to which both the Congress and the Muslim League were consenting parties, and although these two political organizations were recognized and named in the Indian Independence Act itself as the successor authorities to the British for purposes of the transfer of power, certain influential sections of people in the Indian Union, including persons holding responsible positions, have been acting contrary to the spirit of that agreement, and are branding the Muslim minority in the Indian Union as disloyal because of their support of the very solution of the long-standing political problem which the Congress itself had ultimately and finally accepted and ratified, notwithstanding the most categorical declarations and assurances by representative Muslim leaders, in the Indian Constituent Assembly and outside, that the Muslims in the Indian Dominion had completely identified themselves with the country in which their lot had been cast and of which they had become natural citizens with all the rights as well as the obligations of such citizenship.

This Council strongly condemns and deplores that, in spite of the strict injunctions, given privately and publicly by the Quaid-i-Azam and the Muslim League, not to harm the minorities in any way, unfortunately, acts of violence were also committed in certain parts of Pakistan, inflicting loss of life and sufferings on the non-Muslim minorities, and expresses satisfaction that these were suppressed and brought under control by timely and vigorous action on the part of the government concerned. The Council reminds the governments of both the Indian Union and Pakistan that they jointly gave the most categorical assurances to their respective minorities of full protection of life and property and of a full guarantee of their rights and interests, and most emphatically urges the governments of the Indian Union and Pakistan, and the authorities concerned, that the pledges given to the minorities be fulfilled in all sincerity.

The Council hopes that both governments will realize their responsibility in this behalf and prepare, after deliberations, a charter of minority rights which will ensure an honourable existence for the minorities in the two Dominions. The Council further hopes that the two Dominion governments will be able to conclude agreements and treaties which will promote and stabilize friendly relations between the two Dominions.

The Council of the All-India Muslim League views with great satisfaction the attainment of its main objective, namely the establishment of Pakistan, and congratulates the Musalmans of the Indian subcontinent on the sacrifices they have made for the achievement of their national goal. The Council feels confident that the unique struggle of the Muslim League for the establishment of a fully independent sovereign state, under the superb leadership of Quaid-i-Azam Mohammed Ali Jinnah, and its ultimate triumph in the birth of the largest Muslim state and the fifth largest of all states in the world, will go down in history as the most outstanding world event of modern times. The Council now calls upon the Musalmans of Pakistan and all other loyal citizens of the state to make the greatest possible contribution towards building up of this new-born state, so that in as short a time as possible it can attain an honourable position in the comity of nations of the world as an ideal democratic state based on social justice as an upholder of human freedom and world peace, in which all its citizens will enjoy equal rights and be free from fear, want, and ignorance.

Now that the main object of the All-India Muslim League has been fulfilled and India has been divided into two independent and sovereign states, certain changes are inevitable in the structure, objectives, and policies of the All-India Muslim League organization. It is obvious that the Musalmans of Pakistan and India can no longer have one and the same political organization.

The Council therefore resolves:

1. (i) That in place of the All-India Muslim League there shall be separate Muslim League organizations for Pakistan and the Indian Union. (ii) That all members of the Council of the All-India Muslim League for the time being who have become ordinarily residents of the territories comprised by Pakistan, or have settled therein, and all Muslim members of the Pakistan Constituent Assembly who are primary members of the Muslim League do hereby constitute the Council of the Pakistan Muslim League. (iii) That all members of the Council of the All-India Muslim League who have become ordinarily residents of the territories comprised by the Indian Union, or have settled therein, and all Muslim members of the Indian Union Constituent Assembly who are primary members of the Muslim League do hereby constitute the Council of the Indian Union Muslim League. (iv) That a convenor each be appointed for the Pakistan Muslim League and the Indian Union Muslim League, with instructions to convene at very early dates meetings of the two respective Councils as defined above, for

the purpose of electing office bearers, framing the constitution and transacting such other business as arises by virtue of this decision. (v) That the following be elected the convenors respectively: for the Pakistan Muslim League, the Honourable Mr Liaquat Ali Khan; for the Indian Union Muslim League, Mr Mohammad Ismail, president, Madras Provincial Muslim League. (vi) That the meeting of the Council of the Pakistan Muslim League will be held at Karachi, and that of the Indian Union Muslim League at Madras.

2. That all primary members of the All-India Muslim League who are now ordinarily residents of Pakistan, or have settled therein, should be deemed ipso facto to have become primary members of the Pakistan Muslim League; and all members of the All-India Muslim League who are now ordinarily residents of the Indian Union, or have settled therein, be deemed to have become ipso facto primary members of the Indian Union Muslim League.

3. That when meetings of the respective Councils of the Pakistan Muslim League and the Indian Union Muslim League are convened, each Council shall elect its representatives, not exceeding three in each case, as members of a joint ad hoc committee for the purpose of deciding how the assets and liabilities of the All-India Muslim League are to be equitably divided between the Pakistan Muslim League and the Indian Union Muslim League. In the event of a difference of opinion in the ad hoc committee, the issues in dispute will be finally decided by the Quaid-i-Azam.

4. That in case of dispute regarding the membership of the Council, a written declaration by an existing member of the Council of the All-India Muslim League to the effect that he is ordinarily resident of, or has settled in, Pakistan or the Indian Union shall be conclusive.

5. That the existing Central Parliamentary Board of the All-India Muslim League shall continue to function in accordance with the Constitution and Rules for the Muslim League organization in Pakistan till such time as the Council of the Pakistan Muslim League meets, and for the Muslim League organization in the Indian Union till such time as the Council of the Indian Union Muslim League meets.

[1]Syed Sharifuddin Pizada (ed.), *Foundations of Pakistan, All-India Muslim League Documents 1906–1947*, vol. ii, 1924–1947, Karachi: National Publishing House, Karachi, 1970, pp. 570–6.

[2]Sources: *The Times of India*, Bombay, 15–16 December 1947; *The Statesman*, Delhi, 15 December 1947; *The Daily Gazette*, Karachi, 16 December 1947; *People's Age*, Bombay, 11 January 1948.

7. Gandhi's Advice to Indian Muslims Delivered on 22 December 1947 in a Post-Prayer Meeting[1]

In view of the decision recently arrived at by the Muslim League meeting held in Karachi, and in view of the meeting to be held in Lucknow, at the instance of Maulana Azad, the Muslim friends have been asking me whether, if they were members of the Muslim League, they should also attend the meeting of the Muslim League members to be held in Madras, and in any event, what the attitude of the members of the Muslim League in the Union should be. I have no doubt that if they are invited specially or publicly, they should attend the Lucknow meeting, as also the later meeting at Madras. And at each meeting, they should express their views fearlessly and frankly. That the Muslims in the Indian Union find themselves in a minority, without the protection from the majority in Pakistan, is no disadvantage, if they at all followed the technique of non-violence during the past thirty years. It was not necessary for them to have faith in non-violence, to be able to appreciate the fact that a minority, however small it might be, never has any cause for fear, as to the preservation of their honour and all that must be near and dear to man. Man is so made that, if he understood his Maker and himself as made in His image, no power on earth could rob him of self-respect, except he himself. The Union Muslims are now free from the oppressiveness they were under, whilst they were falsely proud of the Muslim majority in the west and in the east. If they would realize the virtue of being in a minority they would know that they could now express in their own lives the best that is in Islam. Will they remember that Islam gave its best during the Prophet's ministry in Mecca? Christianity waned, when Constantine came to it. But I must not here carry this argument further. My advice is based upon implicit belief in it. Therefore, if my Muslim friends do not share the belief, they will perhaps do well to reject the advice.

In my opinion, while they should hold themselves in readiness to join the Congress, they should refrain from applying for admission, until they are welcomed with open arms and on terms of absolute equality. In theory, at least, the Congress has no major and no minor communities. It has no religion but the religion of humanity. For the Congress, every man and every woman is equal to any other. The Congress is a purely secular, political, national

organisation in which Hindus, Muslims, Sikhs, Christians, Parsis, Jews are equal. Because the Congress has not always been able to live up to its profession, it has appeared to many Muslims as a predominantly caste Hindu organization. Anyway, the Muslims should have dignified aloofness, so long as the tension lasts. They would be in the Congress, when their services are wanted by it. In the meantime, they should be of the Congress, even as I am. That I have an influence, without being a four-anna member, is because I have served the Congress faithfully, ever since my return from South Africa in 1915. Every Muslim can do so from now, and he will realize that his services are as much valued as mine. Today, every Muslim is assumed to be a Leaguer and, therefore, to be an enemy of the Congress. Such, unfortunately, has been the teaching of the Muslim League. There is now not the slightest cause for enmity. Four months are too short a period, to be free from the communal poison. Unfortunately for this unhappy land, the Hindus and the Sikhs mistook the poison for nectar, and they have, therefore, become the enemies of the Muslims of India, and have, to their disgrace, retaliated and become so even with the Muslims of Pakistan. I should, therefore, strongly urge the Muslim minority to rise superior to the poisonous atmosphere, and live down the thoughtless prejudice by proving by their exemplary conduct that the only honourable way of living in the Indian Union is that they should be full citizens, without any mental reservations. It follows then that the Muslim League cannot remain a political organization, even as the Hindu Mahasabha, or the Sikh Sabha, or the Parsi Sabha cannot. They may function as religious organizations for the internal religious reforms, for the purpose of exploring the best and living the best that is in their religions. Then they will purify the atmosphere of all poison and will vie with one another in well-doing. They will be friendly to one another, and thus help the state. Their political ambition can only be satisfied through the Congress, whether they are in it or not. The Congress will be a caucus, when it thinks of those only who are in it. It has very few such, even now. It has as yet an unrivalled position, because it strives to represent the whole of India, without exception. It aims to serve even unto this last.

[1] D.G. Tendulkar, *Mahatma*, D.G. Tendulkar and Vithalbhai K. Jhaveri, Bombay, vol. 8, 1954.

8. Suhrawardy on Gandhi's Advice[1]

Mr H.S. Suhrawardy, former Premier of Bengal, is in a state in readiness to join the Congress but not to enter its folds until welcomed.

Welcoming the advice given by Mahatma Gandhi to the Muslims of the Indian Union, Mr Suhrawardy says: 'Shall we be welcomed wholeheartedly and sincerely, shall we be trusted? Will the Congress be prepared to give due consideration to our voice and listen to our suggestions? Is it really prepared to throw its doors open to us and admit all? These and similar questions assail us.'

'It is almost immaterial from the point of safeguarding their interests whether the Indian Muslims keep the League or liquidate it and join a non-communal organization,' he continues. 'Their position can only be stabilized if Pakistan and the Indian Union get together and draw up a charter of minority rights and set up a machinery for implementing the charter.'

'The political conflict between the Congress and the Muslim League being at an end,' he adds, 'nothing now stands in the way of our joining the Congress, from which we can expect justice, fair play, and a sympathetic consideration of our grievances, guided, as it is, by Mahatma Gandhi and inspired as it is, by the idealism of Jawaharlal Nehru.'

'The next question is, when shall we know that we are welcome and how?' Mr Suhrawardy asks. 'We know little of the forces at play within the Congress and I feel that we must leave it to Mahatma Gandhi to tell us when. He is the one man who has brought back sanity to an insane world, and has fought for the rights of the oppressed against injustice and cruelty. He has given hope and strengthened their morale. The Muslims as the principal minority of India, have reasons to be particularly grateful to him and we can trust him to give us the right lead. I appeal to my Muslim brethren to pay heed to his advice. We await his signal.'

[1]*The Times of India*, Calcutta, 26 December 1947.

9. Maulana Azad Calls on Indian Muslims to Dissolve the Muslim League and Join the Congress[1]

A strong appeal to the All-India Muslim League to dissolve the organization, as communal bodies were dangerous and had

no place in the political life of the country, and join the Indian National Congress was made by Maulana Abul Kalam Azad, in his presidential address at the Indian Union Muslim Conference today.

The audience, which numbered more than 60,000 Muslims from all walks of life, including a large number of Muslim Leaguers, who attended the conference in their individual capacity, heard the Maulana in pin-drop silence and cheered him when he condemned communalism in every shape and form.

The Maulana said that a mere change in the leadership or policy of the Muslim League, which had been responsible in the past for communal disunity in the country, would not change the situation. He added: 'All communal organizations must be liquidated. Even the Jamiat-ul-Ulema-i-Hind, whose main function has been to guide the Muslims in the cultural and religious spheres, but which entered the political field in the cause of Indian nationalism, will have to cease its political activities now that India has achieved liberation.' The Maulana declared that any political organization of the Muslims and, for that matter, of any other community—howsoever nationalist and progressive its outlook—would be harmful to the interest of Muslims and the country as a whole and could not be tolerated in the changed circumstances of the country.

Religious organizations

Maulana Azad observed that there could be no objection to the functioning in the country of communal organizations which confined their activities to religion and culture alone, and kept themselves scrupulously aloof from political squabbles. He said that the responsibility of those who participated in the conference would not end with the taking of decisions to dissolve all communal bodies and joining non-communal, political, and progressive organizations. They had also to devise a machinery in order to make their decisions operative. A non-communal committee should be formed to change the prevailing atmosphere in the country in the light of the decisions of the conference.

Mr Hafiz Mohammad Ibrahim, chairman of the reception committee, in his address advised the Muslims to join the Congress and strengthen it. He said: 'Congress is today based on true and correct principles. The freedom of India is not meant for any particular community or class or religion; it is for all who live in this land.'

[1] Presidential address at the Indian Union Muslim Conference at Lucknow on 27 December 1947. *The Times of India*, Lucknow, 28 December 1947.

10. Indian Union Muslim Conference's Call to Abjure Communal Politics[1]

The Indian Union Muslim Conference, which resumed its session at Lucknow on 28 December 1947 under the presidentship of Maulana Abul Kalam Azad, unanimously passed a resolution calling upon Muslims of all shades of political opinion to take a united decision and abjure communal politics. Over 50,000 attended the conference.

The resolution which was moved by Maulana Ahmad Said, vice-president of Jamiat-ul-Ulmaigai-Hind, said: 'This conference of the Muslims of the Indian Union has surveyed the terrible happenings that have taken place in India since August 1947 and come to the conclusion that they reveal an alarming growth of disruptive, antisocial, and reactionary ideas and tendencies in Indian political life masquerading under communal and false religious slogans.

'Communal parties have, in the past, done immense harm to the country and specially the minorities of India and are pregnant with even greater danger to their future. The time has, therefore, come when Muslims of all shades of political opinion must take a united decision and abjure communal politics.'

Another resolution moved by Mr S.A. Brelvi, unanimously adopted by the conference called upon the Muslims of India to be members only of non-communal political parties and advised them to join the Indian National Congress.

[1]Resolution adopted at the Indian Union Muslim Conference on 28 December 1947. *The Times of India*, Lucknow, 29 December 1947.

11. Sardar Patel Refutes League Leaders' Charge of Sabotaging Pakistan[1]

Sardar Vallabhbhai Patel, India's deputy prime minister, addressing a huge public meeting at Lucknow on 6 January 1948, appealed to the younger generation of India to help the administration in consolidating India's position and making her impregnable.

'Our achievement during the last four months,' said the Sardar, 'have to some extent restored the prestige which the country lost in

the eyes of the world by the unfortunate happenings following the partition.'

Sardar Patel observed that the maintenance of communal and industrial peace was essential if the newly born democratic state of India was to lead the Asiatic countries on the road to progress and emancipation from foreign domination.

Speaking of the communal problem, Sardar Patel said that he was a true friend of the Muslims although he had been described as their greatest enemy. 'I believe in plain speaking. I do not know how to mince words. I want to tell the Muslims frankly that mere declaration of loyalty to the Indian Union will not help them at this critical juncture,' the deputy prime minister said.

Sardar Patel referred to 'the ever-changing, indecisive, and non-committal attitude of Pakistan,' and said that the Pakistan government should change its policy in its own interest. The Junagadh and Kashmir incidents, he said, had demonstrated Pakistan's intentions.

'If you want to divide the rest of India also,' Sardar Patel declared, 'Say boldly and let us decide the issue in the open field.'

The deputy prime minister then dealt with the charge made by Pakistan leaders that the Congress had tried to sabotage Pakistan and said that the charge was baseless. 'The establishment of Pakistan had been advocated as a heaven on earth for Muslims,' he continued. 'We should be glad if they make it a heaven. They must realize that the enemies of Pakistan are inside and not outside it. If Pakistan collapses, she would collapse by her own mistakes and sins.'

Refutes Pakistan charge

Sardar Patel dealt at length with the considerations that had influenced the Congress to agree to the division of the country and said, 'We did not think that we will not get breathing time even after separation. It is said today that plans for sabotaging Pakistan are being hatched in Hindustan. But I assure you all that no plan for destroying Pakistan is being hatched in Hindustan. If any such plan is being hatched, it is being hatched in Pakistan. It is the situation in Pakistan that will ruin Pakistan. Some times they accuse the Hindus, the Sikhs, and the Central government of creating trouble. But I tell you that if Pakistan falls, it will not fall on account of us but on account of its own enemies from within.'

Sardar Patel continued: 'The Muslim Leaguers call me their greatest enemy. Formerly, they used to call Mahatma Gandhi as

their enemy number one. Now they think that Gandhiji is their friend and have substituted me in his place because I speak out the truth. They believed that if they get Pakistan they would ensure full protection for the Muslims. But have they ever looked at the Muslims living in Hindustan? Have they ever sympathized with them?

'When freedom was won, came the Punjab massacre which had lowered our prestige. Then came the Junagadh issue followed by the Kashmir problem. We raised the question with Pakistan. They replied, "We are not concerned." "It was the Azad government in Kashmir and the Kashmiri Muslims who were responsible for the aggression," they said. But it was no secret that the frontier tribesmen were receiving rations, war material, motor trucks, and petrol from Pakistan.'

Kashmir issue

Insisting that the Indian Union referred the Kashmir issue to the UNO 'as a last resort' Sardar Patel addressed himself to Muslims in India and said: 'I want to ask the Indian Muslims only one question. In the recent All-India Muslim Conference why did you not open your mouth on the Kashmir issue? Why did you not condemn the action of Pakistan?'

'These things create doubt in the minds of the people. So I want to say a word as a friend of Muslims because it is the duty of a good friend to speak frankly. It is your duty now to sail in the same boat and sink or swim together. I want to tell you very clearly that you cannot ride on two horses. You select one horse whichever you like best.

'In the Constituent Assembly one of the Lucknow Muslim Leaguers pleaded for separate electorate and reservation of seats. I had to open my mouth and say that he could not have it both ways. Now he is in Pakistan. Those who want to go to Pakistan can go there and live in peace. Let us live here in peace to work for ourselves.

Sardar Patel recounted the enormous tasks that the new Government of India had been able to achieve since partition and said, 'If such a burden had fallen all of a sudden on any new government it would have collapsed. But we did not fail. As a matter of fact, the manner in which we have discharged our most difficult duties has raised our prestige in the world.

'Now two things are needed for the reconstruction of India: a strong Central government and a formidable army. By army I mean all its branches—naval, air, and land forces.

'If the relations between Pakistan and Hindustan continue as at present, the consequences can be foreseen. I am not hiding anything but I am stating the bare fact. I should not like that anybody should throw dust into our eyes.'

Sardar Patel then appealed to the Hindu Mahasabha to join the Congress. He said, 'No good will be served by remaining aloof. If you think that you are the only custodians of Hinduism, you are mistaken. Hinduism preaches a broader outlook on life. There is much more tolerance in Hinduism than is interpreted for it in certain quarters,' Sardar Patel added.

Fear of disastrous end

While on the subject of India's need for a strong defence force, Sardar Patel declared that industrial progress and a steady industrial production were the first essentials. 'If there was labour unrest, a strong and formidable army could not be built up. At the last industrial conference, the labour leaders were in agreement with the government, but still there was a one-day strike in Bombay. If we proceed on these lines, India will meet with a disastrous end. India is not an industrial country. She has to be industrialized first. This sort of foolishness will only put obstacles in the uplift of the country.'

Appeal to labour leaders

Sardar Patel appealed to labour leaders not to foment strike and create disturbances and said, 'There is no alien power here now. It is easy to approach us. Why not labour leaders come straight to us and tell us about the grievances of labour? The Trade Union Congress is working under the influence of the communists. The days of strike and hartal are gone. They were needed when we were fighting against the foreign power. Those tactics must now cease. Give us time. At least let us have three or four years' truce and then see what we do.'

Sardar Patel invited the Rashtriya Swayamsevak Sangh to join the Congress and appealed to them not to weaken the administration by creating unrest in the country. He realized that they were not actuated by selfish motives, but the situation demanded that they

should strengthen the hands of the government and assist in maintaining peace.

Win over RSS by love

He also had a word of warning 'to those who are in power in the Congress'. He said, 'In the Congress, those who are in power feel that by virtue of authority they will be able to crush the RSS. You cannot crush an organization by using the *danda*. The *danda* is meant for thieves and dacoits. After all the RSS men are not thieves and dacoits. They are patriots who love their country. Only their trend of thought is diverted. They are to be won over by Congressmen by love.'

[1]*Bombay Chronicle*, Bombay, 7 January 1948.

12. Muslim League Party in the Constituent Assembly Dissolved[1]

Fourteen out of the total of twenty-seven Muslim League members of the Constituent Assembly met in New Delhi on 29 February 1948 and by a majority decided to dissolve the League Party in the Constituent Assembly. Nawab Ismail Khan presided.

The following resolution was passed:

'The Muslim League Party of the Constituent Assembly which was formed by a resolution on 13 July 1947, resolves that in view of the changed conditions in the country, this party realizes that it cannot perform any useful service to the Muslims of the Indian Union as a communal party and, therefore, decides to dissolve itself from 1 March 1948.'

Four disagree

Four members of the party who voted against this resolution in a statement said: 'We regret that the decision to dissolve the Muslim League Party in the Constituent Assembly has been taken by eight out of the total of twenty-seven members of the party. In view of the fact that all members of the party were elected on the Muslim League ticket, constitutionally, the party can only be dissolved by the Muslim organization in the Indian Union, a meeting of which is being held at Madras on 19 March 1948. Until a final decision is taken, the League Party in the Constituent Assembly continues.

'In our view the constitutional course open to any member who feels that the party should not function is to resign from the Constituent Assembly to which he was elected on the League ticket.'

The statement was signed by Qazi Issak Sait, chief of the party, Mr Pocker Sahib, Mr Ibrahim and Mr Abdul Kader Sheikh.

[1]*Bombay Chronicle*, Bombay, 1 March 1948.

13. Policies and Programmes of the Indian Union Muslim League Formulated in its Council Meeting at Madras[1]

The Indian Union Muslim League Council met at Madras on 10 March 1948 and resolved that a subcommittee should draw up a new constitution for the League keeping in view 'the radically changed conditions in the country and the supreme necessity for Hindu-Muslim unity, communal goodwill, and understanding in general'.

The new constitution shall also provide for the Muslim League joining with any other political party that can deliver the goods for the people.

The Council, by a resolution, decided that the present constitution of the All-India Muslim League shall be the constitution of the Indian Muslim League with the following amendment until the new constitution is framed after the consideration of the report to be submitted by the subcommittee within three months.

The aims and the objectives of the Indian Union Muslim League shall be (a) to uphold, defend, maintain, and assist in upholding, defending, and maintaining the independence, freedom, and honour of the state of the Indian Union and to work for and contribute towards the ever-increasing strength, prosperity, and happiness of the people; (b) to secure and protect the rights and interests of the Muslims and other minorities in the state; and (c) to promote mutual understanding, goodwill, amity, cordiality, harmony, and unity between the Muslims and every other community of India.

The Council resolved that 'the present members of the primary Muslim League in the Indian Union shall continue until such date as may be fixed by the working committee of the Indian Union Muslim League. The existing Indian Union Muslim League Council and the provincial, district and city, and primary Muslim Leagues

shall continue to function until fresh elections are held according to the programme to be prescribed by the working committee of the Indian Union Muslim League.

By another resolution, the Council, while declaring the arrests of the Muslim National Guards as 'absolutely unwarranted and unjustified', resolved that 'the Muslim National Guards organization do stand dissolved and disbanded as already announced by the convener of the Indian Union Muslim League'.

The Council also appointed an ad hoc committee for the purpose of dividing the assets and liabilities of the All-India Muslim League between the Pakistan and the Indian Union Muslim League.

The chairman, it is understood, disallowed an amendment to the main resolution seeking to divest the Indian Union Muslim League of its political and parliamentary activities.

Seven of the thirty members present including Maulana Hazrat Mohani (member from UP) voted against the main resolution, it is stated, for not including the amendment.

Mr Mohammed Ismail (convener) was elected president and Haji Hussanali P. Ibrahim Sahib (Bombay) and Mr Mahaboob Ali Baig (Madras) as treasurer and general secretary, respectively.

The following is the main resolution passed by the Council:

'Whereas in view of the attainment of the independence of the country it is essential that the policy of the Indian Union Muslim League should be clarified, this meeting of the Council of the Indian Union Muslim League declares that it shall be the wholehearted and devoted endeavour of the Muslim League to bring about perfect harmony and goodwill and mutual understanding among the various sections of the people of the country ensuring the swiftest possible progress of the people towards prosperity and happiness. This meeting calls upon all the Muslims to cooperate in every possible way with other organizations and parties in the matter of establishment of peace and harmony between various communities.

'This meeting further resolves that the Muslim League shall now devote its attention principally to the promotion of the religious, cultural, educational, and economic interests of the Muslims of the Union.

'With a view to contributing to the post-independence nation-building activities in the country, the meeting formulates a constructive programme to be adopted by the various Muslim League legislature parties with necessary modifications. In the execution of the said programme, the parties may combine or cooperate under any name they choose with any other parties,

groups, or individuals in the land whose economic programmes are identical with or approximate, as far as possible, to this said programme.'

[1]*The Times of India*, 12 March 1948.

14. Suhrawardy Opposes Continuance of Muslim League[1]

'There is no justification for the existence or continuance of a communal political organization for Muslims,' said Mr H.S. Suhrawardy, commenting on the Muslim League's decision to continue functioning in India. He said the Muslim League had obtained its political objective, and two independent states had come into being. A political organization at this stage was liable to be suspected of 'irridentism' or 'separatism' or 'ascendency', all of which were not in accord with Muslim opinion.

Mr Suhrawardy expressed the opinion that the Muslims would not merely be able to safeguard their interests by joining one or other of the various non-communal political organizations, but would be able also to express themselves, realize themselves and assert themselves adequately through such organizations. Such conduct would not be equal to submission.

End separatist feeling

Continuing, he said that as long as there was a feeling of separatism and as long as Muslims were discriminated against either by the government or government officials or by the majority community, there would always be a demand for expression by Muslims through an organization of their own. So the barriers must be broken down, and the Muslims should do so by winding up their communal political organization, thus qualifying themselves for equal citizenship. At the same time, sufficient sense of justice and fairplay should be roused in the minority community that their interests would be safeguarded. For this purpose, organizations mainly of the majority community, must be set up in both the Dominions, supported by the respective governments and by the administrative machinery.

[1]*The Times of India*, 13 March 1948.

15. Maulana Azad Advises Jamiat to Shun Politics and Confine Itself to Religious and Social Activities[1]

Maulana Abul Kalam Azad, education minister, government of India, addressing the Central Council of the Jamiat-ul-Ulema-e-Hind at New Delhi on 20 March 1948 advised the Jamiat to give up politics and confine its future activities to safeguarding the cultural, educational, economic, and religious interests of the Muslims of the Indian Union.

Maulana Azad reviewed the events leading to the present political set-up in the country and said that there was no justification in future for any organization to exist on communal grounds. If the Muslims in the Indian Union wanted to keep their communal entity intact even after independence, the majority community in the Union would also insist on a communal existence. What would be the result of such communalism? The communalism of the Muslim League was responsible for a reciprocal communalism in the ranks of Hindus and Sikhs. Where had it landed them? Under such circumstances, his advice to the Jamiat would be to concentrate its activities on strengthening the Muslim community in the Union by safeguarding their religious, economic, cultural, and educational interests and keep aloof from the political field, with which it had a twenty-seven-year-old connection.

Lucknow decisions

Referring to the decisions of the Lucknow conference under his presidentship, Maulana Azad said that the lead given by that conference was being pursued not only by the Congress and by the people but even by the government of the country. It was a matter of pleasure for him to know that the body of Ulemas in the country had realized the necessity of introducing in their constitution a change which would fit in with present conditions.

If they felt that bidding goodbye to politics would lessen their responsibility to their constituents, they were mistaken. Their burden would actually be doubled after independence.

Maulana Hussain Ahmad Madni, president of the Jamiat, was in the chair. One hundred fifty out of 212 members attended, the Pakistan members being absent.

Maulana Ahmad Saeed, deputy president referred to the sacrifices made by members of the organization in the cause of the

country's freedom in alliance with the Congress under the leadership of Mahatma Gandhi.

[1]*The Times of India*, 21 March 1948.

16. Muslim Members of Bombay Legislature Form a New Party[1]

Mr A.A. Khan, leader of the newly formed party in the Bombay legislature, issued the following statement regarding the policy and programme of the party:

Pursuant to the resolution of the Muslim League dated 10 March 1948, the Muslim members of the Bombay legislature have formed a party, the membership of which shall be open to all who are in substantial agreement with the policy and programme detailed below.

This policy contemplates full opportunity for employment to all citizens of the Union on the basis that the Earth and all that it contains are a free gift of Providence to all mankind.

The party shall recognize the institution of property but as a trust, of which the owner and his dependants shall be the first beneficiaries and the state the beneficiary of the remainder. All luxurious use, dissipation, and waste by the first beneficiaries, resulting in the diminution or total loss of the remainder shall be forbidden by the state by legislation designed to restrict the use of property so as to level down all economical inequalities and the party shall bring forward such legislation for acceptance by the legislatures.

It follows, therefore, that in the matter of wealth creation the party seeks a via media between the Marxist philosophy and that of laissez-faire as more suitable to the peculiar constitution of human nature.

It is the considered opinion of the party that national planning and nationalization, though in their inception they possess a democratic and attractive character, to a society suffering from the evil effects of the free and unmoral use of capital, will in the long run lead to the gradual development of tendencies of a highly fascist character which may eventually dominate other aspects of life as well.

Top priority to agriculture

In the programme of the party, top priority will be given to the improvement of agriculture. This is proposed to be achieved in two ways by mechanization of agriculture and by major irrigation schemes for the construction of a chain of dams on the big rivers of the country. The latter project will require capital. The policy of the party being that the nation is the beneficiary of all surplus property, it will advocate the diversion of all uninvested capital for investment in such projects and will urge upon the provincial governments not to wait for schemes of the Central government to materialize, but to take up the development of irrigation schemes independently.

If need be, the party will assign second place to large-scale industries to make capital available for this purpose, and will press the claims of small-scale and cottage industries.

The party is of the opinion that this will in no way slow down the process of industrialization and will make labour self-reliant. When the irrigation of each province is fully developed the generation of electricity will enable small-scale and cottage industries to supply fully the needs of the country.

Construction of roads to connect villages with each other and the market towns, cattle breeding, poultry and dairy farming, and hand-loom industry will be further aids to the improvement of the agricultural condition.

Cooperative farming

The highlights of the land policy of the party are personal and cooperative, and not collective, cultivation. If the owner of the land contributes his own labour, he will receive both, land and labour dividends, when final distribution takes place. If he does not, he will be entitled to a small percentage of the land dividend, the rest going to the person who actually cultivates the land.

Liquidation of illiteracy

The liquidation of illiteracy in the shortest time possible will be the aim of the party.

Pro-prohibition

In general, the party shall oppose all gaming and wagering, all specultive transactions, and manufacture and sale of intoxicants and shall support the policy of prohibition. Immediate hospitalization in the rural area and free and periodical medical and X-ray examination in schools and colleges will also be items in its policy.

In the matter of education the party considers the present system as highly defective and will urge its thorough overhaul by experts, who shall consider the question of women's education independently and from the point of view of the part which the women of the country will have to play as good wives and efficient mothers and not as raw material for cheaper clerical service.

[1]*Bombay Chronicle*, Bombay, 12 April 1948.

17. Maulana Azad Calls Upon Muslims to Organize for Social and Religious Activities and Not for Politics[1]

Muslims in India were called upon to give their unqualified allegiance and support to the Indian Union and its government by Maulana Abul Kalam Azad, India's education minister, addressing a mammoth Muslim meeting arranged by the Calcutta branch of the Jamiat-ul-Ulema-e-Hind, at the Mohammed Ali Park on 28 January 1949.

'India is a democratic secular state where every citizen, whether he is a Hindu, a Muslim or Sikh, has equal rights and privileges,' Mualana Azad said. 'The government is determined to crush all communal elements and has already put an end to the communal atmosphere that was vitiating the atmosphere of the country only eighteen months ago. It is a great achievement for the government to bring this change in the atmosphere in such a short time. 'Do not always think you are a minority community and the Hindus are in a majority in this country. The Congress is pledged to establish a form of government, where communal minorities and majorities will have no place.'

Maulana Azad asserted that he could speak with a full sense of responsibility that the communal situation was improving every

day. Spokesmen of the government and the Congress had repeatedly declared that they would not recognize or encourage communal organizations. That was the decision of the Government of India and communal politics would have to be liquidated in India.

Continuing, Maulana Azad said that in Lucknow last year he had told the Muslim Leaguers that their organization had no future in the Indian Union and he was happy that in all the provinces the League had been liquidated. He, however, warned that the Muslims must not try to set up a commuanl political organization in place of the Muslim League. He further assured the Muslims that they had perfect liberty to set up organizations for safeguarding their religious, cultural, and educational rights, but, he added, these organizations should scrupulously keep off from politics.

Maulana Azad referred to the RSS satyagraha and observed that the movement had fizzled out for want of public sympathy which proved the success of Mahatma Gandhi's mission and showed in unequivocal terms that people were no longer influenced by or interested in a communal movement.

[1]*The Times of India*, 29 January 1949.

18. Indian Union Muslim League's Appeal to Indian Muslims to Co-operate with the Government[1]

The Working Committee of the Indian Union Muslim League, which met at Madras during 1–2 February 1949 under the presidentship of Mr M. Mohammed Ismail, appealed to the Indian Muslims through a resolution, particularly in view of the confusion, anarchy, and violence prevailing in some of the adjoining countries, to continue their active assistance and cooperation with the government in eliminating all subversive activities from the land and thereby strengthening the hands of the government in maintaining law and order in the country.

Representatives from Tamil Nadu, Andhra, Bangalore, Coorg, and Malabar attended the meeting.

The meeting welcomed the 'genuine' and friendly attitude of both the governments of India and Pakistan in regard to their mutual relations and particularly on the Kashmir question and fully supported the decision of both the governments to solve the problem by democratic method of free and peaceful plebiscite. The committee

expressed the hope that the cordial relations started so happily would be further strengthened and perpetuated by both governments.

[1]*The Times of India*, 3 February 1949.

19. Demand for Separate Electorates[1]

The working committee of the Indian Union Muslim League, which met at Madras on 2 February 1949 under the presidentship of Mr M. Mohamed Ismail, reiterated its demand for separate electorates and requested the Constituent Assembly to reconsider this question and do justice to the minority communities by restoring separate electorates.

Referring to the great hardship caused to Indian nationals who went to Pakistan for business and other purposes and who now desired to come back and settle down in the Indian Union, the committee requested the Central government to permit them to return to India and to settle down if they expressed a bona fide desire to do so.

The action taken by certain provinces and states in totally prohibiting the slaughter of cattle was deplored and the government was urged to relax this measure at least in the case of non-serviceable cattle.

The proposed formation of a Kerala Muslim League Federation, consisting of the District Muslim League of Malabar and the State Muslim League organizations of Travancore and Cochin, and its affiliation to the Indian Union Mulsim League were approved. A subcommittee was constituted to formulate a scheme for this purpose.

[1]*The Times of India*, 4 February 1949.

20. Jamiat's Policy—Giving up Politics and Devoting to Welfare of Poor Muslim Masses[1]

The future policy and programme of the Jamiat-ul-Hind will come up for discussion at its during sixteenth annual session which will be held in Lucknow during 16–18 April 1949. Maulana

Hussain Ahmad Madani, who has been elected president for the current year, will preside.

A resolution laying down the policy is understood to have been drafted by the working committee of the Jamiat, which met here for the past two days. Maulana Azad, education minister, was also present at the meeting.

Welfare activities

The decision to give up political activities and devote all its energies to the welfare of poor Muslim masses was tentatively taken by the Jamiat-ul-Ulema-e-Hind conference which concluded at Bareilly after three-day session.

The decision, which was declared by Mr Hifzur Rahman, general secretary of the All-India Jamiat Conference, was received with acclamation by all present. The conference further decided that all members of the Jamiat should join the Congress and should not participate in the elections from Jamiat platform.

The Jamiat conference unequivocally opposed the division of Kashmir.

[1]*The Times of India*, 16 March 1949.

20a. Jamiat Goes Apolitical[1]

The Jamiat-ul-Ulema-e-Hind has been changed into a non-political body which will henceforth concentrate on the religious and cultural uplift of the Muslim masses of India.

The Jamiat's policy resolution embodying the change moved by the general secretary, Maulana Hifzur Rahaman, was adopted early this morning by more than ten thousand Muslims attending the annual session, which is being held at Lucknow under the presidentship of Maulana Hussain Ahmed Madni.

Speakers supporting the resolution referred to the political role of the Jamiat for over a century and said that its object had been fulfilled after the achievement of freedom. The Jamiat should, therefore, centralize its activities in spheres other than politics.

The policy resolution emphasized that Muslims should be persuaded to learn the Devanagari script, and pamphlets and booklets explaining the fundamental principles of Islam be published

in both scripts, Devanagari and Urdu, for the development of better understanding among the Indian people.

Maulana Ahmad Saeed, who supported the resolution, advised Indian Muslims 'not to look to Pakistan for inspiration and guidance' because such a course 'is highly detrimental to your interests'.

He added that if they wished to prevent the tide of communism engulfing Asia, it was necessary to bring about reforms in Islamic civilization.

The Jamiat resolution on education said that separate arrangements should be made to impart religious education to Muslim children reading in government institutions for the development of social and moral character.

The Jamiat urged the Central government to encourage application of the Muslim marriage and divorce laws framed on the basis of 'shariat' during the British regime.

[1]*The Times of India*, 19 April 1949.

21. Constituent Assembly Debates on Separate Electorate, August 1947[1]

Mr Vallabhbhai Patel presented to the Constituent Assembly the report of its advisory committee's subcommittee on minorities dated 8 August 1947. It provided for reservation of seats for minorities within a joint electorate on the basis of their population. Separate electorates were abolished. The Assembly debated the report on 27 and 28 August 1947 and adopted its recommendations. Extracts from speeches are presented here. Clauses on minorities as adopted are presented in the appendix.

B. Pocker Saheb Bahadur: Sir, I shall move my first amendment which is on the agenda. My amendment runs as follows:

That on a consideration of the report of the advisory committee on minorities, fundamental rights etc., on minority rights this meeting of the Constituent Assembly resolves that all elections to the central and provincial legislatures should, as far as Muslims are concerned, be held on the basis of separate electorates.

In making this motion, Sir, I am fully aware that there is a very strong section who feel differently from me and who not only feel that separate electorates are not desirable. . . .

Chaudhary Khaliquzzaman (Muslim, UP): . . . Should we really visualize the situation as it stands today in its true perspective, much of the suspicion that hangs round this system of separate electorates will disappear. After all, if they are conceded to us, what will happen to this great majority? Today there is no third party to whom we can appeal. . . . We have to go to Sardar Patel, because he has become the final arbiter of the fate of the minorities. . . . If you conceded separate electorates, the Muslim community feels that they will help in returning their true representatives, representatives who will lay before you—not to any other power, not to any other government, not even to Pakistan—our grievances and our claims. Therefore, I beg of you and beg of this House to consider the new situation in which this question is being discussed.

Mr Govind Ballabh Pant: . . . In the new status that we have now secured, every citizen in this country should, in my opinion, be able to rise to the fullest stature and always have the opportunity of influencing the decisions effectively; so I believe separate electorates will be suicidal to the minorities and will do them tremendous harm. If they are isolated for ever, they can never convert themselves into a majority and the feeling of frustration will cripple them even from the very beginning. What is it that you desire and what is our ultimate objective? Do the minorities always want to remain as minorities or do they ever expect *to form an integral part of a great nation and as such to guide and control its destinies*? If they do, can they ever achieve that aspiration and that ideal if they are isolated from the rest of the community? I think it would be extremely dangerous for them if they were segregated from the rest of the community and kept aloof in an air-tight compartment where they would have to rely on others even for the air they breathed. *I want them to have a position in which their voice may cease to be discordant and shrill but may become powerful.*

Then again what do the minorities desire? Do they want to have any share in the government of the country and in its administration? I tell you, you cannot have a genuine seat in the Cabinet if you segregate yourself from the rest of the community, for the Cabinet can only act as a team in a harmonious manner and unless every member of the Cabinet is answerable to a common electorate the Cabinet cannot function in a fruitful manner. Are you prepared to give up your right of representation in the government? . . .

If you have separate electorates for the minorities, the inevitable result is that the majority becomes isolated from the minorities, and being thus cut off from the minorities, it can ride roughshod upon them.

So I ask you whether you want the majority to be cut off in such a way that the majority will not be answerable to anybody belonging to your community and no one in the majority will have to care for your sentiments or for the reactions of his acts on you and your associates? Nothing will be more harmful than that.

Kazi Syed Karimuddin (CP and Berar): (Excerpts) My submission is that in the interests of the provision of reservation of seats, it is necessary for a particular period that we should give this minimum number of votes to a candidate of a particular community. I do not agree, Sir, that the mere introduction of joint electorates is a magic wand to do away with all these evils. The problem of the Scheduled Castes is over and above this joint electorate for centuries. There are many other considerations which have contributed to the present position. I make an earnest appeal that as you have made a generous gesture of giving reservation of seats, you should also concede that for a particular period, the Muslim minority should be allowed to have a minimum number of votes from the community which will satisfy their political aspirations.

The Honourable Sardar Vallabhbhai J. Patel: (Excerpts) When I agreed to the reservation on the population basis, I thought that our friends of the Muslim League will see the reasonableness of our attitude and allow themselves to accommodate themselves to the changed conditions after the separation of the country. But I now find them adopting the same methods which were adopted when the separate electorates were first introduced in this country, and in spite of ample sweetness in the language used there is a full dose of poison in the method adopted. . . .

. . . *I know how it cost me to protect the Muslim minorities here under the present condition and in the present atmosphere. Therefore, I suggest that you don't forget that the days in which the agitation of the type you carried on are closed and we begin a new chapter. Therefore, I once more appeal to you to forget the past. Forget what has happened. You have got what you wanted. You have got a separate state and remember, you are the people who were responsible for it, and not those who remain in Pakistan.* You led the agitation. You got it. What is it that you want now? I don't understand. In the majority Hindu provinces you, the minorities, you led the agitation. You got the

partition and now again you tell me and ask me to say for the purpose of securing the affection of the younger brother that I must agree to the same thing again, to divide the country again in the divided part. . . .

[1]*Constituent Assembly Debates*, vol. V, 27–28 August 1947, pp. 211–72.

21a. Extracts of clauses on minorities as adopted by the Constituent Assembly on 27–28 August 1947

Representation in legislatures

1. *Electorates*: All elections to the central and provincial legislatures will be on the basis of joint electorates:

Provided that, as a general rule, there shall be reservation of seats for the minorities shown in the Schedule and the section of the Hindu community referred to in paragraph 1-A hereof in the various provincial legislative assemblies on the basis of their population:

Provided further that such reservation shall be for ten years, the position to be reconsidered at the end of the period.

Schedule

Group A: Population less than ½ per cent in the Indian Dominion, omitting Indian States.
 i. Anglo-Indians
 ii. Parsees
 iii. Plains tribesmen in Assam, other tea garden tribes.
Group B: Population not more than 1.5 per cent.
 iv. Indian Christians
 v. Sikhs
Group C. : Population exceeding 1.5 per cent.
 vi. Muslims
 (c) Muslims: There shall be reservation of seats for the Muslims in the lower House of the central and provincial legislatures on the basis of their population. . . .

4. Additional Right to Minorities: The members of a minority community who have reserved seats shall have the right to contest unreserved seats as well. . . .

In view of the special situation of West Bengal, the question relation to it will be considered later.

5. No Weightage: The minorities for whom representation has been reserved will be allotted seats on their population ratio, and there shall be no weightage for any community.

6. No Condition for a Minimum Number of Votes of one's Own Community: There shall be no stipulation that a minority candidate standing for election for a reserved seat shall poll a minimum number of votes of his community before he is declared elected.

7. Method of Voting: There may be plural-member constituencies, but the voting shall be distributive, that is, each voter will have as many votes as there are members and he should give only one vote to a candidate.

Representation of minorities in Cabinets

8. No Reservation for Minorities: There shall be no statutory reservation of seats for the minorities in Cabinets but a convention on the lines of paragraph VII of the Instrument of Instructions (reproduced below) issued to Governors under the Government of India Act, 1935, shall be provided in a Schedule to the Constitution.

VII. In making appointments to his Council of Ministers our Governor shall use his best endeavours to select his Ministers in the following manner, that is to say, to appoint in consultation with the person who in his judgement is most likely to command a stable majority in the legislature those persons (including so far as practicable members of important minority communities) who will best be in a position collectively to command the confidence of the legislature. In so acting, he shall bear constantly in mind the need for fostering a sense of joint responsibility among his Ministers.

Recruitment in services

9. Due Share to All minorities Guaranteed: In the all-India and provincial services, the claims of all the minorities shall be kept in view in making appointments to these services consistently with the consideration of efficiency of administration.

(Note: Appropriate provision shall be embodied in the Constitution or a Schedule thereto to this effect.)

Working of safeguards

10. Officers to be Appointed: An officer shall be appointed by the president at the Centre and by the governors in the provinces to

report to the union and provincial legislatures respectively about the working of the safeguards provided for the minorities.[1]

Special officers for minorities for the Union and the States

299. There shall be a Special Officer for minorities for the Union who shall be appointed by the President, and a Special Officer for minorities for each State for the time being specified in Part I of the First Schedule who shall be appointed by the Governor of the State.

(2) It shall be the duty of the Special Officer for the Union to investigate all matters relating to the safeguards provided for minorities under this Constitution in connection with the affairs of the Union and to report to the President upon the working of the safeguards at such intervals as the President may direct, and the President shall cause all such reports to be laid before Parliament.

(3) It shall be the duty of the Special Officer for a State so specified to investigate all matters relating to the safeguards provided for minorities under this Constitution in connection with the affairs of the State and to report to the Governor of the State upon the working of the safeguards at such intervals as the Governor may direct and the Governor shall cause all such reports to be laid before the Legislature of the State.[2]

[1]B. Shiva Rao. *The Framing of India's Constitution: Select Documents*, vol. II, pp 426–9.
[2]Article 299 as it figured in the draft Constitution, February 1948.

21b. Constituent Assembly Debates on Separate Electorate, May 1949[1]

*M*r Mohammed Ismail (Muslim League, Madras): 'Then, the report further on says that the Committee are satisfied that the minorities themselves feel that statutory reservation of seats should be abolished. I do not know how the Committee came to be satisfied in that. So far as the Muslims are concerned, some members of this honourable House might have agreed to the abolition of reservation. I admit it, but then what is the nature of their agreement? What is the nature of any action of theirs with reference to the community which they seek to represent? Some of them have repudiated the ticket on which they were elected and on which they have come to the Assembly. Thereby, they have demolished

their representative character. Therefore, to take them as representing the views of the minorities or the Muslims, I think, is not fair. I know that there was canvassing sometime past in connection with this question and now we have got the report before us.

Sir, I assert and say definitely that the Muslims, as a community, are not for giving up reservation. Not only that, they implore this House to retain separate electorates which alone will give them the right sort of representation in the legislatures. The Muslim League, which still is the representative organization of the Muslim community, has more than once within this year not only expressed a definite view in favour of reservation of seats, but has also urged the retention of separate electorates.

Mr Z.H. Lari (Muslim, League UP): It is my ambition that my representative, be he a Muslim or a Hindu, shall have an effective voice in the governance of the country. In that view of the matter, I am positively opposed to separate electorates, and I do not favour reservation of seats in the legislature. The first is positively dangerous and the other ineffectual and has the taint of separatism. But I am not content with a negative approach. It is not enough to say that reservation must cease, that it is vicious, that separate electorate is bad. There must be a positive approach to ensure due recognition of the political rights of the minorities. My amendment merely means that there should be multi-member constituencies, of say two, three, or four to be fixed by Parliament—resulting in allowing the minorities to group their votes. On 15 October 1947, national executive of the Socialist Party adopted a resolution, in the course of which it said 'All elections should be by direct, secret, and adult suffrage, under a system of joint electorates. There should be multi-member constituencies, and voting should be according to the system of cumulative votes, thus providing for minority representation.'

Mr Naziruddin Ahmad: Sir, I believe that reservation of Muslim seats, specially now, would be really harmful to the Muslims themselves. In fact, if we accept reservation and go to the polls, the relation between Hindus and Muslims which now exists will deteriorate. . . . If seats are reserved, one candidate may be set up by Hindus and another by Muslims. Muslims will divide. They will flock to one candidate or the other and this will lead to division among the Muslims themselves on a false issue. I therefore submit that reservation for Muslims would be undesirable. In the present

context, when we have improved relations and with the abolition of separate electorates, it is illogical and an anachronism, and it is positively injurious to the Muslims and the entire body politic. . . . If we contest seats, not reserved seats, the result would be that Hindus and Muslims would be brought nearer to each other. Although we are a minority. . . . I think it will be impossible for any Hindu candidate to ignore the Muslims. In fact, for one seat there will be at least two Hindu candidates, and in case of a contest, the Muslims will have an important role to play, and they may well be able to tip the scale, by playing the part of an intelligent minority, suitably aligning themselves with one side or the other. . . . No man who contests an election, however promising his prospects may be, can ignore Muslim votes. Therefore, the safety of the Muslims lies in intelligently playing their part and mixing themselves with the Hindus in public affairs. . . .

Begum Aizaz Rasul (Muslim, UP): Sir, I have from the beginning felt that in a secular state separate electorates have no place. Therefore, the principle of joint electorates having once been accepted, the reservation of seats for minorities to me seems meaningless and useless. The candidate returned on the joint votes of the Hindus and Muslims in the very nature of things cannot represent the point of view of the Muslims only and, therefore, this reservation is entirely unsubstantial. To my mind reservation is a self-destructive weapon which separates the minorities from the majority for all time.

Syed Muhammad Saadulla (Muslim, Assam): Mr President, Sir, I will be giving out no official secret when I say that this vital question whether the Muslims will be benefiting by reservation of seats or by swimming in the general stream of no reservation was discussed informally by many Muslim members of this House in December last. We could not come to any decision at the time and a suggestion of mine that we should consult our electorates was accepted. I do not know whether my other friends consulted their electorates but I wrote to all the Muslim members of my party in the Assam legislature and they gave me the unanimous mandate of claiming reservation for the Muslims.

Mr B. Pocker Sahib: The honourable member says that all the Muslim members of this House considered the question in December last. It is not a statement of fact.

Syed Muhammad Saadulla: I cannot help Mr Pocker Bahadur. Perhaps he was absent from Delhi at the time when we held this

meeting. Sir, the sorry spectacle I have witnessed today that even on this vital matter the handful of Muslim members could not come to any decision and that they were giving contradictory opinions on the floor of this House, makes me sad. The Minorities Advisory Committee in its sitting on 11 May came to a momentous conclusion—I am afraid, according to me—on very insufficient material or data. The report which the honourable president of the Minorities Advisory Committee has submitted to the Constituent Assembly is full of very sound maxims of politics. And I can personally testify—as I am a member of the Minorities Committee and have attended many of its sittings, although on account of a domestic trouble, I could not attend on the eleventh of his month— he has struck the right path and has often declared that as the Constituent Assembly has already decided to give reservation to different minorities in the open session of the House, it is up to the members of those minorities to declare unequivocally if they do not want that reservation. I think, Sir, this is a very correct attitude to take. I remember that on two previous occasions, the Honourable Sardar propounded this dictum. Unfortunately, I find, Sir, that on the meeting of 11 May, when there were only four members from the Muslim minority present, only one supported the resolution moved by my honourable friend, Dr H.C. Mookherjee in his speech and another opposed by vote, thus cancelling the support of one against the other, while one honourable member of the Cabinet— I refer to the Honourable Maulana Abul Kalam Azad—took the very right stand of being neutral; and seeing that one Maulana was neutral, the other Maulana, Maulana Hifzur Rahman, another member, also remained neutral. Sir, if we are to push the dictum of the venerable Sardar Patel to its logical conclusion, he should have left this matter whether the Muslims wanted reservation or not to the Muslim members only. . . .

Personally I am not enamoured of reservation and so far as Assam is concerned, there is no necessity for reservation, but if we take India as a whole, we cannot but concede that the Muslim minority can legitimately claim and it deserves reservation at least for a limited period. . . . We stand on the mercy of the majority community. I am at one with the honourable Sardar Patel when he said that the majority community must comport themselves in such a way that the minority may feel no necessity for constitutional safeguards. Similarly, I request every Muslim friend of mine, who is now domiciled in the Dominion of India, to give his unswerving

loyalty and unstinted cooperation in the interests of the nation and the country. . . . We must start give and take. I will request my Madras friends to give up their strong plea of separate electorates. I shall request, on the other hand, the majority community to rise to the occasion and give reservation to Muslim minority for a limited period.

Mr Muhammad Ismail Khan (Muslim, UP): Sir, I give my unstinted support to the revised decision of the Advisory Committee which has done away with reservation of seats, which only kept alive communalism and did not constitute an effective safeguard. With the vast superiority of the majority community in the number of voters, they could have had no difficulty in using this device for their own ends by electing men of their own choice and I, therefore, congratulate them that they have not thought fit to take advantage of this device. . . . My honourable friend, Mr Muhammad Saadulla has said that this reservation of seats had been given away by the solitary vote of Begum Aizaz Rasul. May I remind him in this connection of a meeting which was held ten or twelve months ago in which many Muslim members of this Constituent Assembly took part in which it was decided that we should take steps to do away with reservation. So Begum Aizaz Rasul in casting her vote was not casting a solitary vote, but she did so on behalf of those people who had taken part in that meeting. I do not say that Sir Syed Saadulla agreed with it, but there were ten or twelve members present who agreed that they should take steps to have this reservation done away with. . . .

I wish to point out to my Madras friends that even twenty years back the Muslims were thinking of giving up separate electorates provided certain safeguards were provided and conceded, but in the Constitution that was framed, for instance, in the Act of 1935, no safeguards were given. The responsibility for the protection of their rights was entrusted to the governors of the provinces by the Instrument of Instructions, but today the conditions are different. Here we have got statutory safeguards. Why then do we want separate representation? How will it help us? Would it not always keep us from joining other parties? After all, with communal electorates, you would have to have a communal organization to put up candidates and frame a programme and policy for their work in the legislatures which means that the present state of affairs would continue and keep alive communalism in its worst form. Would this lead to the establishment of harmonious relations? No.

Mr Tajamul Husain: Mr President, Sir, reservation of seats in any shape or form and for any community or group of people is, in my opinion, absolutely wrong in principle. Therefore, I am strongly of the opinion that there should be no reservation of seats for anyone and I, as a Muslim, speak for the Muslims. There be no reservation of seats for the Muslim community. . . . I say to Mr Ismail also that as long as there is reservation of seats or separate electorate the mentality of the Hindus will never change. You do away with these two things and the mentality will automatically change. I do not want to go into the history of this mentality; I am not going to apportion blame as that will take a long time and you have allotted me a short time and I want to be brief and finish my speech within that time. You all know how the mentality of the Hindus became such, but we have to live in this country, we must change their mentality and it is our duty to change their mentality and the only way the mentality can be changed is to become a part and parcel of the Indian Union. You should say that they are no longer our enemies and then they will be like brothers to us. . . .

I come to the speech of my honourable and esteemed friend, for whom I have very great regard, Sir Saadulla, ex-premier of Assam. He complains before us that the majority of the Muslim members of the Advisory Committee on Minorities, Fundamental Rights, etc., did not support the resolution that there should be no reservation of seats for the Muslims. . . . I am afraid I must differ from him on this point. I sent my resolution to the Committee to the effect that there should be no reservation of seats. My resolution was discussed under the chairmanship of the Honourable Sardar Patel. I spoke on my resolution. Begum Aizaz Rasul supported me. Maulana Azad was present there; he did not oppose me. The only person who opposed me was my honourable friend Mr Jafar Imam, from Bihar. There too, I had a majority: Begum Aizaz Rasul, Maulana Azad, and myself as against one. The meeting could not be finished and was adjourned sine die. Then it was held on the eleventh of this month. I wanted to attend that meeting, particularly because my resolution was there. I wanted to move it again. But I never received notice of the meeting. The notice was lying in Delhi; it never reached me. If I had got notice of the meeting, I would have attended it. When I came to Delhi, I learnt that there was the meeting that day. I was happy to learn that the substance of my resolution had been accepted though I was absent. I sent a statement to the press why I could not attend the meeting that day and it was

published in all the papers. Sir Saadulla could not attend the meeting; I do not know why. That meeting was attended by four honourable members: Maulana Azad, Maulana Hifzur Rahman, Begum Aizaz Rasul, and Mr Jaffar Imam. Maulana Azad and Maulana Hifzur Rahman did not oppose my resolution that there should be no reservation of seats. Every member of this House does not speak. If he opposes, he opposes. If he does not speak, but says 'I vote for it', then he is with it. Maulana Azad was present. If he wanted to oppose, he would have opposed. The two Maulanas did not oppose. Begum Aizaz Rasul supported my resolution in substance. The resolution was moved by my honourable friend, Dr Mookherjee. It was the same as my own. Begum Aizaz Rasul supported it. My honourable friend, Mr Jafar Imam opposed it. If the Maulanas were not with my resolution, they would have sided with Mr Jafar Imam. They said nothing. Votes were taken. There was a clear majority. The honourable Sardar Patel, I understand, declared that the Muslims were in favour of the motion in spite of the two Maulanas remaining silent. It means that they were with me: three to one voting: there was a majority.

I believe—I do not remember exactly—there are seven Muslim members on the Committee. Only two are opposed to my resolution; five are with me. The two who are against me are my honourable friends, Sir Saadulla and Mr Jafar Imam. The five who are in favour are, Maulana Azad, Maulana Hafzur Rahman, Begum Aizaz Rasul, Mr Husseinboy Laljee, and myself. . . . I may remind my honourable friend, Sir Saadulla that when the Muslim members came here to Delhi for the first time there was a meeting of all the Muslim members in Western Court. All of them were present. I was the first man to have got up and said that there should be no reservation of seats. I sent my resolution to the Constituent Assembly when you, Sir, were presiding. I regret to say, except one, not a single member supported me. I found that the Muslims wanted reservation. So, I did not move my resolution. That was the first meeting in which the Muslims were against me. The next meeting was in the house of Nawab Muhammad Ismail—about which he also has told you—in 18 Windsor Place. There, my view was accepted by an overwhelming majority. The same Muslim members who were present in Western Court were present here also, and it was passed by an overwhelming majority that there should be no reservation of seats. See how time had changed. The only member who opposed it was my honourable friend, Sir Saadulla. He is honestly of that

opinion; I respect his view. I hope he will respect my view. He said, 'No, there must be reservation of seats.' But, one thing he said, 'Personally I am not in favour of reservation, but the Muslims want it.' Most humbly I wish to tell him that he is wrong. The Muslims do not want it. Sir Saadulla was the only opposing member. Then there was the Madras group. They are a group by themselves. They have throughout been saying, 'No reservation, but separate electorates; let us have separate electorates.' At the Western Court, they said, 'Let us have separate electorate.' At Nawab Ismail Sahib's place also they asked for separate electorates and here also they ask for separate electorates. They are welcome to their opinion. But that there should be no reservation was passed by an overwhelming majority. . . .

I have here a list of all the members. Briefly, it shows that there are thirty-one members from the provinces and two from the states, making a total of thirty-three Muslims. Out of these, four are from Madras and I must say that many of the members are permanently absent. As they have migrated to Pakistan—especially all the members from the Punjab—they have gone, and out of the five from Bengal, three have migrated. Now, coming to the list, four from Madras are for separate electorates. There are only twenty-three members on the roll of the Constituent Assembly. As I said, four are for separate electorates, four are for reservation of seats— two from Bihar and two from Assam—one for cumulative votes, and the view of one member is not known, i.e., of Mr Husain Imam. I had discussions with him, but I do not know his views. So we find that out of the twenty-three members on the roll of the Constituent Assembly, four are for separate electorates, four for reservation of seats, one for cumulative voting, one unknown, and thirteen entirely for joint electorate, with no reservation of seats. If you add those who are not with me, they will come to only ten, and we are thirteen, and if I add Mr Lari, who too is not for reservation of seats or separate electorates, our number would be fourteen. Actually today there are fifteen members present. And of them, four are for reservation of seats, three for separate electorates, and the rest eight with me. Even then I have a majority. . . .

Maulana Hasrat Mohani (Muslim, UP): Sir, I have come forward today to give my entire support to the motion of Sardar Patel. I am really glad to do so, because recently I have had occasions to differ from him, though very reluctantly. . . .

Now, while giving my entire support to this motion, I come to the amendments proposed by some of my Madras friends. My opposition is based on the fact that they want to revive the Muslim League. The Muslim League is no more. Mr Mohammad Ismail is proclaiming the existence of the All-India Muslim League. I ask, 'Where is the Muslim League?' Let us once and for all decide that we will not have any communal parties among us. If we are to establish a true democratic state, there is no room for any religious or communal parties. As everybody knows, democracy means majority rule and, therefore, it follows that minorities will have to submit to the decisions of the majority. Now, Sir, what is the reason for minorities submitting themselves to the decisions of the majority? They do so on the supposition that it may be possible at some future date, with the change of public opinion in their favour, that they may occupy the seat of government and in that case the erstwhile majority will become a minority and the minority will become the majority. So this democratic system can work only with political parties. If we have only communal parties or parties based on religion, the whole object of democracy will remain unfulfilled. If we have Muslim parties, Christian parties, and Sikh parties, what will be the result? How can they expect to become the majority party under a democratic system of government? When they cannot become the majority party, it is hopelessly absurd to allow the formation of parties on communal or religious basis. I submit that the Muslims should form a distinct political party called the Independent or the Independent Socialist Party. I would prefer to call it the Azadi party allied to the party organized by my friend, Shri Sarat Chandra Bose. They can form a coalition party with that left-wing party. In that case only, my Muslim friends can expect to take part in democratic government. Even if the Nationalist Party is in the majority, it will be possible for this coalition party to become the majority at some future date. In that case, the Congress or the Nationalist Party will become the minority. Unless and until we do that, there is no hope for any minority which does not want coalition with left-wing parties. No single party, socialist or communist or other, if it wants to oppose and come forward and contest elections against the Nationalist Party, can succeed. We have the example of the Socialist Party's defeat in the United Provinces. Therefore, it is necessary for political parties other than the Nationalist Party to form a coalition if they want to become the majority party and run the administration.

[1]Extracts from *Constituent Assembly Debates*, 25–26 May 1949, vol. III, pp. 277–342.

21c. Constituent Assembly Reopens the Issue of Rights and Privileges of Minorities[1]

Sardar Bhopinder Singh Man: The principle underlying this, the main principle on which this is based, has been agreed to in very clear and emphatic terms. I shall make it clear. In the report submitted by the honourable Sardar Patel as Chairman of the Advisory Committee on Minorities, Fundamental Rights, etc., presented to this House on 27 August 1947, clearly the minorities were defined on the one hand; and secondly, four points were discussed one by one distinctly, separately, and quite clearly. The four points were: first, representation in the legislatures, joint versus separate electorate; second, reservation of seats for the minorities in the Cabinet; third, reservation for the minorities in the public services; and fourth, administrative machinery to ensure the protection of minority rights.

This report was submitted to the House and was later agreed to by this House. In this appendix, as adopted by the Constituent Assembly during the August 1947 session, it was agreed in regard to representation of minorities in the Cabinet as well as recruitment of the services — it is paragraph 9 — that due share will be given to the minorities in the all-India services and provincial services and the claims of the minorities shall be kept in view in making appointments to these services, consistently with efficiency of administration. Not only that. They make it further clear in emphatic and clear terms. They say, appropriate provision shall be embodied in the Constitution or a schedule thereto to this effect.

Having agreed to that, actually the drafting committee moved a special Article 299 in which the rights of all the minorities were granted. Not only that. A later report was submitted to this House by the Advisory Committee on the subject of political safeguards to minorities on 11 May 1949. *In this report the earlier decisions were reiterated and confirmed and not denied. Only in so far as the first item was concerned, that is safeguards in the legislatures were concerned, they were abrogated. So far as the other rights were concerned, they were allowed to remain intact.* What had been conceded or passed by this House is now being taken away. I submit Sir, that this is a substantial change and unless a special resolution is brought in this House, this House cannot go back upon its earlier decisions.

Mr Naziruddin Ahmad: Mr President, Sir, I raised this point of order some time ago when this clause was moved by Dr Ambedkar.

The point of order is this. I refer to the proceedings of this House dated 28 May last. It appears that there was a Minorities Advisory Committee which appointed a Special Subcommittee to consider the question of the minorities. I find that the members of the Special Subcommittee were: The honourable Shri Jawaharlal Nehru, the honourable Dr Rajendra Prasad, Shri K.M. Munshi, and the honourable Dr B.R. Ambedkar.

This Subcommittee reported, amongst others, that there should be reservation of seats in the legislatures for the minorities and also that so far as all-India and provincial services were concerned, there should be no reservation but the claims of all minorities shall be kept in view in making appointments to the services consistently with the consideration of efficiency and administration.

Now this was accepted by the House in its August 1947 session. This was later on partly reopened on the strength of a letter by honourable Sardar Patel dated 11 May 1949 to reopen, not the consideration for the minorities about the services, but only the reservations in the legislatures. I submit that Sardar Patel sent a report that the system of reservations for the minorities other than castes, in the legislatures be abolished. This resolution was accepted by this House on 26 May 1949 at the instance of Sardar Patel. That is also to the same effect. It is absolutely clear on a perusal of the original report, the letter of Sardar Patel, the resolution moved by him and the speeches in the House, that they all attempted reconsideration only of the reservations for the minorities in the legislatures. I may add, this was done with the fullest concurrence of the Muslim members of this House. I was one of those who thought that the reservation in the legislatures would not be good for the minorities themselves; but with regard to the consideration of their cases in making appointments, subject to efficiency, that was not reopened.

Mr President: We have to keep things apart—the question of the point of order and the merits of the question. For the moment, I am concerned only with the point of order and the point that has been made by the two honourable members comes to this. This House on a previous occasion took certain decisions which are sought to be reversed by the proposition which is now going to be moved. The only rule which deals with reopening of decisions is Rule No. 32 of our rules, and that lays down that no question which has once been decided by the assembly shall be reopened except with the consent of at least one-fourth of the members present and voting. . . .

As regards the merits of the case, I do not think I should express any opinion at this stage or at any stage. It is for the House to decide. We are concerned at the moment only with the point of order, and my ruling is if one-fourth of the Members present and voting are in favour of reopening, the question can be reopened.

If the House agrees to reverse the old decision, it will be a reversal; otherwise, the old decision will stand; but for the present I am concerned only with the question of whether we can take into consideration the question of reversing the old decision.

You need not argue the point. I would like to know from the House what its opinion is. The question is: 'Is the House in favour of reopening the question?'

Honourable Members: Yes.

The motion was adopted. . . .

Sardar Hukam Singh: The Minorities Committee never recommended any change in these two articles. My third point is that the *minorities themselves never agreed to give up these safeguards at any time.* It was given out now and then that the safeguards would only be taken back if the minorities themselves thought and were convinced that it is to their own interests. But I submit here that so far as these two Articles 296 and 299 are concerned, the minorities themselves never agreed to give up these safeguards at any time. . . .

Sardar Vallabhbhai Patel: I know that the atmosphere so far as the Muslims are concerned is not quite as happy as it should be. But there are reasons for that. The Congress is not responsible for this. If there had been no partition, perhaps we would have been able to settle our differences. But there was partition. This partition by agreement brought about subsequent events. But, since partition, whatever is being done on the other side is having a reaction here for which we have to struggle day and night.

You do not know the immense difficulties of a secular state being governed peacefully in such conditions. Now, the world is in such a condition that we cannot take any independent action of our own accord. Even though there is injustice done, we have to wait, pause, ponder, and consider, because there is an organisation known as the UNO, which day and night watches the situation all the world over and tries to see how peace could be maintained. I do not wish to say anything about the work of the UNO, because I know nothing about it. But the other part of the country known as Pakistan misses no opportunity of defaming and blackmailing us

all over the world, whether there is occasion for it or no occasion for it. So we have to be specially careful. They break promises and charge us with breach of faith; and yet we cannot solve it without reference to the other countries or without any regard for its reaction in other countries.

Therefore we have to be very careful. *Do not add to our difficulties by creating internal difficulties in which there will be disputes between the communities. Help us and it will be to your advantage and it will be to the advantage of the whole country. You will have no cause for regret if you drop the claims for minor provisions for small minorities in regard mainly to service questions.* Fight over issues beneficial to the whole country. So, for God's sake, those who are interested in the well-being of the country should create a different atmosphere and not an atmosphere of distrust and discord. . . .

Sardar Bhopindar Singh Man: Nos. 67 and 69 relate to the amendment that was to be moved by Mr Munshi, No. 63. Sir, I move:

That in amendment No. 63 above, in clause (1) of the proposed Article 299, after the words 'by the President' the words 'and a Special Officer for minorities for each State for the time being specified in Parts I and II and Part III of the First Schedule who shall be appointed by the Governor or Rajpramukh of the State, as the case may be' be added.

That in amendment No. 63 above, in clause (2) of the proposed Article 299, after the words 'under this Constitution and' the words 'their representation in different legislatures and services of the country' be inserted.

That in amendment No. 63 above, at the end of the Explanation to the proposed Article 299, the words 'Muslims, Christians, and Sikhs' be added.

My first amendment states that the minority officers as originally proposed to be appointed in the state should be permitted to continue. I feel that a minority officer appointed at the Centre will be at too distant a place to investigate and see the daily working of the Constitution. If minority officers are not there, this safeguard contained in Article 299 will not be effective. After all, it is the daily life and daily administration and governance that count more than anything. I request that minority officers in the states should continue and there should not be merely one officer appointed at the Centre.

My other two amendments state that there should be minority officers not only to investigate the safeguards contained in the Constitution but also to look into matters pertaining to all minorities and see how they have fared so far as representation in legislatures

is concerned or securing of services in the administrative machinery is concerned. There seems to be some confusion about minorities. Certain friends say that because the Minorities Advisory Committee resolved that there will be no political reservations in the legislatures, there will henceforward be no minorities in the country. It takes my breath away how a paper resolution can do away with minorities, and that too, in so short an interval as just a year or so.[2]

The amendment was negatived.

[1]Constituent Assembly Debates, vol. X, 14 October 1949, pp. 229–53.
[2]Mr K.M. Munshi's amendment resticted Article 299 to Scheduled Castes. It was adopted (Art. 338 of the Constitution).

22. Jayaprakash Narayan Appeals to Muslims to Join the Socialist Party[1]

Mr J.P. Narayan, socialist leader, called upon the Muslims of India to decide their political future 'with courage and conviction'. He asked them to shed their 'fear complex' and cast their lot with the Socialist Party which stood for the 'poor and the downtrodden'.

Addressing a public meeting at Burhampur, on 13 January 1950, he condemned the 'shifts' in the economic policies of the government and added that as long as they did not intend to introduce policies which would radically transform the basis of their social structure, mere sermons to produce more would be futile. Calling for a bold policy in regard to distribution, he said that if things continued as they were, they would only make the rich richer and the poor poorer.

[1]*The Times of India*, 14 January 1950.

23. Muslim Convention at Madras Discusses the Future of the Muslim League[1]

The future of the Muslim League as a political party and the Muslim community in this province came in for consideration at a special convention of Muslims held at Madras on 14 January 1950. While some speakers suggested the liquidation of the League, others

pleaded that there should be no hasty decisions; but all laid stress on the need for amity and close cooperation between Hindus and Muslims.

Muslims had to live and work with Hindus and other majority communities in a spirit of cooperation and it would be wrong for them to assume that there were other people to carry on the government and that they had no right to share in it, said Mr Abdul Hameed Khan, MLA, presiding over the convention. After referring to the assurances to minorities contained in the Constitution, Mr Hameed Khan said that in the present political framework there was no place for communal political parties. Though Muslims had a grievance because of the abolition of reservation and separate electorates, as realists they should recognize that no purpose would now be served by reservation.

Referring to a suggestion that Muslims should join the Congress, one speaker said: 'After all, the Congress is a leaky boat today. Why should we get into it and sink?'

The convention appointed a committee of thirty-four members to consult public opinion in the province as to whether Muslims should join any of the present political parties or form a new political party and submit a report before the end of February.

[1]*The Times of India*, 16 January 1950.

24. Indian Union Muslim League Adopts its Constitution on 1 September 1951[1]

Name
 1. The name of the organization shall be the '*Indian Union Muslim League*'.

Aims and Objects of the League

2. The aims and objects of the Indian Union Muslim League shall be:
 (a) To uphold, defend and maintain, and assist in upholding, defending, and maintaining the independence, freedom, and honour of the state of the Indian Union and to work for, and contribute to the strength, prosperity, and happiness of the people of the state;
 (b) To secure, protect, and maintain the religious, cultural, official, educational, economic, political, administrative, and other

legitimate rights and interests of the Muslims and other minorities in the Indian Union; and

(c) To promote mutual understanding, goodwill, amity, cordiality, harmony, and unity between the Muslims and other communities of the Indian Union.

3. (a) Any person who is a Muslim and a citizen of the Indian Union and who is not less than eighteen years of age, shall be eligible to become a member of any Primary Muslim League of the Indian Union Muslim League.

Provided that any person may be exempted by the State League concerned from all or any of the above conditions.

[1] Pamphlet published by Indian Union Muslim League, Chennai, 1951.

25. UP Muslims Demand Indo-Pak Treaty on Minority Rights[1]

More than two hundred prominent Muslims from various districts of Uttar Pradesh met at Lucknow on 19 March 1950 and demanded a treaty between India and Pakistan 'determining and specifying the political, cultural, educational, and other rights of the minorities in both the countries and devising a machinery for implementing these rights'.

The meeting—the first of its kind to be held after the partition—was convened by eleven UP legislators, formerly members of the UP Muslim League Legislature Party, and was presided over by Mr Z.H. Lari, leader of the Opposition in the state assembly.

The meeting declared that 'in order to shake off their present lethargy and frustration and to play due part in the administration of the country and reconstruction of society, the Muslims of Uttar Pradesh should join some non-communal party'.

A standing committee of eighteen members, with Mufti Fakhrul Islam, MLA (UP) as convenor, was formed to advise the Muslims on this matter not later than June 1950. 'The advice of the committee will, however, be only advisory and not mandatory,' a resolution said.

Merge together

The meeting appealed to 'all Muslim religious or cultural organizations particularly Jamiat-ul-Ulema-e-Hind, Muslim League,

Jamiat Islamia, All-India Shia Conference, and Jamiat-ul-Ansar to merge and amalgamate themselves into one body so that all the Muslims irrespective of party affiliations may join it and work for the betterment of the community more effectively'.

The meeting expressed its 'strong' opinion that there must be 'one live common non-parliamentary organization to promote and safeguard cultural, religious, educational, economic, and other rights and interests of Musalmans'.

A resolution moved by the chair expressed 'deep sympathy with the victims of unfortunate communal riots that took place recently in East Pakistan, West Bengal, western districts of Uttar Pradesh, and in some other places'.

The meeting also passed a resolution, moved by Begum Aizaz Rasul, recommending the formation of Minority Board for the protection of the rights of the minorities.

Retrace steps

A resolution condemning the detention of Khan brothers in NWFP, notice of which was given by Mr Ansar Harwani, member of the AICC, was ruled out by the chair on the ground that it was outside the scope of the meeting.

There were only two dissenting voices at the meeting, those of Mr Ansar Harwani and Mr M.N. Abidi.

Mr Harwani said: 'For the last ten years you have given a wrong lead to the Muslims. Now you must retrace those steps and form an organization for the reunion of India and Pakistan.'

Mr Abidi said: 'If you join any organization as Muslims, it will only create suspicion against you. Do not join as Muslims but as Indians'.

Specific rights

Speaker on the resolution demanding treaty between India and Pakistan, Mr Lari referred to the proposed joint declaration by the prime ministers of India and Pakistan to be issued shortly guaranteeing protection to the minorities. He said: 'The declaration should not be an abstract declaration but should lay down specific rights of the minorities.'

Mr Lari said that as was evident from Pandit Nehru's statement in Parliament, there was little difference between the number of those coming over to India and those migrating to Pakistan. That

indicated that minorities in both the countries were not feeling secure.

Mr Lari said that the Constitution of India did not provide adequate safeguards for the Muslim minority. It was wrong to say that representatives of Muslim minority had fully approved the provisions of the Constitution, he added.

[1]*Bombay Chronicle*, 20 March 1950.

26. Fourteen Muslim Leaders of India Submit Memorandum on Kashmir on 14 August 1951 to Dr Frank P. Graham, UN Representative[1]

It is a remarkable fact that, while the Security Council and its various agencies have devoted so much time to the study of the Kashmir dispute and made various suggestions for its resolution, none of them has tried to ascertain the views of Indian Muslims nor the possible effect of any hasty step in Kashmir, however well intentioned, on the interests and well-being of the Indian Muslims. We are convinced that no lasting solution for the problem can be found unless the position of Muslims in Indian society is clearly understood.

Supporters of the idea of Pakistan, before this subcontinent was partitioned, discouraged any attempt to define Pakistan clearly and did little to anticipate the conflicting problems which were bound to arise as a result of the advocacy of the two-nation theory. The concept of Pakistan, therefore, became an emotional slogan with little rational content. It never occurred to the Muslim League or its leaders that if a minority was not prepared to live with a majority on the subcontinent, how could the majority be expected to tolerate the minority.

It is, therefore, small wonder that the result of partition has been disastrous to Muslims. In the undivided India, their strength lay about a hundred million. Partition split up the Muslim people, confining them to the three isolated regions. Thus, Muslims number twenty-five million in West Pakistan, thirty-five million to forty million in India, and the rest in East Pakistan. A single undivided community has been broken into three fragments, each faced with its own problems.

Pakistan was not created on a religious basis. If it had been, our fate as well as the fate of other minorities would have been settled at that time. Nor would the division of the subcontinent for reasons of religion have left large minorities in India or Pakistan.

This merely illustrates what we have said above that the concept of Pakistan was vague, obscure, and never clearly defined, nor its likely consequences foreseen by the Muslim League, even when some of these should have been obvious.

When the partition took place, Muslims in India were left in the lurch by the Muslim League and its leaders. Most of them departed to Pakistan and a few who stayed behind stayed long enough to wind up their affairs and dispose of their property. Those who went over to Pakistan left a large number of relations and friends behind.

Having brought about a division of the country, Pakistani leaders proclaimed that they would convert Pakistan into a land where people would live a life according to the tenets of Islam. This created nervousness and alarm among the minorities living in Pakistan. Not satisfied with this, Pakistani leaders went further and announced again and again their determination to protect and safeguard the interests of Muslims in India. This naturally aroused suspicion amongst the Hindus against us and our loyalty to India was questioned.

Pakistan had made our position weaker by driving out Hindus from West Pakistan in utter disregard of the consequences of such a policy to us and our welfare. A similar process is in operation in Eastern Pakistan from where Hindus are coming over to India in a larger and larger number.

If Hindus are not welcome in Pakistan, how can we, in all fairness, expect Muslims to be welcomed in India? Such a policy must inevitably, as the past has already shown, result in the uprooting of Muslims in this country and their migration to Pakistan, where, as it became clear last year, they are no longer welcome, lest their influx should destroy Pakistan's economy.

Neither some of those Muslims who did migrate to Pakistan after partition, and following the widespread bloodshed and conflict on both sides of the Indo-Pakistan border in the north-west, have been able to find a happy asylum in what they had been told would be their homeland. Consequently, some of them have had to return to India, e.g. Meos who are now being rehabilitated in their former areas.

If we are living honourably in India today, it is, therefore, certainly not due to Pakistan which, if anything, has by her policy and action weakened our position.

The credit goes to the broad-minded leadership of India, to Mahatma Gandhi and Pandit Jawaharlal Nehru, to the traditions of tolerance in this country, and to the Constitution which ensures equal rights to all citizens of India, irrespective of their religion, caste, creed, colour, or sex.

We, therefore, feel that, tragically as Muslims were misled by the Muslim League and subsequently by Pakistan and the unnecessary suffering which we and our Hindu brethren have had to go through in Pakistan and in India since partition, we must be given an opportunity to settle down to a life of tolerance and understanding to the mutual benefit of Hindus and Muslims in our country—if only Pakistan would let us do it. To us it is a matter of no small consequence.

Despite continuous provocation, first from the Muslim League and since then from Pakistan, the Hindu majority in India has not thrown us or members of other minorities out of civil services, armed forces, the judiciary, trade, commerce, business, and industry. There are Muslim ministers in the Union and state Cabinets, Muslim governors, Muslim ambassadors, representing India in foreign countries, fully enjoying the confidence of the Indian nation. Muslim members in Parliament and state legislatures, Muslim judges serving on the Supreme Court and the High Courts, high-ranking officers in the armed forces and civil services, including the police. Muslims have large landed estates, run big business and commercial houses in various parts of the country, notably in Bombay and Calcutta, have their share in industrial production and enterprise in export and import trade. Our famous sacred shrines and places of cultural interest are mostly in India.

Not that our lot is entirely happy. We wish some of the state governments showed a little greater sympathy to us in the field of education and employment. Nevertheless, we feel we have an honourable place in India. Under the law of the land, our religious and cultural life is protected and we shall share in the opportunities open to all citizens to ensure progress for the people of this country.

It is, therefore, clear that our interest and welfare do not coincide with Pakistan's conception of the welfare and interests of Muslims in Pakistan.

This is clear from Pakistan's attitude towards Kashmir. Pakistan claims Kashmir, first, on the ground of the majority of the state's

people being Muslims and, secondly, on the ground of the state being essential to its economy and defence. To achieve its object it has been threatening to launch *jehad* against Kashmir and India.

It is a strange commentary on political beliefs that the same Muslims of Pakistan who would like the Muslims of Kashmir to join them invaded the state, in October 1947, killing and plundering Muslims in the state and dishonouring Muslim women, all in the interests of what they described as the liberation of Muslims of the state. In its oft proclaimed anxiety to rescue the three million Muslims from what it describes as the tyranny of a handful of Hindus in the state, Pakistan evidently is prepared to sacrifice the interests of forty million Muslims in India—a strange exhibition of concern for the welfare of fellow Muslims. Our misguided brothers in Pakistan do not realize that if Muslims in Pakistan can wage a war against Hindus in Kashmir why should not Hindus, sooner or later, retaliate against Muslims in India?

Does Pakistan seriously think that it could give us any help if such an emergency arose or that we would deserve any help, thanks to its own follies? It is incapable of providing room and livelihood to the forty million Muslims of India, should they migrate to Pakistan. Yet its policy and action, if not changed soon, may well produce the result which it dreads.

We are convinced that India will never attack our interests. First of all, it would be contrary to the spirit animating the political movement in this country. Secondly, it would be opposed to the Constitution and to the sincere leadership of the prime minister. Thirdly, India, by committing such a folly, would be playing straight into the hands of Pakistan.

We wish we were equally convinced of the soundness of Pakistan's policy. So completely oblivious is it of our present problems and of our future that it is willing to sell us into slavery if only it can secure Kashmir.

It ignores the fact that Muslims in Kashmir may also have a point of view of their own, that there is a democratic movement with a democratic leadership in the state, both inspired by the progress of a broad-minded, secular, democratic movement in India and both naturally being in sympathy with India. Otherwise, the Muslim raiders should have been welcomed with open arms by the Muslims of the state when the invasion took place in 1947.

Persistent propaganda about *jehad* is intended, among other things, to inflame religious passions in this country. For it would, of course, be in Pakistan's interests to promote communal rioting in India to show to the Kashmiri Muslims how they can find security

only in Pakistan. Such a policy, however, can only bring untold misery and suffering to India and Pakistan generally and to Indian Muslims particularly.

Pakistan never tires of asserting that it is determined to protect the interests of Muslims in Kashmir and India. Why does not Pakistan express the same concern for Pathans who are fighting for Pakhtoonistan, an independent homeland of their own? The freedom-loving Pathans under the leadership of Khan Abdul Ghaffar Khan and Dr Khan Sahib, both nurtured in the traditions of democratic tolerance of the Indian National Congress, are being subjected to political repression of the worst possible kind by their Muslim brethren in power in Pakistan and in the NWFP. Contradictory as Pakistan's policy generally is, it is no surprise to us that while it insists on a fair and impartial plebiscite in Kashmir, it denies a fair and impartial plebiscite to Pathans.

Pakistan's policy in general and her attitude towards Kashmir in particular thus tend to create conditions in this country which in the long run can only bring to us Muslims widespread suffering and destruction. Its policy prevents us from settling down, from being honourable citizens of a state, free from the suspicion of our fellow countrymen and adapting ourselves to changing conditions to promote the interests and welfare of India. Its sabre-rattling interferes with its own economy and ours. It expects us to be loyal to it despite its impotence to give us any protection, believing at the same time that we can still claim all the rights of citizenship in a secular democracy.

In the event of a war, it is extremely doubtful whether it will be able to protect the Muslims of East Bengal who are completely cut off from West Pakistan. Are the Muslims of India and East Pakistan to sacrifice themselves completely to enable the twenty-five million Muslims in West Pakistan to embark upon mad, self-destructive adventures?

We should, therefore, like to impress upon you with all the emphasis at our command that Pakistan's policy towards Kashmir is fraught with the gravest peril to the forty million Muslims of India. If the Security Council is really interested in peace, human brotherhood, and international understanding, it should heed this warning while there is still time.

Dr Zakir Husain
(Vice chancellor, Aligarh University)
Sir Sultan Ahmed
(Former member of governor general's executive council)

Sir Mohammed Ahmed Said Khan
(Nawab of Chhatari, former acting governor of United
Provinces and prime minister of Hyderabad)
Sir Mohammed Usman
(Former member of governor general's executive council and
acting governor of Madras and Vice chancellor of Madras
University)
Sir Iqbal Ahmed
(Former chief justice of Allahabad High Court)
Sir Fazal Rahimtoola
(Former sheriff of Bombay)
Maulana Hafiz-ur-Rehman, MP
(General secretary of Anjuman-i-Jamiat-ul-Ulema)
Colonel B.H. Zaidi, MP
(Former prime minister of Rampur state)
Nawab Zain Yar Jung
(Minister, government of Hyderabad)
A.K. Kwaja
(Former president of Muslim Majlis)
T.M. Zarif
(General secretary, West Bengal Bohra Community)
H. Quamar Faruqi
(president, Jamiat-ul-Ulema, Hyderabad)
M.A. Kazimi, MP
(United Provinces)
Hashim Premji
(Former sheriff of Bombay)

[1]B.L. Sharma, *The Kashmir Story*, Asia, 1967, pp. 258–64.

27. Nehru Writes to Chief Minister Ravi Shankar Shukla on How to Deal with Muslims in India[1]

New Delhi
20 March 1954

My dear Shukla*ji*,

You sent me with your letter of 27 January a note on the activities of Muslims in Madhya Pradesh. I am sorry for the delay in acknowledging it.

There are all kinds of trends among the Muslims in India and some of them are undoubtedly objectionable. I think, however, that we should not be led away by these and we should try to judge the broad situation objectively. If Muslims generally in India are unhappy or dissatisfied, the fault is ours and not the Muslims. This indeed would apply to any large group of persons. The Muslims in India have suffered a tremendous shock from the partition and its consequences and it was and is up to us to make them feel that they are completely at home in India and their interests lie in India and not elsewhere. If we fail to do so, it is not much good our saying that Muslims are being misguided by some of their leaders.

It is a fact that there is a great deal of frustration in the Muslim mind in India. I am not referring to people who may be pro-Pakistan. There are not very many like that. But conditions have arisen in India, which bring continuous pressure on the Muslims in various ways. There is the question of employment in government services, all India and state. There is even the question of education facilities in colleges and the rest of it. Even in business there is pressure against them. It is not surprising, therefore, that they lack security for the future.

Reference is made in the note you have sent about the Muslim demand for Urdu. This is a very important matter, because it affects the Muslims psychologically more than almost anything else. According to our educational policy, we should give full facilities for learning Urdu for those who want it. This has nothing to do with opposition to Hindi which stands firmly in its place as our national language. I am afraid that our general policy has not fitted in with our declared educational aims and has undoubtedly created a deep sense of frustration among the Muslims.

We seem to forget that the Muslims form a very large number of people in our country and it is a major problem for us how far we win their goodwill. The whole of the Kashmir question largely depends upon the reaction of the Muslims in India.

The recent elections in East Pakistan have created a new situation in Pakistan which may be favourable to better relations between India and Pakistan. Public feeling in Pakistan is, on the whole, friendly to India. Much depends therefore on how we deal with our Muslim countrymen in India.

<div align="right">
Yours sincerely,

Jawaharlal Nehru
</div>

[1]*Selected Works of Jawaharlal Nehru*, Second Series, vol. 25, Jawaharlal Nehru Memorial Fund, distributed by Oxford University Press, 1999, pp. 226–7.

28. Extract from Nehru's Letter to Chief Ministers on 26 April 1954[1]

I have written to you previously about a matter which has troubled me greatly and continues to exercise my mind. This is the question of minorities in India. I asked you once to find out the figures of recruitment of these minorities to our services. The figures I received were unsatisfactory. Our Constitution is very good and our laws and rules and regulations are also fair. But the fact remains that in practice some of our minorities, and notably Muslims, suffer from a deep sense of frustration. They feel that the services are not really open to them in any marked degree, whether defence, police, or civil. In business, the evacuee property laws, which unfortunately continue even though they are not applied frequently, bear down upon them and restrict their opportunities. In elections to our assemblies and Parliament, it is not easy for Muslims to come in. Even in our public organizations, it is becoming increasingly difficult for proper Muslim representation. I know this is so in the Congress. It is easy for anyone to become a primary member of the Congress, but when it comes to any elective post, a Muslim is at a disadvantage and there are no reservations now anywhere. I imagine that this applies to other political and like organizations also. It is not that there is any anti-Muslim feeling as such, though sometimes even this is present. It is more the recrudescence of local and caste feelings.

[1]Jawaharlal Nehru. Letters to Chief Ministers 1947–65. General Edition, G. Parthasarathi, Jawaharlal Nehru Memorial Fund, New Delhi, distributed by Oxford University Press, 1987, vol. III, p. 535.

29. Leaders Decide Dissolution of the Fourth Party[1]

A decision to dissolve the Fourth Party, the majority of which comprises former Muslim Leaguers, has been taken by the party leaders in Bombay who will advise its members to join the Indian National Congress.

A joint appeal to workers of the Fourth Party, made by Mr A.A. Khan, former leader of the Opposition in Bombay assembly, Haji Sasanally P. Ibrahim, president of the party, and Mr A.K. Hafizka, secretary, stated that under the existing circumstances, the party should dissolve itself. A directive should be given to the

members to join the Congress in 'large numbers and take active interest in the nation-building programmes', the appeal said.

It added that in the present context of international affairs and particularly when every enlightened citizen should realize his responsibility to contribute his mite to the best of his ability to the development of the country, 'we feel that Congress is the one organization, more than any other, which deserves full support'.

Communal parties

Mr Hafizka said the decision was the first organized effort of the Muslims to break up with the past and do away with the communal organization. Though prominent Muslims in other parts of the country had joined the Congress or other political parties, he added that no collective decision on state-wise basis had been taken any where so far to dissolve communal parties.

He stated that though its policies and programmes had been based on non-communal basis, the Fourth Party had received very poor response from the Muslims. He affirmed this 'discouraging attitude' of non-Muslims to certain 'historical factors'.

He said that after the provincial convention an all-India conference of prominent Muslim leaders would be held to find ways and means to completely root out communal organizations and cooperate with the government on nation-building work.

The Fourth Party came into existence soon after independence when the Bombay Provincial Muslim League divested itself of politics.

In the Bombay Municipal Corporation, the Fourth Party functions as a separate group, but most of its members vote with the Congress.

In order to finalize the dissolution of the party and also to ensure mass enrolment of its members into the Congress fold, a convention of prominent representatives of the Fourth Party will meet in Bombay on 10 September 1955.

[1]*The Times of India*, 24 August 1955.

30. Indian Union Muslim League Decides to Contest the 1957 Elections[1]

The two-day meeting of the council and working committee of the Indian Union Muslim League, which concluded at Madras

on 22 October 1956, resolved that the League should set up its candidates in the forthcoming elections in such constituencies as it might select for the purpose.

The council decided that, in the constituencies where Muslim League candidates could not be set up, the League might extend its support to independent and other party candidates, excepting those of Hindu Mahasabha and Jan Sangh.

It also authorized the president of the League to enter into any alliance or agreement with other parties whose aims and objects did not conflict with those of the League.

The council extended its support to the Congress party and its aim of 'socialistic pattern of society', but took 'strong exception to the attitude taken by the Congress in general and its high command in particular, towards the Muslims as a community and their aspirations'.

Mr M. Mohammed Ismail, MP, president of the League presided.

[1]*The Times of India*, 23 October 1956.

Mobilization for Redress
of Grievances

1. Congress not to Oppose Muslim Convention[1]

The Congress Working Committee agreed on 18 May 1961 not to oppose the Muslim convention proposed to be held at New Delhi on 11 and 12 June following overnight moves and solemn assurances given by some leading Congress Muslims about its nationalist and secular character.

In a prepared statement, the Congress president later declared that though 'we do not generally approve of sectional conventions, we think that in the present case and in view of the talks we have had, the proposed convention may serve a useful purpose'.

The meeting of the Working Committee lasted about an hour and was devoted mainly to the question of the convention. Maulana Hifzur Rahman and Professor Humayun Kabir were present as special invitees to explain the viewpoints of the sponsors of the convention.

No intervention now

It was explained by the Congress president to newsmen that the Working Committee did not consider it advisable to intervene at this stage 'when preparations for the convention had begun'. It did not wish to create a feeling that it 'will not even allow a meeting to express views'.

The Congress president's statement, which was approved by the Working Committee, declared: 'There has been some controversy about the holding of a Muslim convention to consider certain matters. Some of us did not like the idea as we do not approve of a convention held on a sectional basis.'

Purpose of convention

'In order to understand the purpose of the proposed convention and to remove doubts and misunderstandings we have discussed this matter with some of the sponsors of this convention. We understand that the main purpose is to help in the full integration of all the people of India and the strengthening of the secular ideal of our state. Communalism and all forms of separatism are to be opposed. Only such persons who accept these ideals and objectives are, we are told, to be invited to the convention.

'These are the basic objectives of the Congress to which it attaches great importance. We welcome all earnest efforts to this end. Although we do not generally approve of sectional conventions we think that in the present case and in view of the talks we had, the proposed convention may serve a useful purpose.'

[1]*The Times of India*, 19 May 1961.

2. Dr Syed Mahmud Moves for the Muslim Convention[1]

Dr Syed Mahmud, MP, a senior Congress leader from Bihar, will preside over the proposed Indian Muslim convention which is programmed to meet at New Delhi on 10 and 11 June.

The convention will set up a committee to pursue its decisions and demand a proper place for Muslims 'in the sphere of national activities and also in the enjoyment of their due rights of citizenship and in all the schemes of national planning of social, cultural, educational, and economic progress of the country on the basis of healthy traditions of mutual understanding'.

As chief convener and chairman of the reception committee of the convention, Maulana Hifzur Rahman explained why this move had become necessary. He said it had nothing to do with the coming general elections. If anything, the move had been precipitated by the Jabalpur riots.

He made it clear to begin with that he had met the prime minister and the Congress president not to seek their permission for a convention. He was emphatic that the convention would have met whether it was liked or not. Nevertheless, since the move had

given rise to misgivings about the intention behind it, he felt it his duty to disabuse the mind of the Congress High Command.

No assurance

Answering a question, he said that he had given no assurance to the High Command regarding the convention but reiterated that only those Muslims were invited to it who had a living faith in secularism and Indian unity. He expected a few non-Muslims to attend the convention in response to his invitation. They would have the right to speak and make suggestions which, however, would not be binding on the convention.

Asked whether Muslim Leaguers had been invited, the Maulana said that no organization as such would be represented on the convention. The invitees would be coming in their individual capacity and not as representatives of the parties they belonged to.

He claimed that the Jamiat-ul-Ulema, which was behind the convention move, had never stood for communalism before and since independence. Otherwise, it was a purely social and cultural body. He gave the following reasons for calling a convention:

Since the dawn of freedom and enforcement of the secular democratic Constitution in our country, Indian Muslims have not been receiving proper encouragements as to enjoy their due constitutional rights. In spite of collective and individual efforts within and outside the legislatures, no substantial result has come out as yet in this behalf. Of course, it has been an encouraging factor of our struggle that the leaders of different national parties and true patriots, despite their divergent political views, have not hesitated in offering their cooperation to the extent of appreciation in order to rectify the reasonable and just grievances of the Muslims but, unfortunately, without satisfactory results.

Today, the Indian Muslims are generally led away by frustration, demoralization and pessimism. It is really very unfortunate that this fifty million population of our country, which is scattered in every corner of our land, is suffering from these feelings with regard even to the safety and security of their lives, properties, and social footing. Obviously, this state of affairs is not only causing anxiety amongst the Indian Muslims but is equally detrimental to the country's solidarity and national prestige. If the biggest minority of the country suffers with the feeling of dissatisfaction and frustration, it is no doubt an indication and symbol of ill health of our nation.

[1]*The Statesman*, 21 May 1961.

2a. Grievances of a the Muslim Minority[1]

M r M. Harris, a member of the Praja Socialist Party and associate of Jayaprakash Narayan was a participant in the June 1961 Muslim conference. His letter to the editor, *The Times of India*, as reproduced below, reflected the mood of the convention:

Sir,—Your comments on 'Minorities' (18 May) are both forthright and commendable. You have been fair in pointing out that while other smaller minorities have small cause for complaint, the 'Muslims do have some cause for grievance'. The attitude of foreign firms operating in India, in so far as they have acquired 'the prejudices of the dominant group' is all the more deplorable. It may be true that the civil services offer equal opportunities to all irrespective of community, but can one say the same about the police and the defence services? It is a well-known fact that for many years now Muslims have been kept out of these services. It is even said that there have been official circulars to that effect.

It is this type of discrimination which is really the main cause of all trouble. Many young Muslims have been nursing a sense of genuine grievance and falling an easy prey to the attempts of those who want to attract them to communal organizations. There can hardly be two opinions that this discrimination needs to be removed, as it is palpably unjust, and more so because it goes against the very basis of our secularism and democracy. A proper share to all sections of the Indian community in all public services and at all levels is necessary not so much because it gives them an economic opportunity as because it imparts to them a sense of active participation in the administration and helps national integration in the real sense.

It would certainly be wrong to suggest that this should be done by the revival of the hated quota system. But surely, there can be other ways and means of doing it. In a democratic set-up, laws, rules, and regulations no doubt have their place and they play their part, but more important than these is the establishment of conventions, traditions, and usages which go a longer way in creating an atmosphere in which real democracy thrives.

M. Harris
Bombay, 20 May

[1]*The Times of India*, 29 May 1961.

2b. Muslim Convention Highlights Demoralization of Minorities as a Fallout of Communal Disturbances[1]

M aulana Hifzar Rahman, MP said at New Delhi on 20 May 1961 that the proposed two-day Indian Muslims' convention,

beginning at New Delhi on 10 June would try to evolve a practical solution to the problems of the Muslim community on a national level within the strict limits of the secular Constitution of India and national unity.

Addressing newsmen, the Maulana, who is the chairman of the reception committee of the convention, emphasized that neither the sponsors nor the invitees had anything to do with communalism.

Replying to a question, he said that the Jamiat Islami and the Muslim League were not among the sponsors. Invitations were not being extended to their members as the two organizations were communal in character.

Dr Syed Mahmud, MP, former minister in the ministry of external affairs, has tentatively agreed to preside over the convention.

Limited purpose

Maulana Hafizur Rahman denied that the convention was being held in the background of the coming general elections and said it had been called with a limited purpose and would not be a permanent platform.

The convention might appoint an implementation committee to carry out its decisions, he added.

Justifying the need for holding the convention, the Maulana said that since independence and enforcement of the secular democratic Constitution, Indian Muslims had not been receiving proper encouragement to enjoy their due constitutional rights.

In spite of collective and individual efforts within and outside the legislatures, no substantial results had come out as yet.

The continuance of a feeling of frustration and dissatisfaction in the biggest minority of the country, he said, was the 'symbol of ill health of the nation'.

In these circumstances, in order to achieve national integration, it is most essential that a proper place should be provided for the Muslims of India in the sphere of national activities and also in the enjoyment of their due rights of citizenship and in all the schemes of national planning of social, cultural, educational, and economic progress, on the basis of healthy traditions of mutual understanding, he added.

Appealing to the secular-minded people to extend their support to the convention, Maulana Hafizur Rahman said it was not

sufficient to remain content by only adopting a secular mode in the national problems.

The spirit of secularism should become the national temperament. The national activities of all the Indian communities should be inspired by and moulded in secularism.

Asked about his talks with Mr Nehru and the Congress president, Mr Sanjiva Reddy, the Maulana said he had explained to them the objects of the convention. 'There was no question of seeking permission to hold the convention,' he added.

Replying to another question, the Maulana said that Mr Nehru would not be invited as he would be the man whom the convention would approach later for redressal of various grievances.

Communal amity

Mrs T. Sinha, Union deputy finance minister, said at Indore on 20 May 1961 that the organizers of the Muslim convention in Delhi had assured the Congress High Command that the convention would help to mobilize Muslims against communalism and bring them under better integrated democratic fold.

Mrs Sinha said that a sense of insecurity and uncertainty had recently developed among Muslims living in India as a result of the recent communal disturbances.

It was, therefore, necessary that efforts should be made to create a proper and healthy atmosphere where members of all communities could come into one fold and live in peace, amity, and friendship.

[1]*The Times of India*, 21 May 1961.

2c. Convention to Seek Solutions to the Problems of the Muslim Community[1]

Nearly 600 prominent Muslims belonging to various parties from all over the country are expected to attend the Indian Muslims' convention in New Delhi on 10 and 11 June 1961 to evolve 'practical solutions' for the problems facing the community within the 'strict limits' of India's secular Constitution.

Maulana Hifzur Rahman, the chairman of the reception committee, claimed on 7 June that the convention had aroused great enthusiasm and its conveners were faced with the problem of

successfully dissuading thousands of people from coming to the capital from all over the country.

Messages, he said, had to be urgently despatched to some hundred thousand people explaining that the convention was not a public meeting but a conference of leaders. Many among them had sought permission to 'attend' even from outside. 'Just fix some loudspeakers outside,' they had pleaded.

Dr Syed Mahmud, a Congress leader, will preside over the convention which will be attended, among others, by Mr Abdul Qayum Ansari (Congress—Bihar), Dr A. J. Faridi, PSP and Mr Z.A. Ahmed, Communist (both UP), Mr Mustafa Faki (Congress—Bombay), Mr G.M. Sadiq (National Conference—Kashmir) and Mr Mohamed Koya (Muslim League—Kerala).

Eight-point agenda

Invitations had also been sent to the Congress president, Mr Sanjiva Reddy, and the chairperson of the National Integration Committee, Mrs Indira Gandhi. Mr Reddy has expressed his inability to attend as he will be away on tour at the time. Mrs Gandhi is abroad.

An eight-point agenda has been drawn up for the convention, the preamble to which asserts that it is an accepted fact that, since the dawn of freedom and birth of the secular democratic Constitution, Indian Muslims have not been enjoying their full constitutional rights in various important walks of life.

The items on the agenda are:

(1) Devising ways and means that would enable every citizen not only to enjoy full freedom of religion and culture but also to live in harmony with others and promote national solidarity in all respects.
(2) Checking of forces that encourage communal passions resulting in heavy loss of life and property.
(3) Examination of how Muslims can get their due share in all government services, including local government organizations and state and Central legislatures.
(4) Finding out ways by which Muslims can get their due share in matters of trade, industry, and other national activities.
(5) Ensuring due recognition for Urdu in the states and the Centre since it is one of the fourteen languages recognized under the Constitution.

(6) Measures to set right the incorporation of views in textbooks prescribed by some of the states which are unacceptable even from the secular viewpoint.

(7) Solution of the problem arising out of inadequate representation of Muslims with regard to admission in various educational, medical, and technical institutions and grant of scholarships.

(8) The rehabilitation of uprooted persons.

Most vital issue

Sources close to the conveners explain that the most vital issue before the convention is one of securing a 'due share' for Muslims in government services and other walks of life.

Maulana Hifzur Rahman said that the convention would be held in Sapru House and its inaugural session would be open to the press. The convention would thereafter split into three or four subcommittees. It would be for these subcommittees to bring forward one or more resolutions before the full convention.

The convention, he reaffirmed, was designed to strengthen, and not weaken India's secular base. There was no question of transforming the convention into some kind of a permanent organization or a political forum. It was no more than an ad hoc get-together. Only such individuals who subscribed to the secular creed and opposed communalism had been invited.

The recent decision of the state chief ministers to implement forthwith the various proposals of the AICC committee on national integration has in no way deflected the organizers. Said the Maulana: 'Every right-thinking Muslim endorses the recommendations of the Integration Committee and welcomes the intention of the prime minister and the state government leaders to implement them. But it is not merely a question of pious resolutions. The crucial issue is one of implementation. The convention still has a purpose.'

[1]*The Times of India*, 8 June 1961.

2d. Convention Demands Effective Role for the Minorities Towards Attainment of National Progress[1]

The two-day Muslim convention got off to an impressive start on 10 June 1961, with some 600 delegates, representing different

sections of opinion, packing the Sapru House auditorium. The day's official speakers drew attention to the parlous state in which the Muslim community found itself.

In fact, the strongest criticism of the majority community and the government's failure to assure a fair deal to Muslims came from two Hindu Congress leaders of Delhi, who declared in moving terms that the very fact that their Muslim brethren were compelled to forge a platform to air their grievances was a matter of shame to the rest.

The prime minister, in a message, welcomed the convention's determination to emphasize the fundamental unity of the Indian community and to discourage trends that tend to divide. On the other hand, he pointed out that sometimes, in the name of such objectives, narrow, parochial views prevailed. He hoped the convention would adopt a broad approach in considering the issues before it and not confine itself merely to a listing of demands.

Committee set up

At the end of the inaugural session, Maulana Hifzur Rehman, chairman of the reception committee, announced that the resolutions for the next day's plenary session would be drafted by three committees into which the house would divide itself. These committees will be presided over by Mr Nooruddin Ahmed (Delhi), Mr Yaseen Nuri (Bombay) and Professor Mujeeb (Delhi). The committees will respectively deal with national integration, law and order, and rehabilitation; services, industry, and commerce; and education, scholarships, and Urdu.

The proceedings opened with recitations from the Koran and the singing of *Hindustan Hamara*.

In his welcome address, Maulana Hifzur Rehman referred to the past of this 'vast and splendid land, which is our dear home'. The most important feature of its history, he said, was the catholicity of approach which had made possible the flourishing of different languages, communities, and religions in fruitful cooperation. Since independence, however, parochial and communal trends, manifesting themselves in the happenings in Assam, Gujarat, Maharashtra, Madhya Pradesh, UP, and Bihar had marred this record.

Source of concern

The treatment received by the Muslim minorities was not the result of a prejudice merely among the majority community but one which

had percolated to different levels of the administration itself. This was a source of concern not merely to the Muslims but to all right-thinking and justice-loving people in the country, prominent among them being the prime minister himself. A realization of the problem was not wanting. What was wanting was implementation of the policies and programmes that flowed from it.

Maulana Hifzur Rehman declared that Muslims were equal partners with the rest in the magnificent future of this land. In no circumstances would they agree to be treated as foreigners or mere tourists.

Referring to the opposition and hostility that the convention had aroused among certain sections, he said the magnificent success that was already assured to it was enough refutation of the baseless doubts and suspicions entertained on this account.

The president, Dr Syed Mahmud, began by demanding for the Muslims an effective role in the advancement of the motherland, adding that their main grouse was that this had been denied to them. Recent separatist and sectional trends held the threat that this country might be plunged into 'unchecked democracy' which, in course of time, could deteriorate into tyranny.

Electoral changes

To arrest the process, he advocated a detailed scheme of constitutional and electoral changes. The present autonomy of the states should end. A strong Central government should enforce its will through administrative subdivisions.

All the fourteen languages, including Urdu, should be given equal treatment and be equally encouraged. Unfair electoral practices should be discouraged. The impact of caste in elections should be eliminated. An enlightened educational system should inculcate patriotism and tolerance among the new generation.

While supporting the demand for amelioration of the Muslims' present plight, Dr Mahmud called upon the community to cut itself free from its past negative approach of 'cow and music' and to ponder carefully over the causes of their economic backwardness. There was no doubt that a great part of this could be traced to the prejudice among the people generally and officialdom.

Let the progressive political parties, he said, call a conference of all the minorities and consider their problems. Let members of the majority community take it up as their duty to give full satisfaction to the minorities in the country. The government too

should take a hand in this. The starting of an effective English daily newspaper to represent Muslim interests was a necessity.

Mr Brij Mohan, president of the Delhi Pradesh Congress Committee, alleged that the convention had been opposed by communal-minded elements among both Muslims and Hindus and that was proof of the basic soundness of approach. Even small communities in this country came to consider their problems. Why should the Muslims then, who numbered five crore, be asked to adduce special reasons for taking counsel on their difficulties and handicaps?

Main issue

Mrs Subhadra Joshi, Congress MP from Delhi, said the issue posed by the convention was not communal but one of progress versus reaction. One felt ashamed that the Muslims had been compelled to come together to seek redress for their grievances, she said.

Referring to her visit to Jabalpur after the riots there, she said Muslims with an unsullied record of opposition to communalism could not make their appearance in the town for days after the happenings.

Mr Yasin Noori (Bombay) said recent events had demonstrated that communal elements still held sway in this country; the Congress itself was not free from them. This convention, he declared, did not ask for charity. 'I demand my rights under the Constitution as a citizen, not merely as a Muslim.'

According to PTI and INS reports, referring to the problems and grievances of the Muslim community, Dr Syed Mahmud said that generally Muslims were treated as suspects, criminals, and traitors and were considered unworthy of holding any position of trust or responsibility. They found it difficult to secure employment in private firms. Most foreign firms were under the impression that the government or officials did not generally favour the employment of Indian Muslims.

Durgapur events

Dr Mahmud said: 'What happened in Durgapur recently is simply deplorable. Some Bengali young men misbehaved badly. By their misbehaviour, they have not only insulted Jawaharlal Nehru and the Congress president, but they have insulted the whole country. Many of you will live to see the woeful condition of the country, God forbid, when Nehru is no more.'

Referring to the language agitation in Assam, Dr Mahmud said it was indeed true that the Bengalis in Assam were unjustly treated, but their young men should have acted with restraint worthy of their great past.

At this there was a breeze. Two legislators from Bengal objected to these remarks about Bengalis. As soon as Dr Mahmud had concluded his address, Mr A.M.O. Ghani and Mr Ghulam Yazdani got up and demanded deletion of the particular remarks.

Maulana Hifzur Rehman told Mr Ghani and Mr Yazdani that they could raise the issue in the committee that would be set up to discuss various problems.

Irony of fate

A Bombay bishop, Father J.S. Williams, addressing the convention, said that the Muslims had made notable contributions to the country's culture and prosperity and it was an irony of fate that in their own land they had to put up with 'so many disabilities'.

He said that as long as Urdu was denied its rightful place in the country, it was idle to expect emotional integration of the people to whom this language was dear.

There were angry murmurs when Mr G.M. Sadiq, Kashmir education minister, demanded that opportunities to make speeches from the dais should be given to all persons.

He made this demand immediately after Maulana Hifzur Rehman had announced the names of the speakers at the opening session. Mr Sadiq was assured that opportunities to speak would be given to all at tomorrow's open session.

[1]*The Times of India*, 11 June 1961.

2e. Resolutions of the Convention to be Presented to the Prime Minister[1]

The All-India Muslim convention concluded at New Delhi late in the evening of 11 June 1961 amidst general acclaim, after adopting a series of resolutions bearing on the problems of the Muslim community without a single dissenting voice.

The chairman, Dr Syed Mahmud, congratulated the participants on the restraint and dignity of approach that had marked the proceedings.

The outcome was a matter of particular pride to Maulana Hifzur Rehman, the moving spirit behind the convention. He admitted as much in his valedictory speech, declaring that the constructive line taken by the speakers must confound the critics, Muslim as well as non-Muslim, who had crusaded against the convention for the last month.

He made an important affirmation of faith in this context. The leaders gathered on the dais, he declared, were men who had devoted the best part of their lives to the cause of national freedom and, after independence, to the defence and support of the secular ideal. He would be a great coward if he did not fight if his community was threatened. He was an Indian and a Muslim at the same time. It was no use asking him which came first. There was no conflict; each came first in its own place.

Nature of resolutions

The resolutions, which call for action by the government on many points, will be presented to the prime minister by Dr Syed Mahmud and Maulana Hifzur Rahman. Interviewed on the subject, Maulana Hifzur Rehman explained he could not say when this would be done. The prime minister was preoccupied with many matters. They would take the earliest convenient opportunity to meet him after his return from Manali.

The resolutions embrace such subjects as national integration; measures to minimize disturbances of a communal nature; restoration of homes, mosques, and *imambaras* to Muslims; adequate share for the community in services, trade, and commerce; encouragement of Urdu including the establishment of an Urdu university.

Moving the main resolution, Maulana Hifzur Rehman commended its three suggestions, namely, taking the message of national integration into the homes of the people by a voluntary social service organization; the convening by the prime minister of a conference of all secular parties and bodies to evolve measures to fight communalism; and the immediate implementation of the Congress National Integration Committee's report.

Seconding it, Mr G.M. Sadiq declared it was clear that a great deal needed to be done to translate the secular ideal into action. Kashmir had provided an example that could well be emulated by the rest of the country. On the other hand, Muslims should realize that a great deal depended also on their own efforts. He was pained

to note, for example, that of the 5000 or so students declared successful at the Delhi higher secondary examination, only 54 were Muslims.

National question

Dr Z.A. Ahmed (Communist) said while communalism among the majority committee was reprehensible, Muslims should also combat similar tendencies in their own ranks. The question of minorities was a national question. All political parties should adopt communal peace as an article of faith.

Commending the resolution on rehabilitation, Maulana Shahid Fakhri (Lucknow) bemoaned the manner in which mosques, *imambaras*, and graveyards continued to be in government or non-Muslim occupation. While crores of rupees had been spent on refugees from East and West Pakistan, very little had been done for Muslims who had been made homeless in their own homeland.

Mr Athar Ali, speaking in support, painted a woeful picture of the heartless attitude of the West Bengal government in the matter.

The resolution on communal disturbances, suggesting drastic action against officials within whose jurisdiction such incidents took place, and of the elements actually concerned, was commended by two well-known Delhi Congressmen, Mufti Atiq-ur-Rehman and Mr Nooruddin Ahmed. The former pointed out it was wrong to think that Muslims could be driven out by physical threats or violence. Not one of the victims of the Jabalpur happenings had so far migrated to Pakistan. The recruitment of Muslims to the police and other administrative services was the best guarantee of communal peace in the country.

Mr Nooruddin's speech was remarkable for his analysis of the genesis of communalism in the country. This was absent till 1857, he declared, when the British began sowing the seeds of dissension between the two communities. Even the revival of Hindu interest in painting and dancing was fostered by them in an attempt to provide as many points of distinction between them and the Muslims as possible.

Professor Mahesh Dutt Misra (Jabalpur) described the extent to which the minds of the local populace had been poisoned by the press. It was imposible even at this distance of time to convince the Hindus of Jabalpur and the surrounding villages that it was the Hindus, not the Muslims, who were to blame for the violence there.

[1]*The Times of India*, 12 June 1964.

3. JP Charges Civil Administration with Inefficiency and Worse in Controlling Communal Riots[1]

It was during my peace work in Jamshedpur that I read of the Lok Sabha unanimously recommending to the government to enlist world opinion against the atrocities perpetrated on the minorities in East Pakistan.

It is but right that members of Parliament should be so concerned over the fate of minorities in a neighbouring nation. But was it not equally right, if not more so, to have shown concern about the fate of the Muslim minority in our own country?

I spent four days in all at Jamshedpur immediately after the terrible events that happened there. (About 140 Shanti Sainiks are still working in the city and the *mofussil*.)

I met all sections of the people in Jamshedpur: leaders of political parties and trade unions, directors and managers of the industrial concerns, high and low officials of the Bihar government, representative citizens, panchayat *mukhias* and *sarpanches*, and Muslim citizens and sufferers.

Only two camps

I visited all the affected areas in the city, but did not have the stomach to visit more than two of the seventeen Muslim refugee camps. (A member of the Lok Sabha is reported to have broken down while speaking about the atrocities committed in East Pakistan, but I doubt if any sensitive person could have stood the sights and stories of atrocities that the Muslim refugee camps in Jamshedpur—the same can be said of Rourkela—presented.)

I also carefully collected reports from various sources about happenings in the rural areas and mining and small industrial townships in the Singbhum district. It has not been possible yet to get accurate reports from Simdega and other areas of the Ranchi district adjoining Orissa.

Regarding the situation in Rourkela and the adjoining rural areas, I heard reports from Shri Nabakrushna Choudhuri (former chief minister, Orissa), Malati Devi (wife of Naba Babu), and Shri Manmohan Choudhuri (president, Sarva Seva Sangh).

No justifiable cause

I am not writing this in order to make a report to you on the situation in these areas of Bihar and Orissa and the vital steel cities.

But I do most earnestly wish to say that India and Indians have no cause to feel smug and complacent or superior and holy.

Terrible things have happened, and on a scale that has not been realized by Delhi or the country at large. The tale of provocation caused by refugee trains is only a small part of the full story.

There is no doubt in my mind that there was an organization behind these dastardly activities which operated from a common centre, manufactured and spread rumours, planned and financed specific actions, and provided the whole operation with a political and philosophical justification.

It is interesting to note that all the political parties (chiefly, three operate in the area: the Congress, PSP, and CPD) and the trade unions were rendered completely impotent in the face of the upsurge of organized criminality. It was also proved that education, including science and engineering education, was no guarantee against animality and criminality.

It was further proved how inadequate and inefficient was the civil administration and how the forces of law and order were themselves infected considerably with the virus of communalism.

In one major industrial establishment at least, the supervisory staff remained inactive, to put it at its best, while lethal weapons were being fabricated for hours within the factory itself out of iron bars and similar things.

As for the nature of atrocities committed, I do not think there were any holds barred. Every revolting kind of deed was done. The tragedy seen in the mass was terrible enough, but some of the individual cases were fathomless, indeed, in their cruelty and degradation.

Therefore, my plea, dear Sir, is that members of Parliament should not let official statements apply salve to their conscience and that Parliament should take immediate steps to inform itself of the situation, so that its discussions and decisions on the question of communal harmony might be more realistic and balanced.

One way of doing this might be to send a study team to the affected areas, not on a flying visit or in the manner of ministerial or official visits, but as an earnest and humble search for the truth.

What Parliament will do with its study team's report, it will, no doubt, decide for itself. But may I say that the obsession about Pakistan misusing Indian facts to their advantage is injuring our moral fabric.

One of the major diseases from which, to my mind, we suffer as a nation, is the weakness, which after all deceives no one, to appear holier than we actually are.

Apart from the ethical aspect, I do not think that any problem, whether that of communal harmony or other, can ever be satisfactorily solved by starting with false premises and pretending that things are not what in truth they happen to be.

Mental preparation

If the people are kept in the dark about what is happening in the country, they may not be mentally prepared to accept the radical remedies that might become necessary.

In any case, the study team's report would have achieved one important purpose, namely, that of informing the representatives of the people of the true state of affairs. That in itself would be no small gain. Policies framed after a correct appreciation of facts are more likely to be effective than those made in the dark.

I do earnestly hope that this grave and urgent matter would receive the consideration it deserves.

[1]Text of Jayaprakash Narayan's letter dated 16 April 1964 addressed to the presiding officers of both Houses of Parliament. *The Hindustan Times*, 17 April 1964.

4. JP and Others Warn Against Smugness[1]

Mr Jayaprakash Narayan, Mr Nabakrushna Chaudhuri, Mr Annada Sankar Roy, Mr Charu Chandra Bhandari, and four other social workers have, in a joint statement issued on 25 April 1964 warned the people of India against moral smugness. The statement reads:

Almost every day we find in the Indian Press, especially in that of the eastern zone, accounts of one or another kind of misbehaviour with the minorities in Pakistan. Tales told by refugees from there of atrocities committed on them are flashed in lurid details. Whenever disturbances take place in Pakistan the press very naturally disbelieves the figures of casualties and damage given out by the Pakistan authorities and publishes higher figures gathered from independent sources or surmises of its own.

Communal disturbances, both big and small, have also taken place in India. The sufferings of victims of these are no less real or intense in

human terms here than in Pakistan. But these barely find any expression in the Indian press. This has created an image in our minds that we are very virtuous people who never engage in any unseemly acts except on an incomparably smaller scale and only when roused to a very understandable and righteous indignation by the terrible atrocities committed in Pakistan. We have, in the same way, imbibed an image of Pakistanis as a nation of thugs and murderers bereft of all human decency.

This attitude of mind is the greatest danger to internal peace in this country and one of the main obstacles in the way of an understanding with Pakistan. And more than this, it is blunting our moral sense and degrading our scale of human values. Atrocities have been committed in India that are as bestial, shameful, and unthinkable as any committed elsewhere, but we fail to perceive any real concern in the people about them, because they do not know the facts. Women—and pregnant women at that—have been cut down, children bludgeoned to death, babies thrown into fires, young women raped to death. These and such other acts make one feel like dying of shame. It may be, and has been, argued by educated persons that a much larger number of such bestialities have taken place in Pakistan, so there is no sense in being shocked at a few such incidents here. This argument itself demonstrates the moral insensibility into which many minds have sunk, inflamed by the continuous exposure to one-sided stories.

It is not only brute numbers that are a measure of human degradation. The degeneracy of the Kaurav court was not measured by whether the assembled princes leered at the nakedness of one Draupadi or a hundred. But even the argument of numbers has lost force since the recent happenings in Orissa and Bihar. We have no way of knowing the real figures of deaths, etc., in East Pakistan, but the figures of the recent happenings here have been quite large.

Distorted facts

We do not believe that the heart of the people of India has been corrupted. It is the presentation of distorted facts that has distorted their scale of values. We also believe that the same is also the case with the people of Pakistan. While the recent killings have uncovered the diabolical depths of human nature in both the countries, they have also brought to the fore its finest efflorescences. In the midst of death and destruction many people have risked their lives to protect the minorities. And, here, on a head count, Pakistan has the edge over India. There at least thirty young Muslims have laid down their lives in trying to protect their Hindu neighbours.

We believe that if the people of India come to know the truth about the monstrosities committed by our countrymen, their minds and hearts will revolt at it and they will be moved to make amends. The withholding of the truth from them only helps to prolong the agony by bolstering our national conceit.

Let us also help the people to get rid of the notion that riots have always originated in Pakistan. They have often enough originated in India, the disturbances in Aligarh and Jabalpur being cases which come to the mind.

We feel that well-intentioned people including the authorities, are often unintentionally parties to this distortion of values. They advise restraint in the publication of facts about disturbances lest these help increase panic and tension. They are anxious about the repercussions the reports may have in Pakistan. They have also an eye on the world at large and are concerned about any damage to the prestige of India abroad.

But what happens in practice? Nothing can be hidden for ever in the modern world. Just as the truth trickled out of the military dictatorship of Pakistan, so also it trickles out of here. Just as we never take at face value the figures given out by the Pakistan authorities, so also the press in Pakistan scorns our official figures and flashes inflated ones of its own. The only people who are kept in the dark successfully are our own who continue to wallow in the conceit of national superiority. And since no one has so far succeeded in checking the publication of lurid accounts of happenings in Pakistan, this conceit continues to grow.

When leaders and public figures talk about the gravity of a situation in general terms, the people, having only a bare idea of the real nature of it, feel that the leaders are making too much fuss about something that is really not so serious. Thus, a contemptuous attitude towards the sense of urgency of our leaders is generated and continues to increase.

It is time we shed our conceit and pretences and faced the truth squarely that we are no better—or no worse—as human beings than our brothers across the border. Let our people repent and make amends for the ghastly deeds committed by our compatriots. This facing up to the truth is an indispensable step for strengthening the moral fibre of our nation and cleansing it of the canker of communalism. It will enhance our respect in the eyes of the world, which knows the truth anyway, and it will strengthen the hands of good and true men in Pakistan to whom we must look to build the bridge of understanding from the other end.

[1]*The Statesman*, 26 April 1964.

5. Syed Mahmud Spells Out Need of the Hour for Muslims[1]

Dr Syed Mahmud, a former Union minister appealed to the All-India Muslim Consultative Convention on 8 August 1964 to concentrate its attention on thinking out a remedy for 'the manifold injustices and prejudices' to which the community may be subjected on cultural, political, and economic planes.

The strategy of shedding tears or complaining against the government or a particular group of citizens had not succeeded. The need of the hour was detachment and large-heartedness.

The two-day convention being held at Darul Uloom Nadwatul Ulema, a centre of Muslim theology, is the representative gathering of Muslim leaders of all shades of political and religious opinion since independence.

It is being attended, among others by Maulana Taiyab, a divine of Deoband, Mr Mohammed Ismail, president of the All-India Muslim League, Mr M.R. Sterwani, MP, Mr Mazhar Imani, Mr Mustafa Fakhri, a former minister of composite Bombay, Mr. Ghulam Rasool Qureshi, Dr A.J. Faridi, Maulana Fakhruddin, and Maulana Atique-ur-Rehaman, president and working president of the Jamiat-ul-Ulema-e-Hind.

Dr Mahmud drew the attention of the convention to six aspects of the situation in the country vis-a-vis Muslims.

Firstly, Muslims should dismiss the idea that they were unwanted and persuade others to come closer to them.

Secondly, the need of the hour was unity among Muslims. This was a basic need without which neither individuals nor society could prosper. The convention should explore all possibilities of unity and integration. If it failed, it would stand convicted in history.

Thirdly, the communal disturbances had put Muslims in a peculiar state of confusion, helplessness, and despair and some were intent upon leaving their homeland. The convention should find ways and means of eliminating the possibility of such disturbances and restore the confidence of Muslims.

Fourthly, Muslims had been isolating themselves from the social and political currents of the country. This state of affairs was neither happy for the country nor for the Muslims.

Fifthly, it could not be denied that on religious and cultural levels, Muslims were exposed to a number of threats.

Finally, Muslims had been lagging behind in the field of education and commerce.

The convention, Dr Mahmud said, was meeting at a time when the Muslim minority was passing through a very critical period of history. The country had fixed its gaze on the convention and Muslims had nursed hopes in their hearts. The leaders should talk frankly on all issues. They should not misunderstand anyone. Before they dispersed they should take unanimous decisions.

The convention passed two condolence resolutions, one on the death of Mr Nehru, and the other on the martyrs killed during the disturbances.

The resolution on Mr Nehru referred to him as a great revolutionary who believed in secularism and democracy and who always rose above parochialism and narrow-mindedness.

By another resolution, the convention appealed to the Pakistani government to create conditions of security for the minority community in that country. It was a matter of anxiety that large numbers of Hindus had been driven out of their hearths and homes. The Pakistani government should create such conditions that they could return to their homes. The communal disturbances have put the Muslims in a peculiar state of confusion, an awful helplessness and an anxious despair and most of them, being disappointed, are intent upon leaving their homeland and a large number of people, it is rumoured, have already crossed the border. One of the stimuli which has greatly contributed to this meeting is to find out devices so as to obscure for good the possibilities of such disturbances, and, thus, restore the confidence of the Muslims.

It is also a fact that the Muslims have been isolating themselves from the social and political current of the country. It is quite obvious that this state of affairs is neither happy for the country nor for the Muslims themselves.

This cannot be denied that on religious and cultural levels we are exposed to a number of threats.

The Muslims have been lagging behind in the field of education and commerce. . . .

Another work which we have to do is to address our Hindu brethren through an appeal. There is no dearth of such Hindus who, caring little even for their life and completely disregarding the storm of oppositions, have called a spade a spade. We want to win their sympathies through our appeal to and contact with them. We shall try our utmost to approach a great number of such non-Muslims who have kept silence, and wish them to strengthen the cause of justice and fairplay, and request them to devote themselves to save the country from utter annihilation and ruin. We are sure that the forces of truth and justice can be mobilized as against those of tyranny and high-handedness. We should like that a deputation consisting of the elite should tour the country. It should, on the one

hand, establish contact with our non-Muslim brethren, and take note, on the other, of the educational, economic, moral, and religious bankruptcy of the Muslims in each state, and the deputationists are required to brace themselves to their uplift. Thus, after having surveyed the whole situation, besides other factors, we shall be able to chalk out an effective programme for the Muslims.

We also propose that a deputation on behalf of this conference should meet the president of the Indian Republic, the prime minister, the Union home minister, and the Congress president and have plain talks with them representing the Indian Muslims about the recent communal carnage. The problem of communal disturbances is also a national and an administrative problem and, hence, the government would be forced to focus their attention on it.

In order to implement our decisions and to push them onwards, I propose that a committee be formed which should consist of a sizeable number of the participants of this conference. If this unity could last even for a year, I am sure, God willing, divine benedictions would take you in their fold as the clouds gather in the sky to water and green the sterile and dreary tracts of land.

It is, no doubt, true, that you have fallen a prey to misunderstanding and hatred and it is also equally true that many of our countrymen have tried to gloss over these communal disturbances by calling them a reaction to what happened in Pakistan. This is an illegal, immoral, and inhuman logic. You are hurt by this strategy. It is also an irrefutable fact that those who were elected to democratic institutions of state assemblies and the Parliament through our votes—to whatever community they belong—did not seem to be the least moved by the unhappy and inhuman events that rocked the whole of northern India. Their silence has shocked you but I, taking these shortcomings as disease, request you to remedy them as a sympathetic physician.

Keep it in mind that all those persons who rose to fulfil a great mission, were made the targets of all these things. Where there is hatred and contempt, it is your duty to cure it with love. Only those have ultimately triumphed who gave out love for hatred and justice for cruelty. In the present India you have to use these moral weapons.

[1]*The Times of India*, 9 August 1964

5a. Some of the Resolutions Adopted at the Convention[1]

Recruit Muslims in CID and SPE

This meeting feels it as a great necessity that in the expansion made in the Central Reserve Police, Muslims should be employed in large numbers in order to enable them to play their part in establishing peace.

In the opinion of this meeting, adequate representation of Muslims in the Central, state, and local police, in the CID and the Special Police Establiahment will constitute a desired step towards prevention of disturbances, and this necessary demand should be met by the government at the earliest.

Resolution No. 8

Dereliction of Legislators

In connection with the recent disturbances of Bengal, Bihar, Orissa, and Madhya Pradesh, this representative meeting of Muslims of India most regretfully and painfully notes the fact that, with a few honourable exceptions, members of Parliament and state assemblies, who have been elected on secular basis, have failed to demonstrate the nobler traditions of speaking out the truth and condemning the oppressors.

On the other hand, if anyone had the courage of performing this duty, he had to face bitter criticism and taunts. The attitude of Muslim members in this respect is, in the opinion of this meeting, particularly disappointing and regrettable, as it was their bounden duty to make every effort to invite the attention of the government to the state of the oppressed Muslims. But here also, with the exception of a few, none had the courage to carry out this duty.

In the opinion of this meeting, this state of affairs is most regrettable and it appeals to all the members of Parliament and state legislatures to re-examine their attitude. This meeting particularly wants to make plain to Muslim members that it is their duty, to voice the problems and grievances of Muslims. The Muslim community can never forgive their avoidance of or indifference to this duty.

Resolution No. 9

Consultative Committee

This representative meeting of Muslims of India resolves to constitute a Muslim Consultative Committee for the purpose of implementing the resolutions passed at this meeting and to take suitable measures on emergent problems after mutual consultations.

This committee will consist of twenty-one members and Dr Syed Mahmud will be its president. The names of members and functions of the committee will be announced by Dr Syed Mahmud after consulting (1) Mufti Atiqur Rahman, (2) Maulana Asad Mian Madani, (3) Maulana Manzur Nomani, (4) Mr Mohammad Islam, (5) Maulana Abul Lais Nadvi, (6) Mulla Jan Mohammad, (7) Maulana Abul Hasan Ali Nadvi, (8) Mr Mohammad Muslim, and (9) Mr Ibrahim Sulaiman Sait.

This committee will be authorized to take all such decisions which it considers necessary for the purpose. The committee is authorized to constitute, as conditions require, deputations to tour different parts of the country and to make representation to the government in the light of the resolutions passed.

Resolution No. 10

All-Communities Convention

The one-sided general massacre of Muslims, which has recently taken place in various parts of the country, covering an area of hundreds of miles, has made it manifest that lawlessness in the country and aggression of mischievous elements of the majority community have reached the highest point and the fire of hatred against Muslims has flared up to the extent that, whether the Muslim population is eliminated from the country or not, the country will suffer irreparable loss.

But in this atmosphere of darkness and gloom, some such prominent leaders and personalities of the majority community have come forward whose hearts were deeply touched by these atrocities and aggressions and they boldly and fearlessly and regardless of the consequences called tyranny by its name and expressed their determination to end this aggression and communal canker and called upon the people to join them.

It is obvious that it is not possible for any single community of India to end this communal canker and aggression and the

cooperation and help of men with human sympathy and justice among the majority community is essential for it.

This meeting, therefore, strongly feels the need of such a convention in which leaders of different minority communities, and clear-headed, sympathetic members of the majority may participate. This meeting, therefore, approves of the proposal of the Jamiat-ul-Ulema-e-Hind to call such a convention.

Resolution No. 11
(Main Resolution at the Conference)

National Integration

This representative meeting of the Muslims of India painfully expresses its disappointment that our brother countrymen have failed to make this country a symbol of unity and national integration.

This meeting, therefore, reminds the Muslims that their main duty, in this respect, is not only to reform themselves, to shed their shortcomings and to seek remedies for their difficulties, but also to keep in mind that Islam has enjoined upon them to devote themselves to remove all blemishes of others as well as of themselves.

This meeting, therefore, requests the Muslims that they should consider it their own duty to solve this vital problem of the country and not to hesitate in staking their very lives to bring about caste and communal unity in the country and its peoples. Koran calls the Muslims as the servants of the people and, therefore, it is their duty to serve the citizens of this country irrespective of caste and creed. This meeting calls upon the executive body to devise ways and means and take immediate steps to achieve this laudable object. It was the duty of the majority community to win the goodwill of the minorities but unfortunately a considerable section of the majority community in this country mistrusts the Muslim minority for some fancied reasons. Therefore, it becomes all the more important for the Muslims to try their mighty best to remove the fancied grievances and mistrust even of that section of the majority so that our motherland may have internal peace and rapidly march towards progress.

[1]Pamphlet distributed by All-India Muslim Consultative Convention.

5b. All-India Muslim Majlis-e-Mushawarat formed[1]

The All-India Muslim Majlis-e-Mushawarat was formed during the All-India Muslim Consultative Convention held at Darul Uloom Nadwatul Ulema, Lucknow, during 8–9 August 1964. Extracts from the constitution of the Mushawarat:

Every organization has its own guiding principles, rules, and regulations. The Muslim Majlis-e-Mushawarat also forms its constitution to enable the Indian Muslims to work unitedly for promoting their religious, educational, linguistic, cultural, and economic interests, and ultimately furthering the cause of the country.

I. General

1. Name

The name of the organization shall be the All-India Muslim Majlis-e-Mushawarat, hereinafter to be referred to as the Majlis.

2. Headquarters

The headquarters of the Majlis shall be at Delhi or any other place as decided by the Working Committee of the Majlis.

3. Title

This Constitution shall be called the Constitution of the All-India Muslim Majlis-e-Mushawarat.

4. Commencement

This Constitution shall come into force as soon as it is published.

II. Aims and Objects

The aims and objects of the Majlis shall be as follows:

1. To bring about better understanding and promote unity amongst the various communities and sections inhabiting the country, especially Hindus, Muslims, Harijans, Christians, Sikhs, Parsees, Buddhists, Jains, etc.;
2. To organize meetings, seminars, symposiums in various parts of the country in order to promote communal harmony and goodwill;

3. To enlist the support of the members of all communities for the full implementation of the secular ideals of the Constitution of India, that is, the ideals of neutrality and nondiscrimination by the state on grounds of religion, caste, creed, and colour;
4. To endeavour and bring nearer to each other all the Muslim and non-Muslim organizations working for the uplift of the communities and the country;
5. To bring to the notice of the government and the people of India the grievances of the Muslims and others;
6. To ensure that Muslims as a community live up to the high ideals of Islam and do not let themselves drift from the mainstream of the social, cultural, economic, and political progress of the country but play their part in all activities ultimately leading to the country's advancement in the world and of humanity at large;
7. To adopt peaceful and legal measures in connection with the problems relating to the religious, educational, linguistic, cultural, and economic interests of the Muslims in particular and of others in general;
8. To organize units of the Majlis at the state level only for the achievements of the above objects; and
9. To take such other steps as may be necessary with a view to the implementation of the objects hereinbefore mentioned.

III. Membership

The Majlis shall consist of the members of the Central Working Committee and of the state units, and each member shall subscribe a sum of rupees ten per annum as membership fee.

IV. Organization of the Majlis

The Majlis shall consist of:
1. The president of the Majlis,
2. The Central Working Committee of the Majlis, and
3. The state units of the Majlis. . . .

[1]Extracts from pamphlet containing the constitution of the Muslim Majlis-e-Mushawarat.

5c. Muslim Alienation—Result of Increased Hindu Nationalism[1]

Leaders of the Indian Muslims have been meeting in Lucknow during 8–9 August 1964 to discuss the plight of their community, the 'manifold injustices and prejudices' from which they suffer, as one of them put it, and to seek ways by which Muslims can find a fuller and more contented part in Indian life.

As with the last such Muslim convention, which was held in Delhi just three years ago, this meeting is consequent upon outbreaks of murderous violence against Muslims. In 1961, it was the small outbreak in Jabalpur, Madhya Pradesh, which occasioned the Muslim convention. This year the massacres in Rourkela and Jamshedpur and the riots in Calcutta induced the community leaders to foregather again to express their 'confusion, helplessness, and despair'.

The situation of the Muslims in India has sensibly worsened in the past three years, and those in Lucknow this weekend may well feel their helplessness increase when they consider what little impression the complaints and hopes they registered three years ago have had. The chief cause of this deteriorating position of the Muslims is no doubt the strong swell of nationalism in India in recent years, which in north India has had its undercurrents of Hindu nationalism; but as deep a factor is the nature of the Muslim community itself, and this is well projected in the Lucknow meeting, where the elderly predominate and devouts take the leading role.

Standing apart

The Muslims number just over fifty million, a little over 10 per cent of the population, but, sizable as it is, this is not a true community but the rump of one. The great majority of the Muslim middle class became Pakistan citizens at partition, and those who stayed in India are predominantly rural people—many of these of the poorest—artisans or shopkeepers. Of those middle class Muslims who stayed, many are now in the senior ranks of administration and the professions. But these, in the name of secularism, have all too often stood apart from their community. One of the speakers in Lucknow spoke bitterly of the 'selfishness and opportunism' of those well-established Muslims who deny that injustice or discrimination is being felt by the community as a whole. The Indian Muslims, like the American Negroes, have their 'Uncle Toms'.

The attacks on Muslims in Bihar and Orissa during 1964 overshadowed the discussions in Lucknow and it was remarked that the government had not made any thorough inquiry into the riots nor had it been able to mete out any exemplary punishments of the killers. The Muslims had repeatedly been reminded, one speaker said, that their fate in India was dependent not on their behaviour, but on that of the people of a foreign country—in other words, that they would be made to pay in like coin for the sufferings of Hindus in East Pakistan. He might also have noticed the open threats made by Jan Singh speakers to 'reconsider the place of the Muslims in Indian life' if the Kashmiris insist upon self-determination.

But underlying all such sharp fears is the feeling among the Muslims that more and more their place in India is at the back of the queue, and that their turn at the front never comes. The backwardness of the community in education accounts undoubtedly for much of the Muslim under-representation in government services. Another factor has been pointed out by Mr B. Tyabji, vice-chancellor of Aligarh Muslim University. The strong caste consciousness of Indian society, he says, finds expression in commerce and industry too, and as the number of Muslim firms and enterprises have been few in proportion to their population Muslims have suffered proportionately more from this attitude of 'jobs for kith and kin first'.

British firms cited

It is distressing to find the conviction among well-placed Indian Muslims that British firms here are among the worst in their reluctance to give employment to Muslims. Inquiry suggests that this impression may have its origin in a minute circulated not long after partition by the late Mr Patel, the minister for home affairs, advising British firms to send Muslim applicants to their Pakistan branches; but with force and some evidence some Muslims here maintain that that policy is still applied by British houses.

For the outsider the most disturbing change has been that in the public attitude to Muslims and to secularism. The government, under Mr Shastri's leadership as under Mr Nehru's stands still adamantly for secularism and the equal rights of all citizens. But there has been a change in the public philosophy on this score, subtle but unmistakable, and it will need strong leadership and

bold talking if this sneaking attitude that a Muslim is not fully an Indian—it has McCarthyite expressions—is to be stamped out.

[1]*The Times*, London, 10 August 1964.

6. Muslim Grievances[1]

It is both strange and sad that even after the country has lived nearly twenty years under a secular Constitution, the issue of Muslim grievances is real and substantial enough for most political parties to have to reckon with in their electoral calculations. This in itself offers perhaps the most telling testimony that secularism has not been the resounding success it is often assumed to be. Apart from historical reasons, many—and sometime quite unconnected—factors are responsible for the community's isolation from the national mainstream. It would be evading the truth to pretend that the majority community has shed its communal complex sufficiently to make possible the minority's integration in national life. Discrimination against the Muslims still manifests itself in an insidious rather than overt form and colours many an informal decision at the level of day-to-day living. Nowhere is this tendency more perceptible than in the area of private or public employment, being more pronounced in recruitment to the humbler jobs. While this is a fairly important factor, it would be a simplification to say that communal discrimination practised against them is all that is to the Muslims' peculiar sense of grievance. For, their feeling of isolation has no doubt also been more than somewhat heightened by the ruling party's special effort to woo the Muslim vote.

Whatever the causes, the fact that the Muslims have certain justifiable grievances cannot easily be denied. These stem principally from two sources—the neglect of Urdu which is traditionally regarded as their 'cultural' language, and the inherent inequality of opportunity from which the members of the community suffer because of its 'backwardness'. The complaint about Urdu is entirely justified, although not necessarily because the Muslim community has chosen to make the cause its own. More than even the cultural language of the Muslim minority, Urdu is a language with its origins exclusively rooted in India. It is, moreover, the mother tongue of both the Hindus and the Muslims living in certain regions of the country. The lack of opportunity from which the language in these

areas suffers is a problem which needs urgently to be attended to, if the country is not to forgo its claim to a rich heritage of which it is the natural heir. The Muslim community's complaint about the discrimination it suffers from in the matter of unemployment and educational opportunities, while no doubt justified, is something for which no clear-cut remedy is available today. The community must pull itself up by its bootstraps, instead of putting forward the retrograde and ignoble argument that the government should provide feather-bedding reservations for its members on a communal basis. Mr Fakhruddin Ahmed did well recently to draw the Muslim community's attention to these basic truths. He was right also in maintaining that it remains the government's duty actively to promote conditions in the land where the underprivileged of all communities, and not of the Muslim alone, will receive a square deal.

[1]Editorial in *The Hindustan Times*, 11 February 1967.

7. Muslim Majlis Born as a New Political Party, Supports Candidates in UP State Assembly Election[1]

A meeting of the Working Committee of the UP Muslim Majlis was held at its state office in Lucknow on 3 June 1968. This meeting was followed by the meeting of the Council of the Muslim Majlis. Dr Abdul Jaleel Faridi, the Majlis chief presided.

In the meetting of the Council it was unanimously resolved that the decision taken by the Working Committee of Muslim Majlis-e-Mushawarat, UP, in its meetings held here regarding the formation of a political party with the name Muslim Majlis, is hereby confirmed. The Council (general body) also adopted the Constitution of the Muslim Majlis.

Policy statement

It was further unanimously resolved that all the branches, office bearers, and members of the UP Muslim Majlis-e-Mushawarat would be deemed to be the branches, office bearers, and members of the Muslim Majlis respectively.

And, the members of Muslim Majlis-e-Mushawarat, UP, are at liberty to inform the office of the Majlis, within fifteen days, in case

any of them was not willing to continue as the member of the Majlis.

A subcommittee of eight members was constituted to draft the policy statement of the Majlis and to finalize the design of Majlis flag.

In view of the forthcoming mid-term election, a Parliamentary Board was also constituted consisting of eleven members to deal with the forthcoming elections. The meeting came to a close with a vote of thanks and with the blessings and prayers by Maulana Ali Mian Saheb.

The Muslims, the Scheduled Castes, and other people belonging to backward classes have been passing through difficult times since independence. The Constitution guaranteed the preservation of their language, religion, and culture but these guarantees were cast to the winds, particularly in Uttar Pradesh. Urdu, which was not only the language of Muslims, but also of the majority community residing in the state was throttled; lessons taught in schools were against the basic tenets of Islam and a culture of a section of people was imposed on the inhabitanis in the name of Indian culture. There was also a wave of planned disturbances of which the victims were always Muslims. All this happened with Congress government in office. Protests invariably fell on deaf ears.

People's manifesto

The General Election of 1967 drew near, and the Majlis-e-Mushawarat decided to take its case before the electorate. It did not set up any candidate of its own but issued a nine-point People's Manifesto and decided to support candidates belonging to all progressive parties, irrespective of caste, creed, or religion who generally agreed with the manifesto. A number of candidates belonging to various parties, supported by the Majlis-e-Mushawarat, were accordingly returned to the legislature.

But once the candidates were elected, they forgot all the promises which they had made in order to gain the support of the Majlis-e-Mushawarat and under the SVD government which they joined, the interests of the minorities remained just as unprotected as they were under Congress regime.

Further, the last General Election had one good lesson to teach, and it was that the Muslims were not a mere vestigial entity but could substantially influence the results of the elections.

Apart from the inroads made into the religious, cultural, and economic well-being of the Muslims and other minorities, the country was faced with other grave problems. The challenge of reactionary forces which were raising their head in the shape of majority communalism, linguism, regionalism, etc., had to be met. The backward classes were, just like the Muslims, subjected to discrimination in all walks of life. Their cause had to be seriously taken up and pressed. Experience of the various political parties in the past had shown that they could not satisfactorily deal with these problems merely by attaching themselves to their apron strings. They, therefore, re-concluded that the time had come when they should form a new political party. This party was formed under the name of the Muslim Majlis at a meeting of the Working Committee of the State Muslim Majlis-e-Mushawarat held at Lucknow on 3 June 1968 and endorsed by the Council of Muslim Majlis-e-Mushawarat on 21 July 1968. The formation of Muslim Majlis was thus the culmination of a long historical process extending over two decades. Its membership was open to all Indian nationals irrespective of religion, caste, or creed who paid 50 paise yearly as membership fee and agreed with its aims and objects which were declared as follows:

(1) To maintain the independence, integrity, and honour of India;

(2) To strive for and maintain the religious, economic, social, political, linguistic, and other rights of Muslims and other minorities and backward classes of UP;

(3) To inculcate a feeling of brotherhood among the various communities residing in UP and to remove hate and narrow-mindedness;

(4) To develop self-confidence, unity, and tolerance amongst the Muslims;

(5) To do away with the curse of untouchability in the country;

(6) To strive for the establishment and maintenance of a secular democratic, and welfare state;

(7) To get Urdu recognized as the second official language in UP and to work for its advancement;

(8) To improve the economic condition of the Muslims and other minorities through constructive means;

(9) To cooperate with the Central Muslim Majlis-e-Mushawarat in the matter relating to the well-being of Muslims and other minorities and to implement its programmes;

(10) To develop contact with the backward classes and solve their difficulties; and

(11) To solve the difficulties of cultivators, artisans, and the working class.

[1]*Siraat News-weekly*, Lucknow, 26 July 1968.

8. All-India Muslim Political Consultative Committee formed[1]

The All-India Muslim Political Convention, convened by the Muslim Majlis, decided on 19 December 1970 to set up an all-India Muslim political consultative committee—a federation of Muslim political organizations formed in the country during the previous four years.

The convention, according to the organizers, was attended by 311 delegates from various states. Former chief minister Bakshi Ghulam Mohamed of Jammu and Kashmir was also present.

The resolution, setting up the federation, was passed in the teeth of opposition from a group of Muslim young men, headed by Mr Shamim Ahmad Shamim, of Kashmir.

They argued if the existing political organizations did not meet the requirement, a new organization might be started but its doors should be kept open to all communities.

But despite this, the resolution was passed by 306 votes to five.

The organizers of the convention had invited all political parties to participate in the discussion. But no party, including the Muslim League, responded.

Congress (O) member of Parliament, Abdul Ghani Dar, who attended the convention, caused a furore by criticizing Jawaharlal Nehru. Protests against his speech from among the participants were so loud that ultimately he had to apologize.

The resolution authorized the convention president, Badruddin Tyabji, to nominate an ad hoc committee to draft a constitution of the organization and present it at the next convention to be held in Hyderabad in March 1971.

Forum

The resolution said inter alia that 'experience of the past twenty years had shown that by and large the existing political parties in the country, be they the rightists or the leftists, have not only failed

to help Muslims in solving their problems, but have accentuated them. Forced by these circumstances, Muslims in various states have formed political parties called by different names, but basically with similar aims and objects'.

This organization, according to the resolution, would provide 'an authentic and authoritative forum, where political and other issues concerning the Muslim community, other minorities, and weaker sections of the Indian people could be discussed'.

The resolution also said that the federation would maintain a liaison between the parties which agreed to join it.

Another resolution, adopted unanimously, invited 'all like-minded persons, to whichever community they may belong, to join it in this national endeavour' of removing the difficulties of minorities and other weaker sections of the people.

It said the convention was well aware that progress and welfare of the Muslim community and preservation of its identity, as a distinctive and enriching element in the Indian society and civilization and polity, can only be assured and justified by the Muslims' cooperation with other communities, specially those which suffer from difficulties similar to their own and in helping them obtain their rightful place in the great family of India.

Erosion

Earlier, Mr Badruddin Tyabji in his presidential address pleaded for the formation of an organization 'to provide an authentic and authoritative forum where Muslim opinion on issues exclusively or particularly concerning the Muslim community can be freely expressed'.

Justifying the formation of the new organization, he said that the organization which sought to work for a solution of particular problems that affected a particular community only or affected them more than other communities could not be stigmatized as communal.

He said the formation of such an organization of Muslims had become all the more necessary because the 'political history of post-independence India has made it abundantly clear that without such an effort, minorities will be unable to secure or even preserve, their legitimate rights. Without it, their place in the society, their individuality, their distinctive culture, even their identity as Indian citizens, will be constantly threatened and its importance eroded'.

He said that after the partition and migration of Muslim League leaders to Pakistan, the Muslims were left without leadership. Those

Muslim leaders who joined other political parties failed to express the grievances of Muslims 'or even to put the Muslim point of view effectively in party meetings let alone Parliament'.

Referring to the grievances of Muslims, Mr Tyabji complained about suppression of Urdu language, falsification of history, and 'dreadful communal riots which are fitfully raging with baleful intensity in several parts of the country'.

He also wanted that the 'Indo-Islamic character' of Aligarh Muslim University should be maintained.

Probe body

Mr Tyabji demanded the setting up of a commission of inquiry to look into the educational and social affairs of Indian Muslims on the lines of the commission of inquiry set up under the presidentship of former Chief Justice of India, Dr P. B. Gajendragadkar, to examine the position, in particular, of the Hindu minority and backward classes in Jammu and Kashmir.

The Muslim community, he said, had fallen into the category of a backward community as a result of partition. 'This should under our Constitution, entitle them to receive special treatment to enable them to come up to the general level. This is, however, totally ignored when anything positive has to be done about it, but is frequently used as a gibe to malign the community.'

He said, 'No one who has lived for years in India and has seen the way in which the Muslim community (which despite partition still remains the second largest community in India) has been treated, or if you prefer, allowed itself to be treated, pushed around from pillar to post carrying a beggar's bowl, pleading for its most basic rights in vain, will be surprised that it is now organizing itself to enable it to make its voice heard in the corridors of power through representatives chosen by itself.'

[1]*The Patriot*, 20 December 1970.

8a. Badruddin Tyabji Emphasizes the Need for a Political Forum for Muslims and Other Backward and Minority Communities[1]

Why should persons or an organization that seek to work for the solution of particular problems that affect a particular

community only (e.g. lack of Muslim representation in the services, in technical institutions, etc.), or affect them more than they do other communities or persons (e.g. the teaching of Urdu), be considered as engaging in anti-national activities, or be stigmatized communal in the Indian pejorative political sense? . . .

I for one, am far from holding that Muslims who belong to non-Muslim parties are less Muslim for that reason, or have legitimate Muslim rights less at heart. But I do begin to doubt whether there are any Muslim leaders left in non-Muslim parties who are now in a position to do anything substantial in the way of redressing the principal Muslim grievances, or even in putting the Muslim point of view effectively across in their party meetings, let alone Parliament. . . .

This is the lacuna that we have to fill by setting up an organization to provide an authentic and authoritative forum where Muslim opinion on issues exclusively or particularly concerning the Muslim community (or other backward or minority communities that choose to join hands with us) can be freely expressed, freely consulted, and freely formulated. The lack of such a forum has been grievously felt during all these post-independence and alas, post-partition years.

We have to remedy this. I am sure that by setting up such a forum we shall also strengthen the hands and loosen the tongues of those who are not here because they are afraid of their party leaders and bosses. To some extent, it will certainly embolden them to utter their private thoughts on Muslim problems in public, and at their party meetings more openly than they do now, if only to justify themselves as representatives of Muslim opinion before their non-Muslim judges. One of the objects of our organization must be to bring the full weight of Muslim opinion to bear on such persons wherever they are. They should be given no excuse either for deceiving themselves, or what is much worse, their non-Muslim party colleagues, on specific issues that vitally affect the community.

In my opinion, Gentlemen, it is a puerile controversy to dub this party 'national' and that 'communal'. Parties cannot be judged by their labels, not even by their religious or caste composition, barely by their professed programmes, but essentially only by their practice. What is their outlook towards other parties, other communities, and the welfare of the nation as a whole? Essentially, they must be judged by their actions. Are they sectarian in their outlook, in the sense of endeavouring to do down any other

community, region, or area? Are they spreading hatred or contempt against the followers of any religion, language, or region? Are they seeking rights or powers disproportionate to their numerical strength in the country? Are they trying in any way to impose their language, way of life, or ideology on others by unconstitutional means? If the answer to any of these questions is in the affirmative, that party, organization, or group is a communal one, and should be branded as such. And I should personally like all constitutional means employed to suppress their activities because such activity on their part undoubtedly harms the nation. . . .

No one who has lived through the post-independence years in India and has seen the way in which the Muslim community (which despite partition still remains the second largest community in India) has been treated (or if you prefer it, allowed itself to be treated) and pushed around from pillar to post carrying a beggar's bowl, pleading for its most basic rights in vain will be surprised that it is now organizing itself to enable it to make its voice heard in the corridors of power through representatives chosen by itself. No self-respecting community in a nation, least of all a community of the size of the Muslim community in India, with such glorious antecedents in administration, architecture, literature, music, etc., can be ignored, slighted, and trodden under, as it has been for the past twenty years, without the most serious repercussions on the life of the nation as a whole. Even a worm will turn, but the Muslims will be well advised to turn before they become worms. For that they must make themselves self-reliant, politically and economically. Their country needs their contribution to its civilization, their sinews to its strength and its prosperity, as much as they need the fruits and flowers and the beneficent air of their motherland to grow to their full stature.

This convention seems to me a natural outgrowth of the All India Muslim Majlis-e-Mushawarat, that came into being, you will recall, in 1964 in direct response to the dreadful communal riots that broke out then, and which have ever since been fitfully raging with baleful intensity in several parts of the country.

In spite of a truly national party under the supreme command of the greatest Indian nationalist of his time, Pandit Jawaharlal Nehru, coming to power after independence and staying there in undisputed control over the whole of India, without a break or even a jolt for the next twenty years, the internal problems of the country—regional, communal, linguistic, educational, and others—

have to a large extent remained unsolved. This was because the dominant governing group within that national party has refused to implement what it has never been tired of professing. It has reiterated ad nauseum its desire to share in an equal way its powers and responsibilities, with all sections of the people, whom it has claimed to represent; but its actions have equally consistently belied its words. . . .

There is no concrete evidence to show that what Panditji wanted to be done about Urdu, or to make the national language Hindi, representative of what was most widely spoken and understood in the country at large (in the sense that Hindustani was and is), had any effect whatsoever on the members of his party who were in power, and in direct charge of these matters, either at the Centre or in the states. There were also Muslim ministers in the government at the time (even as they are now)—Maulana Abul Kalam Azad, the greatest Urdu scholar of his age was in fact education minister—but the Muslim public has yet to discover what they were able to do to protect the community's just rights. In the matter of their language, their culture, and their traditions, leave alone in securing for them fair opportunities of employment— even as foot soldiers, clerks, and policemen if not as officers—in the administration and the economic life of the country, to which they are entitled on a proportionate basis on the same grounds as are other segments of the population, the Muslim case went by default in spite of them— one is almost inclined to say, because of them. The fact is that the Muslims, as a result of partition, have fallen into the category of a backward community. This should under our Constitution entitle them to receive special treatment to enable them to come up to the general level. This is, however, totally ignored when anything positive has to be done about it, but is frequently used as a gibe to malign the community.

Why did Pandit Nehru not do anything about it, and why did his Muslim party colleagues and those in the Cabinet in particular, not put pressure on him to do it? I have no doubt that Panditji's intentions towards the Muslims were honourable, and his anguish at Hindi fanaticism genuine. He even spoke to me more than once about it; but the political forces ranged against him were too strong. And above all, he seems to have been misled, both by his non-Muslim party bosses, and his Muslim colleagues, about the strength and power of Muslim feelings in these matters. Had there then been a Muslim forum of the type that we are now thinking of

setting up, where matters of particular concern to Muslims could have been discussed, and the course of action to be taken in regard to them chalked out, and if necessary directly reflected at the polls, and so in Parliament and the legislatures, things would have been very different. . . .

Personally, I should have liked the Majlis-e-Mushawarat itself to have convened it in order to review its own work, and in the light of the circumstances of today, to decide whether it was not necessary for it now to extend its activities into the political field from which it has so far voluntarily, but explicitly, refrained from entering. I know that there is a difference of opinion among some of its constituent members over this issue. Personally, I do not think that this should present an insuperable difficulty. There seem to me to be no reasons why the Majlis-e-Mushawarat should not be able to keep its original character intact in order to cater for those of its constituent members who do not wish to participate in any political discussions or to take a hand in their solution, while setting up a political wing which would deal with those aspects. Its political wing could be an autonomous body with its own separate membership but affiliated to itself. The political wing would have its own chairman; and liaison between the two wings could be maintained by their having a common president. He would be the president of the Mushawarat as a whole (including its political wing) but would delegate his powers as far as possible to the chairman of the political wing for dealing with political affairs. He would keep himself in close touch with its work, however, by attending such of its meetings as he desires in his capacity as an ex officio member of all its committees, etc. All members of the Mushawarat's political wing would ipso facto be members of the Mushawarat as a whole, but all members of the original Mushawarat need not be members of its political wing.

There should also be provision made for individuals, qua individuals, to become members of the political wing. I have in mind persons who see the necessity of the Muslims of India having a forum at which their particular problems as a community in India could be discussed, and ways and means sought for resolving them. Such persons may belong to any community, party or organization, whether it was a non-Muslim or a Muslim organization, an all-India one, or a state, regional, or area one, or to none. All that we should be concerned about would be an assurance of the desire of the person concerned to do what he could to help in the solution

of problems particularly concerning Muslims and backward elements of the population. In suggesting this form of membership, I have in mind the constitution of the recently formed Insani Biradari organization.

We should work out ways and means by which we should be able to cooperate with all other bodies and persons who are engaged in advancing the legitimate rights of backward classes and underprivileged people. We should always bear in mind that the Muslim problem is not an isolated one, and that we can only advance if the nation of which we are an integral part advances; that while we have to catch up with those who have marched ahead of us, we have also to take along with us those of our countrymen who have fallen behind. . . .

To me, it seems evident that whatever organization is set up, it can function only as a consultative body with its members reflecting as wide a spectrum of Muslim opinion as possible; and that ordinarily it will deal only with the kind of problems that affect Muslims in particular and the backward classes in general, and on which it is desirable that they should present a united front. The decisions of this body can only be advisory, arrived at by consensus. All its members should be entitled to accept them or dissent from them. Its main function should be to serve as a forum or clearing house, if you like, of enlightened Muslim opinion of all shades and from all quarters, on current problems particularly affecting Muslims. The exact form of the organization, its wherewithals, staff, etc., will have to be worked out by an expert committee which I suggest you should set up for the purpose.

[1]Extracts from the presidential address at the All-India Muslim Political Convention in New Delhi on 19 December 1970.

9. Muslims Urged to Study English for Progress[1]

Mr Basheer Ahmed Sayeed, retired judge of the Madras High Court, called on the Muslims to learn English. There was a danger of the Muslim minority becoming still more backward without learning English, Mr Basheer Ahmed said, presiding over the Indian Muslim Educational Conference at Madras on 26 December 1970. Nearly a thousand delegates attended the conference held at the Farook College.



said that it was still not too late to make an attempt at establishing south Indian culture in all spheres of life and added that the administration would be efficient and easier if the country was divided into five zones.

Mr K.A. Jaleel, Principal of the Farook College and chairman, reception committee welcomed the delegates.

The conference, he said, was an attempt to unite every one for the purpose of constructive action in social and educational matters.

Inaugurating the conference, Syed Abdul Wahab Bukhari of Madras congratulated the Muslim Educational Society on the good work it was doing for improving the economic conditions of the Muslims in Kerala.

[1]*The Hindustan Times*, 27–28 December 1970.

10. All-India Muslim Personal Law Convention Condemns Attempt to Change Muslim Personal Law[1]

There is no need at all to change the personal law given by Shariat, Dr Y. Najmuddin, rector, Al Jamea-tus-Saifiyah (Arabic Academy) of Surat, said in Bombay on Wednesday, 27 December.

'Our personal law given by Shariat is worthy of emulation,' he added.

Dr Najmuddin made the statement in his opening address to the two-day All-India Muslim Personal Law Convention.

The convention was not open to the press. An English translation of his Urdu speech was made available to reporters.

To the question 'What is Muslim personal law?' he replied that the word personal connoted a Western concept, of Europe of the industrial age, publicized in the fifteenth and the sixteenth centuries by the Christian movement for freeing the individual from his religious bonds.

Not purely personal

The Din (as Islam was described by the Prophet) was not purely a personal affair but a matter of social action. The phrase Muslim personal law itself indicated that the Muslims had their own religious laws. The law was not made for one individual but for

the whole society. A thorough study of the law would show that there was no 'social action' for which guidance had not been provided by Shariat.

He stated that in spite of inconsequential differences and different interpretations given by different lances, countries, and groups, there was a common understanding of the concept of Shariat. If some people now sought a change in the Muslim personal law, it was worth ascertaining whether they had studied in depth 'the interior and exterior of Shariat, its form and meaning, the Arabic language and literature, and understood the essence of Islamic spirit.'

Hollowness of claim

It would be found, he said, that those who sought the change in the personal law 'are persons who have learnt by rote the Christian translation.' They had not studied the original text, nor cared for them.

If the hollowness of the claim of those seeking the change was exposed, the convention would have achieved its goal, Dr Najmuddin said.

He told the gathering that the concept of change and reform had today become a source of discussion and dissension between the two major modern systems, Russia and China. 'We, people of Shariat, have passed through the stage long ago. We say that precept and practice go together,' he said.

[1]*The Times of India*, 28 December 1972.

10a. Muslims Oppose Change in Personal Law[1]

A representative conference of the Indian Muslims which concluded at Bombay on 28 December 1972 has made it clear that any attempt by the Union government to amend their personal law will be taken by the community as an attack on Islam and that the Muslims will not hesitate to offer any sacrifice to prevent this greatest catastrophe.

'We have lost everything—the government, our honour, property, and the Urdu language—and if attempts are made to take away from us our religion and the personal law given by God himself, we shall be left with nothing to fall back upon.' This was

stated by several speakers who participated in the three-hour debate on the resolution which expressed the Indian Muslims' deep concern over the attempts to amend their law.

The resolution, moved by Maulana Mohammed Minnutullah Rahmani, Ameer-e-Shariat, Bihar, said the Indian Muslims were not bound by any amendments carried out in the personal law in India before independence or in other countries.

As a religious minority, the Muslims have full right to defend their way of living and Article 25 of the Constitution also guarantees this. There should, therefore, be no uniform civil code or any amendment in the Muslim personal law.

Uniform civil code

The resolution also made it clear that Article 44 of the Constitution calling for a uniform civil code could not be applied to the Muslim personal law and that the Muslims refuse to accept any move to change it by Parliament or any other law-making body.

Presided over by Maulana Qari Mohammed Tayyeb of the Dar-ul-Uloom, Deoband, the conference was inaugurated by the rector of the Arabic Academy, Dr Yusuf Najmuddin.

Among those who attended the conference were the representatives of the Muslim Majlis, Lucknow, Jamat-e-Tabigh, Delhi, Jamiat-e-Ulema-e-Hind, Jamat-e-Islami, Ittehad-ul-Muslimeen, Hyderabad, the Islamic Research Institute, Lucknow, Sulemani Bohra Community, and the Sunni Jamat. Besides, people from the Aligarh Muslim University, and some Congressmen including Mr Mustafa Faki were also present.

Maulana Tayyeb said it was very unfortunate that a particular section in the country was trying to create an impression that the Islamic law is outdated and cruel, and was preparing the ground for enforcement of un-Islamic laws in the form of a common civil code.

Mr Ibrahim Suleman Sait, general secretary of the Muslim League, saw in the move to amend the Muslim personal law a conspiracy to end the very existence of the Muslims. 'The eighty million Muslims will not tolerate this and if it comes, it will be on our bodies,' he said.

Mr Justice Khalid Ahmed said while others were getting an opportunity to progress, it was not the case with the Muslims.

Mr K. Abid of Shia Conference said Article 44 of the Constitution was subordinate to Article 25. 'Why do you bother if we want to

carry on with a bad law? It will not affect the majority community and the majority rule.'

[1]*The Hindustan Times*, 29 December 1972.

10b. Resolutions Adopted in the All-India Muslim Personal Law Convention Held at Bombay During 27–28 December 1972[1]

Resolution No. 1

The Muslims of India are greatly perturbed over the attempts being made through various legislative assemblies and enactment to abrogate their personal law and to prepare grounds for introducing a uniform civil code. This representative gathering of the Muslims of India, held in Bombay on 27 and 28 December 1972, which represents all the schools of thought and shades of opinion and all religious, political, social, and cultural institutions, organization and societies, unanimously and categorically, expresses its settled belief that the injunctions of the Islamic Shariat are not wanting in any addition nor do contain anything undesirable requiring to be removed.

(i) This convention also expresses its belief that the Muslim personal law is a part of their religion and it is not proper for a Muslim to disregard the injunctions of Shariat; nor can he accept any decision which prohibits what is lawful in Islam and sanctions what is unlawful. This convention also expresses its firm resolve that Parliament or state legislative assemblies have no right to amend or abrogate Islamic Shariat and that it is only the recognized and trusted Ulema of respective Islamic sects and schools of thought who can decide finally which laws are or are not in accordance with or related to the Islamic Shariat.

(ii) This convention expresses its resentment at the reprehensible attempt being made by certain persons, who are preparing ground for interference in the Islamic Shariat under the guise of reforming the Muslim personal law.

(iii) If during the days of our slavery, certain amendments were effected in the religious laws, or if some changes are effected

in the Muslim personal law in Muslim countries, these instances cannot constitute justification for amendment or abrogation of the Shariat laws.

(iv) This convention also believes that retention of personal law of a community is necessary for the preservation of the identity of a people and ensure its distinctive entity and cultural characteristics, and no Muslim can give up his religious individuality and distinctiveness and his cultural characteristics at any cost.

(v) It is an acknowledged principle of the civilized world that every religious and cultural unit has a complete right to protect and preserve its own religion and culture. Further, if an attempt is made to destroy the religious and cultural identity of that people, it is considered equivalent to genocide. Therefore, the architects of free India, who have given full guarantee as to fundamental rights in the Constitution, believed that the Indian people would not let any attempt succeed calculated to destroy the spirit of the Constitution or to deprive a community of its constitutional rights.

In the light of the above facts, this convention declares that:

(a) Any attempt to abrogate the Muslim personal law, which is an integral part of their religion, and to replace it by a uniform civil code or effect changes in the Muslim personal law through direct legislation or to make it ineffective by parallel legislation is a negation of the international Charter of Human Rights, is equivalent to cultural genocide and is in contravention of the fundamental rights enshrined in the Constitution of India. Any such step would amount to compelling the Muslims to go against the Holy Koran and the Sunnat, which is absolutely intolerable for any Muslim under any condition.

(b) This convention also believes that Article 44 of the Constitution pertaining to directive principles of state policy is subservient to the article guaranteeing the fundamental rights and hence Muslim personal law is outside the purview of Article 44.

(c) This convention declares all the bills before the Parliament or the state legislative assemblies calculated to indirectly affect the Muslim personal law as unacceptable to Muslims.

(d) This convention also feels the need to educate Muslims in religious teachings, concerning the family life and social

life, so that they may be obeying these injunctions and be able to build up the society on virtuous foundation.

Resolution No. 2

This gathering considers the Adoption of Children Bill, 1972, and the Public Trust Bill in their present form as an interference in the Shariat laws and demands that Muslims be exempted from their application.

Resolution No. 3

The All-India Muslim Personal Law Convention resolves to constitute an All-India Muslim Personal Law Board consisting of Muslim scholars, experts, jurists, and other eminent persons of the *Millat*, belonging to various sects and schools of thought in order to implement the decisions of the convention. The Board will see to it that such representative character is retained in its subcommittees also.

(a) The said All-India Muslim Personal Law Board shall be responsible for taking all steps necessary and organize struggle for the retention and preservation of the Shariat laws.

(b) This Board shall also be responsible to constitute a permanent committee which shall scrutinize the existing enactments and also the different bills introduced in Parliament or state legislatures from time to time and circulars of Central and state governments with a view to finding out their effect on the Muslim personal law.

(c) This Board shall prepare a comprehensive plan for the propagation and implementation of Islamic family laws. It shall also have power to form an Action Committee if needed, to organize a movement for the protection of the Muslim personal law and further implementation of the decisions of the Board.

[1]*Muslim India*, February 1983.

10c. All-India Muslim Personal Law Board : A Backgrounder[1]

The All-India Muslim Personal Law Board is a representative body of the Indian Muslims belonging to different schools of thought and organizations.

One can trace back its origin to a meeting held in the middle of 1972 at Deoband under the presidentship of late Qari Mohammed Tayyab. It was followed by a grand All-India Convention of the Indian Muslims at Bombay during 27–28 December 1972. There the All-India Muslim Personal Law Board (AIMPLB) was formally established.

So far ten all-India sessions of the AIMPLB have been held in different parts of the country: (1) Hyderabad (7–8 April 1973), (2) Ranchi (1975), (3) Bangalore (1977), (4) Pune, (5) Hyderabad, (6) Bombay, (7) Madras, (8) Kanpur, (9) Calcutta, and 10) New Delhi (23–24 November 1991).

It was at its first session when its executive body and office bearers were elected and its Constitution was finalized. Qari Mohammed Tayyab and Maulana Syed Minnatullah Rahmani became its first president and general secretary respectively. After the death of Qari Tayyab, Mufti Ateequr Rahman Usmani, the then president, All-India Muslim Majlis-e-Mushawarat, officiated as the acting president of the AIMPLB. Finally, Maulana Syed Abul Hassan Ali Nadvi was elected its president. Maulana Minnatuallah Rahmani, who died in 1991, was succeeded by Maulana Syed Nizamuddin, Nazim, Imaarat Shariah, Bihar and Orissa.

The All-India Muslim Personal Law Board has its two-point aims and objects: (1) to adopt effective methodology for the protection of the Muslim personal law in India and to confront every effort that is being made directly, indirectly, or through legislation to interfere in the Shariat and (2) to apprise the Muslims of the Shariat injuctions and their rights and duties; to struggle for the application of the personal law; to manage for the research-oriented study of the Islamic *Fiqah* and to strive for the solution to the new problems under the light of Koran and Sunnah, while sticking to the principles of the Islamic Shariat.

The Board's achievements include:

The withdrawal of the Child Adoption Bill, 1972, by the Janata Party government on 19 July 1978; exemption of Muslims from the purview of the Adoption Bill, again presented in the Parliament during Mrs Gandhi's regime on 16 December 1980; declaration of *nasbandi* (sterilization) as *haram* (prohibited) at its extraordinary meeting held during 17–18 April 1976 at Delhi at a time when a number of its leaders, including Maulana Abul Lais Islahi–Nadvi, Maulana Mohammad Yusuf, Maulana Afzal Hussain, and Maulana Mohammed Muslim were behind bars during the Emergency (1975–77); restoration of two mosques and a graveyard at Lucknow

and a mosque at Jaipur, acquired by the municipal corporations as per the decision of the Lucknow Bench of the Allahabad High Court in October 1978, regarding mosques and graveyards; a few amendments in Section 127 of the new Cr PC regarding divorce; enactment of the Muslim Women Act, on 6 May 1986, repealing the Supreme Court judgment in the Shah Bano case; keeping Muslim Awkaf out of the purview of Income Tax in 1980, and stopping amendments in Waqf Law in 1988.

The AIMPLB has had been consistently struggling for the exemption of Muslims from the purview of the common civil code or repeal it through amendment in the Constitution of the country. It also played a key role when an Ordinance to acquire the land in Ayodhya was promulgated by the president of India during the V.P. Singh regime and forced it to withdraw. It has, time and again, spoken against the proposal for compulsory Nikah Registration Act, in some states, particularly West Bengal.

The AIMPLB also pays attention towards reforms in the Muslim society. It has also planned reorganization of the Islamic laws under the light of Koran and Sunnah.

The AIMPLB has taken a clear and decisive stand on the Babri Masjid issue. At an emergency meeting of the executive body of the AIMPLB in November 1990, it decided that 'Babri Masjid is a mosque and it is neither situated on an acquired land, nor built after demolishing any temple. Therefore, it would remain a mosque and it can neither be transferred, nor sold, nor demolished.' It reiterated its stand on the issue at its tenth all-India session held in New Delhi last year.

However, the most remarkable contribution of the AIMPLB has been the mobilization of general opinion in favour of the Muslim personal law. The AIMPLB has 100 founder members and forty-nine term members, beside a forty-one-member executive body.

[1]*Radiance*, 5 April 1992.

11. A Word to Indian Muslims by Sheikh Mohammed Abdullah[1]

A person who does not fashion his utterances according to the dictates of expediency but chooses to base them on values and principles must always be resigned to being misunderstood and

misrepresented; misunderstood because of his candour and misrepresented by those whose schemes his very candour endangers. Neither has deterred me in the past or upsets me now even if, as it seems, the ranks of unfair critics have acquired some new recruits.

However, these few words are addressed to Indian Muslims not so much in reply to some recent statements in the press but mainly because they were long overdue. Let me at the very outset remind my readers that there was little I said recently at the meeting of the Majlis-e-Mushawarat at Baroda which had not been said before. After my release from internment in January 1968, I had occasion to address many a gathering of Indian Muslims and express my deeply felt thoughts. The problem of Kashmir preoccupied me but never for a moment did I neglect the problems of Indian Muslims.

The Muslims of India today are face to face with a situation more or less identical with the one they had to encounter after the 1857 war of independence. The victorious British suspected them of having been mainly responsible for the 'revolt' and in the flush of their victory they took full revenge. The Muslim leadership, by and large, was put to the gallows and eliminated. The community was left high and dry, without anybody to show them the way. All avenues of employment and economic advancement were closed to them and the ruling power eyed them with hate and suspicion. A mood of frustration engulfed them and they retreated into their own shell, refusing to adjust themselves to the changing patterns. Their fellow countrymen, recognizing the changes, immediately started adjusting themselves accordingly. The result was that the Muslim community was left miles behind in the race. It was after a spell of thirty years or more that men like Sir Syed Ahmed Khan and others came on the scene and made valiant efforts to bring the community out of its shell and make it move with the times. The result was that slowly but steadily a new leadership emerged amongst the community, most of whom fought shoulder to shoulder with their other countrymen for the freedom of their motherland and directed the activities of the community.

Unfortunately, because of misunderstandings between the two major communities of India—Hindus and Muslims— the country was partitioned and the Muslim leadership by and large opted for Pakistan. The community was again left without leadership and had to face, and is facing, an identical situation which their forefathers had to face in the last century. The same mood of despondency and frustration is slowly overwhelming them and

they are again retiring into their shell as before. If this mood continues, Muslims will again be left behind, as happened before. They must realize that pre-partition India is dead and gone and a new India is emerging. They must accept this reality, however unpalatable it may be. If they desire to live with honour and respect, they shall have to adjust themselves according to the needs of the situation, in word, deed, and thought.

Unfortunately, however, the politics of Indian Muslims has not changed much after independence. As in the British days, Muslims are divided between a group affiliated to the ruling party and other groups which work on communal lines in search of protection. But independence has brought about a vital change. Gone is the third party. The separate electorates which were the basis for communal parties and communal politics are also gone. But the political pattern of the Indian Muslims is not altered. There is the same politics of grievance and bargaining and recrimination. A quarter century's experience should convince us that this course has led us nowhere.

Far from improving our condition, it has led to deterioration, economically, culturally, and politically. The legitimate grievances of the Muslims of India cry for redress. I am deeply conscious of them—denial of due representation in the public services, of fair opportunities in trade, commerce, and industry, of adequate representation in the legislatures and in government, discrimination in admission to colleges, particularly to technical and professional schools, misleading and mischievous textbooks, discrimination against Urdu and, not the least, the utter failure to prevent and contain the persistent threat to the lives and property of Muslims which communal riots pose. Many a time the police abets the communal forces in their attack on Muslims. Nor is this all. The callous way in which the Aligarh Muslim University Bill was rushed through in Parliament, despite the near unanimous opposition of Muslims from within and outside the Congress party, and the total denial of autonomy to one of the country's leading educational institutions for the minority community are injustices to which the Muslims cannot and should not submit.

My approach to these problems is fairly well-known. I would like the Muslims to banish pessimism and gloom from their minds, fear from their hearts and a sense of dependence from their spirit. Instead they should stand up boldly as men of pride who are conscious of their religious, cultural, and national heritage and who are determined to fight to preserve them.

It is only if this mood of despondency, that has held the community in its grip for the last quarter of a century, is overcome that we shall be able to undertake those tasks which are a prerequisite to correct action. They are rational thinking and objective self-analysis. As I said at a meeting held under the auspices of the Jamiat-ul-Ulema in Delhi on 17 January 1968, Muslims must find out their own weaknesses and shortcomings and overcome them instead of blaming others for their fate. To no small extent are we responsible for our misfortunes. I deeply believe in the Koranic saying, 'Verily, God never changes the condition of a community unless and until it changes its own conditions.' What, I ask, have we done in all these years to improve our condition?

Having refused all these years to submit to repression in Kashmir, I shall not be the one ever to advise Muslims to bow before injustice and falsehood. I counsel them to organize themselves and combat these wrongs manfully. But I also counsel them both for their own good and that of the country to do so in a manner which will improve matters and not worsen them. It is my earnest belief that the communal approach in fighting communalism only exacerbates the situation and the worst sufferers always turn out to be the wronged one— the minority community.

Why not associate non-Muslims in the fight? Has the cause of Urdu gained or lost by the association of others? And are Muslims the only ones to suffer wrong? What about the Harijans, who are under continuous attack and whose fate continues to be a singularly unfortunate one? Similarly, other minorities suffer from injustices, which are no less than those Muslims suffer from. Even sections in the majority community as well suffer from many injustices. Neither recrimination nor exclusiveness will help us. What we must do is first and foremost reactivate the social and educational institutions of the community and impart to them urgency and direction. Self-help is not an antithesis of interdependence but a corollary of it. We must destroy the communication barriers that exist not only between Hindus and Muslims but among the diverse communities of this country which exist as parallel societies with little communication or understanding. Ours is a free plural society of diverse creeds, cultures, and languages, united by a common faith in the ideals of democracy, secularism, and socialism.

It is from this perspective that the injustices to individual elements must be viewed. They are lapses from the common ideal and should be combated by all. Our separate grievances are as

formidable as our common foes — poverty, illiteracy, disease, social injustice, backward customs, corruption, and maladministration.

My appeal to Muslims, in sum, is that, shaking off their inhibitions, they should bestir themselves to improve their own lot, educationally, economically, and socially; fight for the redress of their grievances but uniting at the same time with their fellow Indians to remove those ills which affect them in common.

[1]*The Indian Express*, 10 August 1973.

12. Prime Minister Indira Gandhi Receives Muslim Delegation, Hears Grievances[1]

Record notes of the meeting of the deputation which met the Prime Minister Indira Gandhi in her office at New Delhi at 11 a.m. on Saturday, 18 August 1973. The deputationists included the following:

1. Maulana Mufti Atiqur Rahman Sahib Usmani, president of the Majlis-e-Mushawarat.
2. Sheikh Mohammed Abdullah.
3. Mr Justice Khaleel Ahmed, former Chief Justice of Orissa.
4. Mr Justice Basheer Ahmed Sayeed, former Judge of the Madras High Court.
5. Maulana Mohammed Yusuf Sahib, president of the Jamiat-e-Islami Hind.
6. Maulana Mohammed Minnatullah Rahmani Sahib, Amir Shariat, Bihar and Orissa, and general secretary, Muslim Personal Law Board.
7. Sheikh Abdus Sattar of Bombay, joint secretary, Muslim Personal Law Board.

The meeting with the prime minister lasted about two hours during which various problems concerning the Muslim minority were discussed.

After introducing the deputationists to the prime minister, Sheikh Mohammed Abdullah explained the purpose of the meeting. He said that during the course of his meetings with Mrs Gandhi, the prime minister had complained that in spite of her repeated assurances that the government had no intention to interfere with Muslim personal law, she is not believed and this had naturally

distressed her. 'I suggested that she should directly meet the representatives of Muslim minority and find out the reasons of their dissatisfaction. She was kind enough to accept my suggestion and hence this meeting.' He then requested Maulana Atiqur Rahman to explain the position.

Maulana Mufti Atiqur Rahman opened the discussion expressing gratitude to the prime minister for the opportunity afforded to the deputation to wait on her.

He placed before the prime minister the feelings of the Muslim community in regard to attempts to bring about changes in the Muslim personal law.

The prime minister observed that in spite of the declaration of the government that it did not intend to interfere with the Muslim personal law, doubts were being entertained by the Muslim community about her bona fides. In her view no dialogue could be possible between the two parties if one doubted the bona fides of the other. In this context she drew the attention of the deputationists to the secular role and outlook of the entire Nehru family. 'I have fought against the communalism when I was not in power, am fighting while in power and will continue when out of power; and nobody should entertain any doubts in this regard.'

She pointed out that the Muslim community had sought the support of the opposition parties without appreciating what the ideals and policies of those parties were. She assured the deputation that she was not looking at the Muslim problems with a view to securing their votes. Her desire was to help all the underprivileged sections of the society.

Mufti Atiqur Rahman assured the prime minister that the Muslims in general had no doubt about her bona fides but, unfortunately, some of her colleagues and high officials of the government have been indulging in loose talk regarding the desirability of changes in the Muslim personal law. In this connection, he referred to the statements of Mr Gajendragadkar, chairman, Law Commission, and Mr Gokhale, Union law minister. Mufti Sahib drew the attention of the prime minister to the Adoption Bill, now before the Parliament. This Bill does not exempt the Muslim community from its application and, if passed, will change not only the Muslim law of adoption but of inheritance too.

As far as the Adoption Bill was concerned, Mrs Gandhi said that the Bill was in fact meant for the protection of children adopted by foreigners and she did not realize that the Bill, if passed, would

amount to an interference. 'Now that its implications have been brought to my notice, I will ask the law ministry to re-examine the Bill.'

Another matter raised by Mufti Sahib pertained to the maintenance payable to a divorced wife by a Muslim. In terms of the amendment of Section 488 of the Cr PC, under consideration of a parliamentary select committee, the husband is to pay maintenance to his wife even after the divorce becomes absolute. According to the proposed amendment, he shall continue paying the same till the remarriage of his divorced wife. This is in clear contravention of Muslim personal law because according to Muslim law of marriage, marriage is a contract and when the contract comes to an end, parties are free from all bondages, responsibilities, and liabilities. The prime minister, however, had some misgivings regarding the nature of maintenance payable to the divorced wife. According to her, the maintenance was to be paid till the dower debt was not paid to the divorced wife and in case the husband paid the dower debt immediately after the divorce, he was not to pay the maintenance. This was not the correct position in terms of the proposed amendment to Section 488 of the Cr PC. Explaining this, Mufti Atiqur Rahman distinguished between the dower and the maintenance. Mere non-payment of dower cannot, under the Islamic Law, result in the accrual of the right of maintenance for any period beyond *iddat* while maintenance in terms of the proposed amendment is payable for an indefinite period. The responsibility comes to an end only on remarriage. While the former is a part of the contract, the latter is extraneous to the terms of the contract.

Mr Justice Basheer Ahmed Sayeed referred to another important matter concerning the Muslim Waqfs, charitable and religious trusts, with special reference to the effects of the land reforms and taxation bills passed by various states and the Centre. Mr Justice Sayeed pointed out that the application of these laws to Muslim Waqfs, trusts, and other charitable institutions will have serious consequences on the functioning and effectiveness of these institutions. He, therefore, made a strong plea for exempting these institutions from the operation of these laws as has been done in case of gurdwaras.

Justice Khaleel Ahmed stressed the desirability of ascertaining Muslim public opinion in the country before any legislation affecting their personal law is brought before Parliament. In his view such a procedure would go a long way in removing misunderstandings. The prime minister promised to keep this in mind.

Justice Basheer Ahmed Sayeed raised the issue of Aligarh Muslim University and said that though repeated assurances were being given to Muslims that the historical character of the University would not be changed, the amending Act had completely destroyed the historical character of this institution as understood by the Muslims. In this connection he took the prime minister back to 1915 when the Beneras Hindu University Bill was being debated in the then legislative assembly. Sir Ghaznavi and Mr C.L. Setalvad had objected to Clause 2 of the Bill which provided that no one other than a Hindu could become a member of the University Court. Malaviya*ji* in a passionate speech replied that as the University was built mostly through the efforts of the Hindus, in order to promote and preserve Hindu culture and impart instructions to that end, only those who believe in that culture and way of life could become members of the Court. The argument was accepted and Clause 2 retained. Thus in 1920 an identical clause was included in the Muslim University Act which, inter alia, provided that no one other than a Muslim should be elected to the University Court. Nobody had raised an objection. This was the historical character of the Aligarh University as understood by the Muslims.

Justice Sayeed then referred to the Beg Committee Report. Narrating its history, he said that it was at the initiative of the prime minister that the opinion of nearly 200 eminent Muslim educationinsts, jurists, politicians, parliamentarians, and others was sought through the good offices of Mr Fakhruddin Ali Ahmed, Union agriculture minister. Nearly 100 Muslims met in Delhi to discuss in detail the opinions received. A committee under the secretaryship of Mr M.M. Beg was appointed to frame a report on the basis of consensus arrived at in the meeting. This report has made minimum changes in the Act of 1920 and 1951, needed for the progressive functioning of the University and was unanimous on the retention of its minority and democratic character. The report was submitted to the education ministry which was then headed by Mr Triguna Sen. Mr Sen is on record to have described the report as a 'good one'. Later on, Mr V.K.R.V. Rao, his successor, is understood to have prepared a bill on the basis of the same report. In the meantime Parliament was dissolved.

Justice Sayeed expressed his deep sorrow and anguish that this report should have been thrown in the dustbin and an entirely new bill eroding both the democratic and minority character of the institution introduced and passed by Parliament with indecent haste.

Justice Sayeed wanted to know the reasons for disregarding the opinion of the 99.9 per cent Muslims and instead adopting the draft prepared by one individual.

The prime minister replied that the difficulty in reaching an understanding on various points and disputes with regard to the future of the Muslim University was caused because some of the leaders of the community adopted and advocated an agitational approach in this matter and she does not temperamentally yield to pressures. The matter had, however, been referred to the Teachers' Association for suggesting changes in the statutes which will restore the democratic character of the University. In Justice Sayeed's view this procedure was not going to satisfy the Muslim community. He pointed out that any amendments made to the statutes must be in conformity with the sections of the Act and, therefore, mere change in the statutes could be of no avail. Further, it was pointed out that any incorporation of amendments in the statutes in consultation with teachers and other present authorities of the University would not be proper for the reason that the teachers had their own vested interests and the employees did not represent the Muslim community of the country which was vitally interested in the minority and democratic character of the University. Nominated and ex officio members of the University could not be expected to be dispassionate or disinterested in the matter. It was, therefore, urged by the deputation that the minimum amendments suggested by the Beg Committee to the sections of the original Act and to the statutes should be accepted and given effect to by the government. To them, nothing short of this would satisfy the Muslim community in regard to the restoration of the University as an institution established and administered by it.

The prime minister pointed out that there is a good deal of doubt as to whether if the University was recognized as a minority institution it would still be entitled to receive grants from the Central government as is the case now. It was impressed upon the prime minister by Justice Khaleel Ahmed that under Article 30, Clause 2 of the Constitution, the government was not entitled to refuse grants to any institution established and administered by any minority in the land and that in the Kerala case reported in 1958 Supreme Court (AIR) this aspect of the view canvassed on behalf of the government was turned down and it was held that the provision made in Article 30(2) was mandatory and the government could not in the matter of grant discriminate on the ground that the institution was a minority institution. It was also brought to her

notice that all minority institutions in the states were receiving grants-in-aid according to the rules framed for the purpose and no discrimination existed in the other.

In support of the demand regarding minority character, Justice Khaleel Ahmed elaborately submitted before the prime minister that the country being multicultural, multilingual, and multi-religious, special safeguards have been provided in the Constitution for the full growth of all cultures, religions, and languages in their own autonomous and healthy atmosphere. Therefore, once any attempt was allowed to succeed in denying the minority character of the Muslim University, the very basis of the Constitution would stand nullified. In support of his view, Justice Khaleel also suggested to the prime minister that the Constitutional minority character might be conveniently discussed with the help of the present vice-president of India, who was a senior lawyer who had appeared on behalf of the minority concerned in the Kerala case, and other legal counsel along with a few trusted legal experts of the community.

Justice Basheer Ahmed impressed upon the prime minister that there should be no confusion between 'establishment' and 'incorporation' of an existing institution. It was brought home to her that the legislations in 1915 in respect of the Beneras Hindu University and in 1920 in respect of the Aligarh Muslim University were nothing more than 'incorporations' of the existing colleges and allied institutions and organizations into a university and converting all assets of these existing colleges and organizations to those of the university. This does not amount by any stretch of imagination to 'establishment' of the University when the government of the day did nothing more than what has been described above. It was, therefore, urged that the claim of the government that it had established the Aligarh Muslim University was not tenable. Mere 'incorporation' on 'affiliation' of existing colleges would not amount to establishment, was the contention of the deputation. The prime minister appeared to have appreciated the distinction made out.

On the issue of the spread of education while discussing the growth of the Muslim University, Justice Basheer Ahmed Sayeed pointed out that but for the efforts of private institutions, established and maintained by Christian missionaries, Muslim and Hindu organizations, the progress of education in the country would have remained far behind what it is today. Instead of the present 29.9 per cent on the population having become educated, the proportion

of educated people would have been far less than 5 or 6 per cent. It was also pointed out to the prime minister that but for the foreign exchange regulations and the income tax laws, the rate of progress of education of all grades in the country would have been far greater and that the prime minister should be pleased to direct that these laws are relaxed in the case of privately-managed institutions so long as the funds received by way of donations from the generous and charitably minded persons, both inside India and abroad, are properly utilized for the purpose of promoting education. It was also brought to the notice of the prime minister that there was large scope of abundant charity flowing from Indian nationals residing in foreign countries and the inflow of such charitable donations was hindered and obstructed by the enforcement of foreign exchange regulations and income tax laws against such donations.

The prime minister was impressed with this plea and gave an impression to the deputation that this matter would be looked into in the interest of the rapid progress of education in the country. It was urged upon the prime minister that by and large the teachers and students of the University of Aligarh have conducted themselves in a far better way than those in other universities. Therefore, she was requested that the students and teachers of the Muslim University, now under detention under various repressive and preventive laws of the country, or under suspension, or expulsion, should be released, reinstated and readmitted with a view to restoring a healthy and harmonious atmosphere in the university campus.

The prime minister replied that she had met the teachers' delegation and would be meeting a students' delegation as well. She promised to consider their cases sympathetically so as to give effect to the desire of the deputation.

The prime minister in the course of the discussion also referred to the efforts made, under her instructions, for the spread of Urdu in various directions and of the progress made in the matter of recruitment of more Muslims in the services.

The deputation appreciated the interest evinced by the prime minister in the matter of progress of representation of Muslims in the services but pointed out that it was still not commensurate to their proportion in the population of the country.

Before the discussion concluded, Maulana Minnatullah Rahmani Amir Shariat, Bihar and Orissa, and secretary of the Muslim Personal Law Board, summarized his points relating to

personal law and got the assurance from the prime minister that the government had no intention whatsoever to change and amend any part of the Muslim personal law and the government would see that legislations already enacted contrary to the Muslim personal law were got rectified in some available way. Maulana Rahmani also raised the point that all proposed legislations likely to affect directly or indirectly any provisions of Muslim personal law should be referred to the Muslim Personal Law Board in order that the government may be in a position to have full knowledge of the Muslim law about the matter. The prime minister noted the points and the deputation took leave of her, thanking her profusely for listening to their grievances with patience and sympathy.

[1]Cyclostyled copy distributed by the Delegation. Delhi, 22 August 1973.

13. West Bengal Chief Minister Announces Determination to Meet Major Muslim Demands[1]

Mr Siddhartha Shankar Ray, West Bengal's chief minister has said that the state government is 'determined' to meet two major demands of the Muslims: (i) in every police station, particularly in the Muslim areas, there should be a Muslim police officer; and (ii) measures will be taken to ensure employment of Muslims in administrative services particularly in the class III and IV grades.

The chief minister made this announcement at a gathering of 'Muslim citizens of Calcutta' who organized a reception to President Fakhruddin Ali Ahmed at the Mohammedan Sporting Club on 2 January 1975. The speakers included Mr Abdus Sattar, Dr Zainul Abedin, and Mr Justice S.A. Masud who was the chairman of the reception committee.

The major theme of the president's speech was that the Constitution had guaranteed no special privilege for any religious group and that 'the Muslims will be mistaken if they feel that they have no place in this country'.

The president said that irrespective of religion people should fight for their rights enshrined in the Constitution. He reminded the gathering that all religions enjoined people to live together in peace and harmony. 'What is the use of attending a *namaz* or visiting masjids, if we do not obey religious teachings?' he asked.

Referring to the challenge facing the country Mr Ahmed said that the Indian people should think not in terms of the religion or the state they might belong to but as citizens of the country. While demanding that their rights be ensured people should also remember that they had obligations to the country and duties to perform.

Increasing production in agriculture and industry, and improving exports were among the tasks ennumerated by the president.

Mr Ahmed said that unemployment was a malady which afflicted all sections of the population and it was not a special problem for Muslims. He felt that the country would suffer, if employment was not assured to all people, irrespective of religion.

The chief minister said that his government was 'particularly careful about the minorities and would try its best to proteet them in every possible way. In so far as our Muslim friends are concerned, I know that they had some very genuine grievances in the past and we have been able to remove many of them. I want you to know and realize that the Muslims need have no fear, for I shall never discriminate between a Hindu and a Muslim.'

Representatives of Jamiat Ulema-e-Hind, Calcutta met the president at Raj Bhavan and assured him that the organization, as in the past, would continue to work against communalism and do its best for the prosperity of the country.

[1]*The Statesman*, 3 January 1975.

Political Strategy for Grievance Redressal

1. Muslim League Supports Emergency[1]

As far as my party and other parties like CPI and ADMK are concerned, all of us have supported the Emergency because we felt—and felt earnestly—that if such an action was not taken by the prime minister, the right reactionaries, the militant communal elements, and the extreme leftist would have taken our country to anarchy and chaos. Therefore, we have supported the declaration of Emergency. But it pains me to point out that such important pieces of legislation are brought before Parliament without taking us into confidence. It has been the practice—a very healthy pratice— in the past that whenever an important bill came before Parliament, the opposition parties were consulted. Now, the right reactionaries and arch communalists are not there, but it does not mean that other parties have to be taken for granted. . . .

. . . So far, we have had thirty-nine amendments to the Constitution and this is the fortieth amendment of the Constitution. That means, we really are on the way to change the very character of the Constitution. I would desire that the democratic character, the secular character of our Constitution must be maintained and protected and must not be altered. As far as our Constitution is concerned, it is a very sacred Constitution among the constitutions of the world, and particularly our Constitution has got fundamental rights given to minorities together with the democratic rights given to all people—the citizens of the country. Our Constitution has a democratic character. . . . Minorities have been given the fundamental rights. This makes the Constitution secular.

. . . I want to put forth this fact that whatever may be the change in the Constitution, whatever may be fate of this bill, fundamental rights of the minorities must not be touched because then the minorities will not feel safe and will have to resist. . . .

... Our party has always thought it fit to support the government in a period of emergency. We do not want a feeling to go round that there is a difference of opinion among friends. Organizations like the RSS and the Anand Marg have been put down. I welcome this because we, the Muslims, were the main targets of all these reactionary elements. We have been actually demanding that there should be a ban on these right reactionary elements like the RSS and armed militant communal forces. This has been done now. But I would like to make one thing clear that our support must not always be taken for granted because we have thought it fit to support the government at this period of crisis. There should be consultation; and only after consultation, such bills should be introduced. Today we stand with the government because the country is passing through a national crisis and I feel that we should strengthen the hands of the government and of the prime minister, so that the country might be saved from reactionary elements and disruptive forces, from chaos and confusion, and led on the path of peace and progress, in the interest of the people.

[1]Extracts from Ebrahim Sulaiman Sait's speech in the Lok Sabha on 7 August 1975. *Lok Sabha Debates*, Fifth Series, vol. LIV, No. 14, 7 August 1975, Cols. 48–51.

2. Muslim Leaders Decry Suspension of Various Civil Liberties During the Emergency[1]

A consultative meeting of prominent public men, legal luminaries, Muslim League MPs, and Muslim League leaders from different parts of the country, convened by the Indian Union Muslim League, was held on Saturday and Sunday 22 and 23 October 1976 at New Delhi. The meeting was presided over by Mr Ebrahim Sulaiman Sait, MP, president of the Indian Union Muslim League.

The meeting welcomed the move to amend the Constitution to make it more responsive to the emergent dictates of time in the interest of expeditious economic regeneration of society. While the need for a re-look at the Constitution at the present crucial stage in the constitutional and economic history of the country is manifestly imminent, it is the considered view of the meeting that a state of emergency with the suspension of various civil liberties is both

inconsistent and inopportune for the discussion and adoption of drastic amendments to the constitution of a democratic country. Such an attempt not only fails to have the advantages of fruitful, free, and frank discussions on all comprehensive and national basis, but may also fail to inspire national and international respect for the Constitution that proclaims the state to be sovereign, democratic, socialist, and secular in nature. This meeting is, therefore, of the opinion that a duly democratic atmosphere free from any lurking fear and apprehension should first be restored before the proposed amendments are considered. These amendments need to be studied in depth and a national consensus should be achieved since the ultimate sovereignty rests with the people.

This meeting, considering the draft of the Constitution (44th Amendment) Bill 1976, welcomes the proposal to amend the preamble to declare the state not only to be sovereign and democratic but also socialist and secular. The proposals for inclusion of fundamental duties, constitution of administrative tribunals, provision of free legal aid, and participation of workers in management of industries are some of the welcome features of the Constitution (44th Amendment) Bill, 1976.

The proposed amendment of Article 31C is, however, a serious inroad into the democratic and secular nature of our republic and is totally destructive of fundamental rights. The meeting unanimously considers the precedence sought to be given to directive principles over fundamental rights as retrograde in character. It is very regrettable to note that in this vital respect the scope of the constitutional amendment bill is wider than even the proposals of the Swaran Singh Committee. The guarantee contained in the Swaran Singh Committee proposals to the effect that any law purporting to be for implementation of any directive principles shall not affect the special safeguards or fundamental rights conferred on the minorities, the Scheduled Castes or Tribes, or other backward classes, is conspicuous by its absence. It is imperative to incorporate this vital provision, if article 31C is at all to be amended. The inviolability of such minority rights has also to be secured with respect to the Amendment proposed to Article 368.

Similarly, the proposed amendment to Article 31A is destructive of the fundamental right to constitutional remedies in case of state laws. The High Court of a state has powers under Article 226 to pronounce upon the validity of the state laws, but abrogation of a fundamental right of a citizen to constitutional remedy guaranteed

in Article 32, may reduce the various fundamental rights in Part III of the Constitution to mere paper guarantee in respect of state laws. Likewise an insistence on a two-thirds majority of judges to declare any law unconstitutional will lead to such an anomalous situation where a law may continue to be held valid pursuant to a minority judgment.

This meeting further feels that the insertion of the proposed new Article 31D is both unnecessary and undesirable in view of the Unlawful Activities (Prevention) Act, 1967, which has not failed to deal effectively with the various exigencies of the situation. A further disquieting feature of the said Article 31D is the absence of any specific provision for judicial review of executive action.

This meeting fervently hopes that its consensus will receive due consideration of the government and all others. It is necessary that a constructive approach to the Constitution (44th Amendment) Bill, 1976, should be considered by one and all in true national spirit.

Prominent among those who participated in the meeting were Mr Badruddin Tayyabji, Maulana Mufti Ateegur Rahman, Habibullah Badshah, Advocate, Madras, Mr C.H. Mohamed Koya, MP, Mr G.M. Banatwala, MLA, Bombay, Mr Manzoor Alam, Advocate, Tonk, Mr A.K.A. Abdul Samad, ex-MP, Madras, and Maulana Mohd. Yousuff Sahib, Delhi.

[1]Cyclortyled leaflet distributed by the organizers of the meeting.

3. Communist Party of India Highlights Muslim Grievances, Demands Redress[1]

A convention on the problems of the Muslims of Delhi, organized by the Delhi state council of the Communist Party, has demanded job reservation for Muslims in government services and public sector, recognition of Urdu under Article 345 or 347 of the Constitution in Delhi for specified official purposes, and granting of the same facilities to Muslim professional communities which are available to their counterparts of other religious groups.

Inaugurating the largely attended convention on 31 October 1976, CPI general secretary C. Rajeswara Rao warned that if the problems of Muslim minority in our country are not solved, its very democratic and secular fibre would be in peril.

He pointed out that there had been discrimination against Muslims in various forms including denial of jobs to them in government and private sector services. Although there have been two Muslim presidents of the Republic and some others have risen to high positions, the conditions of Muslims generally had been very bad.

He said that the injustice done to the Muslims in a quarter of a century could be done away with only by initiating courageous actions like reservation of jobs for them in the government services and public sector.

Rao welcomed the establishment of Urdu academies in several states and appealed to the government to take more concrete steps for promoting the language which is the heritage of the composite culture of India.

Dealing with the five-point solution which has been presented by the party, Rao explained that the demands were not on communal lines. By keeping a vast section of the population backward, the country could not move forward with ease, he said, adding that the demand for tackling the immediate problems of Muslims was part and parcel of the wider democratic struggle.

Congress MP Syed Ahmad Hashmi, general secretary of the Jamiat-ul-Ulema-e-Hind, supported the five-point solution presented by the CPI and pointed out that since long Muslims have been discriminated against. He explained that the Jamiat had always been of the opinion that the problems of Muslims in free India could be solved only with the help of progressive and democratic organizations.

Justice for minority community

The central executive committee member of the CPI, Mr M. Farooqi dealt in detail with the concept of secular democracy. He said that the concept of secular democracy had been under attack from two sides. From one side, Jana Sangh and RSS had always opposed the secular democratic set-up and pleaded for 'Hindu Rashtra'. From the other end, the followers of Jammat-e-Islami had helped them by preaching obscurantist and isolationist ideas among the Muslims.

He condemned the anti-Muslim attitude of certain bureaucrats and said that in certain cases these bureaucrats had scuttled the good steps of the government.

Explaining the attitude of CPI towards problems of the Muslims, he said that it had always advocated justice for the minority

community. In the existing circumstances, under a secular democratic rule, the minorities' problems had to be tackled at a proper level. The discrimination against them had to be ended.

B.D. Joshi, leader of the CPI group in Delhi Metropolitan Council, in his presidential speech, dealt with the specific problems of Muslims in Delhi. CPI state council secretary Prem Sagar Gupta moved the resolution which was seconded by Nandlal Gupta. The resolution, among other things, demanded:

- Reservation of jobs in government, semi-government and administrative bodies, corporations, and public sector units. Similarly, government should insist on such quotas in private sector units.
- A quota for Muslims in apprenticeship schemes and ITIs and in IITs for training.
- Special plan for providing help to educated Muslim youth under 'self-employment scheme'.
- Special care in providing financial help to the Muslim artisans and their cooperatives. Provide sheds and flats to these artisans and handicraftmen.
- Recognition of Urdu under Article 345 or 347 of the Constitution for specified official purposes.
- Establishment of a minority department under Delhi administration to look into the genuine problems of Muslims.

The resolution urged all progressive and democratic forces to support and struggle for these demands so that Muslims are inspired to take more active part in the national democratic life.

[1]*New Age*, 7 November 1976.

4. Resolutions of the Milli Convention[1]

The following are some of the resolutions passed by the All India Milli Convention held at Delhi on 4 and 5 October 1977:

I. The Milli Convention affirms its faith in the democratic and secular nature of the Indian Constitution and records that the fundamental rights are the essence of the Constitution and were meant to be and should always be paramount, inviolable, and permanent. The fundamental rights contain essential and valuable

safeguards for all people, amongst other things, in the matters of religion which are particularly vital to the minority communities.

Article 31C which gives precedence to the directive principles over the fundamental rights guaranteed by Articles 14, 19, and 31 is the very negation of the concept of democratic order which our Constitution seeks to establish while the amending powers contained in Article 8 weaken the very fabric of the fundamental rights.

The Convention considered several amendments made in the Constitution and in this regard resolved as under:

> 'Resolved that the Milli Convention calls upon the Union government to delete Article 31C of the Constitution of India and to suitably amend the relevant provisions of the Constitution including Article 368 and in particular by deleting clauses (3), (4), and (5) of Article 368 so that the fundamental rights are made paramount, inviolable and permanent.

II. The Milli Convention also records that Article 31D, apart from being derogatory to the fundamental rights guaranteed by Articles 14, 19, and 31, is open to gross abuse and is arbitrary. The Convention is of the view that the existing laws are sufficient to deal with the unlawful or anti-national associations and activities.

> 'Resolved that the Milli Convention calls upon the Union government to delete Article 31D of the Constitution of India.

III. This Convention also desires the deletion of Article 44 of the Constitution which provides for the establishment of a uniform civil code.

> 'Resolved that the Milli Convention calls upon the Union government to delete Article 44 of the Constitution of India.

IV. The Milli Convention considered the last part of clause (e) of Article 51A reading to 'renounce practices derogatory to the dignity of women' and desired that it should be so clarified that it did not lead to interference in the personal laws of any community.

> 'Resolved that the following explanation be added to Article 51-AW.
> "Explanation: Nothing in sub-clause (e) of this Article shall interfere with the personal laws of any community.

V. The Milli Convention requests the Muslims to adhere to their personal law and rectify any evil that may have crept in contrary to the Islamic Shariat.

The Convention is happy to note that the Muslim Personal Law Board has appointed a committee to look into the abuse by Muslims of the Islamic Shariat and requests it to proceed expeditiously.

VI. The Convention welcomes the statement of the prime minister about the appointment of a Minorities Commission and urges the government to set it up without any further delay.

It is vitally necessary to appoint such persons on the Commission as are able to inspire confidence in the minorities.

The Convention recommends, amongst others, the following terms of reference for the proposed Commission:

1. To investigate and determine the causes and the extent of the educational and economic backwardness of the minorities and formulate concrete recommendations for their speedy redressal.
2. To investigate and assess the discrimination against the minorities in public services, trade, commerce, and industry and formulate recommendations for their removal.
3. To ensure the representation of the minorities in government services commensurate with their population. . . .

[1]*Radiance*, 9 October 1977. Some more resolutions were published in a subsequent issue.

5. Government of India Establishes a Minorities Commission[1]

Despite the safeguards provided in the Constitution and the laws in force, there persists amongst the minorities a feeling of inequality and discrimination. In order to preserve secular traditions and to promote national integration, the Government of India attaches the highest importance to the enforcement of the safeguards provided for the minorities and is of the firm view that effective institutional arrangements are urgently required for the effective enforcement and implementation of all the safeguards provided for the minorities in the Constitution, in Central and state laws, and in government policies and administrative schemes enunciated from time to time.

2. The Government of India has, therefore, resolved to set up a Minorities Commission to safeguard the interests of minorities whether based on religion or language.

3. The Minorities Commission shall consist of a Chairman and two other members, whose term of office would not ordinarily exceed three years. The officer appointed as special officer in terms of Article 350(B) of the Constitution will function as the secretary of the Commission.

4. The Commission shall be entrusted with the following functions:

(i) to evaluate the working of the various safeguards provided in the Constitution for the protection of minorities and in laws passed by the Union and state governments;

(ii) to make recommendations with a view to ensuring effective implementation and enforcement of all the safeguards and the laws;

(iii) to undertake a review of the implementation of the policies pursued by the Union and the state governments with respect to the minorities;

(iv) to look into specific complaints regarding deprivation of rights and safeguards of the minorities;

(v) to conduct studies, researches, and analyses on the question of avoidance of discrimination against minorities;

(vi) to suggest appropriate legal and welfare measures in respect of any minority to be undertaken by the Central or the state governments;

(vii) to serve as a national clearing house for information in respect of the conditions of the minorities; and

(viii) to make periodical reports at prescribed intervals to the government.

5. The headquarters of the Commission will be located at Delhi.

6. The Commission will devise its own procedures in the discharge of its functions. All the ministries and departments of the Government of India will furnish such information and documents and provide such assistance as may be required by the Commission from time to time. The Government of India trusts that the state governments and union territory administrations and others concerned will extend their fullest cooperation and assistance to the Commission.

7. The Commission will submit an annual report to the president detailing its activities and recommendations. This will, however, not preclude the Commission from submitting reports to the government at any time they consider necessary on matters within their scope of work. The annual report together with a memorandum outlining the action taken on the recommendations and explaining

the reasons for non-acceptance of recommendations, if any, in so far as it relates to the Central government will be laid before each house of Parliament.

[1]Text of government resolution dated 12 January 1978.

6. Prime Minister Desai Concedes Inadequate Representation of Minorities in Police Forces[1]

The prime minister, Mr Morarji Desai, told the Lok Sabha on 5 December 1978 that the government was trying to ensure that all communities had adequate representation in the police forces in the country.

Intervening in a two-day discussion on communal riots, Mr Desai conceded that the Provincial Armed Constabulary (PAC) had committed excesses in Aligarh. 'It happened because there was very little representation of the minorities in the PAC,' he said.

The prime minister pointed out that if the minorities had inadequate representation in the PAC, it was the previous government that was responsible for it.

Mr Desai referred to the proposed meeting of representatives of all political parties being convened on 17 December to discuss communal conflicts to find a lasting solution to the problem.

[1]*The Times of India*, 6 December 1978.

7. Indira Gandhi Writes to Shahi Imam of Jama Masjid Conceding his Demands[1]

The following is the text of Mrs Indira Gandhi's letter to the Shahi Imam of Jama Masjid, Syed Abdullah Bukhari:[2]

Dear Bukhari Sahib,

Throughout the country, all secular-minded people are deeply concerned with the deteriorating communal situation. Various organizations of the minorities have approached us in this regard. Shri Antulay has told me of his talk with you and I have gone through the pamphlet containing your demands. Most of these are covered by the decisions already taken by us.

Some incidents, including the 1975 Jama Masjid incident, which took place in the past and during the Emergency, resulted in stress and strain and I am sorry that they left an atmosphere of misunderstanding and bitterness. Let this past be forgotten so that we can begin on a note of harmony and cooperation.

Congress, being irrevocably committed to secularism, will take positive measures to build a secular society and to counter the trends of disharmony brought about by the policies and actions of the Janata Party government. It will safeguard the rights of the minorities, including Muslims and Christians, and ensure their effective participation in all spheres of national life, with full protection to their educational institutions and full freedom of religious practice and cultural pursuit.

Riot control

So far as the prevention of communal riots is concerned, we shall certainly take all necessary measures including the formation of peace corps composed of all communities. The effective and timely control of communal disturbances will rest squarely on the district administration and any failure on their part will entail prompt and suitable action. Special measures will be taken to bring offenders to book speedily and deterrently.

We agree that all derogatory references to religious leaders should be deleted from textbooks.

Our party is committed not to interfere in Muslim personal law. We have also assured the minority character of the Aligarh University.

You are probably aware that our party had already declared in some states that Urdu would be recognized as a second language to be used for official purposes in some areas. It will be the endeavour of our party to continue to strive for the protection, preservation, and promotion of this great language by providing all facilities for the teaching of Urdu at all levels.

Immediate corrective steps will be taken to ensure proper management of *waqf* properties by necessary amendments in the existing legislation.

Job provision

Equitable employment opportunities to minorities, including Muslims and Christians, will be ensured in government services including the law and order and security personnel.

So far as the economic condition of minorities, Scheduled Castes, Scheduled Tribes, and other weaker sections of the society is concerned, thorough examination is needed to ascertain if the benefits of various fiscal policies of governments, both Union and states, do really reach them. It is learnt that incentives, facilities and other encouragements, entitlements like licences, quotas, loans, etc., are not being fully availed of. A high-power panel, including members belonging to the minorities, Scheduled

Castes and Scheduled Tribes, and weaker sections will be appointed to go into the whole question and make recommendations.

The social, educational, and economic upliftment of all weaker sections and minorities, including Muslims and Christians, will be our endeavour and we shall take effective measures in that direction.

It has always been the policy of the Congress to give adequate representation to minorities, including Muslims and Christians, both in the organizations and in the parliamentary wings. We feel that in every field of national activity as also in the affairs of the government, the totality of the population should be properly and effectively reflected and represented in the interest of national integration.

Waqf property

The forcible eviction of minorities from Assam is indeed a shameful blot on the fair name of our secular society. It is our considered opinion that no Indian citizen, regardless of his religious denomination, should be treated as a foreigner and forced to leave the country.

The Jama Masjid is not only a monument of architectural beauty but a sacred place for millions of people in India and abroad. It will be our endeavour to work out a scheme providing adequate safeguards for the proper management of Jama Masjid. Such a scheme will call for a proposal to make the management of the mosque self-supporting.

The working of Muslim aukaf and laws connected therewith requires periodic review and it will be our endeavour that the supervision and management of *waqf* property are looked into seriously and advice sought from Muslim religious leaders like yourself in order to streamline and remove defects, if any, in the existing laws or make such improvements as may be necessary in the light of the experiences gained in their working so far.

Yours sincerely,
Indira Gandhi

[1]*The Times of India*, New Delhi, 22 November 1979.
[2]Letter dated 20 November 1979.

Hindu Revivalism and Muslim Reaction

1. The Meenakshipuram Conversions: No Money, or Foreign Hand, Says Official Report[1]

Extracts from the Report of the Regional Director for SC/ST Welfare, Government of India, Madras, on conversion of Harijans to Islam in February 1981 in the village of Meenakshipuram, Tirunelveli district, Tamil Nadu:

Introduction

The Madras edition of *Sunday Standard* of 12 April 1981 carried a news item headlined 'A whole village goes Islamic' narrating that 180 Hindu Harijan families have changed their faith into Islam, and that another fifty families are likely to embrace it by the end of April. Shri R.P. Khanna, secretary, Commission for Scheduled Castes and Scheduled Tribes, Government of India, in his d.o. letter No. TN/3/7/SCTC/81-Gen dated 29 April 1981 desired that the director for Scheduled Castes and Scheduled Tribes, Madras, may personally conduct an enquiry into the matter to find out the real causes that have compelled them to such a mass conversion of religion and send a report to the Commission as early as possible. Accordingly, the enquiry was conducted by Shri K. Arumugam, director for SCs and STs, Madras, assisted by Shri T. Suryanarayana Murty, investigator of his office from 15 April 1981. . . .

Detailed discussion was held with the district collector and the district revenue officer who had already enquired into the matter and submitted their reports to the state government. . . . And the latter got details of the news item from him. . . . The director had discussions with Shri Gurunathan, tahsildar of Tenkasi. . . . In addition to meeting Shri R. Rajagopalan, superintendent of police,

Tirunelveli and Shri S. Ramanathan, assistant superintendent of police, Ambasamudram, the director met Shri K.M. Chenniappan, inspector of police, Shecottai circle, Shri V. Sankara Krishnana, deputy inspector of police, Tenkasi circle, and Shri Annadorai, sub-inspector of police, Shencotta police station. Shri Ramachandran, part-time correspondent of *Indian Express* at Tenkasi met the director.

On 16 May 1981 the converted Harijans were interviewed for about six hours in Meenakshipuram village, then the non-converted Harijans of Meenakshipuram were approached before meeting the caste Hindus of Meenakshipuram and Panpoli villages. Important caste Hindu members of the neighbouring villages were also contacted, including the members of Hindu Samudaya Valakshi Manram. . . . Thus more than three-fourths of the time was devoted on 16 and 17 May in Meenakshipuram village by contacting people of all castes so that opinions of all shades were heard. In the end, other Muslim religious leaders of the district met the director at Courtallam along with five important Harijans converted Muslims of Meenakshipuram and apprised the director as to how the conversion took place. Shri Ashok Kumar, a Harijan advocate of Tirunelveli met the director on 15 and 16 May 1981 and gave details of how Harijans are harassed by caste Hindus. . . .

Shri Ram Gopal Shalvale, Shri O.P. Tyagi, ex-MP, Shri Vandemataram Ramachandra Rao, chairman, Official Language Commission, Government of Andhra Pradesh, Shri Prithvi Singh, Shri B. Krishnalal, and Shri T. Narayanan met the director at Panpoli on 17 May 1981. They said that they belonged to the Arya Samaj and they came there to find out the reasons for the mass conversion.

In order to know the causes of the mass conversion, efforts were made to have a free and frank talk with the Harijans converted into Islam. Only important persons amongst them were present to give details of the incidents that took place in the past. They explained in detail various incidents in which they felt social discrimination. They wanted to emphasize that social discrimination was more in relation to the educated and employed persons. They also emphasized that on top of these, came harassment by certain police officers.

The Harijans could not go to temples and schools freely without any discrimination. The services of barbers and washermen were not available to the Harijans. With regard to drinking water, there were separate wells in the localities of Pallans, Arunathathiyars, and Thevars. Pallans had their own barbers. Harijans could not get

water from the wells in the Thevar locality. There were three tea stalls at Panpoli run by a Moopanar, a Thevar, and a Muslim. Harijans could get service at the tea shop run by the Muslim but not from the other two stalls.

A meeting was held on 16 May 1981 with caste Hindus and representatives of Hindu Samudaya Manram, Panpoli/Hindu Viswa Parishad.

Immediately after the conversions took place, the caste Hindus were shocked at the news and formed an association on 22 February 1981 known as Suthuvattara Hindu Samudaya Valarachi Manram with its headquarters at Panpoli. It was registered on 27 March 1981 under the Tamil Nadu Societies Registration Rules. The Manram had 150 members of the caste at the beginning, and its membership is 500 now. Shri T. Ramachandran Thevar is the president and Shri S. Subramanian (an SC) is the vice-president. The main activities of the society are to find out and analyse the reasons for the conversions. The society provides legal protection to Hindus who formed the minority in the village. The society claims that thirty-eight Scheduled Caste persons were reconverted to Hinduism on 6 March 1981.

They also mentioned that money was used for this conversion. However, no details could be furnished as to who paid to whom, etc.

It was also reported that the Viswa Hindu Parishad, an organization of the Vivekananda Rural Development Society located at No. 32, Perumal South Street, Tirunelveli junction, had been organizing discourses on Hindu religion. Representatives from all over India and abroad were invited and speeches were delivered about Hinduism. On 16 May 1981 an American converted to Hinduism was brought for giving a speech near Meenakshipuram.

The Hindu Samudaya Valarachi Manram is raising an objection for the proposed mosque that is likely to be built in the village. It was alleged that this would cause breach of peace in the village and they suggested the mosque be constructed at an alternative place in the village. It was reported by the correspondent of the *Indian Express* at Tirunelveli that a sum of about Rs. 20,000 was received as donation from Indian Muslims staying abroad, for construction of the mosque.

S. Subramanian (an SC) is the vice-president of Suthuvattara Hindu Samudaya Valarachi Manram. He said that he was forced to accept the post of vice-president. He said that he would not go to the barber shop as he was afraid of the consequences. He was

advised by some of his friends to convert to Islam, but he thought that he had availed himself of a good number of benefits and concessions from the government and that he would be betraying Hinduism, if he got converted to Islam. He said that the initiative for conversion was from Harijans and that too educated and employed ones.

Mass conversion to Islam

Hence they held a meeting on 9 February 1981 and took a decision to embrace Islam which was the only course to get away from the word 'pallan'. They went to Tirunelveli and approached Muslim leaders to allow them to embrace Islam. They had also reported to the director for Scheduled Castes and Scheduled Tribes that their elders were thinking of converting to Islam for the last twenty years. They had been having this idea time and again. Since there was no support and unanimity three times earlier, they did not convert. This was the fourth time when a good number of them came forward to get converted. It was their belief that at least their children and grandchildren would not be called 'pallan' and would not be subjected to ill-treatment and harassment.

Meeting with the Muslim leaders of Tirunelveli district

On 17 May 1981, the following Muslim leaders met the director for Scheduled Castes and Schedule Tribes and the superintendent of police, Tirunelveli district, at the circuit house, Courtallam, and gave the details of conversion of Harijans of Meenakshipuram to Islam.

1. Shri A.K. Rafaya, ex-MP and president, South Indian Ishathul Islam Society, Tirunelveli.
2. Shri Hazib Mohammad Musthabin Sahib.
3. Shri Jamal Mohammed Sahib, retired divisional revenue officer.
4. Shri S.M. Mohaideen Sahib, retired divisional revenue officer.

It was explained that the Society was started in 1944 and it was registered in 1954. The main functions of the Society were social and religious. It was reported that Uma Shariff (earlier Shri Dorai Raj) of Meenakshipuram approached them about the ill-treatment meted out to Harijans and expressed the desire to embrace Islam along with some others. He had been approaching them for the last

four years. He gave three petitions during the last four years and the latest one was given in January 1981. It was reported that the Society had helped the mass conversion during 1945–46 at Thenkupatti (near Manur) in Tirunelveli district wherein 4000 had embraced Islam. The society is now running one higher elementary school there. It was further explained that they receive individual representations as well as mass petitions seeking conversion to Islam. The Society claims that they had so far converted seven to eight thousand persons. They convert about thirty to forty persons in a month on an average. They get subscription from members and they use the money for community purposes.

Discussion with the district collector and the superintendent of police

The director for Scheduled Castes and Scheduled Tribes, Madras, had met the district collector of Tiruneveli on 15 May 1981 and the collector informed the director that the Harijans did not say anything about the police excesses to him. He added that other social disabilities might be the reasons for their being converted to Islam.

Conclusions

From the discussions with the converted Scheduled Castes it was obvious that a long-standing social discrimination, based on untouchability and indifference of the Hindu society at large, towards them was the major cause for the conversions. This discrimination was felt more by the educated persons among the Harijans. It may be noted here that the caste Hindus considered the incidents quoted by the converted Harijans to support their conversion due to social discrimination as trivial or expressed ignorance about these incidents. Even then, the incident of the barber being made to close his shop because he served the Harijans was confirmed in the presence of the caste Hindus. It also appears that no action was taken under the PCR Act in these cases.

Even now the provisions of the PCR Act are not understood properly and are not taken into account. This may be evident from the manner in which the incident of misbehaviour of Shri Murugaiah with the conductor of bus No. TMN 2505 was dealt with. Though an offence under Section 7(1)(d) of the PCR Act was made out, the case was registered only under the MCP Act (Madras City Police Act).

The harassment meted out to Harijans by the inspector of police in the course of investigation/interrogation in the double murder case has also caused a feeling of frustration in the minds of the Harijans. It was a genuine feeling that they had to face this treatment mainly because they belonged to the pallan caste. This atmosphere has been taken advantage of by a few leaders like Shri Dorai Raj (now Uma Shariff).

The caste Hindus mentioned that money had played a role in the conversion. The representatives of the Arya Samaj were of the opinion that foreign money had played a major role. As for the inducement by way of money is concerned, the converted Harijans categorically denied any allurement and they also said that it was they who approached the Muslim leaders first. Confidential enquiries with some of the non-converted Harijans also revealed that it was only after the Harijans of the village took the initiative, the Muslim leaders took the action for conversion. Hence it is not possible to say in this regard, anything categorically, about the involvement of the foreign money.

[1]*Muslim India*, March 1983.

2. Neither Foreign Money Nor Coercion is the Cause of Conversions[1]

What exactly is the reason for the mass conversion of Harijans to Islam in Meenakshipuram, a desolate hamlet, 12 kilometres from Tenkasi in Tirunelveli district or in Kilakaraj and Theriruveli villages in Mudugalathur *taluk* of Ramanathapuram district of Tamil Nadu?

Talks with a cross-section of the Harijans, Muslims, and caste Hindus in some of the interior villages of these two districts as also of Thanjavur district, give the impression that neither foreign money nor coercion made them embrace Islam. Acute poverty, social inequality, and persecution by upper-caste Hindus forced some of the Harijans to do so.

Meenakshipuram has a twenty-year-old history of acute caste Hindu–Harijan tension. There were sporadic incidents in the last two or three years. But relations between the two have never been so bad as they are today. Though officials claim that the village is inhabited by 945 Harijans of which 558 have embraced Islam in

February 1981, a survey of the village is being undertaken to make a correct assessment and also a review of the work done.

'It is not poverty that made us switch over to Islam,' said Paramasivam, a former president of the Panchayat Board, who now calls himself Syed Sulaiman, 'but the torture the select Harijans in the village were subjected to by the police.' He alleged that following the murder of two members of the Thevar community at Mekkarai village, near Meenakshipuram, the Harijans were frequently interrogated in an attempt to trace the culprits involved in the murder but still absconding.

Another convert said that most Harijans in the villages were farm workers. To reach their place of work they had to go through the village of Panpozhil inhabited by caste Hindus who always humiliated them. His contention seemed to be that the idea of conversion was not of recent origin but was lingering in their minds for the last few years. He said that a Harijan's attempts to open a tea stall were thwarted by caste Hindus. Another man had to close down a hairdressing shop he was running because of threat from the upper-caste Hindus.

Better respect now

Syed Sulaiman denied having to pay money for conversion and asserted that after he and a group of Harijans got converted, they were getting better respect from the same old caste Hindu families.

However, S. Paramasivam (31) and R. Arunachalam (30) who became Muslims have now come back to the Hindu religion. They denied having taken Rs. 500 for becoming Muslims. 'The concessions extended to Harijans by the state and Central governments are substantial and it is only to escape humiliation and torture at the hands of the caste Hindus that one has to embrace Islam,' Arunachalam said. He conceded that the living conditions of Harijans continued to be the same even after conversion to Islam.

There were educated Harijans like Miss Selvam at Meenakshipuram who were 'proud to be Hindus and to fight for our rights remaining in the Hindu fold'. She recalled the poverty of her family as also the way in which she completed her BA with government scholarship money and said many like her among the Harijans did realize that once they embraced Islam, the concessions now extended would be lost and they too would become one among several lakhs in the backward communities.

Recently in Melamadai in Ramnad revenue division, printed circulars were distributed among Harijans appealing to them to embrace Islam.

A doctor with MBBS qualification—Dr Palraj—became a Muslim in the early seventies. A former Harijan, this assistant surgeon in Ramnad town said that he did so out of love towards Islam. He dismissed as 'nonsense' the allegation that money played a prominent role in such conversions. He admitted however that certain well-to-do persons did come forward to extend monetary assistance for undergoing circumcision.

Ramnad town which was the centre of rioting recently following the clash between the Harijans and the caste Hindus has returned to normalcy. At least 500 persons (300 Harijans and 200 caste Hindus) were arrested following the riot. The police had to open fire which resulted in the death of two persons.

Peace committees

According to Mr S. Adiseshiah, divisional revenue officer in Ramnad, peace committees had been formed with members drawn both from among the Harijans and the caste Hindus in twenty-five villages. He said that the attention of the people had been diverted by providing them drought relief work for which one crore of rupees had been earmarked and the work would keep them engaged till September end.

The rioting in Ramnad followed a section of Harijan students resorting to eve-teasing of caste Hindu girls in the town. In Kilakarai and Melamadai villages, the Harijans who became Muslims pointed out that they were not addressed with objectionable words now by the caste Hindus. The officials claimed rioting was due to illicit distillation by both caste Hindus and Harijans.

In all the three districts of Ramanathapuram, Thanjavur, and Tirunelveli, untouchability is practised in rural areas. In Tirunelveli district, eighty cases were pending under the Untouchability Offences Act of 1955 up to 1978. Out of this, seventy-four cases were disposed of while only one case ended in conviction and sentence. No case has been disposed of in 1981 so far though nine cases have been booked.

In East Thanjavur district also, during May this year, 162 cases were reported while charges were framed in 149 of them. Of these eighteen resulted in conviction. In West Thanjavur, during March, twenty-five cases were registered but only three were disposed of.

A separate mobile police squad has been formed in every district to detect any infringement of the provisions of the Untouchability Act and to book offenders. These squads commenced work in 1972. But the squads could not do anything as the Harijans who were actually involved in the cases failed to give evidence before the squads fearing harassment form caste Hindus.

In Kuppunapuram village of Ottapidaram constituency in Tirunelveli district, the Harijans were not allowed to take water from the public well. Mr M. Appadurai, MLA, said that similarly in Kulayakarisal village, Harijans could not enter a tea shop. In Vasudevanallur constituency, according to Mr R. Krishnan, Marxist MLA, tea was served in separate glasses to Harijans. The legislators claimed that these poor innocent people could not draw the attention of police since they would be harassed by the caste Hindus in their villages.

The Elayaperumal Committee set up by the Government of India in 1965 to study various aspects of untouchability and formulate measures for the educational and economic development of the Scheduled Castes submitted its report early in 1969. It recommended the constitution of State, District, and Taluk Harijan Welfare Boards. These Boards were asked to review matters relating to the problems of untouchability and suggest ways and means to improve the lot of the Harijans. The taluk-level Board was to meet once a month and bring to the notice of the police any case of untouchability which came to its notice. The Committees send their resolutions to the director of Harijan welfare, who after scrutinizing them, passes them on to the government for taking appropriate action.

These Boards can be revitalized now only if the 'affected parties' came forward boldly to give evidence in the cases booked.

Sub-sects among Harijans

Even among Harijans there were sub-sects. One Harijan in Ambasamudram (Tirunelveli district) said that in South Arcot and Thanjavur districts, the Harijans would neither be hosts nor the guests of certain sub-sects of Harijans. In Tirunelveli itself, he added, intermarriage is prohibited between these groups and the Samban caste is supposed to be superior to others. There are instances where barbers and washermen do not serve Harijans and the Harijans have washermen of their own caste.

The Harijan welfare officials feel that establishment of separate Harijan hostels and granting of scholarships cannot promote social integration. On the other hand, it would only strengthen and widen social inequalities and promote a feeling of segregation and inferiority. The Vasudevanallur legislator, Mr Krishnan, suggested the setting up of a development corporation for the Scheduled Castes and Scheduled Tribes to deal exclusively with their economic conditions.

The Muslims in Tenkasi claimed that caste Hindus did not like the growing prosperity of the Harijans. They said that when the harassment reached a point of no return, some Harijans approached the South Indian Islamic Society at Tirunelveli with a proposal for conversion. This society was engaged in converting Harijans and others who of their own accord embraced Islam and nearly 8000 had thus been converted in the last fifteen years or so. Such conversions, they said, were nothing new.

Hindus deny charge

The caste Hindu communities in Tirunelveli and Ramanathapuram deny that there was animosity between them and the Harijans. In areas like Tenkasi, Ambasamudram, and Tirunelveli itself as also in Watrap, Srivilliputtur, and Sivaganga, in Ramnad district, the caste Hindu farmers referred to the aid given by them to the Harijans in the form of credit advance or giving paddy as also providing money to the children of Harijan farm workers. They cited instances of a few Harijans who were well-off with landed properties.

Mr T.M. Arumugham, collector of Tirunelveli, believed that steps had been taken to provide all amenities in Meenakshipuram village for the uplift of Harijans. Explaining that 30 per cent of the total population of thirty-six lakh in the district were Harijans, he pointed out that last year a sum of Rs. 44.74 lakh had been spent for the education of Harijans while another sum of Rs. 11.50 lakh had been spent on health, housing, and other social schemes. Expense incurred for land acquisition was Rs. 1.01 lakh in 1969. But last year, it rose to Rs. 4.61 lakh.

Mr H.M. Pandey, collector of Ramanathapuram, said that for the uplift of Harijans in his district, a sum of Rs. 80 lakhs had been allotted. It was proposed this year to bring at least 150 Harijan families above the poverty line in each block.

The collector said that there were a few isolated cases of conversions but no case of compulsion had been reported. After the

out how a Harijan candidate—Mr Balraj—supported by the AIADMK won the Corporation election in a ward in Madurai defeating Mr Thennarasu of the DMK who was a caste Hindu.

In Lilkulam village near Ambasamudram, a graduate Harijan youth said that he was unemployed for the last three years. He had now to attend to farm work along with his father. The District Employment Exchange in Tirunelveli, however, said that of the total number of 71,904 registered with the Exchange, 11,913 were Harijans. Of these, 297 were graduates. In the last one year, out of 11,913 Harijans on the live register, 621 were provided with jobs.

Educated Harijans said that it was not enough if education was given to them. They were not getting jobs. A Harijan youth who graduated in April last year said that during his college course he stayed in the hostel with all facilities. But now when he returned to live with his parents in 'Cheris', the atmosphere completely neutralized the good effect that the hostel and the college life produced on him. He said that Harijan youths could get jobs only if they possessed some 'influence'.

[1]*The Hindu*, 15 June 1981.

3. Muslim MPs Submit a Memorandum to the Prime Minister on Communal Riots[1]

On 5 November 1982, forty-four Muslim members of Parliament, including those belonging to the ruling Congress (I), submitted a memorandum to Prime Minister Gandhi. Following is the text of the memorandum:

The recent communal disturbances in Meerut and other places have once again brought to the fore some basic questions regarding the future of the secular order, the rule of law, the role of the law and order machinery, the responsibility of the mass media, and the duty of the government towards the citizens.

People all over the country ask us: How long shall we live this recurrent nightmare?

The yielding secular forces

Communal virus is ever present in our body politic. So, an outbreak

People all over the country ask us: How long shall we live this recurrent nightmare?

The yielding secular forces

Communal virus is ever present in our body politic. So, an outbreak of communal violence cannot be prevented. But communal violence can, and must, be controlled within twenty-four hours, if there is political will and if the administration is neutral and effective.

All around us we see secular forces yielding ground to the forces of communalism which have penetrated deeply in the political system and in the administration. The nationwide campaign of vicious propaganda against the Muslim community by the Vishwa Hindu Parishad, has corroded the foundations of the secular order and widened the gulf between the Hindus and the Muslims. Today chauvinism is on the offensive with the slogan of 'Hinduism in danger'. Its object is to generate hatred and distrust against the Muslim community and to force it into cultural assimilation and thus turn secular India into Hindu *Rashtra*. Irresponsible talk about the wave of Islamic fundamentalism and the banal references to 'foreign hand' and 'foreign money', not only poison the atmosphere but serve to create a fear psychosis in the Hindu community, to check its generous and tolerant impulses.

Today political parties compromise with communalism and maintain silence on atrocities against the minorities. Today the administration, specially the armed constabularies, like the Provincial Armed Constabulary (PAC) in UP and Bihar Military Police (BMP) in Bihar, act in a blatantly partisan and communal manner. Today communal violence is turning more and more into police action against the Muslim minority. Today the victim is being projected as the aggressor, as a rebel, and as a traitor. Today Muslims are arrested in hundreds and tortured, their limbs are broken, the privacy of their homes is violated, their property is destroyed, their places of business are put to flames, and their places of worship are desecrated, all with the connivance and support of the so-called guardians of law and order. Consequently, the Muslim minority is losing faith in the neutrality of the administration, and the credibility of the government as the protector of the weaker sections is being corroded. Is there no one to end this macabre dance of injustice and destruction? Have we lost our sense of values? Have we surrendered our future to the demon of violence? Are our dreams of a New India destined to turn into a nightmare? Shall the dawn of freedom turn into the night of fascism?

Effective steps

We beseech you to take effective steps to stop this downward slide before the country falls prey to the purveyors of hatred and violence, before the nation loses its vision and before the weaker sections lose faith in the system.

And to this end, we have come to seek your advice and to submit some suggestions for your consideration:

1. The defenze and protection of the minorities against violence should become the responsibility of the Central government and be treated as a national issue, and not simply as a law and order problem in the same manner as atrocities against Harijans are, through a constitutional amendment, if necessary.

2. The police force and the intelligence machinery must be purged of communal elements and restructured to provide due and effective representation to all sections of our people. The ethos of the force should be changed through proper training aimed at imparting secular and professional values. As promised in your manifesto and on the floor of Parliament, special anti-riot task forces should be constituted, both at Central and state levels for exclusive deployment in riot situations. Until such forces are raised, the CRPF and BSF should alone be deployed and not state armed constabularies.

3. The record of senior police and executive officers should be screened for communal bias and for performance during communal disturbances and anyone suspected of communal bias or found wanting should not be posted to sensitive districts. In such districts, there should be a proper mix of officers to generate all-round confidence. Officials against whom there are specific charges of committing atrocities or of using force with communal bias should be denied the protection of the state, and they should face the legal consequences of their action as common criminals, through an amendment of the criminal law, if necessary.

The CM's duty

4. If communal disturbances do not stop within twenty-four hours of the first loss of life, the chief minister must personally rush to and camp in the area till normalcy is restored. The DM and SSP should be held responsible and immediately suspended and replaced by a pre-selected team of officers known and tested for their efficiency, integrity, and secularism and for commanding the confidence of the weaker sections, as in Bihar Sharif in May 1981.

5. The victims of violence should be appropriately compensated for loss of life and limb in accordance with uniformly prescribed scale. All property, movable or immovable, lost or damaged, should be replaced or

reconstructed at state expense. Compensation so paid should be recovered by imposing a punitive fine on the two communities in inverse proportion to the loss suffered.

6. The criminal cases arising out of communal disturbances should be expeditiously investigated by Central intelligence agencies and tried by special courts, to restore the faith of the people in the rule of law and in the judicial process.

Ban communal organizations

7. All para-military or extremist organizations preaching communal hatred such as Vishwa Hindu Parishad and RSS should be banned and, to begin with, their public activities should be restrained.

8. During the riot period, all newspapers and periodicals should be screened for rumours and misreporting, and malicious and mischievous writings should be dealt with in accordance with law. Rumours or wrong information should be officially contradicted on a daily basis. Detailed information about casualties, including names of those killed, hospitalized, and arrested should be published in daily bulletins, in order to scotch misinformation and to apprise the nation of the truth, the whole truth, and nothing but the truth.

9. To impart a secular outlook to our younger generation, all textbooks of history and languages should be screened expeditiously to purge objectionable matter and the educational system should be reviewed.

If our great nation is to fulfil its destiny, if we are to survive as a civilized society, if our ideals have some meaning, we cannot afford to ignore the spate of violence which affects our development and our stability and the setback that brutalities and atrocities cause to the process of national integration.

As the prime minister of the country and as the leader of its biggest political party, you have to play the key role in restoring our vision, in ensuring security and equality to all, and in awakening the conscience of the nation.

[1]*Janata*, 19 December 1982.

4. Prime Minister Decides to Set Up a Panel for Looking into Muslim Grievances[1]

The Prime Minister has decided to set up a committee headed by the Union home minister to go into the grievances of the Muslims and take effective steps to redress them. The five-member

memorandum by Muslim MPs and leaders of the Mulk-o-Millat movement (Tehreek).

An official release issued by the Ministry said:

The government fully stands by the decisions taken by the National Integration Council and is determined to implement it by fixing responsibility on district officials who have failed in their duty to maintain law and order. A beginning has already been made in raising a special peace-keeping force in which adequate representation has already been given to the members of the minority community at all levels. This force will be suitably expanded in due course.

Question of suitable compensation and other demands will be considered sympathetically by the government on the recommendation of the committee.

[1]*The Statesman*, 21 February 1983.

4a. Government Replies to Muslim MPs' Memorandum on Communal Riots[1]

24 February 1983

Please refer to the memorandum dated 5 November 1982 submitted by Muslim members of Parliament to the prime minister, regarding communal disturbances.

2. I appreciate the concern expressed in the memorandum regarding the need to maintain the secular ethos of our country and note the various suggestions made in this regard.

3. The Central government has always assigned, and has constantly advised the state governments to give the highest priority for the protection of minorities. Detailed instructions have also been issued to the state governments on the subject. I have myself been writing to the chief ministers to ensure that state governments initiate and continue suitable measures for the maintenance of communal harmony. We have also been keeping watch on activities which undermine the forces of secularism.

4. In the guidelines issued to the state governments, which are quite exhaustive, and also in my personal communications to the chief ministers, we have been constantly attempting to ensure that the composition of the police forces and intelligence agencies is made more broad-based so as to be representative of a cross section of the society.

chief ministers, we have been constantly attempting to ensure that the composition of the police forces and intelligence agencies is made more broad-based so as to be representative of a cross section of the society.

5. In your memorandum you made mention of the need for special anti-riot task forces. The state governments keep on reviewing their requirements to meet the law and order situation and necessary steps are then initiated by them. Nevertheless, the Central government have already raised three peace-keeping battalions of the CRPF for such purposes. There is a proposal for raising more such battalions. I may add that we have also impressed upon the state governments that special training should be imparted to police personnel so as to give them proper orientation for handling communal situations. A course on police–community relations has also been suggested. Certain state governments have set up Working Groups for an in-depth study of the causes of communal disharmony and for evolving suitable measures to deal with its basic causes.

6. We have advised the state governments to ensure the posting of suitable police and executive officers for communally sensitive areas. However, you may appreciate that no predetermined line of action against officers can be laid down in situations of communal disharmony, since one situation would be very different from another. The basic point is that the concerned senior officers should be aware of their responsibility in ensuring that the communal happenings are contained at the earliest. The erring should be brought to book. The senior officers and chief ministers and other ministers have been visiting places of disturbances. I had also, as you know, gone to Baroda and Meerut. More recently, the prime minister herself visited Moradabad, Meerut, and Baroda.

7. We are aware that great hardship is caused to the people during communal disturbances. We have advised the state governments to draw up proper schemes for the rehabilitation of victims of communal violence. The ministry also pursues the matter in specific cases. We have also asked the concerned governments to examine the need for special courts to deal with the cases arising out of communal violences. This has also been done in some cases. Punitive action has been proposed and even the setting up of special machinery to supervise investigation and prosecution of cases connected with communal matters has been suggested by us. Similarly, various other measures have been proposed and both the Centre and the state governments are actively engaged in improving the administrative systems to deal with communal disturbances.

8. Regarding the suggestions made by you about correct reporting and publicity to counter rumour-mongering during and about communal disturbances, we have issued detailed guidelines to the state governments which take care of the suggestions made by you. The committee on education set up by the National Integration Council is seized of the need to screen all textbooks to ensure that objectionable matter in the educational system, if any, be removed. This is being looked into by the ministry of education, and this aspect is being expedited.

9. Government is keeping a watch on the activities of various communal organizations. State governments have been advised to ensure that government employees do not get involved with organizations which fan communal passions.

10. I would like to assure you that we are making all possible efforts to see that the virus of communalism is contained and that prompt action is taken by all concerned to prevent and control communal incidents. It is also our intention to continue our vigil in this direction even in future and provide reinforcement, as and when called for, to contain this evil.

With best wishes,

Yours sincerely,
Sd.
P.C. Sethi

[1]*Muslim India*, April 1983.

5. General Shah Nawaz Khan, Leader of the Mulk-o-Millat Bachao Tehrik Writes to Prime Minister Indira Gandhi[1]

The Prime Minister
Government of India,
New Delhi

We the undersigned bring, with deep pain and anguish, to your notice the unabated violation of the values of secularism and the unmitigated Muslim-baiting at the hands of communal chauvinist forces with active connivance and collaboration of sizeable sections of administration and police in various states.

Secular democracy is a precious legacy that we have inherited from our long freedom struggle. . . . This glorious legacy, Madam, is being callously trampled underfoot. Moradabad, Meerut, and Baroda are gaping wounds on its body calling for serious thinking and determined action. The active involvement of some sections of the government machinery in these patently anti-Muslim actions, the indifference of a large section of society, the failure of political leadership, and the apparent helplessness of secular forces have caused frustration and dismay all around, particularly among the Muslims who are victims of this ruthless violence.

An atmosphere has been generated through high-pressure propaganda in which even a voice of protest against manifest injustice is difficult to raise, what to speak of demanding justice for the suffering community. The verbal assault that has been launched under the leadership of the RSS and Vishwa Hindu Parishad against the entire Muslim community over a few conversions in Meenakshipuram—unmindful of the fact that the fundamental right of propagation and freedom of faith is being exercised in the form of conversions and reconversions in all directions—is not only flagrant violation of the Constitution but also an indication of the deep inroads that fascist ideas and techniques have made into our social and political life. The pity is that no powerful voice is raised against all this vulgarization and brutalization of human feelings and those that are raised find no response from the ruling circles. On the other hand, there goes on loud, irresponsible, and unchecked propaganda about Muslims receiving foreign money to convert India into a Muslim-majority nation. Sometimes even official agencies lend a hand to add to the credibility of such falsehoods. . . .

Madam, you know it very well that Jamiat Ulama-i-Hind, from its very inception, has constituted an integral flank of the army of freedom fighters, and its founders and early leaders were among those who developed and fostered the ideas of composite nationalism and united endeavour for better life on a secular basis. Naturally, the Jamiat cannot remain a silent spectator to the erosion of those values.

Then came the elections. The Indian National Congress (I) under your leadership issued a manifesto which included the promise to implement all the demands that the Jamiat had been making to strengthen the secular character of Indian society and politics. It promised to create conditions in which minorities could act freely and participate in all walks of life, to protect their culture and

204 The Muslims of India

belief, to curb the activities of communal and divisive forces, to take effective steps to stop communal riots, and to provide full compensation to victims of communal violence.

Specific mention was made of a resolve to create a special force to deal with communal riots.

Madam, we regret to say that none of those promises has been fulfilled. In fact, within a few months of your coming back to power occurred the tragic happening in Moradabad where the festival of Id had been drenched in the blood of innocents by the PAC. Speaking from the Red Fort on 15 August 1980 you had announced that you would see to it that those responsible for Moradabad tragedy would be given exemplary punishment.

What happened? No culprit was apprehended. None was punished. Anti-Muslim tirade continued. The communal elements amongst the general population and within the police got emboldened. The tragedy was repeated in Bihar Sharif, in Meerut, in Baroda, and now in Trivandrum. The poison is going deeper and wider with every passing day.

It is in these circumstances of despair and frustration that we approach you with the following demands:

1.	The district authorities and intelligence services should be held responsible for outbreak of communal disturbances. If they fail in controlling disturbances they should be suspended forthwith and if they are proved guilty they should be strictly dealt with.
2.	The intelligence services should be entrusted with the responsibility of tracing out persons suspected of communal riots and special courts should be set up for the disposal of cases and matters relating to communal riots.
3.	Those suffering loss of life and property during communal disturbances should be fully compensated or paid at least Rs. 100,000 per person dead. Those wounded and those who suffer financial loss should be fully compensated and riot protection compulsory insurance scheme on nominal premium should be enforced.
4.	In security forces like PAC and BMP there should be 33 per cent reservation for Muslims and 33 per cent reservation for other minorities. A code of conduct and training programme should be evolved for such forces so that they may be morally and mentally equipped for shouldering their responsibilities in a secular and democratic set-up. Till the remoulding and restructuring of these security forces is completed, they should not be deployed in riot-affected areas; in such areas Central security forces should be posted.

5. Semi-military drills of RSS and other communal organizations, should be banned and the government should arrange for physical training of all children and youth, irrespective of their caste, community, and religion.
6. All departments, agencies, and organizations of the government should be purged of persons connected with RSS and other such fascist organizations.
7. The clause relating to the uniform civil code should be deleted from the Constitution of the country.
8. Permanent arrangement should be made for the protection of mosques, graveyards, and Auqaf of Muslims, and immediate effective action should be taken to free them from adverse illegal possession wherever it has taken place. . . .

We, therefore, urge you to implement these demands, which are your own promises made through the Congress (I) election manifesto of 1980, with immedatte effect. . . . In case no satisfactory response is received before 21 February 1983, we shall be constrained to launch a civil disobedience movement in collaboration with other like-minded secular forces. . . .

(General Shah Nawaz Khan)
Amir, Mulk-o-Millat Bachao Tehrik,
17, Balwant Rai Mehta Lane,
New Delhi

[1]Pamphlet published in February 1983 by the Jamiat-ul-Ulama-e-Hind which launched the Mulk-o-Millat Bachao Tehrik.

5a. Indira Gandhi Replies to General Shah Nawaz Khan[1]

Prime Minister's House
New Delhi
21 January 1983

Dear General Shah Nawaz Khan,

I have received your letter in your capacity as Amir, Mulk-o-Millat Bachao Tehrik.

You already know of my deep concern for the welfare of minorities and of my distress at communal disturbance and violence.

Our election promises made in 1980 have not been neglected. They have been largely fulfilled or action taken to fulfil them by the Central government.

The home minister has written to all chief ministers regarding the responsibilities of district authorities and intelligence service. Some states have already introduced compensation schemes for riot victims. State governments have also been advised to prohibit RSS *shakha*s in public places.

Reservation for Muslims and other minorities in security forces has come up against constitutional impediments. However, we are doing whatever is possible. I have spoken publicly and privately to employing agencies. We have already raised three CRP battalions as a special peace-keeping force which are posted in Delhi, Hyderabad, and Durgapur. These battalions have considerable minority representation. I am looking into what more can be done.

You have also spoken of deleting the clause relating to uniform civil code from the Constitution. In our manifesto, the Congress pledge was not to interfere in Muslim personal law and we have not done so in any way.

We discourage proliferation of RSS sympathizers in any government organization and have given instructions that *shakha*s should not be allowed. You will agree that under the rules, it is not easy to dismiss people. In new appointments, such attitudes are kept in mind.

If you can cite any specific instances of religious places under adverse possession, government will take action under the law.

It is true that much more can be done to improve the living conditions of Muslims. The government and our party must indeed be more active. I am urging all state governments to do their part. Initiative also has to come from the community itself like availing of better educational facilities. But confrontation and the spreading of an atmosphere of desperation are likely to be more damaging to the minorities themselves by arousing reaction in other communities.

In Karnataka, the Muslims did not vote for us, with the result that now there are only two Muslim MLAs.

Yours sincerely,
Sd.
Indira Gandhi

[1]Pamphlet published in February 1983 by the Jamiat-ul-Ulama-e-Hind which launched the Mulk-o-Millat Bachao Tehrik.

6. Prime Minister Indira Gandhi's Fifteen-Point Scheme Plan[1]

Prime Minister Indira Gandhi issued a directive on 12 May 1983 to all the Central ministries as well as the states to ensure that special consideration is shown to the minorities in the matter of recruitment to police forces.

In a letter addressed to members of the Union Council of Ministers on the problems facing the minorities and recurrence of communal incidents, she said that to ensure proper representation to minorities in the police forces and services, the selection committees should also have representatives of various communities.

She has underlined the need to attend problems relating to minorities on a continuing basis so that their apprehensions are allayed and genuine grievances redressed. A step in this direction will be the setting up of a special cell in the Union home ministry to deal with matters relating to minorities.

While listing fifteen points for urgent consideration and implementation by the Centre and the states, the prime minister has said that other measures under consideration will be announced very soon. This will facilitate the participation of Muslims and other minority groups in all aspects of national life and thus promote the cause of national integration.

She has asked the states as well as the Union ministries to send her a quarterly report on the results of the action taken to implement the decisions conveyed to them through her letter.

The prime minister has, in particular, stressed the need to set up special courts to try communal offences, payment of adequate relief to the victims of communal riots, and provision of employment opportunities for the minorities in the railways, nationalized banks, and public sector undertakings.

Since the home ministry is directly responsible for law and order and minority affairs, its major role in removing the grievances of the minorities has been underlined.

The following is the text of the prime minister's letter:

The increase of communalism in recent months and the large number of attacks on the lives and properties of minorities is cause for deep sorrow. These incidents are a blot on the good name of our country. They have been deliberately created by militant communal elements who do not hesitate to sacrifice the strength and security of the country for their own narrow nefarious ends.

From my earliest childhood I have been committed to the secular ideal. In India of our dreams Muslims and other minorities can live in absolute safety and confidence. Since the meeting of the Integration Council in Srinagar, several measures have been suggested from time to time. But perhaps because the situation had improved, some slackness crept in and there is need to take new initiatives to combat this growth of communalism and to prevent and deal promptly and firmly with communal tension. We must devise mechanisms by which the conscience and political power of the entire nation are enlisted to deal with such situations.

I have met several delegations of members of Parliament and other representatives of Muslim and other minority groups and have discussed measures to prevent the recurrence of communal violence and to improve the economic conditions of minorities. After careful consideration of the suggestions which emerged, I have decided that immediate action should be taken as indicated below:

I. Communal riots

1. The state governments are being advised that in the areas which have been identified as communally sensitive and riot prone, district and police officials of the highest known efficiency, impartiality, and secular record must be posted. In such areas and even elsewhere, the prevention of communal tension should be one of the primary duties of DM and SP. Their performances in this regard should be an important factor in determining their promotion prospects.

2. Good work done in this regard by district and police officials should be rewarded.

3. Severe action should be taken against all those who incite communal tensions or take part in violence.

4. Special courts or courts specially earmarked to try communal offences should be set up so that offences are brought to book speedily.

5. Victims of communal riots should be given immediate relief and provided prompt and adequate financial assistance for their rehabilitation.

6. Radio and TV must also help in restoring confidence, communal harmony, and peace in such affected areas.

7. It is unfortunate that certain sections of the press sometimes indulge in tendentious reporting and publication of objectionable end inflammatory material which may incite communal tension. I hope that editors, printers, publishers, and others concerned will cooperate in finding a way to avoid publication of such material.

II. Recruitment to State and Central services

1. In the recruitment of police personnel, state governments should be advised to give special consideration to minorities. For this purpose, the composition of selection committees should be representative.

2. The Central government should take similar action in the recruitment of personnel to the Central police forces.

3. Large-scale employment opportunities are provided by the railways, nationalized banks, and public sector enterprises. In these cases also, the departments concerned should ensure that special consideration is given to recruitment from minority communities.

4. In many areas, recruitment is done through competitive examinations. Often minority groups have been handicapped in taking advantage of the educational system to compete on equal terms in such examinations. To help them to overcome these handicaps, steps should be taken to encourage the starting of coaching classes in minority educational institutions to train persons to compete successfully in these examinations.

5. The acquisition of technical skills by those minorities which are today lagging behind would also help in national development. Arrangements should be made to set up ITIs and polytechnics by government or private agencies in predominantly minority areas so as to encourage admission in such institutions of adequate number of persons belonging to these communities.

III. Other measures

1. In various development programmes, including the twenty-point programme, care should be taken to see that minorities secure, in a fair and adequate measure, the benefits flowing therefrom. In the various committees which are set up to oversee the implementation of such programmes, members of these communities should be actively involved.

2. Apart from the general issues to which I have referred, there are various local problems which develop into needless irritants to minorities. For instance, encroachment of *wakf* properties and of graveyards has led to protests and grievances in some places. Suitable steps should be taken to deal with such problems on an expeditious and satisfactory basis.

3. Problems relating to minorities need to be attended to on a continuing basis so that apprehensions are allayed and genuine grievances redressed. To facilitate this, a special cell will be created in the ministry of home affairs to deal with matters relating to minorities.

Some other measures are also under consideration. Decisions on them will be announced as early as possible. I am sure that the measures that I have indicated above and others which will be announced shortly will facilitate the full participation of Muslims and other minority groups in all aspects of national life and thus promote the cause of national integration.

I would like to receive from you a special report every quarter on the results of action taken to implement the above decisions.

[1]*The Hindustan Times*, 13 May 1983.

7. Majlis-e-Mushawarat Raises the Issue of Restriction on Prayers in Mosques Within Protected Monuments[1]

The All-India Muslim Majlis-e-Mushawarat memorandum was addressed to Prime Minister Indira Gandhi. The PM's secretariat was asked in writing to fix an appointment with the prime minister for its presentation. A member of Parliament belonging to Mrs Gandhi's own Congress-I party was asked to make personal contact. He met Secretary R.K. Dhawan and then Mrs Gandhi herself. Nothing came out.

Finding that precious time was being lost unless the prime minister was apprised of the situation, the Mushawarat approached the home minister and delivered the memorandum to him with a request that it be immediately transmitted to the prime minister.

The memorandum is signed by Maulana Saminuddin, Mr Maqsood Ali Khan, both Congress-I MPs, Mr S. Shahabuddin, MP and vice-president of the Mushawarat, Mr Ebrahim Sulaiman Sait, MP and president of the Indian Union Muslim League, Maulana Syed Ahmad Hashmi, MP, Maulana Ahmad Ali Qasmi, general secretary of the Mushawarat, Justice M.R.A. Ansari, former chairman of the Minorities Commission, Mr Javed Habib, editor, *Hujoom Weekly*, and Mr A.H. Rizvi, editor, *Radiance*. The memorandum is reproduced below:

On behalf of the Muslim community, we submit this memorandum to pray for removal of restrictions on the Muslims offering prayers in mosques which have been declared as national or protected monuments under the Ancient Monuments and Archaeological Sites and Remains Act, 1958, hereinafter referred to as the Act, and the Rules framed thereunder.

Large number of mosques in Delhi and other places in the country have been declared as national or protected monuments under the Act. Some of them are situated within the precincts of tombs, palaces and *dargahs*. Recently, the archaeoogical authorities have imposed a ban on Muslims offering prayers in these mosques. This has led to some agitation and in fact some Muslims attempting to offer prayers have been forcibly prevented by the police and even detained. It is not clear which provision of the Act or the Rules framed thereunder have been invoked to impose the restriction.

Article 25 of the Constitution guarantees the right freely to profess, practise, and propagate religion, subject only to public order, morality, and health. This fundamental right is not subject to any other limitation.

Thus, the right to profess and practise religion cannot be taken away on the ground of preservation of national monuments. Any such restriction would be unconstitutional and void. Any provision to that effect in any law in force would be ultra vires the Constitution.

The Act itself contains no provision under which restriction can be imposed on the offering of prayers in mosques declared as national or protected monuments. On the other hand, Section 5, Subsection (6) of the Act specifically provide for the continuance of religious worship in the places of worship which come under the Act. Section 5(b) states: 'Nothing in this Section shall affect the use of any protected monuments for customary religious observance.' This provision clearly safeguards the right of a Muslim to offer prayer in a mosque which may have been found suitable for being declared as a national or protected monument. As a matter of fact, prayers are freely and regularly offered in innumerable mosques in Delhi and other places which have been so declared.

Article 49 of the Constitution emphasizes the scope as well as the limitation of any law passed for the preservation of national monuments, when it lays down that it shall be the 'obligation of the State to protect every monument . . . for spoliation, disfigurement, destruction, removal, disposal or export, as the case may be'. Prohibition to offer prayer is outside the scope of this Article. Indeed, the authorities are competent to make due arrangements or issue necessary instructions for fulfilling the objects mentioned in this Article. In the case of mosques, the Muslim community will extend wholehearted cooperation in this regard being vitally interested in the upkeep and maintenance of their mosques. It may be added that if places of worship are used for religious worship, such use is not contrary to the demands of preservation and maintenance. Indeed, if they are in disuse, they tend to run into decay, because of neglect.

The fact that in a particular mosque religious worship has been discontinued due to disturbance or movement of population does not take away its character as a mosque or detract congregationally from the right of Muslims to offer prayers individually. Under the Muslim law, once a property is dedicated as a mosque and worship is offered in the mosque, it assumes the permanent character of a mosque. Mulla's *Mohammedan Law* (18th Edition, p. 246) clearly lays down that a mosque belongs to God and is dedicated to his worship and that 'the right to offer prayer in a mosque is a legal right for the disturbance of which a Muslim is entitled to seek relief in a court of law'. As stated above, a mosque does not cease to be a mosque by a declaration under the Act, since the Act was not intended to prevent the use of a mosque as a place of worship, but merely to preserve its historical or artistic value by declaring it as a national or protected monument.

On the one hand, the Act does not give any power to the authority to prohibit the offer of prayers in a protected mosque; on the other, it lays a duty on them to maintain and keep the mosque in a state of good repair. It is our sad experience that the authorities are failing in their statutory

duty and many mosques are turning into ruins. What is worse is that many of them are being subjected to desecration and vandalism with active assistance or passive acquiescence of the immediate authorities concerned. The present condition or several 'protected mosques' in Delhi and other places in the country bear ample testimony to the fact that the department of archaeology is not performing its duties.

In this connection reference may be made to letter No. HM/243/D/179 of 7 March 1979 from Shri Sikandar Bakht, then minister for works and housing, Government of India, to Maulana Mohammad. Yusuf, the Amir of Jamat-e-Islami-Hind. The relevant portion of that letter is reproduced below:

> I am pleased to inform you that a formal decision has already been taken with regard to permitting Muslims to say their prayers individually or in a "Jamaat" in the mosques attached to archaeological monuments. This decision was taken in a formal meeting which was held in the ministry of education in which besides myself, the minister of education and all the officers of archaeological department were present.

The action of the archaeological authorities in prohibiting the offer of prayers in these mosques and in permitting them to decay and to be desecrated is thus clearly uncalled for and is causing great distress to the Muslim community.

We, therefore, pray:

(1) that the government be pleased to examine this question in the light of law and reason and to restore to the Muslim community their constitutional and religious right of offering prayers in the protected mosques;

(2) that the government should allocate due resources for their maintenance and repair if the purposes of 'protection' are to be fulfilled; and

(3) that the attendants employed to look after their day-to-day maintenance should be Muslims.

<div align="right">

With respectful regards,
Yours sincerely,
Ebrahim Sulaiman Sait, MP
Samenuddin, MP
Syed Shahabuddin, MP
Syed Ahmad Hashmi, MP
Mr Maqsood Ali Khan, MP
Justice M.R. Ansari
Ahmad Ali Quasmi
A.H. Rizvi
Jawed Habib

</div>

[1]*Muslim India*, October 1983.

8. Atal Bihari Vajpayee Criticizes Indira Gandhi for Arousing Hindu Communalism[1]

New Delhi, 13 June Wearing a white cotton dhoti, a loincloth that is the badge of the traditional Hindu politician, Atal Bihari Vajpayee today pondered one of the most volatile results of the Indian Army's crackdown on Sikh militants in Punjab. It is called 'the Hindu backlash'.

Mr Vajpayee is president of the opposition Bharatiya Janata Party, a coalition that in normal times should be able to count on the Hindu nationalist vote of northern India. But, like others here, he says he senses that Prime Minister Indira Gandhi is making an open grab for his constituents.

'Mrs Gandhi is playing a very dangerous game,' Mr Vajpayee said. 'The long-term interests of the country are being sacrificed to short-term gains. But encouraging Hindu chauvinism is not going to pay. As the majority community, the Hindus must be above parochial politics.'

Key to political survival

At a time of spreading religious violence in India — and what many Indian commentators see as declining ethical standards among their politicians — the struggle for the populous Hindi-speaking belt of northern India has emerged as the key to Mrs Gandhi's political survival in the national elections that she must call within six months.

But it is also emerging as a test of whether Mrs Gandhi and other politicians will resist the kinds of inflammatory appeals to religious, ethnic, and tribal loyalties that have recently touched off massacres in Assam and the Bombay region and that led first to the collapse of administrative and political institutions in Punjab and then to the Indian Army's assault on the Golden Temple in Amritsar.

In New Delhi's political salons, the speculation is that Mrs Gandhi will try to convert her decisive move against Sikh militants into 'a Falkland factor' — the sort of triumph that catapulted Prime Minister Margaret Thatcher of Britain to a decisive electoral triumph last year.

'For the coming election,' a senior Indian editor said, 'she didn't have a slogan. So this action against the terrorists in Punjab has given her a slogan — preserving the unity and integrity of the nation.'

Such patriotic themes have far greater appeal to India's Hindu

Such patriotic themes have far greater appeal to India's Hindu majority than to its patchwork of minority groups, including Muslims and Sikhs among others.

A switch last year

Several Indian politicians and journalists recall that last year, facing important election tests in Kashmir and New Delhi, Mrs Gandhi abruptly took a hard line in the negotiations with the Sikhs' Akali Dal party in Punjab, evidently calculating that this would rebound to her electoral benefit among Hindus outside the state. Her foes charge that these shifts sabotaged the chances for a negotiated settlement of Sikh demands for greater autonomy; others blame the faction-plagued Akali Dal party.

In the Kashmir campaign, Mrs Gandhi and her lieutenants blatantly appealed to the insecurities of the state's Hindu minority, losing the election but routing the Bharatiya Janata Party. 'She wanted to take advantage of the Hindu backlash,' Mr Vajpayee said. 'Mrs Gandhi's whole strategy has been to pit moderates against extremists.'

The Hindi-speaking belt is vital to Mrs Gandhi's strategy because much of southern India has drifted out of the grip of her Congress party.

The country is heading into an election at a time of sharpening tensions, not only between Sikhs and Hindus in Punjab. A new assertiveness is palpable among India's eighty million Muslims, who have new and self-confident leaders succeeding the Muslim middle class that decamped to Pakistan when it was carved out of British India in 1947.

Signs of Hindu revivalism

There are also strains of Hindu revivalism, fuelled by a young organization called the Vishwa Hindu Parishad and by *Yagnas*, or quasi-political processions, that have criss-crossed the country. One of the biggest recent political disputes in India turned suggestively on allegations that cooking oil adulterated with beef tallow had been imported—a grave religious offence to Hindus, who do not eat beef.

'The melting pot theory—that somehow we would merge into one nation—has not worked,' said V.P. Bhatia, editor of the *Organizer*, a far right publication that speaks for the Rashtriya

Swayamsevak Sangh, a powerful Hindu paramilitary organization that supports Mr Vajpayee's party. 'The minorities have become very aggressive because of the same old appeasement policy. They think they can dictate terms.'

Seeking explanations for the rise in sectarian violence, several Indian journalists and political scientists point to the decay of the Congress party, which under Mohandas K. Gandhi and Jawaharlal Nehru led India to independence. In its vigorous days, the party preached a convincing secular message that had considerable appeal among the country's minorities, while its strong regional bosses tried to keep religious extremists in check.

But, under Mrs Gandhi's stewardship, strong regional leadership has been discouraged, the party organization has atrophied, and weak local leaders have at times sought alliances with communally based groups.

'Mrs Gandhi became prime minister when the old order was in a state of fragmentation,' said Rajendra Sareen, an editor and former Congress party activist. 'The fragmentation is the dominant note of Indian politics today.'

Additional source of tensions

Some cite the relative prosperity that has come to the country in the last few years as an additional source of tensions that have bubbled over into violence. They note that Punjab, the site of the Sikh militants' campaign, is the nation's breadbasket and that the coastal state of Gujarat has both the highest economic growth rate in India and its highest sustained level of sectarian violence.

Similarly, Indian Muslims working in Arab nations in the Persian Gulf have sent back considerable sums of money, which has gone into building new mosques and repairing old ones in India. This has provoked Hindu charges that 'Arab petrodollars' are flowing into India and being used for such alarming undertakings as the conversion of Harijans to Islam.

In Punjab, a seasoned Western diplomat noted, a constant source of friction is water, which is needed both by Sikh farmers and Hindu industrialists. 'The quality of political life is such that politicians have an interest in stirring things up,' the diplomat said, 'particularly in areas that are on the move'.

[1]*The New York Times*, 14 June 1984.

CHAPTER 5

The Shah Bano Case

1. Rajiv Gandhi Promises to Open the Gates of Babari Masjid[1]

Mr Rajiv Gandhi had indicated in no uncertain terms that the gates of the Ram Janmabhoomi must open to devotees before Shivaratri on 8 March 1986. The Ram Janmabhoomi Mukti Samiti was planning to break open the temple lock that day and a sadhu had vowed to immolate himself if the temple doors were not flung open. A senior Vishwa Hindu Parishad leader revealed this information confidentially.

The local administration had been prepared in advance. The court verdict was announced at 4.40 p.m. on 1 February and the rusty lock was actually being broken at 5.19 p.m. A Doordarshan team was posted on the spot to capture for posterity surging crowds entering the shrine.

Whatever be the truth in this assertion, Vishwa Hindu Parishad leaders entertain doubt that the temple gates were open because of a 'political decision' at the highest level. They take the credit for it because of the *jan jagran* they created on the subject during the last two years with the *rathyatras*.

They had organized a high-powered group of religious leaders to lobby the support of about 250 Hindu MPs of all parties they met at the end of last year. And using their trump card they ask how can Mr Rajiv Gandhi ignore the 'Hindu vote bank' which gave him such a massive majority at the polls far exceeding the votes his grandfather Jawaharlal Nehru had ever polled?

Somehow an impression has also gained ground, among both Hindus and Muslims, that the young prime minister is amenable to pressure. If enough of a hue and cry is created on an issue he is known to renege his stand.

The Muslim assessment of the situation varies only slightly. Muslim leaders also subscribe to the view that the decision to open the temple doors was a political one but for the moment they exonerate the prime minister of any blame. Mr Rajiv Gandhi was not party to it, they assert. 'We believe he is innocent; this was done deliberately to sabotage his position,' Mr Ahmad Ali Quasami, general secretary of the All India Muslim Majlis-e-Mushawarat said. 'We have met Mr Rajiv Gandhi many times over the question of the Muslim Women Bill and we have confidence in him but not in some of his advisers. Inside the Congress (I) there is a large communal group at work.'

They are awaiting the fate of the Muslim Women Bill before pronouncing a judgment on the prime minister. However, Muslim leaders of western UP are more blunt. 'If the Babari Masjid is not restored to Muslims, they will begin to hate the Congress (I). Muslim Congressmen will not be allowed to enter Muslim areas even to beg for votes and I am saying this with full responsibility,' said Mr Shafiqur Rahman Barq of Sambhal who is also the convener of the Babari Masjid Action Committee of UP.

Hindu leaders say that by bringing in the Muslim Women Bill, the government has increased the importance of those Muslim leaders who want to inflame religious passions for political gains—not unlike the mistake Gandhi and Nehru made vis-a-vis Jinnah. Muslims return the compliment by citing the Ayodhya episode. And the two decisions have widened the rift between the two communities.

The Shah Bano judgment, even if it agitated a section of the Muslims, was a decision of the Supreme Court and not of the Government of India, say Hindu leaders. Even Mrs Gandhi was not prepared to touch this 'hornet's nest' following her return to power in 1980, counter Muslims referring to the disputed Ram Janmabhoomi.

But Mr Rajiv Gandhi wants both to run with the hare and hunt with the hounds. He may find he is able to do neither properly, say Hindus and Muslims. During the last years of her life Mrs Gandhi was deliberately cultivating a Hindu constituency. The Muslims had voted en masse against the Congress (I) in the 1977 elections, angered as they were by the programme of enforced sterilizations of the Emergency era. But even in subsequent elections Mrs Gandhi never regained the Muslim support in quite the same manner. She complained to colleagues following the 1980 elections that the

Muslims had deserted her in several pockets in the country like Karnataka and Andhra Pradesh. Muslims of north India were further alienated by the gruesome communal riots of Moradabad in 1980.

If she could be assured of the support of the majority community she would not have to rely on the Muslim vote as in the past. That she was wooing the Hindu voter was evident in her speeches during the election campaign in Jammu for instance and in her decision-making process on the Punjab question. Many people thought she was becoming pro-Hindu. But as a senior Muslim leader put it, 'Mrs Gandhi was neither pro-Hindu nor pro-Muslim. She was a ruthless politician concerned first and foremost about votes.'

But more important, Mrs Gandhi seemed to understand the changing mood of the Hindus. They were getting increasingly fed up with what they termed a policy of appeasing the minorities for electoral gains. From time to time militant Hindu leaders have expressed apprehension at the rate at which the Muslim population was growing in the country and the arsenals being created along our borders; and the foreign money coming into the country for conversions' which may 'one day lead to the formation of another Pakistan'.

The turning point, however, came in 1980 with Meenakshipuram where Harijans were converted to Islam. It sent out important signals to Hindu leaders. Sheep from the Hindu flock were being 'led astray'. Ironically, it brought several Hindu organizations face to face with the need for reform in their own ranks. Interestingly enough, removal of untouchability is now the avowed aim of both the Vishwa Hindu Parishad and of the Sarvadeshik Arya Pratinidhi Sabha because it is responsible for the 'stagnation' of Hindu society.

For the last six years, these organizations have been at work in the Meenakshipuram area as Mr Ram Gopal Shawlwalla of the Arya Pratinidhi Sabha declared proudly that all but four of those Harijans who were converted to Islam in 1980 have been reconverted to Hinduism.

The Vishwa Hindu Parishad has already built twenty temples in the Ramanathapuram district alone and in the words of its leaders 'the Birlas have promised to give us money to build a hundred temples'. This has reportedly stemmed the process of conversions which 'were being brought about by money given by big Muslim smugglers'.

Meenakshipuram also spurred several Hindu organizations to go on the offensive and 're-establish our moral and spiritual values'.

The Vishwa Hindu Parishad, which came into existence in 1964 was revived as a platform to bring together various Hindu sects on one platform. The Parishad is incidentally running several welfare projects for Harijans now. And it also aims to bring together Hindus from different political parties on one platform on issues—like that of the Ram Janmabhoomi—of common concern to them, like the Muslims do. Their declared aim is to 'protect Hinduism and Hindu values'.

Most of the office bearers of the Vishwa Hindu Parishad are closely connected with the Rashtriya Swayamsevak Sangh. Since the RSS had not been able to overcome the stigma attached to it after Mahatma Gandhi's assassination, it reportedly encouraged other organizations with the same objectives but with greater acceptability.

The Virat Hindu Samaj led by Dr Karan Singh also came into existence in 1982 after the Meenakshipuram conversions with the avowed aim of bringing together various Hindu organizations under one umbrella. Lakhs of people attended its five sammelans held in different parts of the country.

The message of one million people at its gathering in Delhi was not lost on Mrs Gandhi. Before she died she was negotiating with Dr Karan Singh to join the Congress (I) but it did not come to fruition.

Many a Hindu Manch or Hindu Suraksha Samiti in a north Indian city and a Hindu Munani in the south has come into existence. More recently, we have seen the birth and growth of *Trishul*-carrying Hindu Shiv Sena of Lord Shiva, in several towns of Punjab, Jammu and Kashmir, and UP, unlike the Shiv Sena of Shivaji in Maharashtra, to protect the Hindus.

Mrs Gandhi is believed to have given her tacit support to some of these organizations. While Mrs Gandhi discerned the changing Hindu mood and made use of it for electoral purposes, ironically, it bypassed the Bharatiya Janata Party which was trying to acquire a secular image under the leadership of Mr Atal Bihari Vajpayee. In the process the party fell between two stools and lost its traditional constituency to the Congress (I) in election after election. And paradoxically, it was virtually wiped out in those areas where the Hindu reaction was the strongest.

There is an attempt now to remedy the situation and the elevation of Mr L.K. Advani as the party president is one step in that direction. He is supposed to be more acceptable to the rank

and file of the RSS, which has been alienated from the BJP in recent years and which is known to have worked for the Congress (I) in the last elections. Even within the BJP, the RSS lobby is reportedly reasserting.

The RSS too is in a state of ferment, say its middle-level workers. Despite the signals from their leadership to work for the BJP in the 1984 elections—Nanaji Deshmukh was an exception—the rank and file campaigned for the Congress (I) in many areas. 'This was not due to a secret understanding the RSS had reached with the Congress (I) as is widely believed,' an RSS worker said. 'It was due to a crisis within the RSS. There is a growing disillusionment in the RSS cadre towards their leadership whose instructions on political matters they are not obeying. The leaders would prefer to let people go on believing that it was some kind of an agreement.'

After the Janata experiment, many RSS workers began to feel that there was little to differentiate the BJP from the Congress (I). This impression got strengthened as Mrs Gandhi made Hindu noises and the BJP resorted to secular rhetoric. The RSS worker felt that if he strengthened Mr Rajiv Gandhi's hands, Hindu interest would be served. But the Muslim Women Bill has shaken his confidence.

Even though the Muslims are disenchanted with the Congress on the question of the Babari Masjid, they are clear that a Muslim party in north India does not stand a chance. A combination of historical factors and electoral arithmetic would force them to remain with a national party. This was underlined by Mr Quasami of the Muslim Majlis-e-Mushawarat. At the moment the stock of the Lok Dal is high with Muslims in UP, he said, because their state-level leaders have forthrightly criticized the opening of the Ram Janmabhoomi Temple doors.

Mr Quasami also voiced the thinking of many Muslims when he said, 'We know that we cannot rule India. But it is we who will decide who will rule India—provided we can close our ranks.'

And now many a Hindu is also beginning to think along these lines: *We are in a majority. If Muslims can be a vote bank and exercise their clout, why cannot we?*

The government is unfortunately taking decisions which are widening the communal cleavage. Today the polarization is not restricted to electoral politics; it is affecting social relations.

[1]Neerja Chowdhury. 'The Political Fallout', *The Statesman*, 20 April 1986.

2. Muslim Women's Bill, a Quid Pro Quo for Opening the Gates of the Babari Masjid[1]

There is evidence of a connection between the opening of the doors of the disputed Ram Janmabhoomi in Ayodhya and the introduction of the Muslim Women Bill in Parliament both of which have heightened communal tension in the country.

This is evident from the way the bill came to be framed according to information contained in the report of the general secretary of the All India Muslim Personal Law Board which was presented to the Board at its meeting on 23 February 1986 and later circulated to members.

'Dialogue' with Muslims on the Babari Masjid began on 5 January 1986, in a meeting Mr Mata Prasad, home secretary in the Government of Uttar Pradesh had with Mr Farhat Ali, chairman of the Sunni Waqf Board which had filed a suit in 1961 claiming the title of the place of worship. While members of the Muslim Personal Law Board say that the meeting was an attempt by the government to persuade the Muslims not to press their plaint—to which they did not agree—Mr Farhat Ali insists that the meeting was completely 'informal' at which they discussed 'in a friendly fashion' how a compromise could be worked out and the problem which had been pending for thirty-seven years finally settled.

Three weeks later, on 1 February the temple doors were unlocked by an order of the district court in Faizabad to enable the prayers to go on unhampered.

On 2 February agitated Muslim Personal Law Board members passed a resolution at their meeting that they would resort to direct action for the restoration of the Babari Masjid to Muslims if the government did not take suitable action.

On 3 February the prime minister called Maulana Abul Hasan Ali Nadvi, chairman of the All India Muslim Personal Law Board who is also the rector of the prestigious Darul Uloom Nadwatul, for a meeting. The prime minister reportedly expressed his regrets for the delay in bringing in the Muslim Women Bill to undo the damage caused by the Shah Bano judgment. He assured Maulana Ali Nadvi that the bill would be introduced in Parliament soon after it opened a few days later.

On 11 February Mr Ninatullah Rahmani, General Secretary of the All India Muslim Personal Law Board said that the bill was coming very soon.

On 16 February Mr Rahmani and Maulana Ali Nadvi were both sent invitations to come for a meeting with the prime minister the next day. The meeting took place on 17 February at 1.30 p.m. at the prime minister's residence. Also present was Law Minister Ashok Sen who had with him a three-page draft of the proposed bill. This was read out to the Muslim leaders section by section, for their approval. Their suggestions were noted down.

The prime minister reportedly took an extraordinary interest in the details of the bill. Maulana Ali Nadvi also raised with him the question of the Babari Masjid. Mr Rajiv Gandhi told him to discuss the details with Mr M. L. Fotedar to whom they submitted a detailed note on the subject. They demanded that the status quo ante which existed before 1 February be restored till the case for ownership was decided by the court. They also elicited an assurance from the government that the mosque should not be forcibly converted into a temple.

The next day, on 18 February at 7.15 p.m., Maulana Ali Nadvi and Mr Minatullah Rahmani again met the prime minister, this time in his office. Mr Ashok Sen once more read out the contents of the bill, in which many of their suggestions had been incorporated. The prime minister informed the Muslim leaders that he would invite the Opposition leaders on 19 February to consult them on the bill. He also mentioned that he would talk to women's groups on the subject.

On 19 February, Maulana Ali Nadvi and Mr Rahmani had a meeting with the law minister, who gave them copies of the bill and informed them that it would be presented in Parliament on 21 February.

The rest is history. The bill was introduced in Parliament on 25 February, the delay caused by the time required for notice on a point on which Opposition leaders insisted.

Though they welcomed the bill, Muslim leaders also expressed surprise at the speed with which it was brought in. 'To be honest, we were not expecting it to come so soon,' a member of the All India Muslim Personal Law Board remarked candidly. Its timing indicates that it is not unconnected to the opening of the temple doors which they are extremely unhappy about and suspect was a decision 'which the government was instrumental in bringing about'. They point to various irregularities many of which have been cited in the appeal against the order in the High Court.

On 25 January, Mr Umesh Pandey, an advocate in Ayodhya, moved an application in the court of Mr Hari Shankar Dubey, munsif (Sadar) in Faizabad that the locks on the doors of the Ram Janmabhoomi temple be opened to allow a free offering of prayers. But the munsif did not pass any order because the main suit for the title was pending in the High Court. Expressing his inability to dispose of the application, he felt he could not pass an order without the records of the main suit.

Mr Umesh Pandey filed an appeal against this order in the court of the district judge in Faizabad which he said amounted to a refusal of his prayer. This was on 31 January. On 1 February District Judge K.M. Pandey, allowed his appeal and ordered that the locks be opened. But on 31 January, when Umesh Pandey's appeal came before the district judge, the government counsel was present in court to receive the notice personally.

The district judge summoned the district magistrate and the senior superintendent of police the next day. The DM and SSP told the court that they envisaged no law and order problem if the locks on the doors of the temple alias mosque were removed. The judge also heard the arguments for the impleadment of both Mohammed Hashim, who is a plaintiff and the son of another plaintiff in the suit of 1961, and declared that he would give his order at 4.15 p.m. the same day.

At the appointed hour, he disallowed the application for impleadment and allowed Umesh Pandey's plea for the opening of the locks on the disputed temple doors.

The order was complied with by the government within forty minutes of it being delivered, when normally it takes months and years to implement court verdicts. The lock was being broken at 5.19 p.m. in Ayodhya, 7 km away from Faizabad, and the administration had made all arrangements against any untoward incident.

Nor was the procedure of first giving a copy of the order to the appellant who in turn gives to the respondent to comply with it, reportedly adhered to. Nor for that matter was the official receiver appointed by the court to look after the disputed property and in whose possession the key of the lock remained allegedly informed about the order. Consequently the lock had to be broken.

These are some of the issues agitating Muslims. But their leaders have been silent on the Babari Masjid in recent weeks because they do not want to do anything to jeopardize the Muslim Women Bill.

Its likely passage in the current session of Parliament is also expected to defuse the passions building up on the question of the Babari Masjid which the Muslims believe has been converted into a temple.

The hue and cry raised by the All India Muslim Personal Law Board against the Shah Bano judgment and the result of the by-election and the Assam elections in December 1985 appear to have convinced the prime minister that the Muslims had moved away from the Congress (I) and that remedial action was necessary.

While Mr Rajiv Gandhi was promising Muslim leaders even an ordinance to override the effects of the Shah Bano judgment at the end of last year, Vishwa Hindu Parishad-led religious leaders were lobbying the Hindu MPs in Delhi on the opening of the doors of the Ram Janmabhoomi temple which Muslims claim as their Babari Masjid.

A policy of appeasement of both communities being pursued by the government for electoral gains is a vicious cycle which will become difficult to break.

[1]Neerja Chowdhury, 'Short-sighted Move to Appease Communities', *The Statesmen*, 1 May 1986.

3. Section 125 Cr PC not in Conflict with Muslim Personal Law[1]

We are not concerned here with the broad and general question whether a husband is liable to maintain his wife, which includes a divorced wife, in all circumstances and at all events. That is not the subject matter of Section 125. That section deals with cases in which, a person who is possessed of sufficient means neglects or refuses to maintain, amongst others, his wife who is unable to maintain herself. Since the Muslim personal law, which limits the husband's liability to provide for the maintenance of the divorced wife to the period of *iddat*, does not contemplate or countenance the situation envisaged by Section 125, it would be wrong to hold that the Muslim husband, according to his personal law, is not under an obligation to provide maintenance, beyond the period of *iddat*, to his divorced wife who is unable to maintain herself. The argument of the appellant that, according to the Muslim personal law, his liability to provide for the maintenance of his divorced wife is limited to the period of *iddat* despite the fact that

she is unable to maintain herself, has, therefore, to be rejected. The true position is that, if the divorced wife is able to maintain herself, the husband's liability to provide maintenance for her ceases with the expiration of the period of *iddat*. If she is unable to maintain herself, she is entitled to take recourse of Section 125 of the Code. The outcome of this discussion is that there is no conflict between the provisions of Section 125 and those of the Muslim personal law on the question of the Muslim husband's obligation to provide maintenance for a divorced wife who is unable to maintain herself.

[1]Extracts from the Supreme Court's ruling on Shah Bano case. *Mohammed Ahmed Khan v Shah Bano Begum* (1985) 2 Supreme Court Cases, p. 566.

4. Arif Mohammad Khan Defends Supreme Court Judgment in Shah Bano Case[1]

The minister of state for home affairs, Mr Arif Mohammad Khan, on 23 August 1985 upheld the Supreme Court judgment awarding maintenance rights to a divorced Muslim woman unable to maintain herself.

Intervening in the Lok Sabha discussion on Muslim personal law, introduced by Mr G.M. Banatwala (Muslim League) through a private member's bill seeking to amend the Criminal Procedure Code, Mr Arif Mohammad Khan presented a convincing argument, supported by relevant quotations from the Koran and the *Hadis*, that under the personal law, a Muslim woman was fully entitled to maintenance.

Mr Khan urged the proponents of the religion to ensure that it was interpreted correctly and urged them not to vitiate the atmosphere by raising religious slogans and making vitriolic statements. He pointed out that in practice only those provisions of the Muslim personal law which accorded rights to men were followed while those which sought to entrust some responsibility on them were completely ignored.

He regretted that the so-called Shariat experts never raised their voices when women were divorced and thrown out in the streets in complete contradiction to the provisions of the law but were most upset when a rightful interpretation sought to accord maintenance rights to destitute, divorced women.

Mr Khan said the Supreme Court should have confined its judgment to the provisions of the Criminal Procedure Code under which Shah Bano Begum had sought justice.

He also made it clear that no authority had any right to reform the Shariat, maintaining that if it was interpreted correctly, it would not need any reform.

Earlier, Mr Ebrahim Sulaiman Sait (Muslim League) demanded that the Supreme Court judgment be repealed insisting that it amounted to direct interference in the personal law.

Mr Arif Mohammad Khan's well-researched speech was interspersed with lively exchanges between him and the Muslim League members. At one stage when Mr Banatwala tried to censure him, Mr Khan replied that he had made it clear at the onset that his knowledge of the Koran and the Shariat was limited adding, 'You (Mr Banatwala) can remain a custodian of the religion, I am not a custodian and I congratulate you on your custodianship', amid applause and laughter from other members in the House.

At another stage, Mr Sulaiman Sait interrupted the minister who was reading out the names of some judges who were on the Pakistan Law Commission, saying that one of them was dead. Mr Khan replied, 'The problem is that I do not have any direct information from Pakistan and am only going by the document that I have.'

[1]*The Telegraph,* 24 August 1985.

5. Muslim Personal Law Board Submits Memorandum to Prime Minister Rajiv Gandhi on Supreme Court judgment in Shah Bano Case[1]

Recently a nineteen-member delegation of the All India Muslim Personal Law Board led by its president, Maulana Syed Abul Hasan Ali Nadvi, met the prime minister, Mr Rajiv Gandhi, and handed over the following memorandum in connection with the Supreme Court judgment regarding maintenance of divorced women.

The delegation consisted of Maulana Abul Hasan Ali Nadvi (president), Maulana Minnatullah Rahmani (general secretary), Maulana Abdul Karim Parikh, Mr Rahim Quraishi and Mr Abdus

Sattar Sheikh (secretaries), Mr Ibrahim Sulaiman Sait and Mr G.M. Banatwala (Muslim League), Mr Salahuddin Owaisi (Ittehadul Muslimeen), Maulana Abul Lais Islahi Nadvi, Maulana Afzal Hussain (Jamaat-e-Islami Hind), Maulana Hamiduddin Aqil Hussami (Ameer-e-Shariat, Andhra Pradesh), Maulana Mujahidul Islam Qasmi, Maulana Zahiruddin, Maulana Ahmed Ali Quasimi, Mr Syed Shahabuddin, Alhaj Kaka Mohammed Omer, Mr Ibrahim Khalilullah, Mufti Zafiruddin, and Mr Shabbir Bhai Nuruddin.

Text of the memorandum

The Muslim community all over the country has reacted strongly against the Supreme Court judgment of 23 April 1985, given in Mohammad Ahmed Khan vs. Shah Bano case wherein the Supreme Court has categorically held that a Muslim ex-husband will have to pay maintenance to his divorced wife till she remarries even after payment of her dower and maintenance for her *iddat* period and that in case of conflict between Section 125 Cr PC and the Muslim personal law, the provisions of Section 125 Cr PC will prevail. Thus, the addition of Clause (b) in Subsection 3 of Section 127 Cr PC has been rendered ineffective. The Muslim community regards this judgment of the Supreme Court, as a clear interference with the Shariat (Muslim personal law) and their freedom of religion and conscience contained in Articles 25, 26, and 29 of the Constitution of India.

To understand the enormity of the problem, one must restate that the Muslim community regards its personal law as an essential and inseparable part of its religion, as the personal law is based upon the Holy Koran and traditions of the Prophet, as interpreted by the Imams of various schools of Islamic jurisprudence.

The Supreme Court in its judgment has misinterpreted two isolated verses of the Holy Koran quoted by it out of context and has ignored other verses of the Holy Koran on the subject and traditions of the Prophet and their interpretation by the Imams of different schools of Islamic jurisprudence. Its observations are against the unanimous verdict of the *Fuqahas* (jurists) and *Ulemas* (scholars) of different schools of Muslim law and the *ijma* (consensus) of the *Ummah* (Muslim community) for the last 1400 years which has been to the effect that the liability of an ex-husband to maintain his divorced wife lasts only up to the period of *iddat* and cannot be extended further.

In this respect the All India Muslim Personal Law Board would like to clarify that Muslim personal law has adequate provisions for supporting indigent persons including a divorced woman.

You may further recall that when the Criminal Procedure Code was under discussion in Parliament in 1973, the Muslim community had protested against the explanation to Section 125 which extended the definition of wife to include 'divorced wife'. A well-represented delegation of the Board had called upon the then prime minister and represented to her against this provision of Section 125. The then prime minister, Smt Indira Gandhi had taken note of the said protest and even after the bill had been passed by the Rajya Sabha and Sections 125 and 127 Cr PC had been passed by the Lok Sabha, she directed the then minister of state for home affairs, Shri Ram Niwas Mirdha, who was piloting the said bill, to insert Clause (b) in Subsection 3 of Section 127. This was done in the Lok Sabha on 11 December 1973, and this newly added clause was approved by the Rajya Sabha on 18 December 1973.

The clear object of inserting this Clause (b) in Section 127 (3) was to provide that the order for maintenance to a divorced wife under Section 127 Cr PC would be liable to be cancelled if the former husband had discharged his obligations under any personal or customary law thus protecting the Muslim personal law from Section 125 of Cr PC. This is evident even from the proceedings of the Lok Sabha and the Rajya Sabha and in particular from the speeches of Shri Mirdha in the two Houses of Parliament.

However, ignoring the public policy embodied in Clause 3(b) of Section 127 and contrary to the clear intention of the Parliament, the Supreme Court, in its wisdom, has decided that Section 127 Cr PC applied to persons of all religions and Section 127(3)(b) cannot be invoked by Muslim husbands even after payment of dower and maintenance for the period of *iddat*. Thus the very object of Section 127(3)(b) has been negatived and the protection provided to Muslim personal law in 1973 has been demolished.

The Board, therefore, is of the considered opinion that in order to nullify the effect of the Supreme Court judgment, the government must immediately reiterate, in the most unambiguous terms, its commitment to uphold the Muslim personal law, and its intent expressed in 1973 and embodied in Section 127(3)(b) Cr PC be rebuilt on a more secure foundation by suitably amending Section 127 Cr PC.

The Supreme Court has gone further, even beyond the terms of reference, and has criticized in strong terms the delay in the

promulgation of a uniform civil code, thus it has virtually exhorted the Government of India to repeal the Muslim personal law in the name of social reform and national integration.

The Board is of the view that national integration lies in the acceptance of diversity and not in imposing uniformity; it lies in mutual trust and confidence and not in distrust and suspicion. National integration will be strengthened when every religious denomination feels religiously secure and satisfied and convinced that their religion in all its essential aspects is safe and untampered with and that they are free to practise it and their religious identity will be protected against the pressures of assimilation and absorption. The Board, therefore, submits that it would be unwise and against the interest of national unity to arouse fears and apprehensions and to create a sense of religious insecurity.

The Board has every reason to presume that your government have no intention to interfere with the Muslim personal law and will respect the fundamental rights of freedom of religion and conscience. However, Article 44 of the Constitution has been constantly exploited by forces hostile to the Muslim community to exert pressure upon the government to introduce uniform civil code.

The Board, therefore, demands that:

(i) Section 125 Cr PC be so amended as to provide that the explanation defining wife to include divorced wife shall not be applicable to Muslims; and

(ii) Article 44 of the Constitution of India be deleted or at least be so amended as to exempt the Muslim personal law from its purview.

The Board urges upon the government that immediate legislative action be initiated in this respect and necessary amendments in the Criminal Procedure Code and the Constitution be introduced and passed in the current monsoon session of the Parliament.

[1]*Radiance*, 1 September 1985.

6. Union Minister Z.R. Ansari Joins Issue with Arif Mohammad Khan[1]

The long-drawn debate on Muslim personal law took an interesting turn on 22 November 1985 when Minister of State

for environment Z.R. Ansari joined issue with his ministerial colleague Arif Mohammad Khan and argued forcefully against grant of maintenance to Muslim women after divorce beyond that which is stipulated in Islamic law.

Participating in a debate on a private bill moved by Muslim League member G.M. Banatwala, Mr Ansari threw his weight behind the no-changers and said grant of lifelong maintenance by a husband to a divorced woman went against the tenets of natural justice.

Mr Banatwala's bill seeks to amend Sections 125 and 127 of the Criminal Procedure Code to limit the maintenance payable to a divorced woman to the amount stipulated in Muslim personal law. The bill has generated tremendous interest in the House following the Supreme Court verdict in the Shah Bano case wherein the court awarded maintenance to her.

Several Muslim MPs, including the mover of the bill, who have so far participated in the debate, have questioned the jurisdiction of courts in the matter and pointed out that maintenance is payable only as ordained in the Islamic religious texts and only during the period of *iddat* (three menstrual cycles or if the divorced woman is pregnant, until the birth of the child).

The minister of state for energy, Mr Arif Mohammad Khan, who spoke on the bill during the monsoon session of Parliament, stirred a hornet's nest when he argued vehemently in favour of reform.

Mr Ansari said that those who argued in favour of lifelong maintenance probably did so under the notion that they were attempting social reform. He, however, felt that if maintenance was provided to the divorced woman for life, it would lead to social evils and take society to abysmal depths. 'Let us not open the floodgates,' he said.

The minister said that grant of lifelong maintenance went against natural justice. When there is no contact between the husband and the wife, it will be unjust to impose such a lifelong burden on the husband.

The basic tenet of Koran is that only a reasonable burden should be imposed on the husband and this has been clearly quantified for the four types of divorce. The compensation to be paid to the wife on divorce varied depending on whether the divorce was effected immediately after the *nikaah* (marriage ceremony) or after the marriage was consummated. It would be unjust to impose a financial burden on the husband, which he would be unable to bear, Mr Ansari added.

Without mentioning the Supreme Court verdict, the minister said it would be incorrect to interpret the Islamic texts in order to grant maintenance for life. He saw no logic behind giving maintenance for such a long period. He also felt that it was against the dignity and honour of a woman to accept maintenance from a husband with whom she could not live. The Koran looked upon divorce as an extreme step and provided several checks to prevent such an eventuality. However, if divorce was inevitable, it laid down that it should be gone through honourably.

Another interesting fact of today's debate was the stand taken by the Akali Dal on this controversial issue. Mr Balwant Singh Ramoowalia of the party came out strongly against any interference in Muslim personal law. Even if the government had to face some disadvantages, it should protect Muslim personal law, he said.

He said Muslims in the Congress (I) were not speaking out on this issue. He advised them to have a longer perspective and advise their party leaders suitably. This would strengthen communal harmony and national unity. He said even Indira Gandhi had given an assurance that she would protect Muslim personal law.

Mr Saifuddin Soz (National Conference) said Muslims felt terribly insecure because of the presence of Article 44 in the Constitution which speaks of a common civil code. He said a proviso should be added to this article stating that the right of minorities to practise their religion and to adhere to their personal law shall be protected. Mr Soz said Islam was a very progressive religion. The Supreme Court had double standards. It was not the business of the court to be concerned with social reforms. He suggested that the government organize an international conference on Muslim jurisprudence.

Mr Mohammad Jalil Abbasi (Congress-I) said Muslims considered the recent controversy and grant of maintenance to divorced Muslim women as an interference in their religion.

Mr Shyamlal Yadav (Congress-I) said there was no need to be apprehensive about Article 44 because it had never stood in the way of minority rights. He said no one should try to make political capital on such a sensitive issue. The government should encourage a national debate and elicit the views of all sections of the people. He said Islam itself took a socialistic path and had very progressive practices. He said the consent of the bride was a must at Muslim weddings, which was not the case in many other communities. Hence there was need to view the issue dispassionately. He urged

Mr Banatwala to withdraw the bill and help the government in having a meaningful debate on the issue in an atmosphere devoid of rancour.

The debate was inconclusive.

[1]*Indian Express*, 23 November 1985.

7. Ansari Attacks Supreme Court[1]

Minister of State for Environment Z.R. Ansari lambasted the Supreme Court on 20 December 1985 for trying to interpret Muslim personal law and dubbed the court's verdict in the Shah Bano case as 'prejudiced, discriminatory, and full of contradictions'.

Speaking in the Lok Sabha on a private bill pertaining to maintenance for divorced Muslim women, Mr Ansari trained his guns on the former Chief Justice, Mr Y.V. Chandrachud, and said the Chief Justice was incompetent to interpret Islamic law.

Following the court's interpretations, all the Ulema (Muslim clergy) should close shop. Judges who were oblivious to the ethos of Islam were trying to interpret Muslim personal law. If this was accepted they would tomorrow challenge the need for circumcision and even urge Muslims to cremate the dead.

In what amounted to a virtual indictment of Mr Chandrachud, the minister questioned the court's wisdom in discussing social reform in the Shah Bano judgment and to emphasize the need for a common civil code as prescribed in Article 44 of the Constitution. The judgment indicated that the former Chief Justice had tried to usurp the power of Parliament and the executive.

This was nothing short of judicial dishonesty and amounted to degrading the Supreme Court. Mr Ansari said the Chief Justice of the Supreme Court was too small a man to interpret Islamic law. He is incompetent to enter this field and he has tried to wield a sword, the minister said. Mr Ansari, whose speech was incomplete the last time the bill was taken up for discussion, eventually held the floor for around three-and-a-half hours.

The minister argued that Article 44 of the Constitution did not make it obligatory for the state to enforce a common civil code. The article only said the state should endeavour in this direction. This article does not bind the state to frame a common civil code, he said.

Mr Saifuddin Chowdhury (CPI-M), who spoke after Mr Ansari, however, came down heavily on Muslim fundamentalists and said what was being practised in the name of secularism was nothing but hypocrisy.

Amidst angry protests from Muslim MPs from both sides of the House, Mr Chowdhury maintained that the Supreme Court verdict was not antagonistic to Muslim personal law. He said Article 44 asked the government to endeavour to bring in a common civil code. What endeavour has the government made in this direction, he asked.

Congratulating Shah Bano for fighting for maintenance, Mr Chowdhury said her husband Mohammed Khan should be publicly flogged. He disagreed with the view that what was going on in the name of Muslim personal law was sacrosanct and immutable. Nothing is immutable he said, and pointed out that two Muslim countries, Tunisia and Turkey, had abolished bigamy. If bigamy is abolished, how it affects Islam, he asked.

Further, several other countries including Egypt, Morocco, and Syria had banned triple divorce. Several other Muslim countries, including Lebanon, Jordan, Morocco, Iran, and Iraq had made changes.

The members were discussing a private member's bill moved by Mr G.M. Banatwala (Muslim League) seeking to amend Sections 125 and 127 of the Code of Criminal Procedure. The aim of the amendment was to ensure that courts awarded maintenance as prescribed in the personal laws of religions.

The minister of state for energy, Mr Arif Mohammad Khan, who had participated in the debate earlier, had called for reform in order to ensure that a divorced Muslim woman gets adequate maintenance from her husband. Mr Banatwala and several other speakers have so far contended that courts should not award alimony for divorced Muslim women beyond that which is prescribed in Islamic law.

Several others have pointed out that Muslim personal law provides maintenance only for the period of *iddat* (three menstrual cycles) after divorce and that after this period the woman would be rendered a destitute. Mr Saifuddin Chowdhury said that the period of *iddat* referred to in Islamic law is for the purposes of reconciliation and that had nothing to do with alimony. Mr Ansari, however, claimed that under Muslim law, a divorced woman had to return to her parents and that it was obligatory on the part of her parents to maintain her. No parent can escape this duty, he asserted.

Mr Ansari contended that a woman never got 'detached' from her parents after marriage. So, if she were to be divorced, she would 'revert back' to her parents. He said these provisions were there in Muslim personal law but 'we have not paid sufficient attention to them'.

Mr Ansari said there was no other scripture which was as flexible, elastic, and dynamic as the Koran. There was room for change in personal law if the change was for the better but change which struck at the roots of the Koran was not permissible.

The minister then appealed to the Muslim clergy to review the laws 'so that we can go with the times'. He said the Muslim community should take stock of the situation. It was true that divorced women in indigent circumstances were running from pillar to post. The learned men in the community should review the laws and this will enable the government also to take the community into confidence.

Mr Ansari took strong exception to the remarks of Mr Chandrachud about the Shah Bano verdict after his retirement. The former Chief Justice had said that the verdict was a significant landmark in social reform. Mr Chandrachud is understood to have said, 'If a part of society does not like the decision, what about the other half?' Which half is he referring to, Mr Ansari asked and went on to say that the former Chief Justice was absolutely ignorant of the attitude of Muslim women. The tone and tenor of the judgment made it clear that it was no judgment at all. It reads like a paper presented at a seminar. It also constituted an oblique attack on the Koran.

The minister further quoted Mr Chandrachud as having said that the court had interpreted the law as per the mandate of the Holy Koran. 'When Mr Chandrachud is here as the grand mufti to interpret Koran, all Ulemas should close shop,' the minister said.

During the debate, Mr Saifuddin Chowdhury asked the chair how long Mr Ansari would be allowed to hold the floor. This angered Mr Ansari, who had by then already spoken for two-and-a-half hours. 'Go damn Marx. Take your Marxism to West Bengal,' he said.

Mr Madhu Dandavate (Janata) tried to cool tempers and said the minister should not refer to Marx but could refer to God because God was omnipresent. This provoked Mr Ansari to say that the representatives of 'Shaitan' (the devil) were everywhere.

The minister's angry outburst at Marx and Marxists was resented to by some members.

Later, Mr Saifuddin Chowdhury said people were trying to raise passions in the name of Muslim personal law. He wanted the government to strive for a common civil code.

Mr Ansari urged Mr Banatwala to withdraw his bill as the prime minister had himself assured the Muslim community that the government would not interfere with Muslim personal law.

[1]*Indian Express*, 21 December 1985.

8. Prime Minister Rajiv Gandhi Assures the Opposition of a Thorough Examination of the Judgment in Shah Bano Case[1]

The government assured the Opposition leaders on 17 December 1985 that it would examine all aspects of the Supreme Court judgment in the Shah Bano case as it affected Section 127(3)(b), Cr PC which provides for exemptions to minority groups in respect of grant of alimony. The government, however, did not commit that this examination would lead to amendment of the law.

The prime minister met the Opposition leaders for the second time this month to discuss the situation arising from the judgment, against the background of complaints from Muslims that it had seriously encroached into the Muslim fundamental law embodied in the Shariat.

The Muslim League leader, Mr Ebrahim Sulaiman Sait, who was supported by the National Conference (F) leader, Begum Akbar Jahan, told the meeting that the Supreme Court judgment had defeated the intention of Section 127(3)(b), which had been incorporated in the Cr PC through an amendment in 1973.

Mr P.V. Narasimha Rao, minister for human resources development, who participated in the discussion, gave a gist of what he was told by Muslim intellectuals a few days ago in regard to the judgment. He assured the Opposition leaders that the government would examine the issue and also what could be the intention behind the amendment.

The Left Opposition leaders, Mr Indrajit Gupta (CPI), Mr Dwipen Ghosh (CPI-M) and Mr Piyus Tirkey (RSP) asked the minister also to examine whether, after twelve years, the intention behind the amendment remained valid.

What government can do

The prime minister raised the issue by asking the MPs what the government could do in this situation and whether Muslim women were getting adequate protection in the existing system.

The Left Opposition MPs wanted a minor amendment to the prime minster's statement. They wanted the government to ensure that women's rights were protected 'irrespective of religion'. The Muslim League leader maintained that 'divine law is unchallengeable'.

Mr Rajiv Gandhi asked whether a Muslim woman could opt out of the Shariat. The government would examine this.

Opposition leaders wanted to know who would decide whether the civil laws had come in conflict with the religious laws and whether women were getting adequate protection.

Mr Gandhi said a majority of the Muslims perceived the Supreme Court judgment as being contrary to Islamic principles. On a suggestion from Mr Sait, he agreed to meet a group of Muslim intellectuals.

Background paper

It was decided that the government would prepare a background paper on the issue and there would be another meeting between the prime minister and the opposition leaders ten days after the paper was made available to them.

The paper will contain the debate in Parliament in connection with the amendment to the Cr PC with a covering note analysing the intention behind the amendment; the Supreme Court judgment with an analysis by the law ministry; the constituent assembly debate on a uniform civil law; and documents in regard to what was being done in Muslim and secular countries in respect of protecting the rights of women.

The prime minister observed that one of the points to be considered was whether the protection now available to women under their own systems was adequate. Another question was: 'What should be done if Muslim women feel that the Islamic law does not give (them) enough protection?' Judging from the reaction, he said, it appeared the mass of the Muslim community perceived the court judgment as being contrary to Islamic principles. Today's was the second round of discussions between Mr Gandhi and the

Opposition leaders. At the 4 December meeting also the issue figured.[2]

[1]*The Times of India,* 18 December 1985.
[2]*The Hindu,* 18 December 1985.

9. Muslim Leaders Suggest Utilizing *Wakf* Fund for Alimony to Divorced Women[1]

Transferring the 'burden' of looking after the divorced Muslim women to the Wakf Board funds is the main point of a package proposal being seriously considered by the Centre to settle the controversy created by the Shah Bano case on alimony.

Seventeen Muslim leaders belonging to the Congress(I), the Janata Party, and the Muslim League had an hour-long meeting with the prime minister, Mr Rajiv Gandhi, on a set of proposals aimed at protecting both the minorities rights and the interests of the divorced Muslim women.

The Muslim MPs in the delegation were Mr Ibrahim Sulaiman Sait, Syed Shahabuddin, Mrs Abida Ali Ahmed, the chairman of the AICC minorities cell, Mr Aziz Sait, and the Rajya Sabha deputy chairman, Mrs Najma Heptullah. There were also a few Muslim theologians.

At the very outset, Mr Rajiv Gandhi is believed to have made it clear that while the government had no intention to interfere with the Muslim personal law, it would never compromise *on the basic human rights of the divorced women.* Therefore any settlement on this issue could be made within these parameters.

The Muslim delegation also submitted an elaborate memorandum to Mr Gandhi a few days back demanding amendments to Section 125 of the Cr PC to nullify the Supreme Court judgment in the Shah Bano case.

They also argued that Shariat was a civil act, and hence cases under it agonizingly prolonged. Therefore, *they wanted to bring it under the Cr PC.*

Mr Gandhi asked the delegation to specify who would look after the Muslim woman if the husband had no responsibility for this. Members of the delegation replied that according to the Islamic law, the 'burden' would '*naturally*' be passed on to the parents, brothers, and uncles, in that order.

In case none of them were in a position to undertake the responsibility, the 'burden' would then go to the *bait-ul-mal* (state funds). But the question remains as to how in a secular state like India, government funds could be used for the benefit of one community?

It was then pointed out to Mr Gandhi that a part of the *Wakf* funds is presently being utilized for similar purposes. The Muslim leaders argued that *6 per cent of the Wakf funds would be enough for the purpose.* More funds also could be raised on a regular basis for the purpose through other Muslim institutions.

According to the delegation leaders, Mr Gandhi was highly impressed by the suggestions. On his directive they discussed the financial implications and legal issues involved in the proposals with the law minister a few days later. The ministry will now prepare a note on the proposals to Mr Gandhi.

Last week, at a meeting of the Opposition leaders, the prime minister had assured to bring out a detailed note on the overall aspects of the controversy. The note now being prepared is on the practical aspects of the Muslim leaders' suggestions.

Official circles, however, have doubts about whether *Wakf* funds could fully meet the demands.

[1]*Indian Express*, 26 December 1985.

10. Prime Minister Hints at Ordinance on Muslim Personal Law[1]

The government will very soon be issuing an ordinance to codify certain aspects of the Muslim personal law to meet the situation arising out of the controversial Supreme Court verdict on maintenance in the Shah Bano case.

Prime Minister Rajiv Gandhi gave this indication during a one-and-a-half-hour-long meeting at his residence with representatives of five all-India women's organizations and a number of Muslim women on 24 December 1985.

Mr Gandhi told the meeting that the government had prepared certain proposals on the basis of a note submitted by some Muslim jurists. In the proposed scheme of things, it will be the court's responsibility to see to it that *meher* is paid to the divorced Muslim woman. Not only that, the amount of *meher* fixed at the time of the

nikah will automatically be upgraded if the husband's income goes up. But it cannot be downgraded on the plea that the husband's earnings have fallen.

The burden to look after a divorced Muslim woman will henceforth fall not on her husband but on her father and brothers. In case they refuse to take on the responsibility, the community funds *(bait-ul-mal)* could be used for this purpose.

It may be recalled that seventeen Muslim leaders belonging to the Congress(I), the Janata Party, and the Muslim League had an hour-long meeting with the prime minister on 20 December with a set of proposals quite similar to the ones put forward by Mr Gandhi at this meeting. The Muslim leaders included Rajya Sabha Deputy Chairman Najma Heptullah, Janata Party General Secretary Syed Shahabuddin, Muslim League leader Ebrahim Sulaiman Sait, Congress(I) MP Mrs Abida Ali Ahmed and chairman of the AICC(I) minorities cell, Aziz Sait.

Tuesday's meeting, called at the initiative of the prime minister's secretariat, was a sequel to the twenty-minute meeting the women leaders had with Mr Gandhi on 17 December. The prime minister, assisted by Mrs Margaret Alva, minister of state for sports, youth, and women's affairs, and Dr Rajendra Kumari Bajpai, minister of state for welfare, reportedly had a free and frank discussion. Among others present were Pramila Dandavate (Mahila Dakshita), Indu Agnihotri, and Zoya Hasan (All India Democratic Women's Association).

[1]*Sunday Observer*, 29 December 1985.

CHAPTER 6

The Babari Masjid Question

1. The Origin

A radio message sent at 10.30 a.m. on 23 December 1949 by District Magistrate K.K. Nayar to Chief Minister Pandit Govind Ballabh Pant, the chief secretary and the home secretary read thus: 'A few Hindus entered Babari Masjid at night when the Masjid was deserted and installed a deity there. DM and SP and force at spot. Situation under control. Police picket of 15 persons was on duty at night but did not apparently act.'

This message was based on police constable Mata Prasad's report to the Ayodhya police station earlier. Here is a translation of the FIR lodged by Sub-Inspector Ram Dube, Police Station Ayodhya, on 23 December 1949, as certified by the office of the city magistrate on 11 February 1986:

According to Mata (paper no 7), when I reached to (*sic*) Janam Bhumi around 8 o'clock in the morning, I came to know that a group of 50–60 persons had entered Babari Mosque after breaking the compound gate lock of the mosque or through jumping across the walls (of the compound) with a stair and established therein, an idol of Shri Bhagwan and painted Sita Ram, etc., on the outer and inner walls with *geru* (red loam). Hans Raj on duty asked them to defer but they did not. These persons have already entered the mosque before the available PAC (Provincial Armed Constabulary) guards could be commanded. Officials of the district administration came at the site and involved themselves in necessary arrangements. Afterwards, a crowd of 5–6 thousand persons gathered around and while chanting bhajans and raising religious slogans tried to enter the mosque but were deferred and nothing untoward happened thereon because of proper arrangements. Ram Das, Ram Shakti Das and 50–60 unidentified others entered the mosque surreptitiously and spoiled its sanctity. Government servant on duty and several others are witness to it. Therefore it is written and filed.[1]

[1]S. Gopal (ed.), *Anatomy of a Confrontation*, Viking, 1991; pp. 70–1.

2. Nehru's Telegram to G.B. Pant on Ayodhya on 26 December 1949[1]

I am disturbed at developments at Ayodhya.[1] Earnestly hope you will personally interest yourself in this matter. Dangerous example being set there which will have bad consequences.

[1]J.N. Collection.

2a. Nehru's Letter to C. Rajagopalachari, Governor-General of India[1]

New Delhi
7 January 1950

My dear Rajaji,

I wrote to Pantji last night about Ayodhya and sent this letter with a person who was going to Lucknow. Pantji telephoned to me later. He said he was very worried and he was personally looking into this matter. He intended taking action, but he wanted to get some well-known Hindus to explain the situation to people in Ayodhya first. I told him on the telephone of your letter to me, which you sent this morning.

Vallabhhai is going to Lucknow day after tomorrow at Pantji's request. This is in connection with the elections to Parliament.

Yours,
Jawaharlal

[1]J.N. Collection *Selected Works of Jawaharlal Nehru*, Second Series, vol. 14, Part 1, pp. 443–5, a project of Jawaharlal Nehru Memorial Fund, 1992, distributed by Oxford University Press.

2b. Nehru's Letter to G.B. Pant[1]

New Delhi
5 February 1950

My dear Pantji,

I shall be glad if you will keep me informed of the Ayodhya situation. As you know, I attached great importance to it and to its repercussions on all-India affairs and more especially Kashmir. I suggested to you when you were here last that, if necessary, I

would go to Ayodhya. If you think this should be done, I shall try to find the date, although I am terribly busy.

<div align="right">Yours sincerely,
Jawaharlal Nehru</div>

[1]J.N. Collection.

2c. Nehru's Letter to K.G. Mashruwala[1]

<div align="right">New Delhi
5 March 1950</div>

My dear Kishorilal Bhai,

You refer to the Ayodhya mosque. This event occurred two or three months ago and I have been very gravely perturbed over it. The U.P. Government put up a brave show, but actually did little. Their District Officer in Fyzabad[2] rather misbehaved and took no steps to prevent this happening.[3] It is not true that Baba Raghavdas instigated this, but it is true that after it was done, he gave his approval to it. So also some other Congressmen in the U.P. Pandit Govind Ballabh Pant condemned the act on several occasions, but refrained from taking definite action probably for fear of a big-scale riot. I have been greatly distressed about it and have repeatedly drawn Pantji's attention to it.

I am quite convinced that if we on our side behaved properly, it would be far easier to deal with Pakistan. Today many Congressmen have become communal insofar as Pakistan is concerned and this reacts on their behaviour towards Muslims in India. I just do not know what we can do to create a better atmosphere in the country. Merely to preach goodwill irritates people when they are excited. Bapu might have done it, but we are too small for this kind of thing.

I am afraid, in the prevailing atmosphere, there is no chance of Bapu's peaceful march of strikers being copied in Bengal.

<div align="right">Yours sincerely,
Jawaharlal Nehru</div>

[1]J.N. Collection.
[2]K.K. Nayar (b. 1907), joined ICS 1930, served in the United Provinces in various capacities, District Magistrate, Faizabad, at this time.
[3]Nayar refused to carry out the instructions of the chief secretary and inspector general of police for the removal of the idols. 'I cannot in my discretion . . . enforce such a solution as I am fully aware of the widespread suffering which it will entail to many innocent lives.' Nayar was replaced eventually.

2d. Vallabhbhai Patel's Letter to G.B. Pant

New Delhi
9 January 1950

My dear Pantji,

The Prime Minister has already sent to you a telegram expressing his concern over the developments in Ayodhya. I spoke to you about it in Lucknow. I feel that the controversy has been raised at a most inopportune time both from the point of view of the country at large and of your own province in particular. The wider communal issues have only been recently resolved to the mutual satisfaction of the various communities. So far as Muslims are concerned, they are just settling down to their new loyalties. We can reasonably say that the first shock of partition and the resultant uncertainties are just beginning to be over and that it is unlikely that there would be any transfer of loyalties on a mass scale. In your own province, the communal problem has always been a difficult one. I think it has been one of the outstanding achievements of your administration that, despite many upsetting factors, communal relations have generally improved very considerably since 1946. We have our own difficulties in the UP organizationally and administratively as a result of group formations. It would be most unfortunate if we allowed any group advantage to be made on this issue. On all these grounds, therefore, I feel that the issue is one which should be resolved amicably in a spirit of mutual toleration and goodwill between the two communities. I realise there is a great deal of sentiment behind the move which has taken place. At the same time, such matters can only be resolved peacefully if we take the willing consent of the Muslim community with us. There can be no question of resolving such disputes by force. In that case, the forces of law and order will have to maintain peace at all costs. If, therefore, peaceful and persuasive methods are to be followed, *any unilateral action based on an attitude of aggression or coercion cannot be countenanced.* I am therefore quite convinced that the matter should not be made such a live issue and that the present inopportune controversies should be resolved by peaceful (methods) and accomplished facts should not be allowed to stand in the way

of an amicable settlement. I hope your efforts in this direction will meet with success.[1]

<div align="right">
Yours sincerely,

Vallabhbhai Patel
</div>

The Hon'ble Pandit G.B. Pant
Premier of United Provinces
Lucknow

[1]Durga Das (ed.), *Sardar Patel's Correspondence,* Navajivan Publishing House, Ahmedabad, 1974, vol. 9, pp. 310–11.

2e. G.B. Pant's Letter to Vallabhbhai Patel

<div align="right">
Lucknow

13 January 1950
</div>

My dear Sardar Sahib,

I have to thank you for your letter about the Ayodhya affair. It will be of great help to us. *Efforts to set matters right* in a peaceful manner are still continuing and there is a reasonable chance of success, but things are still in a fluid state and it will be hazardous to say more at this stage.[1]

<div align="right">
With best regards,

Yours sincerely,

G.B. Pant
</div>

[1]*Ibid.,* p. 312.

3. All India Muslim Personal Law Board and All India Muslim Majlis-e-Mushawarat on the takeover of the Babari Masjid[1]

(a) AIMPLB Resolution

The joint meeting of the working committee and the central action committee of the All India Muslim Personal Law Board, held in Delhi on 2 February 1986, expresses its deep sense of shock at the

virtual handing over of the Babari Masjid in Ayodhya to the Hindu community without any decision on the substantive question of origin and title. The meeting considers this action a complete travesty of justice and nothing short of legalized housebreaking.

The meeting has noted with regret that an ancient mosque where *namaz* has been performed for nearly 500 years, has been converted illegally into a temple while the case remains sub judice. This unilateral seizure will only serve to undermine the faith of the Muslim community in the political order and the judicial system.

The meeting is of the considered view that no self-respecting community can submit to such forcible takeovers of their places of worship.

The meeting appeals to the Muslim community to act with restraint and not in anger, to pray to Allah for the liberation of the Masjid, and to undertake organized defence of their rights over this mosque.

The meeting appeals to the government at least to prohibit puja in the Masjid till the title suits pending in the court of the Civil Judge, Faizabad, are decided.

The meeting also appeals to the political parties and to all the secular forces to support the demand for the restoration of the mosque to the Muslim community.

Sd/- Abul Hasan Ali Nadwl
Sd/- Minnatullah Rahmani
Sd/- Syed Shahabuddin
Sd/- M. Zulfiqarullah
Sd/- Muzaffar Husain
Sd/- Ahmad Ali Quasmi
Sd/- Anjum Quder
Sd/- Rahim Qureshi
Sd/- Abdul Jalil Chawdhry

(b) Mushawarat's letter to Muslim MPs

The takeover of the Babari Masjid is not only shocking but humiliating for the whole community. The situation demands a calm appraisal with a view to arrive at a strategy for undoing the wrong done to the community. Forgetting our political differences, all the Muslim MPs must, therefore, put their heads together to find the way out. I propose a meet on the eve of the coming Parliament session at 5.00 p.m. on 20 February 1986 at the Constitution Club.

Looking forward to your sharing your thoughts with all of us and with kind regards.

[1]*Muslim India*, March 1986, p. 111.

4. Majlis-e-Mushawarat Submits Memorandum to the Prime Minister on 14 February 1968[1]

On behalf of the Muslim community of India, the All India Muslim Majlis-e-Mushawarat would like to make the following submissions to you on the question of restoration of the Babari Masjid, Ayodhya, to the Muslim community.

As you are aware, on 1 February 1986, the district judge, Faizabad, on an application from a private individual, passed an order for unlocking the gate of the inner courtyard of the Babari Masjid to allow free access by the Hindu community to the mosque and to perform puja. The district authorities, presumably acting under the instructions of the state government, complied with the order forthwith. The mosque has thus, by one stroke of pen, been handed over to the Hindu community and has passed into their de facto possession, while the title suits originating in 1950, are still pending for decision. A historic mosque, built more than 450 years ago, has thus been converted into a Hindu temple, in free India by a judicial writ.

Mr Prime Minister, as stated by the then deputy commissioner, Faizabad, in his affidavit, idols were surreptitiously placed in the mosque in 1949, thus creating a law and order problem. The additional city magistrate then passed an order under Section 145 of the Cr PC on 23 December 1949 calling upon the claimants to the premises to appear and file their written statements. Then, acting under Section 146 of the Cr PC, the city magistrate attached the property until a competent court decides the title, and appointed the chairman of the Municipal Board, Faizabad-cum-Ayodhya, as the receiver and authorized him to arrange for the care of the property and to submit a scheme for its management. Thus, the property was taken away from the Muslim community in 1950. The idols were never removed and in the outer courtyard Hindu rites were regularly performed. Now in 1986, the property has been handed over to the Hindu community.

Mr Prime Minister, the order of the district judge is unprecedented in the annals of Indian judicial system. Its illegality is obvious on the face of the record, because:

1. The matter was sub judice as four title suits were pending in the competent court;
2. The applicant has no locus standi as the Hindu community at large had not acquired any rights over the property under Section 146 and the access to the Masjid had been limited to one Hindu priest only under the order of 1950;
3. No member of the Muslim community, not even the Muslims who were parties to the original suits, were made a party to this hearing;
4. The rights of the Muslim community at large, in this mosque and generally in any mosque, who were bound to feel aggrieved by the performance of puja in a Masjid, were not considered at all;
5. The Sunni Wakf Board, Uttar Pradesh, in whose records the Masjid stands registered as a Wakf property, was not even informed, far less heard by the judge;
6. The receiver, who had presumably put the lock on the inner door, was not called and his domain—care and management of the property—was openly violated;
7. The order was passed on the sole ground that unlocking the door shall make no difference as it will not create any unmanageable law and order problem for the district authorities, but it was forgotten that the de facto conversion of the Masjid into a temple was bound to be taken as a victory by those who had threatened to break open the lock;
8. That the original order of attachment prohibited general access to the premises, lock or no lock, was neatly swept aside and practically revealed;
9. That a fait accompli would make it difficult, if not impossible, to bring about a compromise between the two communities on this long-standing dispute was also ignored.

Yet, Mr Prime Minister, the district authorities meekly and urgently executed the order and the Government of UP, which was the defendant and against whom the order was passed, did not appeal against the order or even ask for time to consider the order and to apply for a stay. Subsequently, the *victory* has been celebrated in many towns and villages with processions and illumination, with distribution of sweets and with provocative speeches and insulting slogans, accompanied with threats to convert more mosques into temples. The Muslim community has been a dazed spectator of these events, maintaining patience in the face of provocations.

Mr Prime Minister, there is no contemporary evidence that Babari Masjid was constructed on the site of a pre-existing temple

after deliberately demolishing it; there is no evidence that the Masjid stands on the birth site of Shri Ram Chandra*ji*. In one sense, the whole of Ayodhya is his birthplace but in a specific sense *the birth site is marked by a platform roughly 20' x 20' which is distinct from and outside the main Masjid and this site has been the object of veneration for centuries.* This site was demarcated by the British authorities towards the middle of the nineteenth century by putting up a railing 'within which in the Mosque the Mohamedans pray, while outside the fence the Hindus have raised a platform on which they make their offerings' (P. Carnegi, Settlement Officer and officiating Commissioner, Faizabad, in *A Historical Sketch of Tahsil Faizabad, Zilla Faizabad, Lucknow, 1870*).

Mr Prime Minister, it will thus be seen that the *janamsthan* is distinct from the Babari Masjid and yet the chauvinist elements in the Hindu community led by the RSS and the Vishwa Hindu Parishad have systematically carried out a campaign for the last two years for the physical occupation of the Babari Masjid on the alleged ground that the Masjid stands on the birth site. They have deliberately tried to build up a religious hysteria by sowing this confusion.

Mr Prime Minister, the object of this campaign is not religious but political. It is to destroy the secular order, to subvert the rule of law and to humiliate the Muslim community, to nurture hatred and ill feeling between the Hindu and the Muslim communities and generally to prepare the country for a takeover by fascist forces in the name of Hindu chauvinism. Unfortunately, there are sympathetic elements in the executive and the judiciary and even in the political parties which have joined hands. Due to democratic compulsions even the secular political parties have preferred to maintain silence.

Mr Prime Minister, we do not have adequate words to convey to you the deep shock caused to the Muslim psyche by this illegal occupation and to describe their resulting anguish and agony. Their faith in the secular order has been eroded; their confidence in the judiciary has been shaken; for them the constitutional guarantees have been drained out of all meaning and the rule of law has become a farce; the political system has shown itself to be subservient to the forces of chauvinism and revanchism; the mass media including the Doordarshan have turned into purveyors of one-sided propaganda because the picture projected by them has been so distorted as to be beyond recognition, as if no *masjid* exists at all

and it is the Muslims who are creating a dispute by obstructing the Hindus from praying in the temple!

Mr Prime Minister, you can well imagine the disastrous consequences if a community, as a whole, feels not only deprived and helpless but frustrated and pushed to the wall. Alienated from the system it shall either freeze into hopeless apathy or adopt extra-legal methods. We respectfully ask you: should you not, as the prime minister of our great country, step in to save the situation in order to restore its faith in the system by defending its dignity as a community and by protecting its fundamental right to freedom of religion?

The All India Muslim Majlis-e-Mushawarat appeals to you, that if the order of 1 February 1986 appears to you to be unfair, uncalled for, and ill conceived which has unnecessarily precipitated a crisis, you may kindly ask the Government of Uttar Pradesh to file an appeal against the order or a writ petition praying that the status quo ante be restored and maintained and that no structural changes be made until the title suits are decided. The Mushawarat also appeals to you that the Union government should directly intervene in the case, on the ground that the case has far-reaching implications and has caused repercussions throughout the country, and depute the Attorney-General of India to represent the views of the Union government.

Mr Prime Minister, the Mushawarat recalls with satisfaction and gratitude your timely intervention in the Koran Case in the Calcutta High Court and has every hope that you shall again rise to the occasion, above short-sighted political considerations or narrow numerical compulsions, and rekindle a little hope in the Muslim community that they can live a life of equality and dignity, as free men in a free country, in their motherland.

[1]*Muslim India*, March 1986.

5. Muslim MPs Across Party Lines Submit Memorandum to the Prime Minister on 3 March 1986[1]

The recent judgment by the district judge, Faizabad, in respect of the Babari Mosque, Ayodhya, has caused deep anguish to the Muslim community and has created a grave situation in the country

which, if not tackled carefully, can cause a national catastrophe beyond any cure.

We, the Muslim members of Parliament, therefore, desire to place the facts before you and request you kindly to intervene in the matter urgently and restore confidence among the Muslim community that they would enjoy religious freedom as equal members of a secular state in accordance with the letter and spirit of the Constitution of India.

At the very outset we assure you that the narration of the following facts is based on an overwhelming and irrefutable evidence in respect of the Babari Mosque's history and its legal position:

That the mosque was built during the regime of Mogul Emperor Babar by one of his governors, namely, Mir Baqui on a vacant plot of land in the year 1528.

That an internationally renowned historian, A.S. Beveridge, who has translated Tuzuk-e-Babri into English and given comprehensive footnotes, has in his book, *Memoirs of Babar* (Vol. II, London, 1924, pp. 67–80) mentioned Babar's passing through Awadh. Beveridge has dealt with the subject with minute details but there is no mention of Babar having entered Ayodhya. After dealing with Shaikh Bayazid the rebel, who was governor of Awadh, Babar appointed Baqui Beg Tasshkandi (Mir Baqui) as governor of Awadh and left. This fact is further proved by the report of the district commissioner of waqfs, Faizabad, submitted to the chief commissioner of waqfs (UP) on 16 September 1938. It is furthermore proved by the inscriptions on the walls of the mosque as acknowledged by the historian, A.S. Beveridge, and also by Pandit Hari Kishan, the sub-judge, Faizabad, in Suit No. 61/280 of 1885, vide his judgment dated 24 December 1885. A copy of the judgment by Pt Hari Kishan forms Annexure-A of this memorandum.

That from the above-mentioned report of district waqf commissioner, it is evident that two villages, namely Bharaipur and Sholeypur, were also granted as revenue-free land in the year 1864 for maintenance of the mosque in lieu of the cash grant of Rs 60/- per year originally sanctioned by Emperor Babar and subsequently enhanced by the king of Awadh to a sum of Rs 302/3/6.

That in the year 1885 one Mahant Reghubar Dass had filed a suit in the court of the sub-judge, Faizabad (Suit No. 61280 of 1885), and had alleged that the *chabutra* of Ram *Janamsthan* was without roof and building and the priests had to face great hardships on account of weather effects like excessive heat, cold, or rain and as such, he prayed for permission to construct a temple over the said *chabutra* of 21 x 17 ft. This suit was filed on 19 January 1885 and it was also contended in Para 4 of the plaint that in April 1883 the deputy commissioner of Faizabad had refused the

permission for construction of the said temple for the reasons of communal harmony.

That the sub-judge, Faizabad, Pandit Hari Kishan, dismissed the said suit no. 61/280 of 1885 by his order dated 24 December 1885. On the basis of the site plan prepared by the court's *amin*, one Mr Gopal Sahai, the court observed that 'in between the Mosque and "Chabutras" there is a wall and it is clear that there are separate boundaries between the Mosque and Chabutra and this fact is also supported by the fact that there is boundary line built by the Government before the recent dispute'. The court further observed: 'Around it, there is the well of the mosque and the word "Allah" is inscribed on it and if permission is given to Hindus for construction of temple then one day or the other a criminal case will be started and thousands of people will be killed . . . awarding permission to construct a temple at this juncture is to lay the foundation of riots and murders, hence the relief claimed should not be granted.'

That against the aforesaid judgment dated 24 December 1885, an appeal was filed (Civil Appeal No. 27 of 1886: Mahant Raghubar Dass vs. Secretary of State and others) in the court of the district judge, Faizabad, who ultimately dismissed it by his order dated 26 March 1886.

That the mosque was damaged in the communal riots of 1934 and the then UP government got it repaired.

That in the 'Misl band' Registrar of 1860 the said mosque is recorded as Masjid Babari.

That in the report of the commissioner of waqfs published in the Government gazette dated 26 February 1944 this mosque is mentioned to be a Sunni waqf.

That on the basis of the aforesaid facts, the UP Sunni Central Board of Waqfs registered the said mosque as a waqf, namely, waqf No. 26 of Faizabad under the UP Muslim Waqf Act, 1960.

That up to 22 December 1949, regular prayers used to be offered by the Muslims in the said mosque and it was in the night of 22–23 December 1949 that a violent mob of anti-Muslim fanatics forcibly occupied the mosque with the connivance of the then District Magistrate K.K. Nayyar who had to resign for his role in that sordid episode. And the idols of Sri Ram Chandra*ji* were surreptitiously installed in the mosque. The very FIR lodged at Ayodhya police station by Constable Mata Prasad posted at the site on 23 December 1949 corroborates the fact that *idols were surreptitiously placed inside the mosque on the night of 22–23 December, 1949.* A copy of the said FIR forms Annexure-B to this memorandum.

That on 23 December 1949 orders under Section 144 Cr PC were imposed in Faizabad and Ayodhya and the mosque was attached under Section 145 Cr PC.

That on 16 January 1950 one Mr Gopal Singh Visharad filed a Suit No. 2 of 1950 in the court of the munsif, Sadar, Faizabad. It is relevant to mention here that in the court of the civil judge, Faizabad, the fact that idols of Shri Ram Chandra*ji* were mischievously put inside the mosque

has been admitted in the written statement dated 24 April 1950 filed by the deputy commissioner, Faizabad, Sri J.N. Ugra, in Suit No. 2 of 1950 as well as in the written statement of the state government in R.S. No. 25 of 1950. Copy of the written statements filed by Sri J.N. Ugra, deputy commissioner, Faizabad, forms Annexures-C and D whereas the written statement of the superintendent of police, Faizabad in Suit No. 2 of 1950 is Annexure-E to this memorandum. Likewise, another suit was filed by Nirmohi Akhara and ultimately a fourth suit was filed by the UP Sunni Central Board of Waqfs, Lucknow, in the court of the civil judge, Faizabad, i.e. Reg Suit No. 12 of 1961. All these four suits were consolidated and the Reg Suit No. 12 of 1961 filed by the Waqf Board was made the leading case. From all the aforesaid written statements filed by the state government it is fully established that the state government had all along been treating the said building as Babari Mosque and not as a temple of Shri Ram Chandra*ji*.

That in a matter relating to the receivership of the mosque, the file of the aforesaid leading case i.e. Suit No. 12 of 1961 was retained by the Allahabad High Court and it is still lying in the same court (at the Lucknow Bench).

That, all of a sudden, on 25 January 1986 one Mr Umesh Chandra Pandey, an advocate of Faizabad, moved an application in Reg. Suit No. 2 of 1950 in the court of munsif, to the effect that the DM and the SP Faizabad, be directed to remove the lock from the premises so that he and other members of the Hindu community may worship there. On 28 January 1986 the learned munsif passed an order for putting up the application on the date fixed as the file of the case was before the High Court.

However, against the aforesaid order of the munsiff, an appeal was filed before the district judge on 30 January 1986 which was heard on 1 February 1986. On this date, some Muslims came to know about these proceedings and moved an application for being impleaded as a party to the appeal, as Mr Umesh Chandra Pandey had not impleaded any of the Muslim parties of the suits. The Muslims, who were already parties in the original suits, moved for impleadment but all these prayers were unjustifiably rejected by the district judge and he irrelevantly examined the district magistrate and the superintendent of police, who also seemed to have connived with the miscreants, and on the basis of their irrational and undemocratic statement that no law and order problem would be created if the lock of the mosque were opened, the district judge allowed the appeal directing the DM and the SP to remove the lock from the premises in dispute, and the lock was broken the same day at about 5.15 p.m.

That it would be relevant to point out that the order, which has been obtained through conspiracy and at the back of the Muslims, manifestly suffers from the following defects:

(i) The applicant who has moved the application in question is not a party to any of the aforesaid suits and as such he has *no locus standi*;

(ii) The Muslims who are parties in the aforesaid original suits and who also applied for impleadment in appeal, *were not impleaded;*

(iii) The statements are never recorded in appeals as were done by the erring district judge;

(iv) The order passed by the munsif was not appealable as he had not yet decided the case;

(v) The appeal was heard by the district judge and one-sided orders were passed and implemented the same day; and

(vi) Above all, no such order could have been passed when the record of the original suit is lying in the Allahabad High Court (Lucknow bench).

That the order of the district judge has resulted in the present situation—riots, imposition of curfew in many parts of the country, and mass arrests. The order has caused a situation in which the confidence and faith of Muslims in the judicial system is shaken.

That we feel constrained to charge that the national television network chose to be a party in the dispute by televising the entry of Hindu devotees into the mosque and described the premises as *Ram Janam Bhoomi.* All India Radio also adopted the same attitude.

That even the peaceful and democratic protest on the part of the Muslim community was resented by the majority community with the active support of the law and order machinery.

What pains us most is that the values that could sustain and enrich a truly democratic and secular way of life in India are fast deteriorating and something needs to be done urgently if India has to remain strong and united. In this connection we would like to bring to the notice of the honourable prime minister the full-throated lament of Shri Akshay Pandit, a freedom fighter and a senior Congress leader of Faizabad, who had drawn the attention of Shri Lal Bahadur Shastri, the then home minster of Uttar Pradesh in 1950, the highhandedness and vandalism of some Hindu miscreants who wanted forcible conversion of Babari Mosque into a temple. Shri Akshay Pandit's lament, titled *Rah-e-Farz Par* in Urdu forms Annexure-F to this memorandum.

Against this background we, the Muslim members of Parliament, request you kindly to take appropriate measures to meet the following demands:

A. That you may kindly intervene in the matter immediately and take urgent measures to get the Babri Mosque restored to the Muslim community.

B. That a writ petition be filed by the Government of UP in the High Court against the order dated 1 February 1986 passed by the district judge, Faizabad.

C. That as the district judge himself has observed in his order dated 1 February 1986 that the authorities can independently take measures

to maintain law and order, the status quo ante as existed on 31 January 1986 should be restored in respect of the Babari Mosque.

D. That all the pending suits relating to the premises in question be got disposed of within a period of six months.

E. That a delegation of MPs representing various political parties be sent to Ayodhya to visit the Babari Mosque and the same delegation be provided facilities to prepare a map of the premises as also to take photographs of the mosque so as to bring on record the actual existing position of the mosque.

F. That the official media be directed not to describe the premises as *Ram Janam Bhoomi*.

[1]*Muslim India*, March 1986.

6. Babari Masjid Movement Coordination Committee Adopts Motion in a Mass Rally at Boat Club Lawns, New Delhi, on 30 March 1987, and Submits it to Parliament and the Government[1]

The historic rally convened by the Babari Masjid Movement Coordination Committee places on record the deep sense of anguish of the Muslims of India at the continued occupation of the historic Babari Masjid, Ayodhya, and its de facto conversion into a temple since 1 February 1986.

The rally regards the Babari Masjid as a national heritage and as a historic monument but, above all, as a place of Islamic worship, whose sanctity must be universally respected by all right-minded persons, whatever their religion, and whose violation should be regarded not only as an offence to the religious sentiments of the Muslims but also to the secular order, because it contravenes Article 25 of the Constitution which guarantees freedom of religion and violates the norms of civilized intercourse.

The rally reaffirms that the sanctity of the Babari Masjid is not negotiable, that the Babari Masjid is inalienable and that its restoration as a *masjid* is absolutely imperative. This restoration can only be effected by stopping the performance of puja and removing the idols surreptitiously installed therein and by guaranteeing the freedom of *namaz*.

The rally reiterates the determination and the resolve of the Muslims of India to regain their *masjid*, howsoever long and hard the struggle might be.

The rally regards the order of the district judge, Faizabad, permitting unrestricted access to the Hindu community to the Babari Masjid to participate in the puja, being performed in the sanctum sanctorum of the *masjid*, as unwarranted and illegal, because while the title suit is yet to be decided and the property is in the hands of the receiver, the order concedes, in practice, the control and use of a disputed premises to one party and that, too, to the party which created the dispute.

The rally expresses its regret that while the title suit remains pending since 1950, even the writ petition challenging the order of the district judge filed in February 1986 is still going through the admission proceedings and the Government of UP, far from challenging the order, has not even submitted its affidavit to the High Court on a matter of such national importance which only goes to confirm the impression of behind-the-scene collusion.

The rally takes note of the fact that the representations made by the All India Muslim Majlis-e-Mushawarat, its committee for the restoration of Babari Masjid, the Babari Masjid Action Committee, UP, the Muslim MPs and the Muslim MLAs of UP to the Governments of India and of UP, have borne no fruit and the assurances by the Prime Minister Rajiv Gandhi in March 1986 to the Muslim MPs and by Home Minister Buta Singh in July 1986 on the floor of the Lok Sabha and on various other occasions to find an early solution of the problem have not been fulfilled. In fact, the governments both at the Centre and in the state have been reduced to silent spectators of the violation of the sanctity of a place of worship.

The rally expresses its disappointment that the democratic and peaceful agitation and declaration of Delhi, adopted by the All India Babari Masjid Conference held in New Delhi on 21–22 December 1986 has so far failed to break through the walls of apathy, insensitivity, inertia, and inaction.

The rally notes with a sense of pride the unanimous support of the Muslim community to the call of non-participation in the official observance of the Republic Day and the expression of total solidarity to the All India bandh on 1 February 1987. But regrettably, even these have been totally ignored by the power structure.

The rally notes that the call of non-participation is seized upon by the official media and the vested interests to mislead public opinion, to create distrust and suspicion against the Muslim community, and to communalize the situation. The rally affirms that the question of Babari Masjid is not a Hindu-Muslim question but a constitutional and legal question, a test for the secular order and the rule of law.

. The rally notes that the government has disregarded the sincere plea of the Babari Masjid Movement to find a just and satisfactory solution of the problem through dialogue and negotiations with Hindu leaders and organizations, or through the appointment of an eminent persons' group to suggest possible options which would safeguard the essential interests of both communities or through suggestions for a discussion of the problem in depth in the Parliament and for consultation with the leaders of all national or regional political parties jointly to find ways and means to resolve this ugly situation, have all fallen on deaf ear.

The rally is convinced that such an attitude towards democratic methods is a negation of the democratic process and can only give rise to disenchantment and frustration towards the democratic way of life, to an upsurge of chauvinism on one hand and of extremism on the other.

The rally considers that the status quo constitutes a slur on the fair name of the country, an attack on religious freedom and human rights, and on the identity and dignity of the Muslim community and that its continuance may result in irreparable damage to the secular order and to the process of national integration and that it must be changed.

The rally declares in unmistakable and unequivocal terms that the patience and forbearance which the Muslim community has demonstrated in its struggle for the restoration of the Babari Masjid are reaching their limits in the face of empty promises and provocations and reaffirms the resolve of the Muslim community of India, if all efforts fail, to march to Ayodhya, to restore the sanctity of the Babari Masjid and to reclaim religious freedom and their constitutional, legal, moral, and human rights to their place of worship.

The rally appeals to the Muslim community to continue to act in a peaceful and dignified manner, to endeavour to maintain communal harmony, to explain their just case to the Hindu brethren and to seek their cooperation in order to save our common motherland, because there can be no peace or tranquillity, no

development or progress, no law or Constitution, if places of worship are not safe and if human rights are violated with impunity.

The rally cautions the government, the secular elements, and the liberal forces that the de facto conversion of the Babari Masjid into a temple is the first move towards the transformation of our polity into a Hindu *rashtra* and seeks their support in the common struggle against the forces of fascism and for an India of our dreams in which all communities can live in freedom and dignity.

Convinced that no democratic system can function except on the basis of rule of law, the rally reiterates that in the interest of inter-communal harmony, a Central law should be immediately enacted to guarantee the status of all places of worship and to protect them as they existed on 15 August 1947 against any claim or any move to alter their status.

The rally demands that the title suit relating to the Babari Masjid, pending since 1950, be heard immediately by a special Bench of a High Court in south India, consisting of three judges, none of whom may be a Hindu or a Muslim and urges that without any further loss of time, the government take necessary steps at the High Court of Allahabad and at the Supreme Court, for the purpose.

<div align="right">

Syed Abdullah Bukhari
Afzal Husain
Syed Ahmed Hashmi
Mohd. Azam Khan
Ebrahim Sulaiman Sait
Muzaffar Husain
Sultan Salahuddin Owaisi
Syed Shahabuddin
Zafaryab Jeelani
Zulfiqarullah

</div>

Boat Club Lawns,
New Delhi.

[1]*Muslim India*, May 1987

7. Home Minister's Assurance to Delegation of Eminent Persons on Babari Issue[1]

On 15 July 1988, Union Home Minister Buta Singh told a deputation of eminent persons led by Col B.H. Zaidi that he

had spoken to Uttar Pradesh Chief Minister N.D. Tiwari to find a mutually acceptable solution to the Babari Masjid–Ram Janam Bhoomi problem.

He said Mr Tiwari had assured him that he was seriously concerned over the moves of some sections of the people. He had further said that no person would be permitted to disturb peace and any move to whip up communal feelings would be firmly dealt with. No efforts will be spared to arrive at a mutually acceptable solution to the problem, he also stated.

The deputation consisting of eleven eminent persons led by Col B. S. Zaidi met the home minister to discuss the situation arising out of the proposed threat of 'march to Ayodhya' by the Babari Masjid Action Committee and the *rathyatra* by Ram Janam Bhoomi protagonists. They discussed in detail the issues involved in the dispute and suggested that government should take immediate steps to defuse the situation by evolving a time-bound action programme to resolve the problem through a mutually acceptable solution by all concerned.

They also suggested that an all-party meeting be convened by the government to mobilize public opinion.

The delegation included Mr A.R. Shervani, Mr Khurshid Alam Khan, Nawab Zafar Zung, Mr Rajendra Sachhar, Diwan Birender Nath, Mr B.G. Verghese, Mr Rajendra Sareen and Mr Kuldip Nayyar.

[1]*The Hindustan Times*, 16 July 1988.

8. All India Babari Masjid Movement Coordination Committee splits[1]

I. Press Release by AIBMC

The All India Babari Masjid Conference held at Park Jama Masjid, Delhi, on during 26–27 November 1988 has decided to constitute an All India Babari Masjid Action Committee in order to carry on the movement at the all-India level for restoration of Babari Masjid at the All India level. . . .

The Conference . . . (drew up) programme for holding seminars and symposia, etc., of non-Muslim intellectuals, politicians, and journalists and others.

The Conference (also) chalked out the future agitational programme. . . . and in this respect a token dharna by the leaders of the movement (including district representatives) would be staged at the prime minister's residence on 22 December 1988 and a token demonstration/court-arrest programme will be held at Lucknow on 1 February 1989. . . .

. . . It has been decided to hold state level conferences during 1989 in the states of Jammu and Kashmir, Bihar, Andhra Pradesh, Karnataka, Rajasthan, and Maharashtra. . . .

The Conference was inaugurated by Syed Abdullah Bukhari and different sessions . . . were presided over by Sultan Salahuddin Owaisi, MP, Syed Muzaffar Hussain Kachhochhwi, G.M. Shah (former chief minister of J and K), and Mohd. Azam Khan, MLA.

II. Resolution on talks with the home minister

We are not satisfied with the talks so far held by the Babari Masjid Movement Coordination Committee with the Central Home Minister Buta Singh. . . . We stick to the demand. . . . that the matter should be referred to a special Bench of three judges of a High Court in south India, with no judge being a Hindu or a Muslim, and the status quo as on 31 January 1986 being restored in the meantime. . . .

. . . The announcement of expediting the judicial proceedings is nothing more than delaying tactics and we do not consider such an assurance conducive to the settlement of the matter. Nor can we withdraw our movement on this basis. . . . Further, the home minister has said nothing so far about our demand for legislation to protect . . . the status and character of all places of worship.

III. Resolution on Ayodhya March

The way the dates of the Ayodhya March have been extended and finally . . . indefinitely postponed has created differences in the leadership and frustration among the masses and gave the communalists an opportunity to indulge in provocations and violence.

We . . . leave the matter to the convenor of the Coordination Committee and his supporters and are unable to say anything decisive about the Ayodhya march. . . .

. . . We want to make it clear . . . that if at any stage we announce any such programme, we will at all cost implement it.

IV. Composition of All India Babari Masjid Action Committee

1. Sayed Abdullah Bukhari — Patron
2. S.S. Owaisi, MP — Chairman
3. Syed Ahmed Bukhari (Delhi) — Vice Chairman
4. Zafaryab Jilani (UP) — Convenor
5. M. Azam Khan — Convenor

Coordination Committee deems Abdullah Bukhari and four others to have opted out

In accordance with the decision taken on 14 November 1988 by the Babari Masjid Movement Coordination Committee, in violation of the mandate of the Babari Masjid Movement Coordination Committee and by accepting the membership of the parallel body formed by the Conference, Janab Syed Abdullah Bukhari, Janab S.S. Owaisi, MP, Janab Mozaffar Husain Kachhochhvi, Janab Zafaryab Jilani and Janab Azam Khan are deemed to have opted out and withdrawn from the Coordination Committee with immediate effect. The vacancies caused thereby shall be filled immediately.

The Babari Masjid Movement Coordination Committee has noted that the proceedings of the so-called All India Conference have not revealed any substantive points of differences on policy or programme of action. The Conference has not even decided to take up Ayodhya march immediately, whose postponement was made the basis for launching the divisive move. The results have shown that behind the disruptive move there was nothing but personal ambition of some individuals.

The BMMCC has noted that the unity and strength of the movement remain largely unimpaired because only a handful of the state conveners, the members of the State Action Committees including that of UP, and the district conveners participated in the Conference. The BMMCC reiterates its resolve to continue the struggle for the restoration of the sanctity of the Babari Masjid through peaceful and democratic means and demands that the Central government, having failed to achieve a negotiated settlement should, without any further loss of precious time, fulfil its commitment to accelerate the judicial process and take immediate necessary steps for the trial of the title suit by a special Bench of three High Court judges.

The BMMCC appeals to the Muslim community to reject those who have tried to sabotage the movement and stand unitedly with all secular forces, for the noble cause, which has become a touchstone of the secular order and of the rule of law.

[1]*Muslim India*, January 1989, p. 14.

9. Home Minister Suggests Solution Through Mutual Goodwill[1]

Home Minister Buta Singh said on 16 May 1989 that the government was not averse to finding a solution to the Ram Janam Bhoomi–Babari Masjid issue through mutual goodwill and understanding side by side with the court proceedings.

The home minister was responding to suggestion made by the leaders of the Opposition in Parliament in the course of their two-day discussion on communal issue in the country.

The meeting was convened by the home minister as a follow-up to the prime minister's statement in the Lok Sabha saying that a meeting of Opposition leaders in Parliament would be convened before holding the full-fledged meeting of the National Integration Council to discuss the communal situation in the country.

The home minister also welcomed the consensus that emerged that religion should not be exploited to propagate the issue of communalism.

An official spokesman briefing newsmen said that many members pointed out during the discussion that while India is a secular country, 'we have a society which has abiding faith in religion'. Many people take advantage of this fact and exploit it for narrow purposes, they said.

The spokesman said Ram Janam Bhoomi–Babari Masjid issue dominated the two-day discussions as every one spoke on the issue.

The home minister said the dispute over the place of worship could be solved through mutual goodwill.

Mr Atal Behari Vajpayee (BJP) said that the dispute could not be solved in the court of law. It should be solved with goodwill from both sides.

In this connection, he said, the site under dispute should be handed over to Hindus who as a goodwill gesture should maintain the structure as it is without there being any worship by either community. A temple and a mosque should be built nearby the disputed shine, he said.

[1]*Indian Express*, 17 May 1989.

10. Syed Shahabuddin's Speech at the National Political Convention of Indian Muslims[1]

Syed Shahabuddin made an impassioned plea to the Muslims on 8 July 1989 to join hands with other deprived sections of society to create an 'anti-status quo force of irresistible power' to change the face of India. However, in the short term they should try and act as a pressure group cutting across party lines so that 'our cries of anguish reverberate through the corridors of power'.

Inaugurating the national political convention of Muslim Indians here today, Mr Shahabuddin said he had called the convention to determine the long-term political strategy and the short-term political alignments of the Muslims not just in their own interest but in the interest of the nation.

The conference was attended among others by Prince Anjum Kadar, president of the All India Shia Conference, Mr-Zulfikarullah, president of the Muslim Majlis-e-Mushawarat, Mr F.H. Mohsin, former minister in the Union government, Mr A.G. Lone from Jammu and Kashmir, and Mr F.M. Khan from Karnataka. Mr Indubhai Patel, president of the Janata Party to which Mr Shahabuddin belongs, also attended.

Presidents of the national parties like Congress-I, Janata Dal, CPI, and CPI(M) who had also been invited, decided to stay away, Janata Dal President V.P. Singh sent a letter to Mr Shahabuddin which was handed over to him during the inaugural session of the convention.

During his inaugural address made in Urdu, Mr Shahabuddin went beyond the sectional demands of the Muslims, be it for Babari Masjid, Urdu, personal law, or reservation in jobs, though all these, he said, were important. He said 'Our concern is the malice in the

polity, the direction in which it is moving, the shape of things to come, and the role we can play as a community to defend the besieged city of secularism.'

At the outset he recalled the words of Abul Kalam Azad who had proclaimed his pride in being a Muslim and in being an Indian. Mr Shahabuddin asserted: 'We are born here; we shall die here; we shall rest here till eternity. This is our motherland. Its love is part of our faith. The service of its people is our duty; its rise our glory; its fall our disgrace. Let us remember performance of duties precede claims of rights.'

Thunderous applause greeted him when he said this. His speech was punctuated by applause particularly when he talked about making common cause with other deprived groups to change Indian society.

The Mavlankar Hall was jampacked with around 1000 social and political workers who had come from all parts of India. The convention started with the recitation of verses from the Koran and ended with the rendering of the national anthem. Several times during his speech Mr Shahabuddin's voice choked with emotions.

The Janata Party MP said the real struggle was for the redistribution of wealth and power. Today 85 per cent of the wealth was controlled by 15 per cent of the people. They formed the elite, controlled the national institutions, and dominated the state, the executive, and indirectly the legislature and the judiciary. That is why Indian society had seen no structural changes during the last forty years. Elections came and went, faces changed but the power structure remained unchanged.

At the same time, Mr Shahabuddin pointed out that democratic pressures had been building up for a just society. This also explained the growing communalization and the brutalization . . . of the Indian polity. The dominant classes wished to insulate themselves against the winds of change and their only recourse was to inject fear in the minds of the Hindu masses and seek their consolidation in the name of dharma or *sanskriti*.

Mr Shahabuddin said there was no conflict between religion and nationhood 'as long as the Indian state is a secular state'. The Muslims, he said, had a stake in the survival of the secular principle. If the secular order gave way, the first victims would be the religious minorities. That is why they must do everything to defend it.

He said he had called a political convention because politics defined the constitutional and legal order and it determined rights and duties and the distribution of goods and services.

Mr Shahabuddin said it was a 'historical task to fashion' an anti-status quo force of irresistible power' if the country was to be changed. There was no national party today which regarded the dispossessed, the exploited, and the deprived social groups either as the centre of its concern or its national constituency. Nor did the parties tap their strength not just as electoral groups but 'as the subject and object of social change'. In fact, no party was truly national today, he said. Every party represented a well-defined social constituency and one or more social groups looked up to it for promotion of their group interest.

The Janata Party leader called upon the Muslims as one of the persecuted oppressed groups to join 'this common struggle of the 85 per cent against the 15 per cent'.

He also called upon members of his community to close their ranks. They had been divided partly because of their fascination 'with the Durbar', partly because of the complexes arising out of the trauma of partition, and partly because of their preoccupation with their own woes. As a result, Muslim Indians had either been taken for granted or ignored by political parties in framing political equations. However, they were not going to be bonded labour of any political party, he said. He said the convention was aimed at evolving the long-term political strategy and short-term electoral alignments not only in their own interests but in the interests of the nation and of the overwhelming majority of the people who were equally oppressed.

Speaking of the long-term goals they should pursue, Mr Sahahabuddin said while no minority group could wield power, they could emerge as a powerful force if they made common cause with 85 per cent of the people because they had the logic of democracy on their side. But in the short term, their objective was to create 'a lobby, a pressure group cutting across party lines so that our cries of anguish reverberate through the corridors of power, so that our case does not go unheard'.

Trying to allay the fears aroused by the convention of Muslim Indians, Mr Shahabuddin said 'our assembly is not a show of force directed against anyone but represents a journey of self discovery'.

[1]*Indian Express*, 9 July 1989.

11. Janata Dal Committed to Secularism, says V.P. Singh[1]

Janata Dal President V.P. Singh today responded on 8 July 1989 to the invitation to attend the national convention of 'Muslim Indians' by stating that the Janata Dal was totally committed to the secular traditions enshrined in the Indian Constitution and believed in respecting all religions. However, the reply addressed to Mr Syed Shahbuddin, Janata Party leader and convenor of the convention did not say whether Mr Singh was accepting the invitation to attend the meet or not.

Explaining the party's position on minorities and secularism, Mr Singh quoted from the policy document adopted by the party during its foundation conference at Bangalore: 'Communal violence must be eradicated permanently from our society and severest punishment meted out to those found guilty of fomenting communal passions. The Minorities Commission will have statutory status in the Constitution and a specially trained police force with effective representation of minorities and Scheduled Castes and Tribes will be organized to put down violence firmly.'

'On the vexed question of the Ram Janam Bhoomi–Babari Masjid, the Janata Dal's stand has already been made clear. I have already clearly stated that the issue should be resolved by a reference to a special Bench of the Allahabad High Court on a priority basis. The judgment of the court should be binding on all concerned. Pending adjudication, we are opposed to any unilateral and precipitous action by any side because it will aggravate the communal conflict,' Mr Singh said. He concluded the letter by saying that 'on these fundamental principles (on minorities and secularism) we shall not compromise with anyone under any circumstance'.

[1]*Indian Express*, 9 July 1989.

12. Charter of Demands Adopted at the Convention of Muslim Indians held on 9 July 1989[1]

I. Constitutional safeguards

1. Constitutional provision to charge the Union government with the responsibility for the protection of the constitutional and

legal rights and for the promotion of the legitimate interests of religious, linguistic, and ethnic minorities.

2. Constitutional protection of the personal law of religious and ethnic minorities against any change against their will or without their consent and against the imposition of a uniform civil code.

3. Grant of statutory status to the Minority Commission at the Centre and in the states and establishment of such Commissions in other states where religious and linguistic minorities together exceed 10 per cent of the population and of Minority Boards in other states/union territories.

4. Introduction of the system of proportional representation in elections at all levels.

5. Constitutional provision for right to information as a fundamental right.

II. Political and administrative action

1. Creation of a department of minorities' affairs in the Central and state governments directly under the prime minister or the chief minister concerned.

2. Establishment of a Joint Parliamentary Committee on the welfare of the religious, linguistic, and ethnic minorities.

3. Reorganization of states and districts so as to create states of a manageable size and districts with a uniform population, more or less coterminous with Lok Sabha constituencies.

4. Delimitation of parliamentary and assembly constituencies in a manner that minority concentration areas are not fragmented.

5. Rotation of reservation among Scheduled Castes/Scheduled Tribes concentration constituencies to every general election.

6. Proportional representation for minorities as party candidates at elections at various levels in minority concentration constituencies.

7. Prohibition of religious rites in any official function and of installation of private shrines in government offices or places of work or on public premises.

8. Reformation of the prime minister's fifteen-point programme for the welfare of the minorities to make it result-oriented and not merely procedure-oriented in order to provide for

quantitative monitoring at all levels from the district to the Centre.

9. Publication of Census data relating to language, literacy, income, and employment for all minorities and caste groups in order to provide a factual basis about their relative socio-economic development status.

10. Composite deployment of civil and police officials, particularly at the district level, keeping in view the demographic structure of the area of jurisdiction.

III. Physical security

1. Reorganization of the police force and the intelligence machinery with at least proportional representation of the minorities and other weaker sections.

2. Establishment of special anti-riot force at the Central and state levels, with at least 50 per cent representation of the minorities and other weaker sections.

3. Statutory compensation for loss of life, limb, and property in social violence.

4. Introduction of compulsory collective fines in riot-affected localities with panchayat/municipal ward as the unit, on the communities involved, in reciprocal proportion to the losses suffered by each measured in terms of the statutory scheme of compensation.

5. Ban on all militant organizations and *senas* and on military training, drill or display of force in public by private organizations.

6. Institution of statutory peace committees at the local and district levels.

7. Liberalization of arms licensing in riot-prone areas to the minorities and other weaker sections.

8. Institution of judicial inquiry in all cases of social violence in which human life is lost.

9. Prosecution of police officers charged with atrocities or with violent misconduct or with negligence of duty against individual citizen or social groups in the case of social violence, if supported by sworn affidavit by the victims or the next of kin.

10. Accession by the Central government to international convention against torture, etc.

IV. Religious freedom

1. Statutory protection of the status of all places of worship as on 15 August 1947 and restoration of all places of religious significance such as mosques, shrines, and graveyards under adverse occupation since that date.

2. Restoration of the Babari Masjid to the Muslim community.

3. Recognition of the freedom of religious service in all protected places of worship.

4. Non-interference with the administration and management of institutions of religious instruction such as *maktabs*, *pathshalas*, and madrasas as charitable institutions run by religious organizations or trusts of societies, such as Musafirkhanas, Dharamshalas, and orphanages.

5. Demarcation and fencing of immovable property of religious significance such as graveyards, cremation sites, etc., at public cost.

6. Exemption from income tax of donations, both in the hands of the donor and the donee, to educational and charitable institutions.

7. Regulation of the use of loudspeakers for call to and performance of congregational service, without causing public nuisance.

8. Amendment to the Muslim Personal Law (Shariat Application) Act, 1937, to make it more comprehensive and the recognition of Imarat-e-Sharia and Shariat Courts and panchayats subordinate thereto, on par with Lok Adalat for resolving family disputes.

9. Prohibition on the propagation by the state of social norms unacceptable to any religious minority.

10. Allotment of public land for religious purposes such as construction of a place of worship, religious instruction, or burial.

11. State intervention against any interference by the mischievous elements, with religious freedom such as obstruction to the performance of religious rites, to construction of places of worship, and to the burial of the dead.

12. Continuance of protective discrimination in favour of backward classes on change of religion.

V. Educational promotion

1. Universalization of primary education and establishment of adequate number of primary and secondary schools in all localities (villages or wards) in accordance with the prescribed national norms.

2. Establishment of vocational schools, ITIs in all blocks.

3. Support to and encouragement of self-endeavour by the minorities in the field of education in the form of prompt recognition to and affiliation of educational institutions, established by the minorities under Article 30, non-interference with their administration and management except in the interest of prescribed physical and academic standards, and non-discrimination against them in the matter of financial aid by the state.

4. Non-interference with the flow of foreign funds for educational purposes.

5. Development of a composite culture free from the religious symbols, ethos, and practices of any religious group.

6. Institutional pre-publication scrutiny of all textbooks especially in languages, literature, history, and social sciences, in order to eliminate misrepresentation of any religion or religious group as well as any material which militates against national integration.

7. Declaration of the Aligarh Muslim University as a minority institution under Article 30 of the Constitution.

8. Restoration of the historical and minority character of the Jamia Millia Islamia.

VI. Linguistic protection

1. Recognition of all languages declared as mother tongue by at least one million people and used as medium of instruction up to the secondary level at least in one state or union territory as national languages and inclusion thereof in Schedule 8 of the Constitution.

2. Recognition of a minority language at the state level as additional official language of the state, to be used for specified purposes, at the state level or at the level of the district, block, or panchayats, where the language is declared as mother tongue by at least 10 per cent of the population at that level.

3. Distribution of the telecast/broadcast time of all centres of Doordarshan and by all stations of AIR amongst various languages in proportion to the linguistic composition of the service area.
4. Distribution of advertising outlay by the Union as well as the state governments among various languages in proportion to the linguistic composition of the country and the state respectively.
5. Provision of the mother tongue as the medium of instruction at the primary and optionally also at the secondary level.
6. Introduction of the mother tongue as the first language under the three-language formula and of the principal language of the state as the compulsory second language for the linguistic minorities of the state and of any other modern Indian language spoken in the state for the linguistic majority.
7. Establishment of a Central university with Urdu as the medium of instruction.
8. Reorganization of the Bureau for the Promotion of Urdu as the national authority for the development of Urdu to serve as the apex organization of the Urdu academies and institution of annual national awards for the best writing in Urdu and of a programme of translation of best writings in Urdu into other national languages and vice versa.

VII. Cultural practice

1. Promotion of unity in diversity as the key to the resumption of the historical process of the evolution of a composite national culture.
2. Prohibition on the use of government media for religious propaganda of indoctrination or for the projection of the socio-cultural values of the religious majority and against the social mores of any religious minorities.
3. Allocation of adequate resources for the repair and maintenance of national monuments protected by the Central and state governments for their protection against vandalism, illegal encroachment, or adverse occupation.
4. Prohibition against the depiction of any social group as such, in films and other mass media, as anti-national or criminal or comic stereotypes.

VIII. Economic development

1. Publication of the report of the high-power panel headed by Dr Gopal Singh on minorities submitted in June 1983 and implementation of its recommendations.

2. Implementation of the recommendations of the report of the Second Backward Classes Commission headed by Shri B.P. Mondal with the provision that the Muslim community as a community be treated as a backward class, as in Kerala and Karnataka.

3. Introduction of a system of universal reservation in public employment and higher education covering all social groups including minorities and caste groups whose educational and economic level is below the national or the state average, in proportion to its population at the appropriate level.

4. Decentralization of development planning as well as execution of development programmes so as to ensure universal and uniform coverage of all states in the Union, of all districts in a state, of all blocks in a district, and of all *gram* panchayats in a block.

5. Protection of the due share for the minorities in the flow of government loan and bank credit at the national, state, district, and block levels, in the allocation of surplus land and house sites in rural areas and of public housing in urban areas, in anti-poverty and self-employment programmes and in grant of dealerships under the public distribution system (PDS) or for the distribution of petroleum and petroleum products.

6. Introduction of a universal programme for the welfare of the aged, the handicapped, the disabled, the widows, and the orphans in a state of destitution.

7. Establishment of a Minorities Finance and Development Corporation under the Central government and under all state governments, with adequate working capital.

8. Introduction of a universal scheme of unemployment allowance for the educated unemployed.

9. Provision of equal and uniform opportunity to all districts in the country in recruitment to large public sector undertakings such as the railways, the Army, the para-military forces, and the police force, with the field of selection for Groups A, B, C, and D posts being defined as state, union territory, district, block, and villages and towns respectively.

10. Provision of due facilities for the craftsmen, particularly the handloom weavers, for the supply of raw materials at controlled rates; for upgradation of technology, skill, and design; and for marketing the finished products at remunerative prices.

11. Promotion of the cottage industry and the small scale industry against competition by the organized sector.

IX. *Wakfs* protection

1. Further amendments to the Wakf Act, 1954, as suggested by the Central Wakf Council and, pending such amendment, promulgation of the essential provisions of the Wakf Act, as amended in 1984, which have been found acceptable by the Muslim community.

2. Exemption of public wakfs from the provision of Income Tax, land ceiling, and rent control legislation.

3. Restoration to Wakf Boards of wakf properties in the occupation or possession of public authorities, particularly in the union territory of Delhi.

4. Establishment of a Wakf Development Corporation with adequate working capital at the Centre as well as in the states for the commercial development of wakf properties in order to maximize wakf income.

5. Establishment of a Wakf Education Foundation for channelization of surplus wakf income for the education and welfare of the community.

6. Inclusion of public wakfs as well as other religious endowments of public benefit in the definition of 'public premises' for purpose of vacation of illegal and adverse occupation.

X. Defence of dignity

1. Statutory prohibition of insult to the dignity of any community, religious, linguistic, ethnic, or caste group.

2. Legal action against any publication or writing which incites hatred or promotes ill will or misunderstanding against a community or defames or insults or ridicules or humiliates any social group or the personalities, symbols, and objects it respects.

[1]*Muslim India*, August 1989.

13. Babari Masjid Action Committee and Babari Masjid Movement Coordination Committee agree to Hold Talks with Government[1]

Both the Babari Masjid Action Committee (BMAC) and the Babari Masjid Coordination Committee (BMCC), have tacitly agreed to have a dialogue with the government if the talks are held within the framework of the declaration made by the chief minister, Mr Kalyan Singh, at the meeting of the National Integration Council on 2 November 1991.

The two panels have requested the government to specify the basis of the negotiations as well as the formula, before the commencement of the talks.

In a letter to the energy minister, Mr Lalji Tandon, the convenor of the All India Babri Masjid Action Committee (AIBMAC), Mr Jafaryab Jilani, has specified that Mr Kalyan Singh has gone on record at the NIC, promising that 'until a final solution, the government will hold itself fully responsible for the protection of the disputed structure'.

Moreover, the chief minister had promised to abide by the court order on the acquisition of the land around the structure. 'The two committees will only hold talks with these as basic premises,' Mr Jilani expressed BMAC's reservations at the government calling the disputed structure the Ram Janmabhoomi and not mentioning the Babari Masjid in their invitation letter, thus making assumptions before talks are even held.

It is highly likely that the two groups will, for the first time, come together across the negotiating table, but it is unlikely that any solution will be reached, as both are adamant on their positions and not willing to budge.

For the government, it is a necessity that must be fulfilled in order to be able to say that they have done everything for an amicable solution, but they failed to deliver the goods. And then they will be in better ground to bring about a legislation to acquire the temple complex and remove all hurdles between them and their Ram *mandir*.

[1]*The Telegraph*, 3 March 1992.

14. Muslim Ministers and MPs Submit Joint Memorandum to the Prime Minister on 19 December 1992[1]

I. Ayodhya situation

1. The situation on the site of the Babari Masjid should be frozen till the *masjid* can be reconstructed, as promised by the prime minister.

2. The entire disputed/acquired land enclosed by the walls on the three sides and the road on the fourth should be taken over by the Central government. Further action on the use of this land should be taken only after the final judicial verdict in the title suit.

II. General

3. The prime minister should visit the affected areas of Bombay, Bhopal, Kanpur, Ahmedabad, Delhi, Mysore/Bangalore, etc. The prime minister should also address public meetings in these areas to reassure the people of protection of life and property, upholding of secularism, Constitution, etc.

4. A senior Cabinet minister of the Central government should be made in charge of each of the states now under president's rule to ensure that the bureaucracy functions effectively and impartially in the implementation of the government's various measures of relief and rehabilitation, curbing communalism, enforcing effective ban on the communal organizations already banned, and reassuring people, particularly the minorities, of protection and gaining their confidence in the government machinery.

5. In each state where president's rule has been imposed, a senior Muslim officer should be posted as adviser to the governor. In Uttar Pradesh, two senior Muslim officers should be appointed as advisers to the governor. The department dealing with the relief and rehabilitation work should be placed under the Muslim advisers to the governor.

III. Relief and rehabilitation

6. The NIC Resolution relating to fixing up of responsibility and accountability on district magistrates and superintendents

of police/police officer-in-charge where the communal outburst takes place should be implemented.

7. A time limit should be fixed to ensure that rehabilitation and compensation works are taken up and completed all over the country.

8. In case of death, the compensation should be rupees two lakh. Likewise, for the injured suitable compensation should be fixed.

9. One ward of a family where death has occurred should be given employment. The compensation for loss of business and damage to property should be adequate on the pattern followed by the Delhi administration in the case of 1984 disturbances.

10. In each of the cities/districts where communal outbursts have occurred, a judicial commission should be appointed to enquire into the incidents and submit their reports within three months.

11. The state police force and particularly, the state armed constabularies like Provincial Armed Constabulary, Bihar Military Police and should be reorganized so as to ensure due representation of the minorities, especially Muslims, and retrained, and all police stations in the riot-prone areas should be compositely staffed.

[1]*Muslim India*, January 1993.

New Trends in Muslim Politics

1. National Convention's Resolution on Reservation for Muslims[1]

The National Convention on Reservation held in New Delhi on 9 October 1994:

Considering the persistent pattern of under-representation of the Muslim community in public employment and education, and of educational and economic and social backwardness;

Noting that the Muslim community which constitutes 12 per cent of the population, aspires to play its due role in promoting development and in managing the affairs of the society;

Considering that it is not in the national interest to allow a pan-Indian community to become a drag on the onward movement of the nation, Taking note of the facts that executive measures and sympathetic notes have failed to make a dent in the overall marginalization of the community, encouraged by the experience of Kerala and by the policy pronouncements of several state governments and political parties, Having considered the constitutional provision in this regard; Has come to the conclusion that the only effective short-term measure for reversing the present trend of under-representation and consequent frustration and demoralization and for reviving the dignity and self-confidence of the Muslim community is the statutory institution of reservation in public employment and education.

The Convention therefore:

Requests that the Muslim community be declared, in the country as a whole and in all states and union territories in accordance with the prescribed procedure, as a backward class within the meaning of Articles 15(4) and 16(4) of the Constitution;

Proposes that the Muslim community be entitled to reservation in public employment and education, particularly in higher and

professional education, in proportion to its population and its index of backwardness (index for SC/ST=100) at the appropriate level;

Decides that the benefit of reservation should accrue first, as a matter of priority, to the Muslim candidates who belong to various sub-communities which have been already notified as backward class by the Central or state/UT governments, in order of their merit inter se and the candidates who belong to other Muslim sub-communities which have not been so notified be admitted to the benefit of reservation, *only if and to the extent* the Muslim quota remains unutilized;

Demands that the reservation quota should apply to the cadre strength of the service or cadre concerned at each level and not to the current vacancies in those cadres and levels;

Further demands that the unutilized quota should not lapse but should be carried over to the succeeding year;

Recommends that reservation should be initially instituted for a period of ten years and should be reviewed thereafter in the light of the latest census as well as the current index of backwardness;

Proposes that in order to facilitate the task of indexation, the economic, educational, and social data collected in the course of 1991 census be cross-tabulated to indicate the current relative status of the Muslim community in the country, as a whole, in each state/UT;

Appeals to the Muslim community to redouble their own efforts in the field of education as well as to secure full implementation of state-funded educational programmes in their areas in order to be in a position to field well-qualified candidates for public and private employment;

Directs that the Association place the case of the Muslim community before the National Commission for Backward Classes and before the Government of India as well as establish working groups in each state of Muslim concentration to place the case before the state-level Commissions and state governments.

[1]*Muslim India*, November 1994.

2. Sitaram Kesri on Injustice to Muslims[1]

Union Minister for Social Welfare Sitaram Kesri has admitted that even the Congress failed to protect the Muslims and said

the party could rectify its mistakes by ensuring reservations to the community in jobs and educational institutions.

Inaugurating the Muslims Education Conference organized by the Maharashtra Qaum Tanzeem in New Bombay on 6 June 1995, Mr Kesri called for a national consensus on the issue of reservations for Muslims. 'The socio-economic condition of Muslims has deteriorated after independence,' he said.

They cannot be left out, the minister said and expressed confidence that the Backward Class Finance Corporation and Maulana Azad Foundation would help in uplifting the oppressed Muslims. The foundation would spend Rs 30 crore to encourage Muslims to get educated. Mr Kesri argued that he was not talking in terms of appeasing the Muslims as his critics would love to say. 'But we must try and undo the injustice perpetuated on the Muslims.'

He attacked the opportunistic alliance between the Bharatiya Janata Party and the Bahujan Samaj Party. Mr Kesri, however, hastened to say that he was not attacking Mayavati who represented the backward class people. His criticism was against BJP which, he said, had vehemently opposed Kanshi Ram's party till the other day.

The minister said even the Chief Election Commissioner, T.N. Seshan had taken objection to the statement on the Muslim reservation issue describing it as a poll-eve policy statement. 'But I am not bothered about the criticism of either Mr Advani or Mr Seshan,' he said. 'For me Congress is the platform, ministry the medium, and public service the aim,' Mr Kesri added.

[1]*Indian Express,* 7 June 1995.

3. Prime Minister Vajpayee Addresses Convention of Muslim Women, Extends Hand of Friendship to Pakistan[1]

Prime Minister Atal Behari Vajpayee, while addressing a convention of Muslim women on 4 October 1998, asserted that India always wanted to make friends with Pakistan.

'It was with this intention we resumed dialogue with Pakistan,' Mr Vajpayee said.

The All India Convention of Muslim Women was organized by the Mahila Morcha of the BJP.

The meeting could be described as the beginning of the BJP's attempt to woo the minorities in the wake of the forthcoming assembly elections in Delhi. The party was also poised to organize a convention of linguistic minorities in the capital before the elections. The prime minister said that India which has resumed the dialogue with Pakistan categorically told that the country was ready to extend the hands of friendship. 'Let us be friends as there was no other way out for us,' Mr Vajpayee claimed to have told the Pakistani premier, Mr Nawaz Sharif.

He maintained that 'even brothers sometime fight with each other. Let us be friends. Friends do not fight among themselves,' the prime minister said amidst loud applause. Mr Vajpayee observed that since both the countries were neighbours, India and Pakistan have to stay together irrespective of the relations between the countries.

To establish the secular credentials of the BJP, the prime minister said that even during the formation of the Jan Sangh, it was decided to throw open the party to people of all religions. Stressing the need to be 'friends' with Pakistan, the prime minister referred to the Islamization of Pakistan, and said in India Muslims were at par with those belonging to other religions.

'I do not want to get into what neighbours have done in this regard. But in India, there was no difference on the basis of religion,' he said. The prime minister claimed that since partition, the Muslims who decided to stay back in India were 'treated as equals.'

Though every religion has its own way of offering prayers, there should not be any differences among people of different religions on this basis, Mr Vajpayee said. 'The BJP stood for unity of all and we want to take everybody along with us. Keeping this in mind we want to develop all languages and the diverse culture,' Mr Vajpayee maintained.

[1]*The Statesman*, 5 October 1998.

4. Muslim Parties Join Hands to Form a New National Party[1]

Two of the Muslim political parties of the south, the Indian Union Muslim League (IUML) of Kerala and Majlis-e-Ittehadul

Muslimeen (MIM) of Andhra Pradesh have made a bid to form a party of Muslims at the national level, on the ground that the secular parties have merely made use of the community for their own end during the past fifty years. The first convention of the Milli Jamhoori Mahaz, formed of four Muslim political parties, was held at Lucknow on 16 November 1998.

The real objective was to emerge as a third power after the 'secular' and the '*Hindutva*' forces in the country, according to Mr Khan Mohd Atif, one of the organizers.

The president of the Indian Union Muslim League (IUML) and Lok Sabha member, Mr G.M. Banatwala, who has been elected chairman of the new forum, MJM, expressed his disillusionment with all 'secular' parties which the Muslims voted for in the last five decades, and which had used the Muslim community as vote bank and neglected them. The Muslims are now left with the only option of emerging as a strong political entity by forming their own political party at the national level. If SCs, OBCs, the *Hindutva* forces, and Sikhs can have their own parties, why not Muslims. Mr Banatwala pointed out the benefits derived by the Muslim League in Kerala. The Muslim Majlis, one-time strong Muslim political outfit, and the Muslim Samaj were the two other organizations represented at the Milli.

In a hard-hitting speech, Mr Khan Mohd. Atif traced the plight of Indian Muslims who had been used as mere vote banks by political parties. The Muslims were now getting a raw deal in government services and the private sector. Muslim representation was coming down steadily in legislatures and Parliament in each passing poll, which showed that the secular parties were paying only lip service to Muslim interests. The Muslim leaders in 'secular' parties were neither representatives of the Muslims nor of the Hindus. The Milli passed ten resolutions demanding reconstruction of the Babari Mosque on the same site, proportionate reservation in services, legislatures, and Parliament, and implementation of the Srikrishna Commission and Parekh Commission reports.

The Uttar Pradesh government has turned down a plea to publish the report of the Parekh Commission on Meerut riots which had engulfed the town in 1982 or to proceed against political leaders and police officers who were indicted. Although the report was submitted a decade ago, the governments of the Congress, Mr Mulayam Singh Yadav, or Ms Mayavati did nothing about it. The non-BJP parties have also skirted the demand on reconstruction of the Babari Mosque.

The Muslim League was sought to be revived in the previous decades in Uttar Pradesh, but with little success. A former BSP leader, Dr Faridi, had floated a Muslim organization of liberal outlook—Muslim Majlis—and won a few seats in the legislature. But after the death of Dr Faridi, the Muslim Majlis lost most of its clout and could not win any seat. Mr Mulayam Singh Yadav, who benefited politically over the Ayodhya issue by taking on the *Hindutva* forces, has been able to divide the electorates of UP between the BJP and the Samajwadi Party. The BJP and the Samajwadi Party are complementary to each other in UP owing to well-sustained communal polarization. This has come as political demise for the Congress, the Janata Dal, the Left parties, and all others, save the BSP, which has been able to thrive on the Dalit sentiments, by siding once with Mr Mulayam Singh and later with the BJP.

[1]*The Hindu*, 17 November 1998.

5. Muslim Agenda Released for Polls[1]

Five leading Muslim organizations unveiled a 'Muslim agenda' on 9 July 1999 for the coming general elections, and urged secular parties to increase the representation of Muslims in the Lok Sabha.

Releasing the document, former Union minister Saifuddin Soz and former MP Syed Shahabuddin said there were no plans at present to form a Muslim party. 'The organizations responsible for drawing up the Muslim agenda have their own political strategies. Muslims are disenchanted with secular parties, and anti-secular forces might exploit this,' said Mr Shahabuddin.

The agenda, drawn up by the Jamiat-ul-Ulema-e-Hind, Jamaat-e-Islami Hind, All India Milli Council, All India Muslim Personal Law Board, and All India Muslim Majlis-e-Mushwarat, will be provided to all secular parties for inclusion in their election manifestos. Mr Soz identified the secular parties as the Left parties, Congress, RJD, Samajwadi Party, and Bahujan Samaj Party.

'Muslims have to support secular parties but they are not united,' said Mr Shahabuddin. He urged the parties to come together to ensure that there was no division of secular votes. 'These parties should close ranks through alliances, adjustments, or understanding to give a one-to-one fight to the communal forces,' said Mr Soz.

Mr Soz said frustration among the Muslims was largely due to their 'under-representation in the legislatures and the power structure in public employment and higher education, its virtual non-participation in governance and administration.' The organizations urged the secular parties to put up one common Muslim candidate in the 100-odd parliamentary constituencies with a strong Muslim population. The agenda called for the promotion of federalism and effective decentralization of power down to the panchayat level. It said departments of minority affairs should be created at the Centre as well as in the states, and seats in the legislatures and panchayati raj institutions should be reserved for Muslims and other backward classes.

The National Minorities Commission should also be empowered for the defence of minority communities, it said.

The Illegal Migrants (Determination by Tribunals) Act in Assam should be retained to determine the citizenship of 'doubtful' persons, the document said.

[1]*Asian Age*, 10 July 1999.

6. Declaration of the National Convention Launching the Movement for Empowerment of Muslim Indians[1]

The National Convention for Movement for Empowerment of Muslims in India was held on 8 May 1999 at New Delhi. A galaxy of eminent Muslims from all over the country, representing all walks of life and all regions of the country, who had scaled great heights in their respective professions, participated.

The Convention
- Noted with the deepest concern and anxiety that the present share and status of the Muslim community in every major area of national well-being is significantly lower today than at the time of independence and well below its share in the country's population.
- Pointed out for the attention of all decision-making bodies that this decline has heightened its sense of frustration and, in consequence, alienation. Unless this trend is reversed visibly, effectively, and quickly, it could lead to despair

with its inevitable and unfortunate fallout on the very socio-political fabric of the national body politic.

This will seriously impair the nation's unity, its strength, and its ability to face the serious challenge of internal dissension and external threats to its smooth and unfettered management of the task of good governance. It will also compromise the nation's will and ability to look to the largest good of the largest number of its members with complete socio-economic justice as its major goal.

The task of remedying this situation of the Muslims in India is of the highest urgency, not just of the community and its leaders, but also of the nation as a whole.

The Convention, therefore, resolved
- That the Movement for Empowerment of Muslims has to be launched on a sustained and enduring basis, always remaining truly and positively secular and apolitical and prioritize for immediate attention on the four issues of
 - Educational empowerment
 - Economic empowerment including employment and self-employment
 - Political and administrative empowerment and
 - Social and cultural empowerment including community development, health, and housing

And in furtherance thereof

Education

- Urges the government to take all necessary steps to empower Muslims in the field of basic and primary education, women's education, and professional education and to establish institutions required to serve these objectives with efficiency and autonomy, safeguarding the legitimate interests of the community;
- Urges the government to secure through adequate reservation, for the Muslim students, their due share in institutions of higher education, especially technical and professional. While doing so, it should be ensured that a major portion of this share is earmarked for those backward Muslim communities who have been so notified in various states;
- Urges the community to strengthen the Madrasa system of education with all requisite financial support, especially providing for the teaching of modern subjects therein;

- Further urges the community that each and every one of its educational institutions pursues the goal of excellence.

Economic upliftment

- Calls upon the government to recognize that all steps hitherto undertaken by the state have failed to ensure adequate representation to Muslims in public employment.
- Urges the government to take positive and affirmative actions, through appropriate reservation to provide employment to Muslims in various state services, including paramilitary and police, public enterprises, autonomous bodies, judiciary, banks, and other financial institutions.
- Urges the government to ensure, through a system of reporting and proper monitoring, an adequate and continuous flow of credit to support the Muslim enterprises especially in the small and tiny sector.
- Urges the government to provide for the drawing up of a special component plan for Muslims and to ensure that they receive proportionate share of various socio-economic development schemes and welfare programmes, both in terms of finances and numbers. This should be supported by a rigorous programme of reporting and monitoring of its implementation.

Political and administrative empowerment

- Urges the government and various political parties to take serious note of the sharp and continuous decline of Muslim representation in Parliament and state legislatures in the last fifty years, which makes a mockery of the assurances extended to the community in the Constituent Assembly.
- Urges the government to take all necessary steps to secure for Muslims a proportionate share of seats in Parliament, sate legislatures, panchayats, and other local bodies.
- Urges the community to ensure enrolment of all eligible Muslim voters; resist by all peaceful and legitimate means any attempt to disenfranchise them; and ensure that they exercise their right to vote.
- Urges the government to use its discretionary powers to nominate adequate number of Muslims to various commissions, committees, panels, boards, tribunals, and other collective administrative and regulatory bodies.

- Urges the political parties and the government to constitute without delay a Parliamentary Committee for Minorities, on the lines of the Parliamentary Committee on SC/ST, with the mandate to safeguard all the legitimate interests of the minorities, examine and supervise measures to protect their life and property, safeguard their civil rights, monitor the representation of the minorities in the public services and its adequacy, and ensure that the benefits of government expenditure flow to them equitably in all sectors.

Social and cultural empowerment including health and housing

- Urges the community to introspect and remedy, without delay, the various social infirmities they are afflicted with.
- Urges the community to develop and maintain friendly social relations with all communities at all times and take initiative to open and maintain a constant dialogue with them to build up mutual understanding and tolerance.
- Urges the government to provide for proportionate representation to Muslim women in the proposed women's reservation bill.

The Movement resolves to constitute a Steering Committee which will take all necessary steps to follow up the resolutions passed by this Convention and to set up a secretariat at its headquarters in Delhi and extend its activities to various states in a phased manner.

[1]*Muslim India*, June 1999.

7. Extracts from the Inaugural Address by Mr Justice A.M. Ahmadi Delivered on 9 May 1999 at the National Convention for the Movement for Empowerment of Muslim Indians[1]

We have just completed fifty years of our Independence. . . . The general impression so far as the Muslim minority is concerned is that there has been a gradual decline after the first twenty or twenty-five years and a sharp decline in the last decade. Is this perception justified? . . .

Muslims constitute about 12 per cent of the total population of India. In 1980, there were forty-six Muslim members in the Lok Sabha (8.5 per cent), which number shrunk to as low as twenty-eight (5.9 per cent) in the just dissolved Lok Sabha. If we take the average from the first Lok Sabha to the last Lok Sabha, it works out to just 5.5 per cent, i.e. less than half of the percentage of Muslim population . . .

In the field of education . . . Muslims . . . are far behind their compatriots, with the dropout ratio both among male and female students being substantially high. It causes anxiety to know that the enrolment rate is fast declining; it stands at 62 per cent lower than that of the majority community. Apart from the main reason being poverty and lack of public funding, the other reason is the lack of job opportunities. The percentage of representation of Muslims in government service is just about 2 per cent which has given rise to a sort of apathy for education. . . . The position is no better in private as well as public sector undertakings. This has been the main cause for frustration. Even in the case of availing of self-employment schemes . . . Muslims received less than 4 per cent of the fund distributed in the 1970s and 1980s.

Unfortunately, the atmosphere created immediately before and after the demolition of the Babari Masjid has permeated the minds of a large section of the non-Muslim population, particularly in the urban areas, which has further aggravated the employment scenario for the Muslims. . . .

. . . To what extent the minorities themselves are responsible for their plight and to what extent external forces are responsible have to be determined and to the extent minorities are responsible they must take corrective action. Education is one area which deserves immediate attention by the community itself. Of course, having regard to the fact that the community is not affluent, assistance of the state would be necessary. . . . This would help in narrowing the literacy gap between the Muslims and non-Muslims. . . . This will help Muslims come into the mainstream to enable them to make contributions in different fields. . . .

The flow of funds from government schemes does not reach the Muslim community in the proportion to which they are entitled. . . . It is the duty of the government in power to ensure that the material resources of the state are equitably distributed. This will also help reduce the inequalities in income which is one of the objectives of Article 38(2) of the Constitution.

It is high time that the Central government and the state governments take effective positive steps to increase the job opportunities for Muslims through affirmative action. The inadequate representation of minorities in government and public sector services has given rise for demands for reservation from certain quarters. . . . It is time that assurance of fair treatment to minorities is fulfilled to remove the frustration that has crept into the psyche of the minorities and to restore the confidence in the fairness of the majority community.

The Founder Members of the Movement were: A.M. Khusro, Arif Mohammed Khan, Badr Sayeed, Saiyid Hamid, I.M. Kadri, C.K. Jaffer Sharief, Nawab M.A.K. Pataudi, Moosa Raza, S.M.H. Burney, Naushad Ali, Saifuddin Soz, Justice Sardar Ali Khan, Mohammed Shafi Moonis, Mohammed Shafi Qureshi, S. Shahabuddin, Tahir Mahomood, Mohammed Yunus Saleem and Zafar Saifullah.

[1]*Muslim India*, June 1999.

Urdu

1. Urdu in India[1]

In every state the Muslims use the language of their own region. However, it may be said that Urdu serves as a common link among them because, in addition to their mother tongue or regional language, the Muslims of every state usually learn Urdu also.

Non-Muslims (Hindus and Sikhs, Jains and Christians), too, cherish and enirch Urdu as their own language. In fact, they are contributing as much as the Muslims in sustaining and building up Urdu literature.

Urdu is strong because instead of having a firm but limited hold in any special corner of India, as is the case with the other Indian languages, it wields a pervasive influence throughout the country. The reason is mainly historical. Punjab and Delhi, Avadh and Deccan have all contributed in equal measure to the evolution, enrichment, and spread of this language. The early Englishmen vied with the later Mughals to patronize it. Thus it also stood as a symbol of political unity. Today the most prominent centres of Urdu are spread all over the country, all the way from Jalandhar, Delhi, Agra, and Lucknow to Allahabad, Patna, Gaya, and Calcutta, as well as Bhopal, Hyderabad, Bangalore, Madras, and Bombay.

[1]*Muslims in India*, Publications Division, Government of India, 19 July 1964, p. 18.

2. Teaching of Urdu Discouraged Affecting Muslim Education[1]

The economic depression in which Muslims of the higher and middle classes found themselves naturally cramped their cultural and educational life. An additional difficulty which they

had to face in the Hindi-speaking states and which had made their cultural crisis more acute, was that the Urdu language was not only being pushed out of courts and offices but also being banished from schools. In the eighteenth and nineteenth centuries, Urdu had been the common cultural language of Hindus and Muslims in these parts. . . . The Muslims as a community had, however, stuck to Urdu because in the course of the last two centuries they had made it, instead of Arabic or Persian, the storehouse of all the religious, scientific, and literary wealth which they had inherited from their ancestors or produced themselves. Abandoning it at this time would have been educational and cultural suicide for them. But now in the Hindi states, especially in Uttar Pradesh, it looked as if the teaching of Urdu to children would be stopped because generally in government schools Urdu was jettisoned from the syllabus. . . . The result was that many Muslims stopped sending their children to schools and as they could make no private arrangements for teaching them, they remained practically illiterate.

[1]S. Abid Husain, *The Destiny of Indian Muslims*, Asia, 1965, pp. 132–3.

3. Banishing Urdu Affects Life and Culture in Lucknow[1]

Lucknow, in the brief span of a year or two, had completely changed its character. . . . The elegance, culture, and etiquette for which Lucknow was justly famed all but vanished, and even the graceful Urdu language was imperilled. Thus, while British style and decorum disappeared almost without trace, the long-celebrated Urdu culture of the city was on the retreat. The pattern—if there was any—was now to be set by the new governing class. . . .

Politeness of speech gave place to raucousness. Not only was the Urdu language frowned upon, but the Devanagari script was sought to be imposed. Words in common parlance came to be substituted by newly contrived expressions never heard before. The Urdu script in current use throughout the province was substituted by the Devanagari. Even in the secretariat some ministers began noting in Hindi to the dismay of the permanent officials, high and low. . . .

[1]Rajeshwar Dayal, *A Life of Our Times*, Orient Longman, 1998, pp. 95–6.

4. Eminent Muslims' Plea Before the Constituent Assembly for Hindustani as the National Language[1]

The adoption of Hindustani as the national language and of Devanagari as its principal, and Urdu as its second script is urged by sixty-one prominent nationalist Muslims from all over India in an appeal to the members of the Constituent Assembly.

The appeal refers to the earlier representation to this effect made by the committee appointed by the Hindustani Prachar Sabha to press the claims of Hindustani and express the hope that the members of the Constituent Assembly would consider it objectively and impartially, in view of the significance their decision will have in the development of the national life of the country.

The appeal states: The democratic ideal of the Indian Union requires that the national language should possess the widest currency, not only as a hypothesis, but in fact, and should derive its vocabulary and idiom from the living speech of the people. Literary Urdu leans too heavily on Persian and Arabic, and Hindi too much on Sanskrit. But Hindustani, which is their basic and popular form, has both character and flexibility; it is inclusive like all progressive languages, having taken words freely from Sanskrit, Arabic, Turkish, Persian, and modern European and Indian languages, and it has an individuality which stamps itself on all that it borrows.

The appeal further says: As regards the script, we readily agree that Devanagari should be declared the principal, and Urdu the second script for this national language. Devanagari represents the largest common element of Indian scripts. Urdu has been an alternative script for Hindustani, wherever Hindustani has been current. It deserves recognition for historical and social reasons.

The signatories include Khwaja Abdul Majid (Aligarh), Mr Fakhruddin Ali Ahmed (Shillong), Dr Zakir Hussain (Delhi), Mr M.Y. Nurie (Bombay), Mr Abid Ali Jafarbhai (Bombay), Syed Nowsher Ali (Calcutta), and Mr Harris (Bombay) and others.

[1]*The Times of India*, 15 July 1949.

5. Muslim Members of the Constituent Assembly Plead for Adoption of Hindustani as the Lingua Franca of India[1]

Muslim members of the Constituent Assembly have urged the members of the Assembly to make Hindustani in either script—Devanagari and Urdu—the 'lingua franca' of India. They suggest that if Hindustani is adopted 'it is bound to lead to fusion of cultures for the ultimate good and prosperity of every section in India'.

In a statement on the question of the national language, they say: 'We, the Muslim members of the Constituent Assembly of India, are distressed at the way the question of language is being canvassed inside and outside the Assembly. Signatures are being obtained. Compromises and adjustments are being made in order that the cause of Hindi should be advanced. There is not the least doubt that the supporters of Hindi in Devanagari script are accentuated by sentiments of momentary political passions and prejudices as a result of the partition of India and are determined to destroy the Urdu script.

'Our illustrious leader, Mahatma Gandhi, had declared in the issue of the *Harijan*, dated 10 August 1947, that "the Congress must stand firm like a rock; it dare not give way on the question of the lingua franca of India. It cannot be Persianized Urdu or Sanskritized Hindi. It must be a beautiful blend of the two simple forms written in either script. Let us not turn away from the Urdu script".

'Today in sheer disregard of the wishes of Mahatma Gandhi and his colleagues and in violation of the declaration of the Congress, the protagonists of Hindi are unmindful of the stand they had taken before the partition of the country. We are fully conscious that in the present communal atmosphere, we are helpless but we assert that it is unto the members of the Constituent Assembly of India, most of whom are Congressmen, and particularly the prime minister of India, to rise to the occasion and be consistent with their past declarations.

'Hindustani, in either script should be the lingua franca of India and, if adopted, it is bound to lead to fusion of cultures for the ultimate good and prosperity of every section in India.'

The signatories include Nawab Ismail Khan, Mr Nazi Ahmad, Mr B. Pocker Sahib, Mr A. H. Ghuznavi and Mr Z. H. Lari.

[1]*The Times of India*, 20 August 1949.

6. Maulana Hasrat Mohani's Plea for Inclusion of Education in the Concurrent List[1]

Maulana Hasrat Mohani (United Provinces, Muslim): Sir, it would be astonishing to you all why I, a protagonist of provincial autonomy and an opponent of making a strong Centre, am trying to make this particular item a Central subject. Education should be included in the Concurrent List and not be made a provincial subject. . . .

I have proposed this because provinces have adopted autocratic and quite unreasonable attitude in regard to the question of the medium of instruction in education, regarding which provinces have been given powers to take any decision they like, irrespective of the wishes of the Centre or of the people. . . . The difficulties which confront the people of the United Provinces are that the UP government has adopted a strange procedure. They say that Hindi is the provincial language, and their regional language is Sanskritized Hindi, and that Urdu has no place in the province. I am not saying this to you at random. You will be simply surprised, if I tell you what is happening there. Mr Tandon, the Speaker of the provincial assembly, has ordered that all bills to be moved in the assembly should be in Hindi and Hindi alone. We do not get its copy in English. There, the agenda is also framed in Sanskritized Hindi and the list of questions is also prepared in Sanskritized Hindi. And if anybody happens to send his questions in Urdu, they are thrown away. This is not all. They have issued instructions in districts that anyone, who wants registration, must produce the document in Hindi. And if the document is brought in Urdu, registration is refused. Please tell us what to do in these circumstances. Urdu is not the language of Muslims only, it is the language of Hindus also.

Now, it is said that up to the primary and secondary stages, the medium of instruction will be the regional language. But they do not follow even this instruction. They ought to impart education in these stages in the regional languages. Boys, between the ages of six and eleven years, should be given instruction in their mother tongue, so that they should be free from the burden of learning other languages. Formerly, we used to oppose the British government for this very reason and used to curse them for they had fixed English as the medium of instruction in high schools. But you have surpassed them. They did so in high schools only. But

apart from this, they started vernacular middle schools and gave the option of passing the middle school in Hindi or Urdu. Those who wanted to acquire further education in English used to join high schools. So I want to say that the provincial governments, now, are doing things which even the British government abstained from doing. . . .

Compulsory education has been introduced in all primary schools in the villages. And it is obligatory on everyone that he should get his children admitted in primary or basic schools, because people are bound to get their children admitted in these schools for their education. Now you see what is happening there. When these boys are admitted in the first class, they are told they would not be taught 'Alif', 'Bay', as there was no arrangement for that. Now you can see for yourself what these boys would do whose mother tongue is Urdu. They are told that they could not learn 'Alif', 'Bay', as there was no arrangement for that. So they should learn 'Ka', 'Kha', 'Gha'. What a cruelty it is, and what an injustice it is. Has any government in the world ever done the injustice which has been perpetrated by the UP government? And moreover, they say that, as it is a provincial subject, they can do whatever they like.

In the University Commission report submitted by Mr Radhakrishnan, it is clearly written. 'Mother language, according to the Commission, should be the medium of instruction in all stages of school education.' . . .

The assertion of the UP government that its state language is Hindi and its regional language is also Hindi and that Urdu has no place there and that Urdu should be wiped off the face of the earth, is highhandedness. You know very well that the birthplace of Urdu is UP.

[1]Translation of speech in Hindustani by Maulana Hasrat Mohani, Muslim member of the Constituent Assembly from UP. CAD, vol. IX , 2 September 1949, pp. 881–3.

7. Maulana Azad Speaks Out for Hindustani in the Constituent Assembly, Announces his Resignation from the Drafting Committee[1]

The Honourable Maulana Abul Kalam Azad (United Provinces, Muslim): Mr President! I shall take some time of the House. I have come here to apprise you of my opinion about the language;

also I would tell you the object with which I gave my advice to the Congress Party and the procedure adopted by the Drafting Committee, thereupon. I shall place before you all these facts and through you shall bring them to the notice of the country. . . .

Regarding language, another question which confronts us is what our national language should be, what name should be given to it?

So far as language is concerned, this has been admitted on all hands that the language spoken in northern India can only be made the lingua franca. But it has got three names—Urdu, Hindi, and Hindustani. Now, the point of dispute is as to what name should be given to it. Naturally, with different names are associated different forms and styles of the language; so in reality it is not a quarrel about the names but about the form or style. I want to give you a brief resume of the points of difference in these three names.

The general framework or the set-up of the language spoken all over northern India is one and the same, but in its literary style it has got two names—a style resplendent with Persian is called Urdu and a style leaning towards Sanskrit is known as Hindi. The term 'Hindustani' has developed a wider connotation; it embraces all forms of the language spoken in northern India. It includes 'Hindi' as well as 'Urdu', and even more than that, it includes each and every shade of the spoken language of the north. It does not exclude any. It covers all.

It was on my suggestion that, about a quarter of a century ago, the All India Congress Committee, when the question was before it, decided in favour of Hindustani. The object behind the decision was that in this language question we should not act with narrow-mindedness; rather we should try to extend its field. By adopting the name of 'Hindustani' we have tried to do away with the differences that separated Urdu and Hindi, because when we try to speak in or write easy Hindi and easy Urdu, both become identical, and the distinction of Hindi and Urdu disappears. In the new framework of this easy vehicle of expression you can coin as many new words and new phrases as you please; there would be no obstacle. Besides, by adopting the name of Hindustani we leave untouched that vast and extensive field which the people of north India have created for their language. We do not put any check or obstacle upon them from above.

Think for a moment of the position in which people of this area find themselves today! Only seventy or eighty years ago, Urdu was spoken and written by them. The movement for Hindi was started

much later and a new literary style came into being which was known as Hindi. Now Urdu and Hindi are being used as two separate names for it. Even then, the language commonly spoken all over UP, CP, Bihar, and Punjab is the same in shape and form. Those who have a liking for Sanskrit literature generally use words of Sanskrit origin and those who have got Persian education commonly use words of Persian origin. What the Congress had decided was that in Hindustani both these styles were included. They all speak Hindustani. If we want to develop a powerful, extensive, and a literary language we ought not to place any artificial obstacles in its way. We should let people speak the language they desire. . . .

By adopting the name of Hindustani, Congress had recognized that natural law according to which languages evolve. Congress only wanted to save it from artificial restrictions. Both Gandhi*ji* and Congress acted on this principle. He toured all over the country and everywhere he spoke in Hindustani. He did not belong to Delhi or Lucknow. He was brought up in Kathiawar. His Hindustani was neither literary Urdu nor literary Hindi, but an intermixture of both. In his vocabulary, there were many words and phrases current in Bombay and Gujarat and he used them quite freely. Even then, the language he spoke was Hindustani, and through its medium his message did reach millions of Indians. If you look at the congress you will see to what extent it has been influenced by him. Prior to his coming, speeches only in English used to be made from the Congress platform, but since his arrival Hindustani came into vogue and up to this day speeches are made in Hindustani. But his Hindustani was neither the idiomatic Urdu of Delhi or Lucknow nor the Sanskritized Hindi of Benaras. The language used by him was wider and more expansive. Any speaker could express himself freely in that language according to his own taste and learning and could make himself intelligible to thousands of his countrymen. Urdu-knowing people could speak in Urdu while Hindi-knowing people could speak in Hindi. A speaker from Bombay would use Bombay-style Hindustani, while a Bengali speaker would speak in Hindustani with his own accent and style. All of them are covered by the wider term of Hindustani. Hindustani has a place for all these styles. . . .

We have to replace English, which is a literary and extensive language, with a national language. That can only be done by making our own language rich and extensive rather than limiting its scope and extent. If you call it 'Urdu', surely you narrow down

its circle; likewise if you name it 'Hindi', you limit its extent. Therefore, by giving it the name of 'Hindustani' alone, you can widen its scope. It is the exact and right word which describes the real state of our language for the present. . . .

Now, when in connection with this Constitution this question came up before the Congress Party, naturally I emphasized the same view and I had hoped that at least the older Congressmen would not forsake their previous stand and would continue to adhere to the Gandhian principles but I need not hide my own feelings from you when I say that I was greatly disappointed. I realized that with a few exceptions all have retraced their steps.

As you are aware, in the party meeting this question was thrashed out for several days, but they could not arrive at any conclusion. . . . At last, the question was left to the Drafting Committee with the request to prepare a fresh draft of this part for the consideration of the party in the light of all those resolutions which were moved during the discussions in the party meeting. Several new members were also added to the Drafting Committee. I was also one of the members.

I attended the first meeting of the Committee, but I felt that the majority of members had a particular type of preconceived notion and they could not agree to adopt 'Hindustani' in place of 'Hindi', nor were they prepared to accept any such interpretation which can widen the scope of 'Hindi'. In the circumstances, I could not associate myself with this Committee. Therefore, I resigned and severed my connection with the Committee.

After my resignation, this question was raised in the Committee afresh and an effort was made to introduce breadth of vision in solving the problem to a certain extent. The amendment of Mr Ayyangar which he had moved in the party meetings was a product of this effort. It is the same amendment which is now before you for your consideration.

This amendment has introduced several alterations in the original draft which are worthy of consideration:

(1) So far as the name of the language is concerned, the name given in the original draft, 'Hindi', has been retained. Then again an effort has been made to explain the characteristic of 'Hindi' by adding an article and it has been emphasized that it includes 'Hindustani' also.

(2) It has been emphasized that India has a 'composite culture', and the national language of India should be the focus of this 'composite culture'.

(3) Regarding Urdu it has been made clear that it is one of the recognized languages . . . of the country.

So far as Urdu is concerned, all of a sudden the events had taken such a turn that in future it might have affected the rights of millions of people, but this amendment has removed that apprehension to a great extent. Although Urdu had spread throughout the length and breadth of northern India, yet in point of fact, UP was its place of birth and growth. After the downfall of Delhi, Lucknow became the centre of its activities, and in the eighteenth and the nineteenth centuries, it gave to this country a fully developed language. If according to the previous decision of the Congress, 'Hindustani' in two scripts would have been accepted, the question of Urdu would not have been taken separately; for in that case according to the commonly accepted concept Urdu would have been a part and parcel of 'Hindustani' and to be sure, eventually, after mutual assimilation, the language would have taken a definite shape; this was not done and 'Hindi' was adopted in place of 'Hindustani'. In the circumstances, fact and fair play demanded that Urdu should have been given official recognition at least in its place of birth, namely, UP. But it has not been done and 'Hindi' in one script has been accepted as the official language.

Naturally the question arose whether Urdu will have any place in the Indian Union? True, if a language is spoken by millions of people in their day-to-day life, its life need not depend on the recognition or non-recognition of any government, as long as the people themselves do not give it up by common consent. None can compel them to renounce it. Nevertheless, it would have been inappropriate for the democratic Constitution of the country not to acknowledge a language which is the common heritage of millions of Hindus and Muslims, and which is their mother tongue. This amendment has made it abundantly clear that Urdu is also one of the recognized languages of the country and it will receive the same treatment at the hands of the government which all the recognized languages should receive. Perhaps I should also tell you that the interpretation of language given in this article was not included in the Constitution at first; it was placed under Directives. But later on, it was incorporated in the Constitution as an irrevocable article. This alteration made the position of Urdu more manifest and firm.

So far as the question of script is concerned, the decision of the Congress was to adopt both the scripts, namely, Devanagari and Urdu scripts. There was objection against this decision on the ground

that if acceptance of both the scripts involves the commitment of giving equal right to both the scripts for the documents in the government offices, it would create difficulties, for the reason that offices will have to work harder and that expenses would increase. I had felt the full weight of this argument and had agreed to adopt Devanagari as the script for the government offices. At the same time, I had emphasized that all the government declarations, resolutions, communiqués, and other similar documents should be published in both the scripts and that government offices and courts should accept applications and petitions in both the scripts. I had also emphasized that this proposal should be incorporated in the Constitution; but this was not accepted. True, the right of the people to submit petitions in the recognized languages of the Indian Union has been accepted.

I do not propose, because I do not think it necessary to conceal the impression which I have got during the discussions over this problem. I was totally disappointed to find out that from one end to the other, narrow-mindedness reigned supreme. . . . Of all the arguments employed against 'Hindustani', greatest emphasis has been laid on the point that if 'Hindustani' is accepted, Urdu also will have to be accommodated. But I would like to tell you that by accommodating Urdu, the heavens will not come down. After all Urdu is one of the Indian languages. It was born and brought up in India and it is the mother tongue of millions of Hindus and Muslims of this country. Even today, this is the language which serves the purpose of a medium of expression between different provinces and it is the only means of inter-provincial relations. Why should we allow our minds to be prejudiced to this extent against one of the languages of our country? Why should we allow ourselves to be swept away by the currents of our narrow-mindedness to such a great distance? . . .

Today you will decide that the national language of the Indian Union will be 'Hindi'. You may decide that. There is nothing substantial in the name of 'Hindi'. The real problem is the question of the characteristics of the language. We wanted to keep it in its real form by calling it 'Hindustani' . Your majority did not agree to it. But it is still in the hands of our countrymen not to allow the shape of Hindi to be deformed and instead of making it an artificial language let it remain an easy and intelligible medium of expression. Let us hope that the present atmosphere of narrow-mindedness which is the residue of the past misfortune will not last long and

[1]Translation of Azad's speech delivered in Hindustani in the Constituent Assembly. *CAD*, vol. IX, pp. 1452–9.

8. Anjuman Taraqqi-e-Urdu (Hind) Submits Memorandum to the President Seeking due Recognition for Urdu[1]

On 15 February 1954 a deputation of Anjuman Taraqqi-e-Urdu (Hind) met Dr Rajendra Prasad, the president of India. It was led by the president of the Anjuman, Dr Zakir Husain.

The memorandum submitted by the Anjuman requested the president to issue a directive under Article 347 of the Constitution of India that Urdu be recognized as one of the regional languages of UP. It was supported by the signatures of over twenty-seven lakh people of UP. Certain other specific demands were made in the memorandum. Among its other prominent signatories were Pandit Hriday Nath Kunzru, Mrs Uma Nehru, Pandit Dattatreya Kaifi, Maulana Hifzur Rehman, Pandit Sunder Lal, Mr Hayatullah Ansari, Mr Krishen Chander, Pandit Kishan Parshad Kaul and Qazi Abdul Ghaffar.

The full text of the Memorandum:

Sir,

With due respect we approach you as members of a deputation on behalf of the All India Anjuman Taraqqi-e-Urdu and also on behalf of the Urdu-speaking population of Uttar Pradesh.

At the outset we crave your indulgence for clarifying certain points which have recently arisen concerning the object of our deputation and have created certain misunderstandings in some quarters.

Article 343 of our Constitution has laid down that 'the official language of the Union shall be Hindi in Devanagari script'. The All India Anjuman Taraqqi-e-Urdu and all those whom we represent bow to that decision of our Constituent Assembly and regard it as their duty and the duty of every citizen of India to learn Hindi in Devanagari script and to help to promote the spread and development of the Hindi language on the lines laid down in Article 351.

their duty and the duty of every citizen of India to learn Hindi in Devanagari script and to help to promote the spread and development of the Hindi language on the lines laid down in Article 351.

In 1950, the UP legislature, under Article 345 of the Constitution, adopted by law Hindi in Devanagari script as the language to be used for all official purposes of the state. This decision, innocuous in itself, ignores the prevalence of the Urdu language and its script in this region. We loyally accept that decision but, at the same time, strongly feel that in the existing circumstances that decision requires to be complemented by a directive from the president, under Article 347 of the Constitution, concerning Urdu. It is with this object that we have now taken the liberty of approaching you.

In the presence of a scholar of your eminence we may not enter into the controversial question whether Hindi and Urdu are two separate languages or two literary styles of the same basic language. It is sufficient for our purpose that for very good reasons, taking an objective and realistic view of existing conditions, the Eighth Schedule of our Constitution has included both Hindi and Urdu among the languages of India.

We submit that Urdu, which, through centuries, has developed a style and a literature which any people can justly be proud of, is today the spoken language of a large number of men and women of all faiths and creeds in Uttar Pradesh, who rightly claim it as their mother tongue or their literary language. All these people while anxious to learn, read, and write Hindi in Devanagari script still read and write Urdu in its own script and, for very good reasons, wish to preserve this national heritage.

In this connection we beg to draw your attention to the following paragraph in a resolution of the Government of India dated 10 August 1948 which lays down the policy of the government in regard to instruction in our basic schools. It runs as follows:

The medium of instruction and examination in the junior basic stage must be the mother tongue of the child. Where the mother tongue is different from the Regional and State language arrangements must be made for instruction in the mother tongue by appointing at least one teacher provided there are not less than 40 pupils speaking this language in the whole school or 10 pupils in a class. The mother tongue will be the language declared by the parents or guardian to be the mother tongue.

This policy was endorsed by the chief minister of Uttar Pradesh in a letter addressed to Mr Z.H. Lari, then a member of the legislative

assembly and was further emphasized by Shri A.N. Sapru, education secretary, UP, in a letter addressed to the director of education. Yet, in spitre of all this, Shri R.S. Sinha, MLA, officer on special duty for compulsory education, wrote to the chairmen of all Municipal Boards as follows:

I am directed to say that the Government has ordered that Hindi should be compulsory subject in all Primary Schools. There is no objection to the teaching of Urdu but it should be an optional subject if any institution wishes to teach it. All students irrespective of caste and community must, therefore, learn Hindi and it should be via-media (sic) in teaching other subjects of the curriculum.

This was a violation of the directive of the Government of India and of the intention of the state government which resulted in the expulsion of Urdu from all municipal schools. At about the same time the teaching of Urdu was discontinued in the schools under District Boards and in spite of repeated representations and reminders, the state government failed to take any steps to redress the wrong. The net result of all this has been that the children whose mother tongue is Urdu are not allowed to receive their basic education in their mother tongue and Urdu is thus expelled from primary stages of all basic schools of this state. A more amazing fact is that in the case of many children, their mother tongue, which till the other day was registered in these basic schools as Urdu, has been almost overnight changed into Hindi without consulting their guardians.

When this state of things came to the notice of the Anjuman Taraqqi-e-Urdu, it appointed a committee to enquire into the matter. After receiving its report and being satisfied that the grievances of the people were legitimate and just, it decided to send a deputation of its members to wait on the education minister of the state to place their grievances before him. A deputation of seven members headed by Dr Zakir Husain, president of the Anjuman, waited on Dr Sampurnanand, the then education minister of Uttar Pradesh, on 22 May 1951, with more than ten thousand applications of guardians from the city of Lucknow alone who desired their children to be educated through Urdu. The deputation was sympathetically received, the legitimacy of its grievances was recognized and the education minister was good enough to admit that the circular issued by Shri Sinha, the compulsory education officer, was not in consonance with the policy of the government. The deputation was assured that in the beginning of the next session, i.e. from July

1951, things would be set right. But the assurance given was never fulfilled. The present education minister repeated the assurance on the floor of the legislative council on 14 July 1952 and declared that instructions had been issued by the director of education to the effect that if in any school there were forty boys who wanted instruction through the medium of Urdu, the necessary arrangements should be made. The instructions are not being followed and things continue as they were. As a test case an application signed by ninety guardians of students of the Musahebgunj School, Daulatgunj Ward, Lucknow, was submitted on 7 August 1952 to the minister of education, UP, and the superintendent of education, Municipal Board, Lucknow, praying that Urdu being the mother tongue of their wards, instruction should be given to them through the medium of Urdu. No reply to this application was received nor any arrangement was made in the school as applied for.

It may also be pointed out in this connection that the system of education in the Normal schools has been so changed that no room has been left for Urdu now. Formerly, it was compulsory for primary school teachers to be conversant with both Hindi and Urdu. But now no Urdu teachers are being trained.

Moreover, an invidious distinction has been made in the matter of publication of Hindi and Urdu textbooks. The department of education invites tenders for Hindi textbooks and places orders with the publishers for a specified number of each book, thereby guaranteeing the sale of Hindi books. On the other hand the director of education, UP, has issued a circular to the effect that publishers may publish Urdu textbooks at their own risk. The result has been that Urdu textbooks are hardly available in the market.

In the circumstances, we had no other constitutional way open to us but to approach you, Mr President, under Article 347 of our Constitution which runs thus:

On demand being made in that behalf the President may, if he is satisfied that a substantial proportion of the population of a state desires the use of any language spoken by them to be recognised by the State, direct that such language shall also be officially recognized throughout the State or any part thereof for such purposes as he may specify.

In order to satisfy the requirements of the above article, the Anjuman decided to collect signatures of adults desiring the recognition of Urdu in Uttar Pradesh. Over twenty lakh fifty thousand signatures have been collected. The signatories have also indicated the number

of non-adult members in their families. The number of such non-adults is over twenty-two lakh. These signatures represent the people of all castes and creeds and have been tabulated according to districts and communities. Those of doubtful value have been rejected after close scrutiny. This work was carried out in a systematic manner more or less on the lines of Census operations.

We need hardly point out that the Urdu language and literature have played a very significant part in the development of 'the composite culture of India' of which it still forms an important 'element'. They have made a specially valuable contribution to the development of the common culture, common life, and common social traditions of Uttar Pradesh.

We believe and submit with all earnestness, that Urdu with its rich vocabulary, its treasure-house of beautiful idioms, its elegant style and all-round progressive literature can yet make an important contribution to the 'enrichment', adornment, and full 'development' of Hindi, the official language of the Union in terms of Article 351 of our Constitution, which lays down that Hindi should so develop 'that it may serve as a medium of expression for all the elements of the composite culture of India'.

We, therefore, on behalf of the Urdu-speaking people of Uttar Pradesh, 'who form a substantial proportion of the population of the state', as evinced by over two million signatures in support of this representation, do hereby pray that you may be pleased to direct under Article 347 of the Constitution, that the Urdu language be recognized as one of the regional languages of Uttar Pradesh and be officially used throughout the state in such manner as to fulfil the following purposes:

1. Urdu should be the medium of instruction at the primary stage for children whose mother tongue is Urdu, and wherever there is a sufficient number of Urdu-speaking children—say forty in a school or ten in a class—arrangements for teaching 'through' the medium of Urdu should be made. In localities where there is a considerable proportion of Urdu-speaking population, schools with Urdu as the medium of instruction should be established. The mother tongue of a child should be determined according to the declaration of his parent or guardian.

2. Arrangements should be made for the training of an adequate number of teachers capable of teaching through the medium of Urdu at the primary stage.

3. Arrangements should be made to secure adequate supply of textbooks in Urdu.

4. Secondary schools which give instruction through the medium of Urdu should receive state recognition and state aid according to rules applicable to other secondary schools.

5. There should be at least one university in Uttar Pradesh where Urdu should gradually be made the medium of instruction.

6. Well-known institutions which cater for higher education and for the propagation of literature and science through Urdu should receive adequate financial help from the state.

7. Urdu writers and scholars of outstanding merit should also be encouraged by the state government through the grant of prizes and awards.

8. Adequate representation should be given to Urdu writers on the Hindustani Academy.

9. Government and aided libraries should be provided with Urdu books.

10. Petitions written in Urdu should be entertained by courts and offices of the state and facilities provided for their consideration and disposal.

11. Important notices, laws, and publications of the government should be issued in Urdu also. Documents which people in general have to use, such as electoral rolls and ration cards, should be in Urdu also.

In the end we beg to express our deep gratitude to you, Sir, for kindly giving us an opportunity to place before you a matter dear to a large section of the Indian population. We are confident that you will kindly give consideration to the sentiments and facts expressed in this memorandum. A favourable gesture on your part will go a long way to contribute to the strengthening of bonds between various peoples of this great land and help realize the ideal of a happy and united country.

We have the honour to be,
Sir,
Your most obedient servants

[1]Pamphlet published and circulated by Anjuman Taraqqi Urdu in 1954.

9. Nehru's letter dated 12 March 1954 to Education Minister Maulana Azad on Urdu and on Anjuman's Deputation to the President[1]

New Delhi
12 March 1954

My dear Maulana,[2]

The president's office has sent me some papers in connection with the deputation[3] which waited upon him recently on behalf of the All-India Anjuman Taraqqi-e-Urdu.[4] With these papers is also a long note sent by the UP government on this subject.[5] I understand that this note has been sent to your ministry directly, so you might have seen it already. However, I am sending it also to you for facility of reference, as it is a part of the papers sent to me by the president.

I should be grateful if you would kindly consider this matter, because we have to advise the president in regard to them.

There is one thing which I do not understand. This collection of signatures on behalf of Urdu has been going on for many months past, or possibly a year or two. I spoke about this matter to the chief minister of UP. At his instance, I asked some of the sponsors of this memorial to go and see him and discuss the matter, but apparently they never thought it worthwhile to do so. This is rather surprising, because the proper course would have been for them to approach the local government or the chief minister, discuss the matter with him, and then come up to the president.

It is, of course, a serious matter to suggest that the president should issue any directive, as suggested. That might well create some kind of a constitutional crisis, and, in addition, it would make the controversy even more acute and bitter, and thus actually injure the prospects of Urdu. It seems to me that the right way to tackle this question is in a friendly, cooperative way.

Anyhow, I should like your advice in regard to this matter.

Yours sincerely,
Jawaharlal Nehru

[1]*Selected Works of Jawaharlal Nehru*, Second Series, vol. 25, pp. 91–2, 1999, Jawaharlal Nehru Memorial Fund, distributed by Oxford University Press.

[2]Union minister for education and natural resources and scientific research.

[3]A deputation led by Zakir Husain, president of the Anjuman, presented a petition signed by over 20 lakh adult citizens. They demanded recognition of Urdu as one of the regional languages of UP and its use for specific purposes namely, i) as a medium of instructions of primary education for children whose mother tongue it was; ii) in applications to law courts and government offices; and iii) in publication of important laws, rules and notifications.

[4]The Anjuman-i-Tarraqqi-i-Urdu (Hind) was established in 1903 and was split into two organizations after the partition in 1947. The reorganized Anjuman in India sought to adopt all possible measures for promoting Urdu and popularizing its simpler form, the Hindustani.

[5]With the enactment of UP Official Language Act, 1951, declaring Hindi in Devanagari script as the official language of the state, the demand for a similar recognition to Urdu became vehement. The Anjuman set up a regional language committee in 1951 to collect signatures and petition the president to issue a directive under Article 347 of the Constitution, asking the state government to redress the linguistic grievances of a substantial population of the state.

10. Maulana Azad on Urdu and Hindi in the Lok Sabha on 29 March 1954[1]

Tandon*ji* . . . referred to this year's non-recurring grant of 60,000 rupees to the Shibli Academy. This Academy continues to function for the last thirty or forty years. It is true that all the books published by the Academy are in Urdu and that Gandhi*ji* liked their books, patronized the Academy and wrote many articles about it. Anyway, the Academy has done useful and valuable work in Urdu. As the people working in this Academy are those who took part in the Congress movement, they have contacts with Congressmen. . . .

The Central education ministry spends about fourteen crore rupees annually and if out of this amount a sum of Rs 60,000 is for once given to a society that works for Urdu, is it anything against which there should have been such severe complaints and such strong opposition? . . .

Urdu is not the language of any religious group. Hindus, Muslims, Christians, and others speak this language. Even if it were only Muslims who spoke Urdu—though that is not the truth—do we not have four-and-a-half crore Muslims in India? And if a society that renders valuable service to Urdu is once given a sum of 60,000 rupees, is it anything that should be opposed and criticised as being a step for progress of Muslim culture? . . .

They do not voice this criticism because they have love for Hindi but because they do not want to see any other language make progress. That is the motive behind it. . . . So far as Hindi is concerned, I can assure you that there is not a single individual in the whole of north India who does not want this language to progress or who is opposed to it. In north India even those people who do not themselves know Hindi ask their children to study this language. . . .

I may tell you frankly that for the misfortune that befell this country as a result of the two-nation theory and the establishment of Pakistan, this sort of mentality, this sort of attitude has been as much responsible as the misguided Muslims and Muslim League.

This responsibility falls on people of such mentality also because you are treading the path of narrow-mindedness when you say that there is no place for any other language, there is no place for another community or for other's rights. It is but natural that people who want to be separate will get an opportunity which they will exploit . . . mind and outlook are represented by Gandhiji and others who stand by him. I drew the attention of the Muslims to this fact and waged my struggle. I brought about a revolution in the minds of lakhs of Muslims. I have not been able to control my feelings in this matter and I must tell you that so long as you continue to have a narrow-minded approach to such matters, you cannot achieve your objective.

[1]*Muslim India*, February 1991.

11. Nehru's Plea for Equal Importance to Both Hindi and Urdu[1]

The prime minister, Mr Nehru characterized the Hindi–Urdu also Hindi-Gurumukhi controversies in north India as a '*tamasha* par excellence'.

Mr Nehru said at Ahmedabad on 5 January 1955 that in Punjab there was a controversy whether Hindi or Gurumukhi should be the state language but the entire dispute was being conducted in Urdu.

In Uttar Pradesh and Delhi, there was also a controversy between the exponents of Hindi and Urdu.

The prime minister said it was difficult to understand why Urdu should not get an equal place when it was a cent per cent Indian language. It was not an exclusively Muslim or Pakistani language. In Delhi itself, Urdu newspapers were being run by Hindu Mahasabhites and had four times the circulation of Hindi newspapers.

Mr Nehru was speaking at the inaugural function of the Gandhi Bhavan Library at the Gujarat Vidyapith.

The prime minister said we had decided to adopt Hindi as the national language because it was the language most likely to be generally understood and spoken in India. We could not run the administration of the country in a foreign language.

[1]*The Times of India*, 6 January 1955.

12. Memorandum Submitted on 24 February 1956 by a Delegation from Bihar to President Rajendra Prasad on Recognition of Urdu as a Regional Language[1]

To,
The President of India,
New Delhi

Sir,

As authorized by a state convention of the Urdu-knowing and Urdu-loving people of Bihar, belonging to all castes and creeds, held at Patna under the presidentship of late Pandit Kishun Prasad 'Koul' on 26 June 1954, subsequent to the collection of about nine lakh fifteen thousand signatures from all over the state to formulate our demands for direction by your honour under Article 347 of the Constitution that Urdu shall also be officially recognized throughout the state for the purposes specified in this memorandum, we seek your indulgence to place certain facts before you, which illustrate the popularity, importance, and value of Urdu in Bihar.

We find very few philologists disagreeing on the point that Urdu and Hindi have much in common and numerous words of the two languages have the same origin. It was on account of this conclusion, arrived at after long-continued and deep researches,

that the Congress, under the wise and able guidance of the Father of the Nation, Mahatma Gandhi, had decided that there should be one language, Hindustani, to be written in two scripts—Persian and Devanagari. The hands of fate worked otherwise. This decision could not be translated into action and the sudden change in the political situation made the Congress view the matter differently. However, this proposal gives strength to the assertion that Urdu is one of the most largely and popularly spoken and understood languages. According to those who can speak with authority on the question of language and whose opinions carry weight everywhere, it is almost impossible to draw a line of distinction between simple Hindi and simple Urdu, as spoken by a vast concourse of people professing different faiths. Hindi has attained a unique position in the country. It is now our official language and we consider it our bounden duty, and in our own interest, to contribute to the growth, development, richness, and glory of this language. There is no question of competition between Urdu and Hindi. But on the strength of common origin and development of the languages, to enable its growth and preservation of the treasure of learning, tradition, and culture associated with this language and this is practical only if Urdu is recognized as a regional language. By its inclusion in the Schedule, Urdu has already been recognized as one of the main regional languages. Therefore, the question of its status to be decided by Your Excellency under Article 347 of the Constitution is whether a certain language is the regional language of a certain region. Special care has been taken by the framers of the Constitution to see that every regional language maintained its due status in its own region. It is a pity that the Government of Uttar Pradesh has been refusing to recognize Urdu as the regional language of UP. Therefore, we apprehend that something like that might happen in Bihar also which is the second home of Urdu. Unless the regional status of Urdu is constitutionally recognized as far as Bihar is concerned, a large number of population whose mother tongue is Urdu will remain dissatisfied. Our object in approaching your Excellency is to ensure recognition of Urdu as the regional language of Bihar.

As regards the position of Urdu in Bihar, nobody can claim to have a better knowledge of the same than your eminent self who has been a patron of this language and has on occasions taken a keen interest in its developments. To recite the fame and glory that Urdu attained in Bihar and influenced the language and learning in other parts of the country and produced reputed and noted writers,

authors, and poets belonging to different religions, will cover chapter after chapters. Without going back to the past history of the language in this state or entering into an academic discussion, if we recall some hard facts of recent years they will amply bear out our statement that Urdu occupies a place of its own and is as commonly spoken and understood as Hindi in Bihar. It was on account of these compelling circumstances that certain facilities were given to Urdu-knowing population in registry offices and courts and only a few years ago the then Government of Bihar was pleased to declare Urdu also as a court language. In educational matters, for a long number of years Urdu was treated on par with Hindi and the students of Urdu had the option to write non-language subjects in Urdu up to BA examination. But several factors have contributed towards swift changes and the said facilities have either been taken away or are in the process of liquidation, thus spelling a great danger to those who claim this as their mother tongue.

Some of the following facts and statistics also go to show the popularity and use of Urdu in this state:

(a) There are near about 1000 Urdu libraries in the state of Bihar. At least 250 of them are major ones which are run efficiently and regularly in every nook and corner of the state. Only this year, more than 350 applications of Urdu libraries, run and managed by only the backward Muslims of the state, were filed with the welfare department, Government of Bihar, out of which about seventy Urdu libraries got grants of Rs 100/- or Rs 50/- each. More than a hundred Urdu libraries besides the ones mentioned earlier are affiliated with the state, district, subdivisional, or the *thana* branches of Rajya Pustakalaya Sangh. Government Urdu Library of Patna was established in 1938 and it is receiving some government grants since then.

(b) Urdu *maktabs*, madrasas and night schools number more than 2500 throughout the state. More than 150 of them are affiliated to the Madrasa Examination Board, Government of Bihar, and are imparting higher education in Persian, Arabic, and Urdu. About 500 *maktabs*, known as welfare *maktabs*, are maintained only by the backward Muslims through the welfare department, Government of Bihar. In Santhal Paraganas alone there are 100 Urdu *maktabs* which are run by the Government of Bihar in that district. In almost every village are found such *maktabs*, madrasas, night

schools, or Darul-Ulums which impart education through the medium of Urdu. At least 200 of them also impart higher education recognized by the government.

(c) In this state two dailies, one biweekly, six weeklies, and ten monthlies are published in Urdu. Out of these nineteen Urdu journals only ten are published from Patna and the rest from other parts of the province.

(d) Similarly, there are twenty-five Urdu litho presses in working order; eleven of them are at Patna and others spread in other parts of the state.

(e) Bihar State Anjuman Taraqqi-e-Urdu, Halqa-e-Adab, Bihar, Bihar State Anjuman Traqqi Pasand Mosannefeen, Bihar, Adara-e-Tahqiq-o-Taraqqi, Bihar Urdu Journalists Association, and Bihar Urdu Libraries Association are six province-wide Urdu organizations working for the betterment of Urdu throughout the state of Bihar, with their living and working branches everywhere. Besides these, there are a number of local organizations.

But in spite of all this, the Urdu-knowing populace of Bihar rightly feel that they are being deprived of the rightful and constitutional rights which they have. Libraries and *maktab*s are not properly supported by the government and more such institutions are required. At places only libraries and *maktab*s of other languages are opened and patronized by the government. Urdu newspapers and presses get a stepmotherly treatment from the government. Urdu organizations are the most neglected ones and the government has in no way helped them so far. It is rightly apprehended therefore that if Urdu is not given the status of a regional language in Bihar, its valuable treasures will in course of time, be used up and finished.

We, therefore, on behalf of the Urdu-speaking people of Bihar, 'who form a substantial proportion of the population of the state,' as evidenced by ten lakh signatures in support of this representation, do hereby pray that you may be pleased to direct under Article 347 of the Constitution, that the Urdu language be recognized as one of the regional languages of Bihar and be officially used throughout the state in such manner as to fulfil the following purposes:

1. Urdu should be the medium of instruction at the primary stage for children whose mother tongue is Urdu. The mother tongue of a child should be determined according to the declaration of his parent or guardian.

2. Facilities should be given for learning Urdu from the secondary stage to the university level to students whose mother tongue is Urdu.

3. Arrangements should be made for the teaching of Urdu in schools where there are at least twenty Urdu reading students.

4. Petitions written in Urdu should be entertained by courts and offices of the state and facilities provided for their consideration and disposal. Permission for the use, also, of Urdu language and Urdu script in courts and government offices of Bihar should be granted.

5. Urdu-knowing members of the legislative bodies should be granted the right to speak in their mother tongue, and such speeches be reported in Urdu language and script.

6. All important notices, laws, annual statistics, budgets, and other publications of the government should be issued in Urdu also. Documents which people in general have to use, such as electoral rolls, ration cards, etc., should be in Urdu also.

7. All signboards and other directing signs, symbols, and digits which are provided for the benefit and facility of the people in general by the government should also be in Urdu.

In this connection we beg to state that we and all those whom we represent accept the decision of our Constituent Assembly about the recognition of Hindi in Devanagari script as the official language of the Indian Union. We regard it as our duty to learn Hindi and to help to promote the spread and development of the Hindi language on the lines laid down in Article 351 of our Constitution.

The Bihar legislature, under Article 345 of the Constitution, has decided that Hindi in Devanagari script shall be used for all official purposes of the state. We accept the decision, but at the same time, strongly feel that in the existing circumstances that decision requires to be complemented by a directive from the president, under Article 347 of the Constitution concerning Urdu as detailed above.

We beg to say that the Eighth Schedule of the Constitution has included Urdu, as distinct from Hindi, among the major languages of India. Urdu has got its own individuality in the diverse and composite pattern of Indian languages. A scholar statesman of your calibre and eminence, knows well that the proportion of *tatsama* words and the structural variety of *tadbhava* words determine the individual morphology and phonology of Indo-Aryan languages

which are interrelated and yet maintain their individualistic and distinctive existence. The modern trend of the Hindi language is establishing the distinct individual status of Urdu all the more.

We submit that Urdu has developed on non-communal lines, through centuries, in India. It is today the spoken language of a large number of men and women of all faiths and communities in Bihar, who claim it as their mother tongue and their literary language. Besides being spread in every part of Bihar, Urdu-reading populace is also concentrated in the divisions of Patna, Bhagalpur, and Tirhut. We are proud of our age-old traditions of Urdu in Bihar. The evolution of Urdu in this state runs almost parallel to its evolution anywhere else in India. The Urdu-speaking people of Bihar have been pioneers and promoters of the linguistic current which brought about the spread of *khari boli* in the eastern region of our country. Hindus and Muslims, men and women, all have contributed to the growth and development of the Urdu language and literature alike in all times, during the eighteenth, nineteenth, and twentieth centuries. Urdu newspapers were published as far back as the early nineteenth century. Raja Ram Narain Lal 'Mozun', Maharaja Kalyan Singh 'Ashiq', Munshi Ganga Lal 'Dimagh', Munshi Mangal Sen 'Ulfat', Raja Bahadur 'Raja', Munshi Anand Lal 'Ulfat', Munshi Beni Prasad 'Dil', Kunwar Sukhraj Bahadur 'Rahmati', Awadh Kishore Prasad 'Kushta', Principal 'Khosla', have always been acknowledged as stalwarts of Urdu along with Hazrat 'Sajjad', Hazrat 'Ammad', Mirza Abdul Qadir 'Bedil', Mulla Abdul Alim 'Tahqiq', Mir Ghulam Ali 'Rasikh', 'Joshis', 'Shad', 'Ahqar', 'Azad', side by side with poetesses like Amirunnisa Begum, Hazrat Bibi Roshan, Hazrat Bibi Wallia, 'Raz', and many others. Biharshariff, Manershariff, Phulwarishariff, and Azimabad have played a very significant part in the development of the Urdu culture which has ever been the living symbol of our united and composite civilization. Urdu has made specially valuable contributions to the stability and progress of the common cultural life and common social traditions of Bihar and to the great and noble freedom movement of our country. Freedom songs by Bihari poets in Urdu can glorify a respectable volume. On the martyrdom of his beloved Siraj-ud-Daula, Raja Ram Narain Lal 'Mozun', the then Subedar of Bihar wailed:

'O' Gazels; you are informed, tell me about the death of Majnun, The love-mad has died, after all, what happened to the wilderness.

The issue of Urdu as regional language in Bihar is in no way connected with a linguistic state deriving its inspiration from the demand of regionalism. On the occasion of the tour of the States Reorganization Commission in Bihar when protagonists of one or two spoken dialects submitted their memorandum for a separate state of their own, about five deputations waited upon the Commission on behalf of one million Urdu-speaking populace of only one district of Bihar, i.e. Purnea. More than half a million inhabitants of Purnea also demonstrated before the Commission saying their mother tongue was Urdu. But in none of the memorandums, deputations or demonstrations a separate state for the Urdu-speaking population was demanded or even hinted to before the Commission. It would not be out of place to mention here that the States Reorganisation Commission, in its report, has clearly admitted the position that unless Urdu is recognized for official purposes in the Muslim region, their linguistic and cultural rights might suffer. Protagonists of Urdu ask for effective protection and encouragement for their mother tongue without jeoparadizing in any way the integrity of the state of Bihar. The Urdu-speaking population is interspersed all over Bihar in general and northern belt of north Bihar comprising Bhagalpur and Tirhut Divisions and also Patna Division in particular. This region may rightly be called the 'Urdu Region'. In Patna Municipal Corporation area above 35 per cent of the population comprises Urdu-speaking people. But the Patna Municipal Corporation and the city parents are treating Urdu as an orphan.

It may also be pointed out in this connection that in some states of India more languages than one have received official recognition. So, if Urdu is also recognized in Bihar officially, this magnanimous gesture on your part will go a long way in contributing to the strengthening of a broad-based democracy in our country and help realize the ideal of a happy and contended welfare state.

In the end, we, once again, express our deep gratitude to you for granting us an audience. We are confident that you will graciously give a favourable consideration to our humble request laid down before you in this memorandum.

We have the honour to be,
Sir,
Your most obedient servants,

[1]Pamphlet published by the delegation that met the President.

13. Nehru says Urdu Deserves Greater Encouragement Being Essentially an Indian Language[1]

The prime minister, Mr Nehru, said that Urdu should be given greater encouragement than was being done now in the country, where it was a fairly widespread language.

He was replying to a question at his press conference in New Delhi on 25 October 1956 as to whether it was a fact that he did not favour the Uttar Pradesh government's policy with regard to Urdu.

Widely spoken

He said Urdu should be given greater encouragement for a variety of reasons. It was one of the languages mentioned in the Constitution and 'rightly so', and it is 'essentially an Indian language'. It was widely spoken in this country and in Delhi Urdu newspapers had a larger circulation, probably larger than Hindi papers. Urdu newspapers were even run by the Hindu Mahasabha.

Apart from these factors, Mr Nehru said, Urdu was actually 'a strengthening element in Hindi'. Hindi and Urdu had basically the same origin with differences in vocabulary, phrases, and script.

[1]*The Times of India*, 26 October 1956.

14. Nehru Denounces Communalism of the Majority as the Greater Evil; Seeks Fair Treatment of the Minorities on Government Service and Language[1]

Mr Nehru warned that the Congress would be 'completely knocked out and left moaning' to the benefit of 'other people' if full justice was not done to the urges and aspirations of the minority communities in regard to language, especially Urdu, and the public services.

Mr Nehru, who was addressing an open session of the All India Congress Committee at New Delhi on 11 May 1958, said that the 'communalism of the majority is far more dangerous than the communalism of the minority'.

The prime minister, in his forty-minute speech winding up the earlier discussion held in camera on the danger of casteism and communalism creeping into the 'majority community', said that only through social cohesiveness and integration could the nation progress.

'If we cannot forget these caste and communal weaknesses, which erupt in us at the slightest provocation, and cannot tolerate other communities, then to hell with Swarajya.'

Mr Nehru said that if the minorities found that the door to the public services was closed to them for some reason or the other, it would become a 'bread-and-butter question' for them. This particular question always hurt the soul of a people and created psychological and pathological reactions which later affected the entire fabric of society.

Evil forces of reaction

Mr Nehru said that these evil forces were manifest in the activities of the Muslim League, giving birth to Pakistan, and of organizations like the Hindu Mahasabha, the RSS, and the Jan Sangh which were, he said, nothing but a replica of the Muslim League.

The communalism of the minority was dangerous, but it petered out sometime or the other.

But the communalism of the majority is far more dangerous than the communalism of the minority because it wears the garb of nationalism. We have thus communalism ingrained in us and it comes out quickly at the slightest provocation and even decent people begin to behave like barbarians when this communalism is aroused in them.

The communal and caste weaknesses of the people had been deprecated repeatedly in numerous resolutions of the Congress Working Committee and the AICC. 'These resolutions were against these caste and communal tendencies. Yet, in our daily life, we do not understand them fully. If a lot is said about these weaknesses of ours, it hurts people.

The biggest question in India today was this casteism and communalism rooted in the minds of the people and not socialism or anything else although socialism should help people to get over these weaknesses. 'This communalism and casteism is a terrible thing and its shadow even fell on Christianity when it came here. Even among Christians there were different sections and castes and a kind of untouchability existed. You should, therefore, understand the terrible nature of this communalism.'

Mr Nehru warned that the Indian people would be deluding themselves if they thought their mutual quarrels were over, now that they were independent and the Muslim League, with its communal fanaticism, had disappeared after the formation of Pakistan. 'We have still these ideas of casteism and communalism with us, whether we are Hindus or Muslims or Sikhs. Even those who say that they are above these considerations become communal on some provocation or the other.'

The prime minister said that the people had to be vigilant and always on the offensive and not on the defensive. 'Eternal vigilance is the price of liberty. It is also necessary to face all forces which tend to separate and weaken us.'

Mr Nehru said that over the question of language 'something comes out from inside, some disruptive idea, and we get worked up'.

This question of language has many facets. I do not want to cover the whole ground. I would only say that it is always the responsibility of the majority community to win over the minority. I do not say that the majority should accept the wrong things done by the minority. How can it do so? But the responsibility of winning over the minority communities ultimately rests with the majority.

I would also like to tell you that the answer (whether justice is done to the minority or not) has to come from the minority and not the majority. It was not enough for the majority to say that it had done its duty and was satisfied about it if the minority did not agree with that view. We want to win over the minority with its willing agreement.

Mr Nehru said that on the question of language, a lot of emotion and excitement were aroused.

It is said, I do not know why, that Urdu is a language of the Muslims. I do not know what kind of brain and intelligence it is from which this idea comes. Was Urdu born with Islam? (laughter). Urdu is a language of India. It is akin to Hindi although the impact of Persian was there on it for centuries. I do not go into the merits of this thing. The point is that we have accepted Urdu in our Constitution as one of the fourteen languages. If you take the number of people who speak Urdu, it will be a very large figure although it is difficult to draw the line between Hindi and Urdu. But even taking the number of people who say that Urdu is their language, it would still be a big number.

Strange picture

Mr Nehru said that a publication of the information and broadcasting ministry had revealed that excepting Hindi and

Bengali, the largest number of periodicals and newspapers in India were published in Urdu. This was a surprising revelation creating a 'strange picture' of Urdu being accepted as an Indian language, being current also as a language of the newspapers and the people, and yet Urdu not finding any shelter or home anywhere except in Jammu and Kashmir. How was one to get over this?

When the president, Mr Dhebar, was heard mentioning Andhra, Mr Nehru said: 'Yes, the president just now reminded me about Andhra. It is correct. I made a mistake. Urdu is accepted there (Andhra).'

The prime minister said that Urdu was, however, the language of Delhi, Lucknow, Allahabad, Uttar Pradesh, some parts of Bihar, and Punjab. It was the 'real language' of these parts. In Punjab a lot of excited debate went on between the protagonists of Hindi and Punjabi, but this debate was carried on in Urdu newspapers. It was all a very strange thing.

Mr Nehru said:

I would, therefore, ask you on this ground that if some people want this (Urdu)—and certainly many people want it—does it not become our duty to accept it? In this matter we should not show narrow-mindedness. It is a strange thing that despite Urdu being given a place in the Constitution and despite there being previous Congress Working Committee and AICC resolutions recognising the position of Urdu, some obstacle or the other has always been there preventing the acceptance of Urdu. Even in the report of the States Reorganization Commission, there was a very good chapter on Urdu. What is the matter then? What is this *tamasha*?

Mr Nehru said that they should ponder over this and come to a decision, despite all 'obstacles'. The education ministry had a policy which did not create any obstacle in the way of Urdu being recognized and accepted. Even then there were obstacles.

Real test

Mr Nehru said that the real test was whether the people speaking Urdu had 'confidence in us or not'. It was important because this question was apt to become more involved later, turning into a 'psychological and pathological' issue. The people speaking Urdu in this mood would take it as an attack on their culture. 'It is a very dangerous thing and there is no reason why we should allow this to happen.'

The prime minister said that in NEFA, the government was trying to educate certain tribes in their own mother tongue even

though it had no script. A new script was being evolved for the language.

If this were not done, the minority would feel hurt. It would think that the majority was having some design against it and was doing injustice to it.

Mr Nehru said that acceptance of Urdu would be no 'attack' on Hindi or any other language, Marathi, Bengali, or Gujarati. Urdu was among the fourteen languages of India. 'Why not open the door to it? he asked.

Departure from gandhi*ji*'s ideal

Opposition to Urdu

Mr Nehru said that acceptance of Urdu was necessary from even fundamental principles, basic principles. But even some of our respected leaders had forgotten that gandhi*ji* had laid great stress through the Hindustani Prachar Sabha on every man learning the Urdu script and Devanagari script. 'I am saying this to show how far we have slipped away from it (gandhi*ji*'s ideal).'

Turning to recruitment in public services, Mr Nehru said that in every country, in India especially, the public services occupied a special place. The Constitution had 'beautiful' provisions about recruitment being open to all.

I have, however, been collecting statistics for the last few years about the percentage of representation of the minorities in the services. I found that the percentage was going down, especially in new recruitments. Why? I am getting this matter inquired into. But one reason for this has been the stipulation that a candidate must pass an examination in Hindi.

If any candidate does not get through the Hindi examination, he fails in the whole examination. Now no one objects to learning Hindi. But learning literary Hindi is not easy. If I am asked to take this Hindi examination, I would not be able to understand it.

A Congress member: You will fail. Mr Nehru: Certainly, I will fail.

Fear is justified

The prime minister said that it was not a question that Hindi should not be learnt. The candidates of the minority communities did try to learn Hindi. But it was very difficult for them to reach the standard of literary Hindi. So they failed in the examination even

though they were highly proficient in other subjects. This developed
a fear among the non-Hindi speaking communities because they
stood at a disadvantage in the matter of these examinations for all-
India services. They took it as an 'injustice perpetrated on them' as
they had to compete with people whose mother tongue was Hindi.
There was no doubt that it was an injustice.

Need to waive condition passing Hindi exam

Mr Nehru said that passing an examination in Hindi should not be
a condition precedent to joining government service. After a
candidate had entered service, he could learn Hindi. He had no
doubt that after some time even people from Tamil Nadu would
begin to read and write Hindi better than those whose mother
tongue it was. This was so because they (Tamils) were a hard-
working people and had gained proficiency in English also.

The prime minister said that even in states like UP and Bihar,
passing in 'stiff Hindi examinations' should not be made a prior
condition. If this were insisted upon, 'we will close the door to
government service to those who know a little Hindi, who can read
and write it, but who do not know literary Hindi'.

Mr Nehru said the difficulty was that the 'Hindi' which was
now being 'made' was practically a new language, a very difficult
language. 'It is artificial and not a genuine thing. I hope this tendency
will be controlled. It does not worry me unduly although I am
sometimes a little worried about it.'

The prime minister posed a question to Hindi enthusiasts:

Suppose an examination in stiff Tamil was made compulsory for
recruitment to government service; would it not be a handicap to the non-
Tamil-speaking candidates? So we have to remove these obstacles
(compulsory passing in Hindi examination) to recruitment to government
service. Remember, Hindi will progress only if it does not create in people's
minds a complex, an obsession, of all kinds of difficulties being created in
their path of earning their living.

Mr Nehru said the fact was that a large number of people in
south India were learning Hindi. They were doing it of their own
free will even at places where Hindi was not a compulsory subject.
'It is now for Hindi enthusiasts to realize that by wielding the
Hindi *danda* (stick) they only annoy people, make them angry and
unhappy, and instil fear in their hearts. It is clear that by using the
big stick these things cannot be done.'

Mr Nehru said that there were several important things about the minorities, but he would stress two of them. One related to language and the other to services. Both these things could be said to be a 'bread-and-butter' question for them. If anybody tried to take away their bread, they naturally felt hurt and got a big jolt. Everyone, therefore, had to keep this in mind and see to it that the minorities were shown all consideration.

Mr Nehru warned members against communal forces and parties like the Hindu Mahasabha and the Jan Sangh which exploited the emotions of people to rouse them against other religious sections.

Muslims not foreigners

Referring to an earlier speaker, Mr Nehru said that there was an insinuation that the Muslims were a foreign nationality. This was the height of stupidity as the Muslims were an Indian people living here for hundreds of generations.

I want to ask: To which race and country our Indian Muslims belong? What are they? Indian Muslims are Indians. They have lived here for generations, for thousands of years. Only a handful of Muslims could be said to have come from outside long long ago. But they also had become part of Indian life. If anyone were now to say that Muslims here were outsiders he only betrays his utter backwardness and primitiveness of thought. You must never mix nationality and race with religion. It is a symbol of reaction and not progress.

Religious tolerance, the prime minister said, had been taught by every religion. It had been taught by the Buddha and Asoka. Mahatma Gandhi had to remind people of its importance because people seemed to have forgotten it.

'For India religious tolerance is only practical good sense. There is no alternative to it but civil war.'

In a passing reference to racialism in South Africa which had earlier been mentioned by a member, Mr Nehru said that a sort of caste system was being established there. In India this system came into being many many years ago. After having seen it work, efforts were now being made to remove it. 'I do not know what the fate of South Africa was,' he added.

[1]*The Times of India*, 12 May 1958.

15. Hindi Enthusiasts Promoting Antagonism Against Urdu, says Nehru; Believes Urdu will Take its Due Place Irrespective of the Attitude of the Government[1]

Mr Nehru deplored the fact that some of the state governments did not encourage the development of Urdu, though the Constitution required them to do so.

Inaugurating the All-India Urdu Conference in New Delhi on 15 February 1958 Mr Nehru said that there could be no doubt that Urdu was a living and vigorous language and would take the place due to it whatever the attitude of the government.

While it was true that no language could develop merely on the strength of state patronage, the state should clear the impediments in the way of the growth of a language, he added.

Lesson of history

A large number of delegates from all over the country are attending the three-day conference which has been organized by Anjuman-e-Taraqqi-e-Urdu.

The prime minister said that it was the lesson of history that great languages survived the worst tyranny on the part of the state. He cited the example of the Polish language which not only survived but developed in the face of Czarist tyranny.

The prime minister said that 3500 books had been published in Urdu during the last ten years. He did not think that a similar number of titles had been published in most of the other regional languages.

Mr Nehru deplored the rivalry between the advocates of different languages. He recalled the controversy between Urdu and Hindi in the pre-independence period and said that unfortunately the controversy persisted even though the constitutional position in respect of the status of the two languages was clear.

Mr Nehru, who was speaking more in his individual capacity than as the prime minister of the country, said that some of the Hindi enthusiasts were responsible for promoting antagonism against Urdu which was a great national asset.

Mr Nehru saw no reason why it was not possible for the government in the states where the people spoke both Hindi and Urdu to receive applications and publish notifications in both these languages; but he did not think it would be possible to maintain all

records in two languages. He himself tried to ensure that he replied to his correspondents in their own languages.

He emphasized that arrangements should be made for education in Urdu wherever there were a sufficient number of students interested in learning this language.

Earlier, Mr Nehru referred to the demand raised by some people in Madras that English should be continued as the official language in India. He said that, while he was not opposed to English, and would like it to be taught in schools and colleges, he was not prepared to accept it as the national language.

Maulana Abul Kalam Azad, who was present on the occasion, said that the old controversy between Hindi and Urdu had been settled when the Constituent Assembly decided that Hindi would be the official language of India. With this decision, Urdu has taken its place among the regional languages of the country. It was unfortunate, he added, that the old attitudes persisted and prevented Urdu from taking its legitimate place in our national life.

In the course of his presidential address, Dr Tara Chand warned the country against the danger of disruption as a result of linguistic controversies. He said that much of the resentment against Hindi was due to the fact that the language was being given a form which was not intelligible by the vast majority of the people in India.

He detailed the history of the development of Urdu to prove it was as much a national language as any other.

Earlier, welcoming the prime minister, Col B.H. Zaidi, MP, president, Anjuman-e-Taraqqi-e-Urdu said that some people tried to impede the growth of Urdu by characterizing it as the language of Pakistan and feudalism. Gandhi*ji* had struggled against this fanaticism, and he was confident that Urdu would find its due place with the progress of democracy in the country.

He claimed that fifteen million people spoke and understood Urdu.

[1]*The Times of India*, 16 February 1958.

16. Press Note by the Government of India Admits Failure to Implement its Policy on Urdu and Reaffirms its Resolve to Implement it[1]

The Union government has restated and clarified its policy steps that should be taken for giving the Urdu language a fair deal

in accordance with the provisions of the Constitution and various official announcements.

Entitled 'Statement on language' and drafted on the lines of the Congress Working Committee resolution on Urdu, the note declares that Urdu is officially and constitutionally 'one of our national languages' and its use by those who consider it their mother tongue should be encouraged and facilitated.

The note frankly admits that there is some justification for the complaint that the government's policy regarding Urdu has not always been fully implemented and states that the following facilities should be provided in areas where Urdu is prevalent, especially Delhi, Punjab, UP, and Bihar:

(1) Facilities should be provided for instruction and examination in the Urdu language at the primary stage to all children whose mother tongue is declared by the parent or guardian to be Urdu.

(2) Arrangements should be made for publishing suitable textbooks in Urdu.

(3) Facilities for instruction in Urdu should also be provided in the secondary stage of education.

(4) Documents in Urdu should be accepted by all courts and offices without the necessity of translation or transliteration in any other language or script and petitions and representations in Urdu should also be accepted.

(5) Important laws, rules and regulations, and notifications should be issued in Urdu language also in areas where this language is prevalent and which may be specified for this purpose.

The note, however, points out that 'it is not necessary that laws should be passed by the legislature in Urdu or that every law should be issued in Urdu'. But these, or a substance of them, should be issued in the Urdu language with a view to giving due publicity.

Of particular interest in this context is the view that 'in the same way, where any border area between two states is considered bilingual, it is necessary to give publicity to important government announcements in both languages'.

The home ministry press note adds that as an Indian language which had literary distinction and vitality, Urdu should be encouraged, 'in addition to other reasons, from the literary points of view'.

The press note says:

A number of representations have been received from the Anjuman-e-Taraqqi-e-Urdu (Hind) urging that Urdu should be officially recognized in various territories where it is prevalent among considerable sections of the population. In particular, various proposals have been made for the encouragement of Urdu and the grant of facilities for instruction and examination in the Urdu language. As it appears from these representations, as well as from other sources, that there is considerable misunderstanding on this issue, it is desirable that this misunderstanding should be removed and the position of Urdu as laid down in the Constitution and in various announcements made by the government and by the provincial education ministers' conference, be restated and clarified.

'Urdu and Hindi are very closely allied and may be considered as basically the same language. But it is true that Urdu has certain distinctive features apart from the script in which it is usually written, and differs not only in literary style but to some extent in its vocabulary, from Hindi. Urdu has grown up in India as a variation of Hindi, being influenced by various cultural currents that came to India from other countries. But it is essentially a language of our country, and its homeland is India. The Constitution has recognized this basic fact by including Urdu among the national languages mentioned in the Eighth Schedule of the Constitution. Thus, Urdu is officially and constitutionally recognized as one of our national languages, and the various provisions that apply to these languages apply to Urdu also.

The press note adds:

While the policy of the government in regard to various languages, and in particular Urdu, has been repeatedly stated and is clear, there appears to be some justification for the complaint that it has not always been fully implemented. It is necessary, therefore, for full publicity to be given to this policy and for every effort to be made to implement it. The government regrets that the question of language has sometimes been considered from a communal point of view or looked upon as one of rivalry between languages. All the principal languages of India are the rich heritage of our country and each of them has drawn abundantly from the others. The growth of any one of them helps others to grow also. The question, therefore, should be considered from the point of view of developing all our national languages and bringing about as large a measure of understanding and cooperation between them as possible.

[1]*The Times of India*, 15 July 1958.

17. Nehru and Education Minister Ask the States to Observe the Centre's Urdu Policy in Letter and Spirit[1]

Separate letters are understood to have been addressed by Mr Nehru and the Union education minister, Dr K.L. Shrimali, to the state chief ministers and education ministers respectively, firmly urging prompt implementation of the Centre's recent 'fair deal' directive on Urdu.

Both the communications are believed to have made it clear that New Delhi is in no mood to allow the directive to be pigeon-holed by the UP or any other government on the familiar, if dubious, plea that four of the five proposals have always been part of the state's language policy.

The state governments have been asked to send in regular periodic reports on the steps taken by them to implement the policy decision on Urdu and, to begin with, let the Centre know of any financial or other difficulties faced or likely to be faced by them in the matter.

Mr Nehru has asked the chief ministers to give wide publicity to the Central directive that facilities be provided for teaching Urdu at the primary and secondary stages, arrangements made for the training of teachers, provision of suitable textbooks and acceptance of Urdu documents by all courts and offices.

The prime minister is believed to have drawn pointed attention to the fifth proposal urging publication of important laws, rules and regulations, and notifications in Urdu in areas where the language is prevalent and in both the languages in border areas which are bilingual.

Of interest is the information in Mr Nehru's communication that the Union government's policy announcement contained in a home ministry press note, entitled 'Statement on Language', was finalized after consultation with the chief ministers of UP, Bihar, and Punjab.

Provision of facilities

The education minister, Dr Shrimali, is reported to have impressed upon the state education ministers the need for carrying out, both in letter and spirit, an earlier directive that facilities for instruction in Urdu at the primary stage should be provided wherever ten or more pupils in a class or forty in a school so desire.

This directive has been honoured more in the breach than in observance. Instances have been reported to the Union government wherein students desirous of learning Urdu have been turned back on the stock plea that not enough of them were forthcoming to justify the special facility.

The attention of the state authorities has also been drawn to the directive that the mother tongue of the children is to be determined 'by the parent or guardian'. In the past, it was the teacher who decided a child's mother tongue after delving into Census and other records. This sometimes caused considerable dissatisfaction.

The Union government's ready willingness to offer all possible assistances has also been underlined. According to one of the many Central schemes, the state governments can secure Central assistance up to 60 per cent of the cost of training Urdu teachers.

[1]*The Times of India,* 22 July 1958

18. MPs Across Party Lines Demand Urdu as a Second Language[1]

In a memorandum to the prime minister, 104 members of Parliament have demanded recognition of Urdu as the second official language in UP, Bihar, Madhya Pradesh, Delhi, Punjab and Rajasthan.

They have also sought facilities for teaching Urdu in other states where Urdu-speaking minorities live.

The memorandum, which was submitted by Dr Syed Mahmud and Begum Anis Kidwai, says the government should accord Urdu its due place. Although the Constitution recognized Urdu as one of the fourteen regional languages, in practice it had not been given the status of a second language despite representations from time to time.

It points out that the claim that Hindustani, which should be the official language of the Union, ought to be written in both Urdu and Devanagari scripts had been accepted even by Mahatma Gandhi. There was no conflict between Urdu and Hindi. In the government's endeavour to make simple Hindi acceptable, Urdu would be the 'best handmaid' to Hindi since it was spoken in areas where Hindi had not yet penetrated.

The memorandum is signed, among others, by Mr P.N. Sapru, Krishna Rao, Mr Gurmukh Singh Musafir, Mr Braham Perkash, Mr I.K. Gujral, Mr M.S. Oberoi, Mr A.D. Mani, Mr Lokenath Mishra, Mr Ramsevak Yadav, Mr Abdul Gani Dar, Mrs Renu Chakravary, Mr Vijaya Lakshmi Pandit, Mr Shamlal Saraf, Mr N.C. Chatterjee, Mr B.P. Maurya and Mr Sadiq Ali.

Another memorandum on similar lines will be submitted to the president and the home minister soon.

[1]*The Hindustan Times*, 17 April 1965.

19. Eminent persons Submit Manifesto to the President on the Position of Urdu in India[1]

Urdu is one of the Indian national languages spoken by vast masses of people in a large number of states, specially in northern India and spoken and understood practically in every state of the Indian Union.

As such Urdu has been recognized as one of the fourteen main languages of India in the Eighth Schedule of the Indian Constitution.

The Urdu language was born in a part of northern India which had Delhi as its centre, a region which was for many centuries termed the *Madhya Desh* and which was since the time of the *Rig Veda* the birthplace of many Indian languages. This language was later nourished, nurtured, and developed in the Deccan, i.e. southern India and soon became the common interprovincial language of the entire subcontinent and remained so for long centuries. Thus the Urdu language is one of the best representatives of the *common Indian culture* as developed through centuries and one of the noblest symbols of India's national integration.

Wherever this language is spoken or understood in the country, it is spoken or understood by all sections of people irrespective of their religion, caste, creed or community. There is no part of India which has not made in the past and which does not now make its contribution to Urdu literature and poetry.

This language, both in poetry and prose, has always claimed and even today claims, among its foremost writers, persons of all creeds and communities.

The sacred books of the main religious communities of India are available in Urdu.

In all struggles for India's freedom, from 1857 to 1947, Urdu's patriotic literature and specially Urdu poetry has always inspired the fighters for freedom to an extent to which probably no other single language and its literature or poetry has done.

From all these points of view, the Urdu language has tried to serve as one of the greatest cementing and unifying factors of the Indian nation, endeavouring to help the cause of India's national integration in a way and to an extent of which any language and its votaries can feel justly proud.

Up to the dawn of independence in 1947, Urdu occupied a place of honour in the life of our country and especially in the provinces of northern India such as the Punjab, Delhi, UP, Bihar, the Central Provinces (Madhya Pradesh), and Rajasthan and even in the southern states like Mysore and Hyderabad. In some of these provinces like UP, for a number of years up to 1947, Urdu was taught as compulsory subject to all students of Hindi and Hindi was taught as a compulsory subject to all students of Urdu, while Urdu was the principal language used in all departments, courts, and offices of administration.

But soon after independence, advocates of the Urdu language and those who claim Urdu as their mother tongue, began to feel that Urdu was *being deliberately neglected* by the governments of free India and systematic efforts were being made to oust it from all branches of administration. Even in *census operations, efforts were made to minimize* as much as possible the numbers of those who claim Urdu as their mother tongue, thus artificially bringing down the importance and status of Urdu. Therefore, wholesome principles such as that every child should be taught and educated first of all in his mother tongue, and that as far as possible, every student should be educated up to the highest university standard through the medium of his mother tongue have been systematically violated in the case of Urdu-speaking people. Even in the case of the well-known three-language formula in states like UP, where hundreds of thousands of people in almost every district own Urdu as their mother tongue and where the main purpose of the three-language formula ought to have been to give an opportunity of learning Urdu to children whose mother tongue it is and who want to learn it, this important purpose of the said formula was deliberately nullified by making provision in schools for the study of Sanskrit, English, and a south Indian language along with Hindi, but not for the study of Urdu.

It is unnecessary for us to narrate such grievances of the Urdu-speaking people in the states of India like UP, Mysore, Madhya Pradesh, Andhra Pradesh, Rajasthan, Bihar, and Delhi in any further detail. These grievances which have been brought to the notice of the various governments times without number have already *reached a limit which is intolerable.* We give here only one example of the indifference of government authorities towards the grievances of the Urdu-speaking people of this country.

Article 347 of the Indian Constitution provides that whenever the president of India is satisfied that a considerable number of people in any state of the Indian Union, who speak a particular language, desire their language to be used for particular purposes, the president may issue a directive to the effect that the said language be officially recognized in that state as one of the regional languages of the state for purposes to be specified in the president's directive.

About thirteen years back a deputation of the Urdu-speaking people of UP headed by Dr Zakir Husain, the present vice-president of India, met the then president of India, Dr Rajendra Prasad, with the request that the president of India be pleased to issue a directive under Article 347 of the Constitution to make Urdu an officially recognized regional language of UP for purposes to be specified in the directive.

This written request was supported by the signatures of nearly *two-and-a-half million adult citizens of UP* who represented not less then ten million people of that state. The then president of India accepted the reasonableness of the demand. The then prime minister of India, Pandit Jawaharlal Nehru, also agreed that the demand was just. We, the signatories to this manifesto, are convinced that if Article 347 of the Constitution can apply in the case of any language in any state of India, surely it applies in the case of Urdu in UP. Yet we are pained to state that there has been no response to our request either from the then president of India or his successor up to this day and no reason has been given for this lack of response.

A similar deputation met the then president of India with a similar request supported by the signatures of one million adult *citizens of Bihar,* and the deputation and its request met the same fate as in the case of UP.

We may, at this stage, refer to another important aspect of this question. We, on our part and on the part of the Urdu-speaking people of India, refuse to accept that the question of the Urdu

language is a communal question. We have already said that
wherever the Urdu language is spoken and understood, it is spoken
and understood by all sections of people irrespective of their
religious faiths or creedal affiliations. We have also said that in the
galaxy of Urdu writers and poets both Hindus and Muslims have
figured equally throughout the centuries and do so now. The
signatories to the manifestos submitted to the president of India
and referred to above included men of all creeds and faiths without
distinction. The question of the Urdu language is purely a language
question and *by no means communal or creedal.*

Many of those, both in government and outside, who are against
Urdu being given full opportunity of growth, development, and
expansion like any other Indian language, and who are actually
thwarting the same by all sorts of manoeuvres openly declare that
the Urdu language was born during the Muslim period of Indian
history, that it bears the impress of Islam and Islamic countries,
and that it is something alien to pure Indian or Hindu culture and
must, therefore, be suppressed. But we feel it our duty to submit
that *no line of thinking could be more anti-national, more anti-integration
and more anti-secular than this.*

Naturally *when such anti-national ideas reach the ears of the Muslim
citizens of India, they begin to feel that their very existence as a cultural
entity is at stake in this country.* They then naturally, as good citizens
of India and as believers in and advocates of India's national
integration and genuine secularism, think that it is their sacred
duty to fight against such anti-national ways of thinking even if it
involves sacrifice and suffering.

At this stage we would like to clear one other important point.
It relates to our attitude towards the Hindi language. We wish to
declare it in the clearest words that there is absolutely no rivalry
between Urdu and Hindi. The Urdu-speaking people of this country
and the lovers and votaries of that language bear absolutely no ill
will towards the Hindi language. They gladly accept Hindi as the
language of the Indian Union or as the interstate language of India
or as the principal official regional language of states in which it
has already been so recognized.

This point was several times made clear by the late Maulana
Abul Kalam Azad from the platform of the Anjuman Taraqqi-e-
Urdu. It was also made clear from the same platform by the late
Pandit Jawaharlal Nehru. We only repeat it because somehow the
misunderstanding persists.

Wherever Hindi, as the language of the Indian Union or as the principal officially recognized language of a state is taught as a compulsory subject, Urdu-speaking children will gladly learn it. What we want and insist upon is only this that, as one of the main and constitutionally recognized languages of India, Urdu should be given all the opportunities and facilities of growth, development, and expansion which the Constitution of India guarantees.

As already said, the grievances of the Urdu-speaking people of India have been placed before the government times without number. Memorandums, delegations, and deputations have been of no avail. We are pained to say that the latest advice of the Union minister of irrigation and power to the UP government to agree to appoint 'a committee to go into the grievances of the Urdu-speaking people in the state from time to time', etc., appears, under the circumstances, only a *cruel joke or an ill-conceived manoeuvre*. Sober-minded critics have already remarked that this advice of the Union minister can do much more harm than good to the cause of Urdu and so to the cause of national integration.

In the above circumstances we now beg to reiterate the following minimum demands of the Urdu-speaking people of India:

1. The president of India may immediately issue directives under Article 347 of the Indian Constitution to the effect that Urdu be recognized as the second official language in states like UP, Bihar, Delhi, Rajasthan, Madhya Pradesh, Andhra Pradesh, and Punjab for purposes such as those mentioned in the memorandums submitted by people of UP and Bihar referred to earlier.
2. An effective statutory machinery be provided in each such state to implement the president's directive.

We humbly declare that if these minimum demands are not conceded by the government at an early date, the Urdu-speaking people of India shall be forced to conclude that *the government refuses to or is unable to do justice* in this matter and does not realize the anti-secular and anti-democratic character of its attitude towards Urdu. This would be a deplorable negation of those high ideals which the people of India cherish, which Mahatma Gandhi stood for, and which the Indian Constitution embodies.

It will be an evil day if we are obliged to conclude that in spite of the commitments of the great leaders of the Congress like Mahatma Gandhi, Pandit Jawaharlal Nehru, and Maulana Abul

Kalam Azad, the Congress party and the Congress government are unwilling or unable to do elementary justice to the wholly reasonable demands of the Urdu-speaking people of India. What the consequences of such a conviction will be it is not difficult to foresee, for thwarted and disillusioned people tend to resort to courses of action which although they bring loss and suffering to themselves, cannot prove pleasant for the authorities.

We, the signatories to this manifesto, if obliged to do so, will call upon all those who speak, value, and advocate the Urdu language and all those who stand for real national integration and genuine secularism to exert all their energies, before the next general elections as well as during the elections, to see that only those succeed who will endeavour to save the nation from reactionary and narrow-minded policies and promote the objectives of secularism, national integration, and cultural harmony enshrined in the Constitution.

We the signatories to this manifesto, pledge ourselves to work for this consummation.

Abdul Ghani Dar, MP, New Delhi.

F.J. Faridi (Dr), Lucknow.

Ali Bahadur Khan (Hafiz), Editor, *Daur-e-Jadid*, Delhi.

Anand Narayan Mulla (Pt), ex-Judge, High Court, Lucknow.

Anis Kidwai (Begum), MP, New Delhi,

Atiqur Rahman Usmani (Mufti), Delhi.

Betab Siddiqi, Anjuman Taraqqi-e-Urdu, Patna.

Bishambhar Nath Pande (Pt), ex-Mayor, Allahabad.

B.P. Maurya, MP, New Delhi.

Ghulam Ahmed Khan Arzoo, Editor, *Hindustan Daily*, Bombay.

Ghulam Sarvar, Secretary, Anjuman Taraqqi-e-Urdu, Patna.

Gyan Singh Vohra (Sardar), Advocate, Supreme Court, New Delhi.

Habibur Rahman (Professor), President, Anjuman Taraqqi-e-Urdu, Hyderabad.

Hamida Habibullah (Begum), Lucknow.

Kulsum Sayani (Mrs), Bombay.

Man Singh (Sardar), Editor, *Mansrovar*, New Delhi.

Maqsood Ansari, Urdu Muhafiz Dasta, Bombay.

Mazhar Imam, ex-MP, Patna.

Mohammad Mujtaba (Syed), Patna.

Mohammad Muslim, Editor, *Dawat*, Delhi.

Mohammad Mustansarullah (Sheikh), Lucknow.

Mohammad Siddiqi, Urdu Muhafiz Dasta, Bombay.
Mohammad Tayyab Siddiqi, Advocate, Meerut.
Mohammad Yaqub Yunus, Advocate, Patna.
Mukhtar Ahmad, Advocate, Moradabad.
Mulla Jan Mohammad, Khilafat Committee, Calcutta.
Sangha Priya Gautam, Advocate, President, Republican Party, Bulandshahar.
Sant Singh (Sardar), Lucknow.
S.P. Sinha, Senior Advocate, Supreme Court, Delhi, ex-Judge, High Court, Allahabad.
Sundar Lal (Pt) MP, New Delhi.
Tara Chand (Dr) MP, New Delhi.
Triloki Singh, Lucknow.
Virendra Kumar Satyavadi (Dr) ex-MP, Editor, *Intibah*, New Delhi.
Wahidurrahaman, Vice-President, Swatantra Party, Lucknow.
Zafar Ahmed, Advocate, Sitapur.
Zakir Hussain Farooqi (Dr), *Hindustan Daily*, Bombay.

I agree subject to one condition. At page 4, we find the expression 'at an early date'. This is much too vague. Past experience tells us that we should be precise and definite. I would suggest that the government should be called upon to take the necessary steps by 1 December 1966.

Sd/ S.P. Sinha

[1]*Radiance*, 27 November 1966.

20. Delegation Meets Prime Minister Indira Gandhi and Submits Memorandum[1]

A presidential decree under Article 347 of the Constitution to accord recognition to Urdu as an official language was sought by a delegation which met Prime Minister Indira Gandhi on 21 January 1967.

The delegation, led by Mr H.N. Kunzru, consisted of Urdu scholars like Col Zaidi, Dr Abid Husain, Mr Gopi Nath Aman, and Pandit Sunder Lal.

The delegation told the prime minister that facilities for teaching Urdu and for its use as an official language were inadequate and unsatisfactory in UP, Bihar, and Delhi.

Citing the report of the Linguistic Minorities Commission, the delegation said the number of pupils studying Urdu was falling in primary and secondary schools.

Mrs Gandhi expressed sympathy with the views placed before her and told the delegation that any major steps would be possible only after new governments were installed after the general elections. She assured the delegation, however, that she would see what could be done in Delhi.

[1]*The Hindustan Times*, 22 January 1967.

21. K.A. Faruqi's Letter Brings out Nehru's Clarification on Urdu[1]

Sir,—Dr Mohammad Hasan in his article 'Urdu: A language Made Alien in its Homeland' refers to the wrong implementation of the three-language formula. It was in UP where this formula went the wrong way: it was made to include classical languages under modern languages, thus carefully excluding Urdu.

The late Maulana Hafizur Rahaman, who was lying critically ill in Madison, Wisconsin, USA, protested to Mr C.B. Gupta, the then chief minister of UP, and to Mr Nehru, then prime minister of India, at the way this formula was being interpreted and implemented in UP, denying Urdu its rightful place in its main homeland. Mr Nehru thought that Maulana Hifzur Rahaman had obviously been misinformed and clarified the formula thus in a letter dated 1 July 1962.

'I think you are under a misapprehension. The formula agreed upon at the chief ministers' conference as well as the integration conference was the three-language one, namely (1) Hindi, (2) English or possible any other foreign language, and (3) any modern Indian language other than Hindi.

'You will see that this obviously includes Urdu. As there was some doubt about this mater, I wrote to the education minister and he has clarified it as stated above by me.'

Yours, etc., Khwaja Ahmad Faruqi.
Delhi, 26 January

[1]*The Statesman*, 7 February 1967.

22. Home Minister Charan Singh Links Urdu with Muslims and Holds it as One of the Principal Causes of India's Partition[1]

When I said that Urdu was imposed by the Turks or the Mongols who came from outside, I was essentially referring to the script in which Urdu is written. You will agree with me that a language is popularly identified by its script. What differentiates Hindi or Hindustani from Urdu is not so much the vocabulary as the script. If this view is correct, whatever opposition there is to Urdu is to the script and not to its vocabulary. This script is Persian in origin and is, therefore, essentially alien to India. It was imposed either when the Turks became rulers of parts of India or the Mongols. Its vocabulary grew more as a 'camp' language. An unfortunate corollary was that the Muslims, who were then the ruling class, somehow came to identify themselves, albeit only in the north, with the script rather than with the content of the language.

You have referred to my remarks about Urdu being one of the principal causes of India's partition. The relative emphasis on the various causes that contributed to the partition of the country can be a matter of opinion. But it is a fact of history that one of the main reasons why the Muslim League and the late Jinnah Sahib insisted on Pakistan was their preference to have Urdu not only as their medium of instruction but as their official language. Indeed, Urdu was identified by the Muslim League and the late Jinnah Sahib as one of the factors which made the Hindus and the Muslims two separate nations. The familiar argument of identifying the separate entity of a people as a separate nation relies heavily on the differences in their languages.

It is again the existence of two different scripts—the Persian script and the Devanagari script—that obviously persuaded our national leadership to go in for Hindi or even Hindustani, although the choice of the latter was strongly advocated by Mahatma Gandhi.

I am in full agreement with you that, as a language, Urdu should have no religious overtones because it is a medium of communication of Hindus and Muslims alike. Unfortunately, however, Muslims of the Hindi region do continue to identify Urdu with their religion. And it is this attitude which creates problems.

The demand for according Urdu the status of a second official language is strongly pressed in Uttar Pradesh, especially during

elections. I have had no doubts in my mind that, because of practical difficulties, it will not be possible to accept this demand.

The previous Congress government of India had also taken the same stand in 1973 just before the assembly elections of Uttar Pradesh were due early in 1974.

I will be sorry if anything were to happen which will result in India losing its heritage of Urdu. For sheer elegance and grace, the Urdu language has few parallels. It has great charm and beauty. A number of popular Hindi journals are increasingly using in their writings Urdu words today. There is, therefore, a growing acceptance of the words and expressions from that language. I will welcome the emergence of some practical proposition by which the genuine aspirations of lovers of the Urdu language and literature could be fulfilled without unnecessarily exciting political and linguistic hostility. It might interest you to know that, as my Muslim friends often tell me, I use more Urdu in my conversation and public utterances than most others.

New Delhi Charan Singh

[1]*The Illustrated Weekly of India*, 29 January 1978.

23. Anjuman Taraqqi-e-Urdu (Hind) Submits Memorandum to Government of India[1]

A delegation of the Anjuman Taraqqi-e-Urdu (Hind) led by President S. Hamid and including A.N. Mulla, M. Ram, S.S. Desnave, R.B. Gour, H. Ansari, and K. Anjum called on P.V. Narsimha Rao, minister for human resources development on 8 June 1988 and presented a memorandum on long-pending demands of Urdu. The text follows:

With reference to the above subject, the Anjuman Taraqqi-e-Urdu (Hind) wishes to submit the following Memorandum:

Disenchantment with government's polices and programmes relating to the Urdu language and the way they are executed is growing at an alarming rate. It is being widely felt that government's interest in the preservation and promotion of Urdu is more verbal than real. The steps taken so far have betrayed a cosmetic character. They have not come to grips with the real problems, the only

significant exception being the award of second language status to Urdu in Bihar.

Expectations were raised when in 1972, government constituted a high-powered committee headed by Shri I.K. Gujral and popularly known by the chairman's name. Curiously, for years together his vitally important report remained in cold storage. At long last when in response to the popular demand and protestations it was made public, decision on its recommendations was unduly and inexplicably delayed. Another committee was set up under the chairmanship of Professor Ale-Ahmed Suroor to spell out the Gujral Committee's report in terms of detailed implementation. The second report went the way of its predecessor and has not been published to this day. These entirely avoidable delays have naturally made Urdu-speaking people suspicious about the bona fides of the administration. This could easily have been avoided.

It is the misfortune of Urdu-speaking people that whatever was conceded by the Central government has been denied by the implementing agencies, the classical example being the short-sighted and callous manner in which the state of Uttar Pradesh has violated the letter and spirit of the three-language formula by substituting Sanskrit for a modern Indian language with the obvious intention of ousting Urdu. The result is there for everyone to see. Urdu is virtually being wiped out from its home state. Two generations have been deliberately denied the opportunity to learn, to read and write their mother tongue.

Nothing could cause greater dissatisfaction. The resulting frustration could easily take an unhealthy course and cause avoidable headache to all concerned.

Urdu Rabita Committee of UP, which has just completed its mass contact programme, is organizing a big conference at Lucknow on 19 June 1988 where it will voice its demands, and present the same before the authorities.

The moment seems to be ripe when pre-emptive action against the spread of dissatisfaction is taken by accepting the just and reasonable demand of the Urdu-speaking people. Urdu should be given its due before it is too late.

It may be stated that Urdu has accepted the superior status of its twin sister Hindi as the language of the Union. The Anjuman Taraqqi-e-Urdu (Hind) which is the highest and the most representative Urdu organization in the country has declared its policy of cultivating Hindi writers and Hindi public opinion and

convincing them that if Urdu is protected and promoted, considerable advantage will accrue ipso facto to Hindi. In fact, the writers of the twin languages are coming together. It is very encouraging that a number of Hindi writers and their organizations have been supporting the cause of Urdu. The Janawadi Lekhak Sangh has held meetings in Madhya Pradesh, Uttar Pradesh, and other places supporting the demands of Urdu.

The Anjuman, therefore, makes the following suggestions for government's immediate consideration.

Three-language formula and its implementation

Three-language formula was conceived by the Union government and the education ministers' conference with the triple objective of (i) protecting and promoting the language of every linguistic community of our multi-lingual country; (ii) promoting the language of the Union, Hindi, 'so that it may serve as a medium of expression for all the elements of the composite culture of India' (Article 351 of the Constitution); and (iii) persuading the pupils to learn English or any other foreign language to be able to communicate with outside world. And those whose mother tongue was Hindi were expected to learn any other modern Indian language. Such were the laudable purposes that we had before us.

But the experience is that this formula is not implemented uniformly all over the country. Some have only a two-language formula. Some others (UP, for example) have included a classical language instead of a modern Indian language, the objective obviously being to oust Urdu and deprive those, whose mother tongue it is, of the opportunity to learn it. This has caused a situation in Uttar Pradesh which violates the provisions of our Constitution relating to linguistic minorities and injures the secular fibre of the national fabric.

Urdu linguistic minority faces the biggest difficulty in this regard. We want that Urdu be included in the formula (e.g. in UP) as a modern Indian language and a categorical assurance to this effect be given.

Mother tongue has to be the first language. Article 350(A) says that it shall be the endeavour of every state and of every local authority within the state to impart primary education in the mother tongue of the pupils. And the Linguistic Minorities Commissioner has already noted that mother tongue is not confined to the languages mentioned in Eighth Schedule. This stresses the

importance of mother tongue as the medium of primary education. However, Urdu is included in this Schedule.

The three-language formula has to be as follows with the above objectives in view:

In Hindi states for Urdu students: First language—Urdu; Second language—Hindi (from third standard); and Third language—English (from sixth standard).

In Hindi states for Hindi students—First language—Hindi; Second language—any modern Indian language including Urdu (from third standard); and Third language—English (from sixth standard).

Classical language could be a subject in post-matriculation stage or an optional composite course of Hindi and Sanskrit could be introduced in the sixth standard, subject to the provision that marks in Sanskrit shall not be added to the aggregate to determine the pass class.

In non-Hindi states for the majority linguistic community the formula could be:

1. Mother Tongue (languages of the state)
2. Hindi (from third standard)
3. English (from sixth standard)

In non-Hindi states for linguistic minorities:

1. Mother Tongue (in our case, Urdu)
2. Language of the state (from third standard)
3. English (from sixth standard)

Here, we have to find a way to promote Hindi. An option could be given from the following alternatives. The parents will select in accordance with the career they wish to chalk out for their wards:

(a) Composite course of Urdu and Hindi subject to the condition that marks in Hindi will not be considered for aggregate, or

(b) a choice between English and Hindi from the sixth standard.

Our main objective is that Urdu students should not be deprived of (a) mother tongue, (b) the language of the state, (c) the languages of the Union, and (d) English. Our only consideration is that Urdu-medium pupils should not be additionally burdened and placed in a position of disadvantage when compared to the students of the linguistic majority.

So much about the three-language formula, its uniform working out, and its implementation.

On Gujral Committee and Suroor Committee's recommendations

The all-India conference convened by Anjuman Taraqqi-e-Urdu (Hind) in Delhi during 25–27 March 1988, has unanimously demanded the implementation of Gujral Committee's recommendations. These recommendations of Gujral Committee cover a wide range for protecting and promoting Urdu. There are recommendations that concern the Union government, its officers, the railways, the post and telegraph department, the Union Public Service Commission, and even the Election Commission (electoral rolls). The Gujral Committee has recommended 10 per cent as the minimum population of Urdu in a district, *tehsil* or municipality for its minimum official use. The committee has dealt with the three-language formula also.

Above all, the Committee has supported official language laws of the states to be amended to include official recognition for minority languages for use for all or some official purposes in the state or any part thereof.

The States Reorganization Commission has supported (and this is repeated in the Union home ministry memorandum submitted to the Parliament in 1956) that the Union government should, in consultation with the states, work out the guidelines for such legislation.

Article 347 of the Constitution empowers the president to issue directions to the states concerned. This implies that the Union government has to advise the president accordingly. It is high time that the Government of India takes the necessary steps in this regard.

In this connection we wish to draw your attention to the fact that a committee headed by Professor Ale-Ahmed Suroor was appointed to work out the details for implementing the Gujral Committee recommendations. This report may also be published and taken into consideration for necessary action.

About Navodaya schools

Urdu-speaking, and for that matter all non-Hindi-speaking students, coming from primary schools where the medium of education is their mother tongue, are at a disadvantage because the competitive entry examination for admission to sixth standard in Navodaya schools is held in Hindi. We propose that the entry test be held in the language that was the medium of instruction in the primary

Navodaya schools the medium will be Hindi is of no serious consequence because at the primary stage the pupils would learn Hindi from third standard, and would have learnt enough of it in three years to switch over to Hindi medium.

It is also necessary that in Navodaya schools Urdu should also be taught as a language under the three-language formula.

These are some of the issues that require your urgent attention and early action. We shall be grateful if the government's decision on these issues is conveyed to us at your earliest convenience so as to enable the Anjuman to explain to its vast clientele, the government's policies relating to Urdu.

[1]*Muslim India*, August 1988, pp. 364–72.

24. Gopichand Narang Calls for Efforts to Promote Urdu[1]

Gopichand Narang, Urdu critic and writer, has called for strong efforts to promote Urdu. 'We should encourage the language and not discriminate against it,' he said.

Mr Narang, who was in Mumbai to receive the Wali Dakhni national award of the Urdu Academy, said Urdu has over the years strengthened cultural bonds between different communities. 'Urdu writing has always been secular. Even after conflicts between India and Pakistan, Urdu writing has been free from communal bias,' Mr Narang said while talking to this newspaper.

Mr Narang said Intazar Husain, the noted Pakistani writer based in Lahore, frequently draws on the *Jataka* and *Panchatantra* tales from India to portray the present-day turmoil in Pakistan. The cultural affinity between the people of the two countries is very strong and cannot be ignored, he said.

Urdu still provides the undercurrent for the cultural affinity between the people of the two countries. People in Pakistan and Pakistanis living in other countries avidly watch Hindi films and Zee TV. The vice-chairperson of the Sahitya Akademi said Urdu has built bridges between two major cultures since the time of Amir Khusro, the Sufis and the *bhagat*s, and Kabir.

Urdu is a part of the Indian heritage. It cannot be treated as a language of one religion just because Pakistan has adopted it. Even in Pakistan, there is not a single district or *tehsil* in which Urdu is

in Pakistan, there is not a single district or *tehsil* in which Urdu is understood by all. 'They have adopted it because of their compulsions. We should be happy about it.'

'We can use the Indianness of Urdu to improve relations with Pakistan. The language is our daughter. It is wrong to tie the language with any religion,' Mr Narang said.

Mr Narang, who has sought to bring out the best in the Indian literary theory, traditions, and modern theories, feels that writings in Indian languages and the Third World literature deserve higher international recognition. He does not agree with Salman Rushdie's view that far better writing is done by Indians writing in English than in regional languages. Mr Narang said writing in Indian languages should not be judged on the basis of translations. The works have to be read in the original. He was glad that the Maharashtra government was promoting Urdu by allowing schools to use Urdu as a medium of instruction while Uttar Pradesh had nearly banished the language as a medium of instruction at the school level.

He feels the Hindi language needs a linguist like Suniti Kumar Chaterjee who can boost research and give a boost to the language. The study of Hindi is declining in the universities. Government patronage and spoon-feeding weaken a cultural cause. The growth must come from within, through an inner urge. This should happen in Hindi, Mr Narang said.

Wali Dakhni, in whose name Mr Narang won the award, was an outstanding Urdu poet of the Deccan of the early eighteenth century. Urdu grew substantially in parts of Maharashtra and Karnataka during the mediaeval era.

[1]*The Times of India*, 16 October 1998.

25. Vajpayee Pleads for Respect for Urdu[1]

Prime Minister A.B. Vajpayee said at Lucknow on 28 March 1999 that Urdu should not be projected as the language of any particular community: '*Urdu batware ki bhasha nahin hai.*' He added, 'It is a national language and, therefore, its dignity must be maintained.'

The prime minister was addressing the silver jubilee celebrations and felicitation function organized by the Uttar Pradesh Urdu Academy at the Ganna Sansthan here.

He criticized the Muslim League for using the language plank to vitiate the communal atmosphere. 'However, they did not succeed and can never succeed,' he asserted. 'There should be no dispute over any language and whenever it is made into an issue, it creates problems,' he pointed out.

The prime minister said that there should be a standard format for all the recognized languages and it should be uniformly implemented all over the country. He regretted that in some states Hindi was not being taught at all which he said was unfair. 'Hindi is a national language and it should be given the due respect.'

He further said that Urdu has been accorded the status of *Rajbhasha* in Kashmir and not Dogri which was the regional language. The different languages and dialects stand testimony to the cultural richness of the country, he pointed out.

Having a dig at previous governments at the Centre, the prime minister said that the recommendations of the Gujral Committee were still gathering dust. '*Hamein abhi ek saal hua hai aur bahut si neetiyan pahele se chali aa rahin hain*' (We have just completed one year and some earlier policies are still in continuance), he said.

But the endeavour of the present government was to accord equal status to all the languages, he said.

Promising full financial support to the UP Urdu Academy, the prime minister, however, made it clear that all plans and projects prepared by it for promotion and popularization of Urdu should not be lacking in substance and content.

Speaking on the occasion, Chief Minister Kalyan Singh announced several sops which included two awards of Rs 2 lakh each after the names of famous Urdu poets Mirza Ghalib and Firaq Gorakhpuri.

He said a selection committee will be set up for finalizing the names of the recipients for these awards. He also announced Rs 10 lakh for the silver jubilee celebrations of the UP Urdu Academy, Rs 5 lakh for its library and an equal amount for furniture and other paraphernalia.

Governor Suraj Bhan, Tourism Minister Kalraj Mishra, Urban Development Minister Lalji Tandon, Education Minister Nepa Singh, other Cabinet ministers, legislators, and some Urdu authors attended the function.

[1]*The Times of India*, 29 March 1999.

Aligarh Muslim University

1. Vice-Chancellor Ali Yavar Jung Refutes Allegations Against AMU[1]

On 21 May 1965 Mr Ali Yavar Jung, vice-chancellor of Aligarh Muslim University, found it necessary to issue a contradiction to a 'backgrounder' issued to the press by the Union education ministry.

The vice-chancellor said in a press statement that the news published in a section of the press that the post of the pro-vice-chancellor of the university had been abolished under the ordinance issued on 20 May 1965 was 'totally incorrect'.

It is the post of honorary treasurer which has been abolished and substituted by a full-time salaried officer, Mr. Ali Yavar Jung said in his statement.

The Ministry's backgrounder had said that the post of pro-vice-chancellor was being 'abolished' under the ordinance though it would be open to the executive council later to have a pro-vice-chancellor.

Recruiting centre

The vice-chancellor has taken exception to the statement in the backgrounder that the university had 'also become a centre for pro-Pakistan activities' and also that it had 'become a recruiting centre for Pakistan for highly skilled persons, for example, doctors and engineers'.

In the press note issued by him, Mr Ali Yavar Jung said:

It has pained me to read allegations in certain sections of the press in the context of the ordinance, that Aligarh Muslim University has become a centre for pro-Pakistani activities and for recruiting highly skilled persons from the engineering and medical faculties for Pakistan. I feel it necessary to publicly refute sweeping and mischievous allegations of this kind.

'If some of our alumni have left for Pakistan or any other country, it has been probably due to lack of suitable employment opportunities for which other persons have also been found to be seeking jobs elsewhere and due to which some Indian students abroad, regardless of community, have been seen to prefer to seek employment in other countries. This is a trend for which it would be wrong to blame only Aligarh; its causes, like its remedies, are of general application.

Col B.H. Zaidi, a former vice-chancellor of Aligarh University has also expressed concern at the allegation. He says in a press statement: 'The greatest proof of how ill-founded government information can be is the accusation that the university has become a recruiting ground of doctors for Pakistan. The medical college of the university was established only three years ago and the first batch of medical graduates will be turned out by it after two years.'

How could Pakistan then recruit doctors produced by Aligarh Muslim University, he asks in his statement.

'Some people do not hesitate to give a dog a bad name and then hang it. I hope our government will not be guilty of such an attitude,' he adds.

[1]*The Statesman*, 22 May 1965.

2. Vice-Chancellor Ali Yavar Jung Writes to Education Minister M.C. Chagla Withdrawing his Resignation[1]

The following is the text of the letter of Mr Ali Yavar Jung to Mr M.C. Chagla:

I am honoured by the confidence which the Visitor and you have placed in me in asking me to withdraw my resignation.

In my letter to you on 2 May, seeking your permission to place my resignation before the president, I had expressed the hope that the developments culminating in the violence of 25 April would not affect the character of Aligarh Muslim University. This I said because I believe that the university can be a source of pride both to the Muslim community and to India as a whole.

The conduct and policy of the university must necessarily be governed by the Act of Parliament which regulates its constitution in conformity with the Constitution of India and the purposes which the university was and is designed to serve. As a result, we have: (a) a university or an institution of higher learning which must maintain and promote high

academic standards, (b) an all-India university which must be open to and attract all-India talent, and (c) at the same time, a Muslim university in the sense that it specializes in subjects connected with Muslim culture and is expected to have due regard to the claims of deserving Muslim students.

National Character

I may here state that the university is financed both by the proceeds of private benefactions and the more substantial funds placed at its disposal by the government. This combination of private and public financial support serves to emphasize the university's Muslim and, at the same time, national character.

With only the one and not the other, the university would lose its special position. What is more, the one without the other would either do violence to the aim of promoting the education of Muslims or ignore the Act of Parliament and, therefore, the reality of the national interest and jurisdiction. There is nothing incompatible in the combination of the two, as the educational advancement of Muslims is in the national interest and the interest of the Muslims of India cannot be different from the interests of the nation as a whole.

I am reminded of the talks I have had with you on this subject and of your assurance that, subject always to the sovereign will of Parliament, there was not the remotest intention on the part of the government to alter the Muslim character of the university. You said it was your abiding aim and hope that the university would justify its purposes by devoting itself to the attainment of high academic standards and the advancement of the education of Muslims in the context of modern India. You have, since, also repudiated the allegations made against the university that it was a centre of pro-Pakistani activities.

Misrepresentations to the contrary notwithstanding, the ordinance does not remotely touch the Muslim character of the university, nor its academic autonomy. Limited as it is in its scope, the ordinance is intended also to be of short duration.

It must be the endeavour of the university's administration to use it more especially for the speedy restoration of effective administration and academic normalcy in conditions of orderliness. In this task, I am sure that it will have the support of the great majority of our staff and students. You will recall that, in my original report, I had stated that the majority of them were right-minded. Some of them could be the pride of any university.

Restoration of Normalcy

The restoration of normalcy in the university would depend in large measure also on the maintenance of an atmosphere of calm and security both inside and outside Aligarh. I have already spoken to you and found you in agreement as to the desirability of the present police and magisterial

inquiry being concluded as soon as possible. The same consideration of time has to be borne in mind with regard to the impending trials of the accused students and of the release of those against whom there is insufficient evidence.

As I mentioned to you, I have, some time ago, passed orders that the processes of arrest and detention should not come in the way of the students being allowed to undertake the immediate examinations of the academic year 1964-65, and in this we have had full police cooperation. This is as it should be, as there must be no victimization of any kind.

The question remains, however, of the present atmosphere of agitation which it should be the endeavour of all to dispel. Otherwise, I fear the smooth running of the university and its best interests are likely to suffer injury.

All that I have submitted above is by way of a summary of the talks we have had as to the aims of the university and the needs of the present situation. It is your agreement with these, carrying as it does the weight of the Government of India behind it, and my knowledge of the determination of the president, as Visitor, despite what has happened, to help Aligarh Muslim University in its aims as an institution of higher learning and as a university devoted particularly to the advancement of the education of Muslims, that persuade me to continue to serve it to the best of my ability.

[1]*The Times of India*, 19 June 1965.

3. Chagla's Assurances to the Vice-Chancellor[1]

The following is the text of Mr Chagla's letter to Mr Ali Yavar Jung.

I am very glad to learn that you have decided to go back to Aligarh and resume your duties as vice-chancellor. It is both an act of faith and an act of courage and I am sure the results will justify both the faith and the courage and you will be able to make Aligarh University a model university in our country — a truly national university, an institution of learning which will attach the greatest importance to the study of Muslim culture and philosophy, which have contributed and will continue to contribute in future so much to the making of our composite culture, of which we are all justly proud.

Much that you have said in your letter entirely coincides with my own views, to which I have given expression in my statement to both Houses of Parliament and in my letters to Dr Syed Mahmud and the secretary of the Jamiat-ul-Ulema-e-Hind.

It is ridiculous and absurd to suggest that the ordinance is aimed at changing the character of the university. The ordinance, which is of a transitional and temporary character, is aimed at arming the vice-chancellor and the executive council with full authority to weed out from the university that reactionary and anti-national element which has brought disrepute to the university and which resulted in the terrible incident which will remain unique even in the history of university indiscipline.

Education of Muslims

From the large and overwhelming evidence I have received, I am glad to note that this element by no means constitutes the majority opinion of the university. On the contrary the majority of the staff and students are right-minded and very often have been misled by a small vociferous and aggressive section, which has spread its tentacles far and wide.

I have made it perfectly clear that there is not the slightest intention on the part of the government to change the essential and basic character of the university. The university must dedicate itself to the attainment of high academic standards and the advancement of the education of Muslims in the context of modern India. Muslims must realize that they cannot hope to flourish in isolation as a separate entity. They must join the great national effort that is being made to advance the country and realize that in the advancement of the country also lies their own advancement.

Just as I am busy piloting the Banaras Hindu University Bill through Parliament in order to restore to that university its normal constitution, I will do the same with regard to Aligarh Muslim University as soon as possible. I have no love for ordinances or for suspensions of the constitution. I have been driven to take these measures by the extraordinary circumstances of which the whole country is aware and nothing will give me greater pleasure than to restore to Aligarh University its normal constitution as soon as normalcy has been restored.

I agree with you that, in order to restore the normal situation, it is necessary that the present police and magisterial inquiry should be concluded as soon as possible and the prosecutions pending against certain students should be brought to a conclusion with as much despatch as possible, subject always, of course, to the due processes of the law.

I also agree with you that there should be no victimization whatsoever. No fair-minded man searches for victims but it is equally important that the guilty should be brought to book after fair trial or inquiry.

You have my permission to publish both your letter to me and my reply.

[3]*The Times of India*, 19 June 1965.

4. Chagla defends ordinance on AMU in the Lok Sabha[1]

In a hard-hitting speech, Union Education Minister M.C. Chagla denied on 2 September in the Lok Sabha the opposition charge that the Aligarh Muslim University (Amendment) Bill was unconstitutional and would deprive the institution of its special character.

Replying to the general debate on the bill amidst repeated and noisy interruptions from Muslim League members, he refuted the argument that the university had either been established or was being administered by a certain community.

The university had been established by law and Parliament had every right to deal with its administration. Mr Chagla argued that the bill was a temporary measure and would be shortly replaced by substantive legislation.

The House approved of the first reading of the bill.

The debate took an interesting turn when the prime minister intervened to deny Mr Prakash Vir Shastri's allegation that Mr Humayun Kabir and Mr Shah Nawaz Khan were on the governing body of the Jamiat-ul-Ulema-e-Hind and carrying on propaganda against Mr Chagla for the stand he had taken on the Aligarh University issue.

Mr Prakash Vir Shastri said his information was based on an announcement printed in the official organ of the Jamiat. The ministers had not issued any disclaimer nor made any statements dissociating themselves from the various anti-Chagla statements issued by the Jamiat.

Kabir's assurance

The prime minister espressed regret over the attack on ministers and said Mr Kabir had assured him that he was not a member of the governing body and had also assured him that he had made no speech and had not participated in any group discussion against Mr Chagla. Mr Kabir had told him that since he was not a member of the governing body, there was no question of his resignation.

There was another interesting interlude when Mr Yashpal Singh, whose resolution seeking disapproval of the ordinance was also under discussion, was not given an opportunity by the deputy Speaker to reply to the debate.

He threatened to undertake a fast 'unto death' in Parliament House to defend his right of reply.

The deputy Speaker said the member was not alert and that he could not help him out because the first reading of the bill had already been approved.

However, before the House adjourned, the Speaker apologized to the member who then gave up his decision to fast.

Mr Chagla found powerful support from the opposition as well as Congress benches. He confirmed Mr Prakash Vir Shastri's statement that he had received a letter from a former Union Minister, Dr Syed Mahmud, asking him to consider the repercussions the ordinance would have in Pakistan.

In his reply to Dr Mahmud, Mr Chagla had said that he was not worried about the reaction the measure would have in Pakistan which was determined to be hostile to India.

Referring to the Republican member, Mr Muzaffar Hussain's contention that the ordinance had displeased 60 million Muslims of India, Mr Chagla asked who had made Mr Hussain the representative of 60 million Muslims. Indian Muslims were patriotic and nationalist.

Referring to the same member's remark that the Congress would lose votes on account of such measures, Mr Chagla said amidst cheers that he would much rather the Congress lost at the polls than win on such votes.

Unity appeal

Appealing for a dispassionate approach to the question, Mr Chagla said the country was living through dangerous and difficult times. 'The enemy has entered our territory. We must present a united front. This is not the time to raise controversies.'

Clause-by-clause consideration of the bill will be taken up tomorrow.

Mr Chagla said most of the criticism against the ordinance was based either on misapprehension or misunderstanding.

Referring to Mrs Renu Chakravarty's criticism of the nominated court and executive council, Mr Chagla said the member forgot this was a temporary emergency measure to be 'replaced as soon as possible by a permanent measure which will not certainly provide for any nominated court or council'.

'The circumstances were such that it was absolutely necessary to suspend the constitution,' he said.

The minister said a similar ordinance for the Banaras Hindu University lasted seven years from 1958 to 1965 'because it was felt that discipline can be restored and administration can be improved through a compact body of men in whom the government and the vice-chancellor had confidence'.

This long period had in no way changed the character, courses of studies, or the academic atmosphere of Banaras University. The ordinance affected only the administrative structure. 'I do not know why such prominence is given to the principle of nomination. The House should trust the Visitor and the education minister,' he said.

Referring to Mr Frank Anthony's arguments, Mr Chagla said he had raised a 'question of very great importance'. 'I think we should solve it because it affects not only Aligarh University but the whole social structure of ours.'

Mr Chagla asked the House to note that Article 30 referred to the right of the minorities to establish and administer educational institutions of their choice. 'My submission to this House is that Aligarh University has neither been established nor is it being administered by the Muslim community. It is not a minority institution in the sense in which Mr Anthony suggests.'

Going into the history of Aligarh University Mr Chagla said the founder of the Muslim convention, Sir Syed Ahmed, asked the British government to establish a university. The British passed an Act in 1920 to establish the university. Therefore, the institution was established by a legislation not by a community. 'Whatever might have been the origin of Aligarh University, the university was established by a legislature.'

Mr Chagla said the Constitution of independent India made some alterations in 1951 which laid down that central universities and other institutions of national importance can be legislated by Parliament. Even the constitution of the executive council and the academic council are regulated by Parliament and not by the minority community, he said.

Another aspect which Mr Anthony had forgotten, Mr Chagla said, was that under the Act of 1920 the British government as a concession said that the court shall consist wholly of Muslims. But in the executive council, the position was not so. Everybody knows that the university is administered by the council and not by the court. The court is a showpiece. The day-to-day administration is carried on by the executive council, he said.

'It is significant that even in the British days it was not provided that the executive council shall consist only of Muslims,' Mr Chagla said. 'I say this institution was not established by the minority community nor can it be administered or was ever administered by the minority community.'

V-C's letter

As Mr Chagla was reading Mr Ali Yavar Jung's letter, Mr Mohammad Koya remarked: He wanted to be a dictator.

Mr Koya tried to raise a point of order but was shouted down by the Congress benches.

The Swatantra leader, Mr N.G. Ranga angrily rose to protest against what he called the 'irresponsible behaviour of the Congress members'.

Another point of order by Mr Muzaffar Hussain was also ruled out.

Mr Chagla read out more letters from the vice-chancellor after the ordinance was passed and said that on 29 August Mr Jung had written that 'it was largely due to the ordinance that we have been able, in spite of obstacles, to reopen the university under conditions of comparative calm.

'This is the certificate of the man on the spot, a certificate both in regard to the necessity of the ordinance and what the ordinance has attained,' Mr Chagla said.

Mr Chagla said he would not mind if he was abused or vilified but it was distressing to hear charges that 'he was out to destroy Aligarh University'.

'Did I organize the murderous attack on the vice-chancellor? Did I foresee that the vice-chancellor would be treated in this way? It is too ridiculous for words,' he said.

Mr Chagla said he was in sickbed when he received the news of the assault. 'Nothing has pained me more than to have taken this step. I believe in autonomy and democracy but I was helpless.'

During the debate, Mr Prakash Vir Shastri contended that since Aligarh University received government grants, these funds could not be utilized for the propagation of Islamic culture. He alleged that there was a conspiracy to murder the vice-chancellor and in this context referred to the role of the university in the pre-independence era. After partition, Pakistan's independence day and Marshal Ayub's victories had been celebrated by certain elements

in the university. The first convention of the Jamaat-i-Islam was also held in Aligarh.

Member's charge

When he alleged that Mr Chagla had been left to fight a lone battle against the communal and obscurantist elements at Aligarh and charged that Mr Kabir and Mr Khan were against the bill, the Congress members protested.

Mr H.C. Mathur got up and said the executive of the Congress Parliamentary Party had supported Mr Chagla and that measure enjoyed the full support of the party.

Mr Prakash Vir Shastri also made a number of allegations against Dr Syed Mahmud, MP. He said Mr Asrarul Haq, a former MLA of Madhya Pradesh, had alleged that wakf money was being used to help the opponents of the bill and Mr Kabir headed the wakf department.

Several members, including Mr Radhey Lal Vyas, and Mrs Renu Chakravarty, strongly protested against Mr Prakash Vir Shastri's remarks.

Mr Vyas said that allegations could not be made against members and ministers without prior notice.

Mrs Chakravarty pointed out that the member had also on previous occasions made allegations which had been denied.

When Mr Prakash Vir Shastri remarked that the government could refute them, the Speaker said members should not make allegations unless they were satisfied that they had substance. It was no use making charges which would defame a person. Subsequent refutation of denial could not undo the damage already done.

Mr G.G. Swell (Independent) regretted the tone of the speeches made by Mr Raghunath Singh and Mr Prakash Vir Shastri. He said these were the 'kind of speeches from members of the majority community that go to lend an air of legitimate fear in the Muslim minority with regard to the provisions of the Bill'. Similarly, some remarks made by Mr Baddrudduja, in his view, were too sweeping.

He said it was wrong to talk of one Indian culture. India had different cultures, religions, and racial groups. 'It is true that there can be such a thing as Indian culture and an Indian personality but that culture can be an amalgam of different cultures.'

Mr P. Muthia (Congress), supporting the bill, said Aligarh University, like other universities, should work for national unity.

Mr Muzaffar Husain (Republican) opposed the bill. He attacked the education minister for magnifying the small incident at Aligarh and then punishing the university for the misguided acts of a few students.

Mr Sheo Narain (Congress) strongly condemned the murderous attack on the vice-chancellor. The university should set an example of Hindu–Muslim unity and promote secular ideals in the same way as the Hindus and Muslims of Kashmir were cooperating in fighting the enemy.

Mrs Subhadra Joshi (Congress) congratulated Mr Chagla for the steps being taken to improve the working of Aligarh University.

Mr Ramachandra Bade (JS) extended his party's support to the bill and hoped the education minister would bring forward the comprehensive bill he had promised. There was no alternative for the government but to promulgate the ordinance, he said.

Mr Bakar Ali Mirza (Congress), supporting the bill, said the question was academic and it should be dealt with on the academic level. He asked why the university was called the Aligarh Muslim University. The character of a university was something different from a communal appellation. 'The whole concept is fundamentally wrong. I wonder what this Muslim culture is. Muslim religion in India, Morocco, Iran or Afghanistan may be the same but how can culture be," he asked. Even the University Grants Commission felt the word 'Muslim' circumscribed the function of a university.

[1]*The Hindustan Times*, 3 September 1965.

5. Vice-Chancellor Ali Yavar Jung Protests Against Changing the Name of the University[1]

Addressing the staff and students of Sir Syed Hall at its annual function on 9 April 1966, the vice-chancellor, Nawab Ali Yavar Jung, congratulated the students on their good record of attainment in extra-curricular activities and said that these provided excellent opportunities for talent search. That process should not neglect the junior students of the pre-university class. He added that it was important that the university should, as far as possible, also look after the students leaving the university in the sense of endeavouring to find them opportunities for employment. Speaking of Sir Syed,

he said that he was an extraordinary personality, deeply religious in the largest and best sense and having the widest interests, ranging from archaeology to science. He stressed the fact that Sir Syed had established a scientific society, the first of its kind in India, twelve years before founding the Mohammedan Anglo-Oriental College. *The character of the university was derived from the objectives he had in view*, and these were to provide *principally*, but not exclusively, *for the Muslims of India* scientific education in English within a residential system and *in the best of Muslim traditions. There would be for Muslims the teaching of their faith and culture. This character must remain* and assurances had been sought and obtained as regards its continuance. That being the case, *there appeared no meaning in attempting to change the name of the university*. The question was raised from time to time, in and out of season, and caused needless unsettlement. The sovereignty of Parliament was unquestioned and its decision must be accepted by all, but, whether in respect of this university or any other, it was natural to assume that no basic change would be made without consulting the institution itself. *Neither the name nor the character stood in the way of India's nationhood which was composite and in which every component part had to respect the other*. What the country and all educational institutions needed above all was the stamping out of communalism, sectarianism, and regionalism, wherever these were found, as they stood in the way of genuine secularism and national integration. He felt sure that Aligarh could make, *as a Muslim University*, its own contribution to such a process and should be left in peace to perform this task without hurt to its sentiment or the sentiment of others.

[1]Press release by the public relations officer of the Aligarh Muslim University.

6. Education Minister Triguna Sen on Aligarh University and Urdu[1]

The following are the extracts from the interview of Dr Triguna Sen, Union education minister conducted by Sohail Ahmed Khan, special correspondent, *Radiance*, at Patna on 22 April 1967:

Q. Would you like to concede to the demand of the religious minorities for maintaining their own academic institutions at all

levels? For example, would you like that the Islamic character of the Aligarh Muslim University, as bequeathed by its founder, should be maintained and protected?

A. It is the fundamental, democratic right of the minorities, guaranteed by the Constitution, to be provided with every opportunity and facility to maintain their own educational institutions at all levels. The basic Islamic character of the Aligarh Muslim University must be maintained and promoted at all costs and in all circumstances. It is obvious that the name of the Muslim University must also be kept unchanged.

Q. But how do you feel in this regard? As you know, he [Mr Chogla] left no stone unturned to demolish the minority character as well as the name of the Muslim University.

A. I personally feel that Mr Chagla was absolutely wrong in his approach. Rather he went beyond his limit.

Q. Would you propose that the history books for the schools and colleges be written in a manner to ensure correct information about facts as well as promote national harmony? In this regard how do you think about the historical fabrications of Mr P.N. Oak? Won't you like that the antics of such 'historians' be immediately checked in the interest of the national harmony?

A. I fully agree with you. Gentlemen like Mr P.N. Oak are not only distorting and perverting the history of India but are, in fact, destroying the unity of the nation. I would like to see the mischievous activities checked. They are a positive danger to our national interests.

Q. Do you think that the tongue of a community is the medium of expression for its culture? Isn't it a truth that Urdu is the cultural medium of the Muslims of India? Would you like that Urdu should be recognized as the regional and official language of the states where there is a considerable population of Urdu-speaking people, like UP, Madhya Pradesh, Maharashtra, Bihar, Andhra, Rajasthan, etc.?

A. Yes! Urdu must be recognized as the regional and official language of the states, where a considerable number of people claim it as their mother tongue.

[1]*Radiance*, Weekly, Bihar, 7 May 1967.

7. Jayaprakash Narayan delivers AMU's Convocation Address[1]

Shri Jayaprakash Narayan, Sarvodaya leader delivered the Aligarh Muslim University's convocation address on 10 February 1968.

Excerpts:

You all know of the revolutionary role played by this university and its great founder in breaking down the barriers of obscurantism and in tearing off the blinkers of a past—a past that was no doubt glorious but that effectively hid the present and obstructed the view into the future—and thus in introducing the Muslim community into the world of modern knowledge.

In many ways the present situation is similar to that encountered by Sir Syed Ahmed Khan. The passage of the Mughal empire and its replacement by British Raj were such a shattering experience for the Muslims of those times that it took the genius of Sir Syed and his colleagues to enable the Muslim community to make a creative adjustment to the changed conditions. One may argue whether the adjustment made was the wisest in the long-range view; but, it was not easy then, in the face of the rising sun of an alien empire, to visualize at once its eventual passage and replacement by an indigenous power.

Alive and kicking

Though, at the height of the Mughal empire the issue of 'Muslim power *v* Hindu power' had seemed to have been finally settled, it was soon after made clear that the issue was alive and kicking. The rise of the British power only pushed the issue aside. Even in those early days, it slowly became clear that there were two ways of resolving the issue. One was for each of the contending communities to try to ally itself with the foreign power in order to secure for itself the maximum benefit. That meant indefinite continuance of the foreign power, and suited it extremely well. The other was for both the communities to combine to expel the foreigner and share power together.

What happened in the event is an oft-told tale, and it will serve little purpose to dwell upon it here. Suffice it to say that at this university too, there were contenders for both philosophies, with perhaps the overall bent being towards the first. For his part, the foreigner did his best to keep it wholly under his sheltering wings,

but it is clear that he did not quite succeed, witness the contribution made by the alumni of this university to the composite national movement and to socio-economic radicalism; also witness one of them joining the non-cooperation movement and eventually coming to occupy the highest office in this secular and democratic state.

What is relevant to the present is that the old issue, in spite of the drastic surgery of partition, still continues to be of paramount importance. The reason is that though the feudal system has been destroyed, the feudal mentality persists. In that feudal system, the religion of the overlord at the top settles the issue decisively. In it, sharing of power can only be nominal. It is only in a secular democracy that power can be shared. As long as the feudal mentality lasts, and the past dominates the minds of men, as it does in India, the question of 'Hindu power and Muslim power' will remain a vexed question and an open, running sore.

Difficult situation

The fact that after partition Pakistan decided in favour of Muslim power and constitutionally established what it called a Muslim state, in which the Hindu minority —the same is true of other minorities— was deliberately placed under certain disabilities, such as no non-Muslim can be the president of Pakistan, inevitably produced a reaction in this country. Accordingly, we have today open and hidden protagonists of the Hindu *rashtra* or Hindu state.

The hangover in the minds of Indian Muslims from the days of the two-nation theory and the psychological reaction to the militant Hindu *rashtra* movement place the Muslims in a most difficult situation.

To my mind the role of this premier Muslim university is cut out by this situation. As I conceive it, that role is to lead the Muslim intelligentsia out of the dilemma in which they are placed. I must at once say that is not by any means an easy role to play, nor can this university alone play it successfully. But the university will find in the enlightened social, economic, and political forces of the country its powerful and effective allies. What is needed is a clear and unaltering vision.

Unreal world

The process as I see it—equally valid for India and Pakistan—is growth out of the feudal mentality and stagnation, into the modern, democratic, secular mind and radical, social, and economic

transformation and development. To put it differently, the solvents of communal reaction, whether expressed in aspirations of domination or in those of isolationism and inward withdrawal, are democracy, secularism, socio-economic radicalism, and economic development.

As a reaction to militant Hindu nationalism, there is a movement among Muslims of isolation and separatism and withdrawal into a dream world that is not of the present or of the future, but of the past. I invite this university to draw the Muslims out of that unreal, artificial, self-regarding, self-satisfying world into the battleground where the fight for secular democracy, a revolutionary social order, and economic growth is being fought. To stand aside from the battle is to strengthen the forces working for a communal state.

[1]*Janata* (weekly from Bombay founded by Jayaprakash Narayan), 17 March 1968, p. 5.

8. A record of persistent breaches of assurance to minorities[1]

For the past seven years the leaders of the Congress party including the prime minister have been assuring the Muslims that a comprehensive bill for the Aligarh Muslim University would soon be adopted by the Parliament. This bill would satisfy the aspirations of the community and would be based on the recommendations of the Chatterji Committee and the Beg Committee.

The Aligarh Muslim University (Amendment) Act, 1972, as passed by the Lok Sabha is a betrayal of these promises and has greatly disappointed Muslims. We give below a few concrete examples of these assurances.

1965: Soon after the 1965 ordinance Muslim members of Parliament under the leadership of the late Dr Syed Mahmood met the late Mr Lal Bahadur Shastri, the then prime minister of India. They were assured by the then PM that the minority character of the University would be restored.

1 September 1965: The late Mr Lal Bahadur Shastri wrote to the secretary of the Old Boys Convention Council on 1 September 1965 assuring him that the character of the AMU will remain the same. (True copy of the letter attached as Annexure 1.)

Mr Fakhruddin Ali Ahmed on many occasions assured the Muslims that the new bill would be in accordance with the aspirations of the Muslims.

30 September 1966: A deputation of Old Boys met Mr Fakhruddin Ali Ahmed who assured them that the PM would visit the university on the occasion of Sir Syed Day (17 October) and would declare the policy in regard to the AMU based on the recommendations of the Chatterji Committee (Annexure 2).

May 1967: The then education minister Shri Triguna Sen assured a delegation of Old Boys that the minority character of the institution will be maintained.

2 August 1968: Mr Fakhruddin Ali Ahmed called a meeting of Muslim luminaries and out of them appointed a committee of eight persons known as the Beg Committee and assured that the bill would be based on its recommendations. In September 1968, the Beg Committee submitted its report to Mr F.A. Ahmed who forwarded it to the minister of education.

7 September 1971: Mr Fakhruddin Ali Ahmed assured a meeting of Amarate-Sharia, Patna, that the AMU bill, based on the recommendations of the Beg Committee would be placed before the Lok Sabha during its forthcoming session.

<div align="right">

Shafiqur Rahman
Convenor
All India Muslim University Action Committee.

</div>

Annexure 1

Late Prime Minister's Assurances

<div align="center">

No. 3735–PMO/65
Prime Minister's House, New Delhi.
1 September 1965

</div>

My dear Abbasi Saheb,

I am very sorry that I could not reply to your letter of 12 August 1965 earlier, as I have been very heavily preoccupied. I have had talks here with friends including a few Muslim members of Parliament. The bill which is before Parliament is only to replace the ordinance which was issued. The main bill will actually come up in the next session of Parliament. The character of the university

will also remain the same. I think now there should not be any cause for further misgivings about this matter.

<div style="text-align:right">Yours sincerely
Sd: Lal Bahadur</div>

Shri Kazi Jalil Abbasi, MLA
31-A, Darul Shafa, Lucknow.

Annexure 2

Prime Minister's Assurances before the 1971 Lok Sabha Elections

A summary of our pre-election talks with the leaders of the Congress party, including Prime Minister Smt Indira Gandhi is given below. A detailed note was sent to Mr D.P. Misra and through him to the PM on 7 April 1972. Mr Misra acknowledged the receipt through a mutual friend, but no receipt has been received from the prime minister's office. Mr Misra has not so far denied any of the facts given below. Moreover, in my presidential address of 6 May 1972, I reiterated the assurances given to me by the Congress leaders. Copies of this document were sent to all concerned. None of the facts mentioned therein have been contradicted by any Congressmen.

I give below a datewise summary of the talks:

30 December 1970: At 6 p.m. I had talks with Mr Chandrajit Yadav, MP and Mr Kedar Nath, MP lasting about two hours at Meena Bagh, New Delhi. They asked me for the exact terms on which Muslim Majlis would support the Congress (R) in the 1971 Lok Sabha elections. After the discussion an eight-point programme was agreed, which was typed and given to Mr Chandrajit Yadav who promised to deliver it to the PM with copies to Mr U.S. Dixit and to Mr D.P. Misra. It contained items regarding: (1) the status of Urdu, (2) economic issues concerning Muslims, (3) constitution of Minority Councils, (4) Aligarh Muslim University, (5) school textbooks, (6) parliamentary constituencies, (7) Rajya Sabha elections, and (8) certain miscellaneous items.

31 December 1970: At the residence of Mr D.P. Misra, 11 Race Course, New Delhi, Mr Misra said that he agreed with each one of the points, but asked me to keep them confidential for the time being and also promised to speak to the PM about them.

3 January 1971: Mr D.P. Misra sent a messenger to Lucknow to ask me to go over to Delhi to talk to the PM and therefore I went there.

4 January 1971: At 10 a.m. Mrs Subhadra Joshi came to see me and I gave her a copy of the above-mentioned programme. At 1 p.m. the prime minister arrived at the residence of Mr D.P. Misra. She had my eight-point programme in her handbag. She brought the paper out and we discussed each point in detail. She suggested another meeting as I had requested Mr D.P. Misra to include as many items as was possible in the election manifesto.

15 January 1971: Bakshi Ghulam Mohammad Saheb, Mufti Atiqur Rahman, and Mr Yunus Saleem came to Lucknow and brought with them a copy of the draft Congress manifesto. At 6 p.m. I went to Bakshi Sabeb's room at Carlton Hotel and immediately after reading it I rejected the draft. Three fresh points on which all of us agreed were added, typed, and handed over to Bakshi Saheb. They left for Delhi the same night.

22 January 1971: At the residence of Sardar Jogendra Singh MP (Electric Lane), Mr H.N. Bahuguna and I discussed the current affairs. At 10 p.m. Mr Bahuguna came to take me to the prime minister's residence for final talks which lasted for about forty-five minutes. Mr H.N. Bahuguna and Mr U.S. Dixit sat outside the room. It was mutually agreed to add the following paragraph in the Congress election manifesto, and Mr Bahuguna wrote them down:

Minorities:

51. In keeping with its past traditions, the Congress is pledged to protect the rights and interests of all minorities.
52. The dark and evil forces of right reaction which masquerade in a variety of forms are intent upon destroying the very base of our democratic and socialist objectives. They are attempting to consolidate their position. They exploit some of the genuine grievances of the people and arouse the emotions of various sections by preaching religious fanaticism, racial supremacy, and chauvinism. History records that fascist forces always emerge through such nefarious manoeuvres. The Congress is determined that this shall not happen in our country. And for this purpose, it will take effective measures in all fields, including education at all its stages.
53. The Constitution lays down that the state and local authorities should provide adequate facilities for instruction in the mother tongue at the primary stage of education to children belonging to linguistic minority groups. It shall be our endeavour to implement this.

54. Secularism is one of the basic tenets of our Constitution. In accordance with this constitutional imperative the Congress will strive to ensure that all minorities have full freedom to establish, manage, and run educational and other institutions.

55. The Congress will strive to ensure the democratic functioning and protect the autonomous character of educational institutions including those established at the instance of and for the benefit of minorities.

56. The Congress is fully alive to the need for encouraging literary pursuits in different languages. In this context, Urdu shall be given its due place which has been denied to it so far.

57. The Congress will make every effort to prevent discrimination against minorities in the matter of recruitment in services.

58. The Congress is pledged to promote with special care the educational, employment, and economic interests of the weaker sections of the people particularly the Scheduled Castes, the Scheduled Tribes and the backward classes. Urgent attention must also be given to the socio-economic problems faced by Muslims, Christians, and other religious and linguistic minorities who have not had equal opportunities.

The PM specifically stated that paragraphs 54 and 55 referred to Aligarh Muslim University. At the PM's suggestion the name of AMU was not mentioned as that would excite the opponents and if the name of one minority institution was mentioned it would be unfair to delete the others, viz., Christian College, etc. The words 'injustice to Urdu' were also added in paragraphs 53 and 56. The PM also remarked that there would be no difficulty in establishing an Urdu university in UP. The formation of Minority Councils was accepted in principle. Some other points were also discussed.

I returned to Western Court at about midnight.

24 January 1971: I met Pandit Kamalapati Tripathi at Sardar Jogendra Singh's residence. He knew all about our talks and assured me 'that all the promises would be fulfilled as they were gentlemen's agreement'.

25 January 1971: Mr H.N. Bahuguna showed me at 1 p.m. the cyclostyled copy of the Congress election manifesto to confirm that all the newly added paragraphs were there and in the correct form agreed to between us. The manifesto was later on released to the press.

6 June 1971: I met the PM in her office at 4 p.m. and requested her to fulfil her pre-election promises. She gave a patient hearing and asked me to speak to the chief minister of UP about the same. Regarding Aligarh Muslim University she said that the home minister was looking into the matter.

31 October—2 November 1971: A deputation of Muslim Majlis met Mr Fakhruddin Ali Ahmed, Mr Moinul Haq Chowdhry, Mr S.S. Ray and Mr Noorul Hassan, because the PM had entrusted the drafting of the bill to these ministers of the Union government. They did not even remotely hint that the bill would take the shape and form in which it has been adopted.

It is, therefore, clear from the above that the Muslim voters in particular were asked by the leaders of the community to vote for the Congress (R) in 1971 general elections for the Lok Sabha, on the basis of specific assurances given by the Congress (R) leaders. Over 90 per cent of Muslims voted for the Congress on our appeals. The two-thirds majority which the Congress got in the Lok Sabha is undoubtedly due to Muslims voting en masse for the Congress party. It is unfortunate that not a single one of the aforesaid promises has so far been fulfilled by the PM or the chief minister of UP in spite of the 'gentleman's agreement' (to quote Pandit Kamalapati Tripathi).

A.J. Faridi

[1]Cyclostyled document dated 4 July 1972 distributed by Dr A.J. Faridi. Excerpts reproduced in *Freedom First*, a Bombay monthly, September 1972.

9. Aligarh not to be Declared a Minority Institution[1]

The minister of state for education, Mr. S. Nurul Hasan, rejected the demand that Aligarh Muslim University be declared a minority institution.

Replying to the debate in the Lok Sabha on the budget demands of his ministry—which were later voted—Mr Hasan said on 6 April 1973: 'Aligarh Muslim University was never a minority institution under the terms of Article 30(1) of the Constitution.

'The government has no intention of changing the character of the university and accepting the contention that it be declared a minority institution.

'The government has, however, no intention of changing the historical character of the university which is defined in the Preamble and Sections 4(1) and 5(2) of the (Aligarh University) Act.'

As a result of historical developments, however, the court, the executive council, and the academic council of the university 'have

a majority of Muslim members and the government has no intention of altering this situation'.

[Article 30(1) of the Constitution, to which Mr Hasan referred says: 'All minorities, whether based on religion or language shall have the right to establish and administer educational institutions of their choice.']

Any changes in the statutes of the university which the academic and executive councils might propose would be given due consideration by the government, the minister added.

'We do not want it to become a football in a playing field,' Mr Hasan said spiritedly.

Full support

The minister said the government would continue to give the fullest support to the vice-chancellors of Aligarh and Benaras universities in whatever steps they might take to maintain discipline on the campuses.

The government, he said, was unhappy with the consistent campaign to denigrate the vice-chancellor of Benaras Hindu university. He agreed with the suggestion that the question of communal activities in BHU required an examination in depth. The government would apply its mind to find out how best to meet this situation.

Mr Hasan said he could not accept the view that the AMU had been deprived of its autonomy. In all essential matters such as the powers of the vice-chancellor, methods of appointment of deans and heads of departments, the provisions of the AMU Act were similar to those of the Jawaharlal Nehru University Act.

If there was any difference at all it was that there was more representation on academic bodies for the younger generation of teachers in the case of AMU.

The minister did not accept the suggestion that the Constitution should be amended to make education a Central or Concurrent subject.

Education, he said, was the common task of the Central and state governments, and the best results could be achieved if they worked in a spirit of cooperation instead of viewing it as a Central versus State issue.

Referring to the various points raised by members, Mr Hasan said the police and customs officials were being specially trained to prevent the smuggling out of this country of antiques and art

treasures and other historical relics, now that the Antiquities and Art Treasures Bill—passed earlier by Parliament—has become law.

'Rules under the law were being urgently framed, and the state governments were extending their cooperation in enforcing the law.'

Distortion of history

The minister referred to the constitutional provision that every child should receive primary education in the mother tongue. The government, he said, stood by the policy that Urdu-teaching facilities at the secondary school level should be provided wherever there was a reasonable number of Urdu-speaking pupils.

Orders had already been passed that Urdu teaching should be provided in twenty-seven Central Schools where there were about 1880 pupils.

Mr Hasan said there was a great deal of distortion of facts in the history books used in schools. It was necessary that these distortions should be removed. The NCERT (National Council of Educational Research and Training) had already brought out three books on history.

Referring to the higher education of the Scheduled Castes and the Scheduled Tribes, Mr Hasan said 20 per cent of the seats in the Indian Institutes of Technology were reserved for them. But they were not being fully utilized.

Mr Hasan also said the Centre was considering a proposal of the Pondicherry government to establish a Central university there. He said the proposal had been supported by the University Grants Commission.

Mr Nageshwar Dwivedi (Congress) called for adequate attention to the development of Sanskrit 'which was the fountain of our culture'.

Mr Paokai Hokip (Congress) suggested that education should be taken over by the Centre for some time so that it could be 'streamlined' throughout the country. He complained that children in the rural areas were not even aware of the facilities such as free midday meals which were available in the urban areas.

Mr A.K.M. Ishaque (Congress) said the government should allow independent functioning of academic bodies instead of gradually encroaching upon their administration.

Mr Chandrika Prasad (Congress) wanted public schools to be closed down. The government schools should be raised to the standard of public schools so that the latter would lose their glamour.

Mr Mulki Raj Saini (Congress, UP) criticized the public schools and demanded that the government should nationalize education. Mr Dalip Singh (also Congress) called attention to the 'neglect' of the village schools. He would have greater discipline enforced in coeducation schools.

Mr Shibbanlal Saxena (Independent) was 'ashamed' of the low priority assigned to education. Larger funds should be allocated for the development of sports, he added.

Aligarh students to apologize

The executive committee of the Aligarh Muslim University Students' Union has unanimously decided to apologize to the members of the university executive council for 'some indecent happenings that took place during the demonstration staged by the students before the council on 3 March 1973'.

The executive committee of the union met the same day and said in a letter that the union noted with regret 'the indecent happenings which might have hurt the feelings of the members' of the university council.

[1]*The Times of India*, 7 April 1973.